IMPRESSIONIST GARDENS

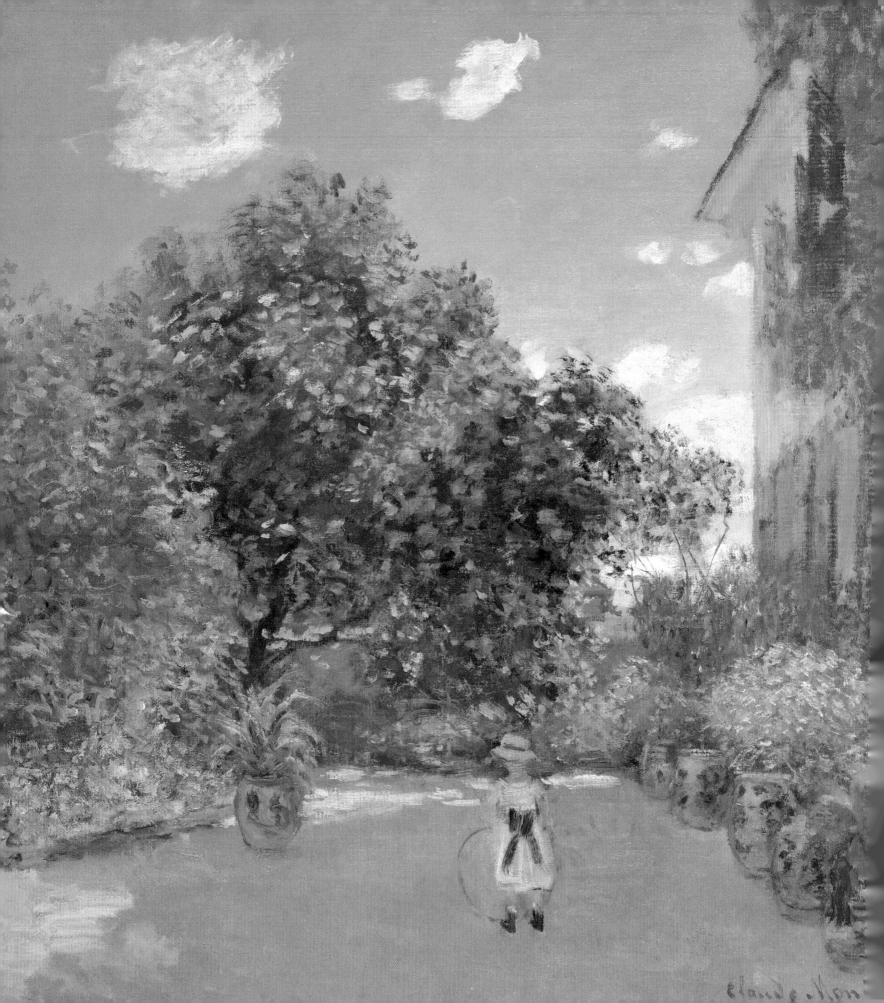

CLARE A. P. WILLSDON

Impressionist Gardens

NATIONAL GALLERIES OF SCOTLAND

EDINBURGH · 2010

Published by the Trustees of the National Galleries of Scotland
to accompany the exhibition *Impressionist Gardens*, held at the
National Gallery Complex, Edinburgh, from 31 July to 17 October
2010. The exhibition was shown at Museo Thyssen-Bornemisza,
Madrid, from 16 November 2010 to 14 February 2011.

The exhibition was curated by Michael Clarke, Director of the
National Gallery of Scotland in Edinburgh and Clare A.P. Willsdon,
Reader in the History of Art at the University of Glasgow.

© The Trustees of the National Galleries of Scotland 2010
The right of Clare A. P. Willsdon to be identified as the author of
this work has been asserted by her in accordance with the
Copyright, Designs and Patents Act 1988
ISBN 978 1 906270 28 5

Designed and typeset in Minion and Fairfield by Dalrymple
Printed on Perigord 150gsm by Die Keure, Belgium

Front cover: detail from Pierre-Auguste Renoir *Woman with Parasol
in a Garden* [21], 1875–6, Museo Thyssen-Bornemisza, Madrid

Back cover: Edouard Manet *The Croquet Party* [17], 1873
Städel Museum, Frankfurt am Main

Frontispiece: Claude Monet *The Artist's House at Argenteuil* [18], 1873
The Art Institute of Chicago

The proceeds from the sale of this book go towards supporting
the National Galleries of Scotland. For a complete list of current
publications, please write to NGS Publishing, Scottish National
Gallery of Modern Art, 75 Belford Road, Edinburgh EH4 3DR
or visit our website: www.nationalgalleries.org

National Galleries of Scotland is a charity registered in Scotland
(no.SC003728)

Contents

Sponsor's Preface

BNY Mellon is committed to assisting in the enrichment of the cultural life of communities around the world and we are delighted to support the National Galleries of Scotland in bringing the remarkable exhibition *Impressionist Gardens* to Edinburgh.

Our commitment to the arts, as part of our wider philanthropic endeavours, has spanned many activities and geographies, and it is always a special privilege to support groundbreaking projects. As the very first exhibition to explore the Impressionists' fascination with gardens, flowers and design, and one which includes masterpieces by Cézanne, Delacroix, Gauguin, Monet, Renoir and Van Gogh to name but a few, *Impressionist Gardens* is certainly one such landmark exhibition.

The National Galleries of Scotland are committed to curating, developing and making accessible the national collection and strive to engage the broadest possible audience through their exhibitions, educational activities and publications. This championing of public access and education reflects the key principles that inform BNY Mellon's international programme of arts sponsorship. We hope that you enjoy visiting *Impressionist Gardens*.

WILLIAM A. KERR
Vice Chairman, Europe
BNY Mellon

BNY MELLON

Directors' Preface

This is one of the most ambitious exhibitions we have mounted at the National Galleries of Scotland. It brings together the two subjects of Impressionism and Gardens and is designed to appeal to enthusiasts of both. Gardens formed one of the major and recurring themes of Impressionism, culminating in Monet's depictions of his famous garden at Giverny. The exhibition preludes with the forerunners of Impressionism, followed by a central focus on the different types of garden depicted by the Impressionists. The final section looks at developments of this subject in Europe and the United States in the aftermath of Impressionism's heyday in the period leading up to the First World War – in many ways a more natural terminus for the exhibition than the end of the nineteenth century.

Impressionist Gardens was suggested to us by its guest curator, Dr Clare Willsdon, Reader in the History of Art at the University of Glasgow. We are deeply grateful for her commitment to the successful realisation of this project and for her tireless endeavours throughout its lengthy and complex gestation. In a Scottish context, it is gratifying that the show represents a collaboration between the National Galleries and one of Scotland's oldest and most distinguished universities. It has also benefited greatly from the expert advice of our colleagues at the Royal Botanic Garden Edinburgh and we thank the Regius Keeper, Professor Stephen Blackmore and his staff, in particular David Mitchell, who has supplied valuable information on many of the plants and flowers depicted in the paintings

The scope of the exhibition is truly international, however, and is presented as our major showpiece to coincide with the 2010 Edinburgh International Festival. We are delighted that the Museo Thyssen-Bornemisza in Madrid agreed to be our partner in this enterprise and express our deep gratitude to its Artistic Director, Guillermo Solana, and his colleagues. Both the Museo and the Baroness Carmen Thyssen-Bornemisza have been most generous with loans. The exhibition will be shown in Madrid from November 2010 to February 2011.

Ambitious exhibitions are heavily reliant on sponsorship and we are most grateful for the enlightened support of BNY Mellon.

The exhibition design has been undertaken by Edward Longbottom, and that of the catalogue by Robert Dalrymple. Many staff colleagues at the National Galleries of Scotland have worked tirelessly on the show's behalf, and particular mention must be made of Janis Adams, Head of Publishing.

Finally, and most importantly, *Impressionist Gardens* would have been impossible without the co-operation of the lenders and we thank them all most warmly for their generous responses to our requests for loans.

JOHN LEIGHTON
Director-General, National Galleries of Scotland

MICHAEL CLARKE
Director, National Gallery of Scotland

Foreword

Gardens occupy a special place in man's relation to nature: they are created by him with varying degrees of control, they are nourished by him but, with their fragile materials, they are also subject to the vagaries of climate and the threat of destruction or ruination by outside forces. Nearly all the great civilisations have embraced gardens, though their forms and purpose have differed widely. In the western Christian tradition, man originally inhabited the paradisal Garden of Eden, from which he was ejected by God for falling prey to temptation. Inherent in this construct was the concept of the garden as a place of refuge, of protection. The garden became the measure of man's safety.

In later medieval art, particularly in illustrations in illuminated manuscripts, we are presented with an earthly vision of Eden in which the wall surrounding the monastic complex represented the boundary between

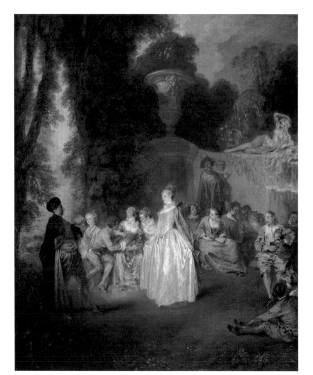

[fig.1] Antoine Watteau
Les Fêtes Vénitiennes, 1718–19
National Gallery of Scotland, Edinburgh

the cultivated and the wild, between order and chaos. The layout of the garden was suffused with symbologies, often connected to the cult of the Virgin Mary. Situated within the garden complex was the necessary food garden, established for the sustenance of the community. It contained both herbaria and orchards and was known by its Latin name, *hortus*, a term dating from antiquity and denoting a garden intended for vegetables and other useful plants. In ancient Rome the garden had been a prestigious ornament of sumptuous private residences. The utilitarian *hortus* was complemented, and later superceded in importance, by the viridarium with its ornamental plants, sculptures and fountains. It was a sacred realm, but also one of repose and ease, a *locus amoenus*, a 'pleasant place'.

By the Renaissance the garden had become planned, ambitious and grander in scale. Building on ancient Roman practice, it was developed as a fitting complement to the villa it surrounded. It looked beyond its confines and took account of the nearby landscape. It was no longer strictly enclosed and took its place more easily in nature, which itself ceased to be seen as such a threatening force by an increasingly curious and knowledgeable populace, who travelled more widely beyond the immediate confines of their cities and states.

Mastery and ordering of nature were signalled in the Baroque garden, often laid out on a vast scale to proclaim the earthly powers of rulers, most notably in Le Nôtre's regimented gardens at Versailles, designed during the seventeenth century for Louis XIV. This was succeeded by the urban sophistication and playful invention which characterised the gardens and parks of the Rococo, memorably adapted by Antoine Watteau and his followers as the settings for their paintings of *fêtes galantes*, images which carried with them a strong hedonistic undertow of amorous intrigue [fig.1].

In the course of the eighteenth century the aesthetic concerns of the garden spilled over into the landscape park, which entailed the design of whole estates on

[fig.2] Detail from Edouard
Manet *The Croquet Party* [17]
1873
Städel Museum, Frankfurt am Main

[fig.3] Detail from Gustave
Caillebotte *The Dahlias,
Garden at Petit-Gennevilliers*
[41] 1893
Private Collection

patterns and principles derived, not from nature, but from art itself, from the idealised landscapes of painters such as the seventeenth-century artist Claude Lorrain. A view could be deemed 'picturesque', literally 'from a picture'.

The various elements that go to make up a garden remained fairly constant throughout the ages – earth, rocks, statuary, water, trees, plants and flowers. The latter, especially, proliferated in their variety. Certainly, by the sixteenth century the number of available species in Europe had greatly increased and in the early years of the nineteenth century we find Napoléon's Empress Joséphine importing an impressive variety of roses with which to decorate her garden at Malmaison on the outskirts of Paris.

In the years leading up to Impressionism there was essentially a bifurcation between public and private gardens, reflecting society's broader separation of the State and the bourgeois individual. Under Louis-Napoléon Paris underwent a radical programme of urban renewal, which sought to eradicate the original medieval plan of the city. Counterbalancing parks were developed in the Bois de Boulogne to the west and the Bois de Vincennes to the east, with the Buttes-Chaumont to the north and Montsouris to the south. No fewer than twenty-four public squares were inserted into the fabric of the city. These public gardens formed the setting for a number of the Impressionists' depictions of urban modern life. Their protagonists, however, were contemporary men and women, not heroes and heroines of antiquity or elaborately costumed courtiers or theatrical types. This was a pullulating 'paradise' based on affluence set amidst the controlled munificence of the State.

The most extraordinary transformation of the garden picture took place in the private sphere. In their suburban gardens in small towns and villages, situated in their favoured indeterminate zone between town and country, the Impressionists used the garden as a visual forcing ground, a place of audacious experiment. The rich growths and refulgent colours of the flowers in these gardens formed a perfect vehicle for the Impressionists' fascination with the contrasts and heightening of colour perception made possible both by their own visual daring, and by the new industrially produced paints that were available to them. Thus it was in the garden that the Impressionists produced some of their most remarkable creations, which today are universally admired.

And yet, for all their modernity and experimentation, the Impressionists' garden scenes also distantly echo older traditions. The sense of intimate privacy, evident in Monet's depictions of his garden and family at his home at Argenteuil, recalls the protected world of the medieval *hortus conclusus*, an enclosed garden. The evidence of labour and produce in the field and in the garden, depicted by Pissarro and Sisley, displays a lineage, in concept at least, that can be traced back to the working gardens of antiquity. Manet's *The Croquet Party* [fig.2] can be loosely interpreted as a modern reworking of the *fête galante*. The affluent Caillebotte's gardens at Petit-Gennevilliers [fig.3] and Yerres exhibit the same ordered production that would have been evident in the great villa gardens of classical times and of the Renaissance. What set the Impressionists most strikingly apart from their predecessors, however, was their direct and highly visual concentration on the garden itself and its rich and seductive beauty. And it is this quality, above all, which still thrills us today.

MICHAEL CLARKE

Impressionist Gardens: Introduction

'As soon as Renoir had crossed the threshold of the door, he was charmed by the view of the garden which resembled a beautiful abandoned park', recalled Georges Rivière of his friend's choice of a studio to rent in Montmartre.[1] Fourteen years later, in 1890, Claude Monet's friend, the writer and amateur gardener Octave Mirbeau, proposed a rendezvous with the Impressionist Gustave Caillebotte with the promise, 'We will talk gardening, as you put it … there is only the soil'.[2] Later still, in 1913, Max Liebermann, the leader of the Berlin Impressionists, writing to his friend Alfred Lichtwark, commented that 'the garden at the moment is in most beautiful flower and gives my wife and me gigantic pleasure'.[3] The artists Pierre Bonnard and Edouard Vuillard, visiting Liebermann at his garden paradise at Wannsee near Berlin the same summer, were in turn reportedly 'charmed' there.[4] These comments are but a snapshot of Impressionist views, but already begin to show that gardens were truly a passion for these artists. Monet even rated his Giverny garden, so famous today, above his paintings, calling it his 'most beautiful work of art'.[5]

Monet anticipated the present exhibition of Impressionist gardens when, in 1909, he brought together some forty-eight paintings of his Giverny water garden in his great *Les Nymphéas, Série de paysages d'eau* (Waterscapes) exhibition in Paris. In turn his gift of his water lily decorations to the French State as its First World War Memorial for the Orangerie in Paris created a permanent exhibition both of his garden and of Impressionism. Three paintings from *Les Nymphéas* are reunited here, together with another painting of his water garden from the same period as his Orangerie murals [78–80, 95].

However, although Monet is the artist most readily associated with Impressionist gardens, this exhibition also takes us across Europe and to America, down tree-lined paths (*allées*), through ivy-clad undergrowth, into hidden corners of the kitchen garden, over spacious lawns – even up to the clouds, via watery reflections. Each painting is a portrait of a garden or type of garden

– and of its artist. As Stéphane Mallarmé, poet, friend and supporter of the Impressionists, wrote in 1876, 'that in which the painter declares most his views is his choice of subjects'.[6] In the case of the Impressionists not only did this apply to their gardens but also to their plants, many of which are believed to be identified here for the first time. Despite the characteristic loose brushwork of the Impressionists, a remarkable number of the plants depicted in their paintings can be recognised, and it is possible to see that they were chosen with care and used to lend significance to the Impressionists' garden imagery or to appeal to particular viewers. Well before Monet's famous plantings of choice water lilies, roses, peonies, irises and orchids at Giverny, for example, the botanical imagery of his paintings clearly shows he was cultivating newly-developed and exotic species in his garden at Argenteuil.

As nature ordered and planted by human hand – what the nineteenth-century French geographer Elisée Reclus called 'nature fashioned by work'– gardens take their place alongside other forms of intervention by mankind in the environment, from the making of cities to the building of railways.[7] Paintings of gardens by the Impressionists complement their other chosen imagery – Paris, the cultivated fields which fascinated Camille Pissarro and Alfred Sisley, and the bridges, roads and canals that so radically altered the relationship of city and country, for example. The many angles recently used by art historians to interpret these other works – class, gender, social and political, to name but a few – are, of course, also relevant to paintings of gardens.[8] The Italian expatriate Federico Zandomeneghi's *Place d'Anvers* [54], for example, a colourful, almost decorative view of one of the garden squares of Paris, yields deeper layers of meaning when class and social history are considered. Its scene of workers at leisure in one of the new gardens in poorer parts of Paris clearly complements the coming to power in France of the 'Republican Republic' which was claimed to be the worker's friend. Similarly, Berthe

Detail from Vincent van Gogh
Garden with Path [72]

Morisot's imagery of her daughter Julie playing with her toys in the flower-filled garden of the family's holiday home at Bougival [29, 31] can be seen as an example of a 'feminine sphere': excluded from the male environments of commerce or government, Morisot painted her own domestic milieu.[9] For her, however, the garden also held a deep romance of its own; in adulthood she recalled her bitter disappointment, as a fourteen-year-old, at being forbidden from spending all night in the garden.[10]

Yet rising above any theoretical interpretations is the heartfelt passion for gardens which shines through the

gardens'.[12] In contrast to the distant mountain peaks and exotic lands favoured by the earlier nineteenth-century Romantic painters, however, gardens were distinctively local landscapes, seen or used every day. Created on a human scale, they offered all the frustrations that are still the lot of modern gardeners. 'I have safely received your package of border plants but I am afraid they won't take root, it is so hot and dry here. It's a disastrous year for my poor garden, because on top of the drought I have cockchafer grubs which are devouring everything of mine', wrote Monet mournfully to Caillebotte in 1891.[13]

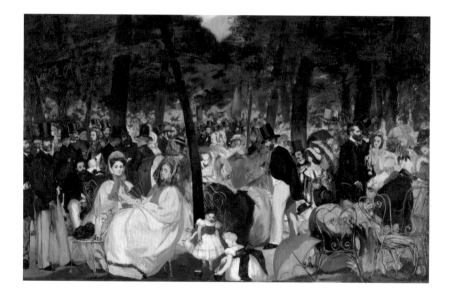

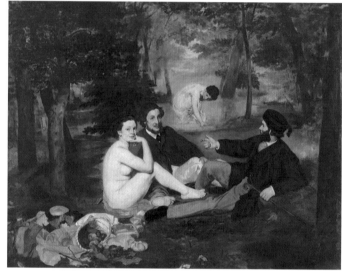

[fig.4] Edouard Manet
Music in the Tuileries Gardens,
1862
The National Gallery, London

[fig.5] Edouard Manet
Le Déjeuner sur l'herbe, 1862–3
Musée d'Orsay, Paris

comments at the start of this chapter, as well as other writings of the period. A complex and infinitely varied motif, governed by the ever-changing seasons and weather, the garden is in one sense an obvious choice for artists so concerned with personal experience and the swift impression. But gardens are peculiarly also places of slow, gradual change – what the French call *la durée* – in contrast to the instant. They are places to be keenly savoured over time, noting the coming into bud of a shrub or the falling of the first leaf; if you grow your own garden, there is also a sense of personal pride or regret at such events. In the eyes of the Impressionists, as the art historian John House has recently argued, gardens could even be 'imaginative spaces', offering scope, for example, to reinvent the 'Garden of Love' imagery of the *fêtes galantes* of Watteau and Fragonard in the eighteenth century.[11] The nineteenth-century novelist George Sand certainly saw the new gardens created in Paris in the 1860s – some appearing almost overnight as flowers and fully-grown trees were transplanted at their prime from nurseries and forests – in terms of fantasy projection, writing of 'the fictions of our theatres and our

In the nineteenth and early twentieth centuries, gardens also became places of modern science and technology, and economic benefit. New developments in horticulture, botany, and urban design were central to their being and produced ever more colourful and extravagant flowers and layouts, as well as improved methods of commercial production of both vegetables and flowers. It is revealing, for example, that it was an engineer, Alphonse Alphand, who was put in charge of the parks of Paris in the mid-nineteenth century, as integral parts of the city's urban planning. As well as the artist's garden, three key types of garden – the public park, the small private leisure garden, and the commercial market garden – were effectively born in the nineteenth century, with the first two arguably reaching a peak of sophistication in the era of Impressionism.

GARDENS AND MODERN LIFE

After coming to power in France in 1851, Louis-Napoléon (Napoléon III) had launched an ambitious renewal of Paris to improve its hygiene and transport, and, not least, to project a public image of beauty.[14] Tree-lined streets

were created by Baron Haussmann, Prefect of the Seine, together with gardens which provided choice flowers, greenery and clean air; purpose-built nurseries and greenhouses were constructed to supply the vast quantities of bedding plants required.[15] New and rare species made the Parc Monceau into a veritable horticultural display, and the Bois de Boulogne, a former royal forest, was laid out with meandering paths for horse riding, flower gardens, two lakes fed by an artesian well, and numerous popular distractions. The Buttes-Chaumont Park was an entirely new creation, regarded by many as artifice taken to extremes. Its hills were concrete and its exotic flowers and shrubs made it seem like a colonial possession transplanted to Paris. It was as much a display of imperial power as the formal gardens at Versailles had been a symbol of absolute monarchy.

The Parisian developments were partnered, and in some cases directly emulated by, those of many other cities in Europe and in the United States of America; they also inspired private gardeners. Horticultural societies, exhibitions and publications abounded, as part of the 'great horticultural movement'.[16] Parks and gardens also provided inspiration for foreign colleagues of the French Impressionists, from the Austrian artist Fritz Schider, who evoked the crowds in the English Garden in Munich in the early 1870s [48], to the Spaniard

[fig.6] Detail showing hearse and funeral procession from the central panel of the triptych by Léon Frédéric *The Ages of the Worker*, 1895–7 Musée d'Orsay, Paris

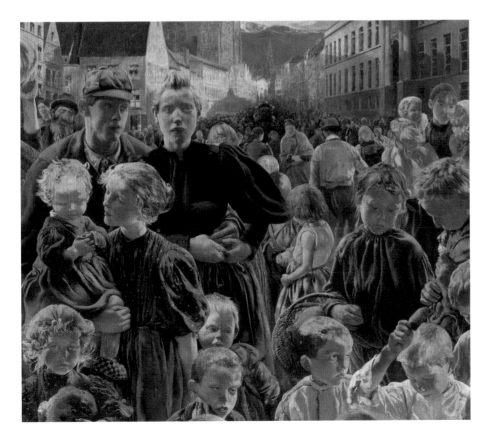

Joaquín Sorolla, who painted the royal gardens in Madrid, Seville and San Ildefonso in the early twentieth century, as well as creating his own garden in Madrid [83–5]. Traditional gardens, meanwhile – kitchen and orchard gardens – remained important in rural areas, and were painted by artists including Pissarro and Gustav Klimt [59, 81].

The Impressionists were above all else painters of modernity, and yet not one portrayed the extravagant Buttes-Chaumont Park. In company with William Morris and Arts and Crafts architects and designers, they typically preferred the more traditional, pre-industrial gardens to the showy, recent creations. Monet, for example, painted the seventeenth-century Garden of the Princess in 1867, the year of the Buttes-Chaumont opening. One of the earliest Impressionist images of modern life likewise portrayed an old rather than a new garden – Manet's *Music in the Tuileries Gardens* [fig.4] of 1862, in which contemporaries enjoy the strains of an unseen band in the former royal garden of the Tuileries Palace in Paris. One of those shown is Manet's friend the poet Charles Baudelaire, whose call for a 'painter of modern life' to show 'how great and poetic we are in our cravats and our patent-leather boots' the picture so vividly answers.[17] Baudelaire stands just in front of the large tree at the left, his top hat almost merging with its trunk, as if to project the intimate relationship between man and nature in his famous poem *Correspondances*. The park with its trees reaching to infinity might almost be a forest, like that featured in Baudelaire's poem, not nature ordered by man. There is an implicit critique of Napoléon III's Second Empire, underlined by Mme Loubens and Mme Lejosne, wives of two of Manet's Republican friends, seated in the foreground. As in his controversial *Le Déjeuner sur l'herbe* [fig.5] of a few years later, with its figures treating nature as if a private garden, Manet already alerts us to the keenly independent character of the Impressionist garden.

In the rapidly-changing, newly-industrialised world of the nineteenth century so sombrely captured in a painting such as Léon Frédéric's *The Ages of the Worker* [fig.6], the increasing loss of the working relationship with the soil taken for granted by earlier generations was keenly felt. Gardens might compensate for the sense of a 'Paradise lost'. The Impressionists occupy a pivotal place here, being typically only a generation away from a traditional society nourished by working the land. Renoir's son recorded his father's fond memories of the Paris of his youth: 'the streets were narrow, and the central gutter stank a little, but behind every house there was a garden. There were plenty of people who still knew the

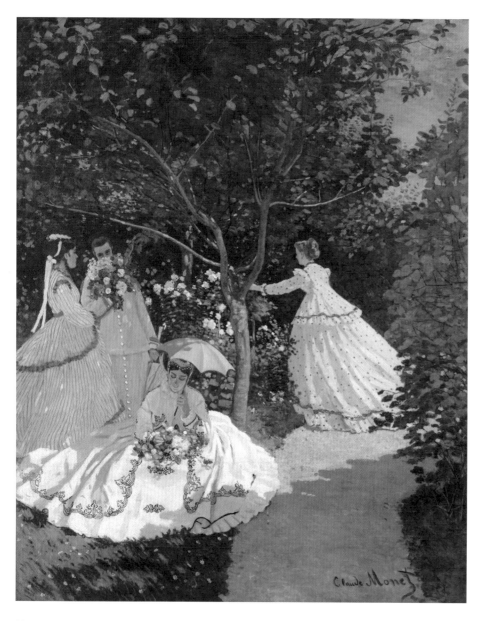

[fig.7] Claude Monet
Women in the Garden, 1867
Musée d'Orsay, Paris

William Morris onwards but also in the early twentieth-century 'Garden-Reform' movement developed from them in Germany. This guided Lichtwark, for example, in advising on Max Liebermann's garden at Wannsee [94]. It is understandable why anthropologists today call gardens 'attachment environments': the activity of cultivating, shaping or physically using a piece of land may engender a greater emotional association than does, for example, the 'static relationship to a treasured possession'.[21]

In the nineteenth century, to a much greater extent than in any previous era, the garden itself became an artist's subject, rather than serving as a setting for such subjects as the Labours of the Months or the Madonna in the Rose Garden in medieval and Renaissance art, or the moral tale of the Dutch seventeenth-century 'merry company' (*Buitenpartij*) in which the transience of garden growth alludes to the vanity of sensory indulgence. Whereas the landscape garden of the eighteenth and early nineteenth centuries had been consciously modelled on the ideal pastoral paintings of artists such as Claude, with Impressionism gardens became inspiration *for* art, and in Monet's conception of his Giverny garden as a work of art, even identical *with* art.

These developments can in part be seen as a reflection of the social changes of the nineteenth century, in which laying out and growing a garden became an activity not just of wealthy landowners or of the Emperor Napoléon and his Paris administration, but also of the newly-empowered common man or bourgeois. The little gardens (*petit parcs*) grown for pleasure by such individuals in the new suburbs offered greenery and air and vividly answered to the Impressionists' art 'based on sensations', as Pissarro termed it.[22] Now flowers with their varied colours and scents, and accompanied perhaps by a few useful fruit trees or rows of beans, replaced the lawns, trees, and symbolic statuary of the older landscape garden, or the vegetables of the traditional rural peasant garden. Although the novelist Guy de Maupassant, a friend of Monet and Renoir, poked fun in 1881 at modern man's 'cultivation of four violet plants, three pansies and a rose-bush',[23] the concentration within a small suburban garden of varied floral colours, scents and textures, together with the sounds of bees, birds, or children playing, made such sensations more personal and perhaps more intense than in the grand public parks, or the great rose garden (*roseraie*) created by the Empress Joséphine in the early nineteenth century at Malmaison. There, a single species of flower was grown and famously recorded in the rose illustrations by the Belgian botanist and artist Pierre-Joseph Redouté.

pleasure of eating freshly-picked lettuce'.[18] The German Impressionist Ernst Eitner – one of the group of young Hamburg artists whom Alfred Lichtwark, Director of the Hamburg Art Gallery, encouraged to adopt an Impressionist style [77] – similarly recalled how his carpenter father had lived 'a fortunate youth in the countryside', and how he himself encountered 'with delight' the smell of dung, remembered from the fields he knew as a boy.[19] Growing and painting a garden must have been a deeply evocative, even nostalgic act for artists such as Renoir and Eitner; Renoir's family was evicted from 'old Paris' to make way for Haussmann's transformation of the city, whilst Eitner played as a child in 'a beautiful old park', later 'eaten up' by new streets, which lay near to his parents' house in Hamburg.[20] Such attitudes not only find parallels in British Arts and Crafts ideals from

This garden had nonetheless marked the start of the popularity of roses in nineteenth-century France and Belgium. By the second half of the nineteenth century this had led to the development of hundreds of new varieties, as vividly reflected in Monet's early *Women in the Garden* [fig.7], painted at Ville-d'Avray near Paris, as well as in such works as the Belgian artist Léon Frédéric's *The Fragrant Air*; Monet's *The House among the Roses*, one of his very last pictures; and Henri Le Sidaner's *The Rose Pavilion*, showing his rose garden at Gerberoy near Beauvais [47, 96, 97].

HORTICULTURE AND CIVILISATION

Already in the early nineteenth century, the utopian writer Charles Fourier outlined a vision of a society founded on horticultural activity, whilst the creator of Central Park in New York, Frederick Law Olmsted, considered public parks 'a democratic development of the highest significance'.[24] Renoir's sister admired Fourier[25] and the artist's great painting *Ball at the Moulin de la Galette* [fig.8], in which artisan seamstresses (workers with the needle) dance with his painter friends (workers with the brush) in the acacia-planted garden of a Montmartre restaurant, is in turn essentially utopian in vision. As with Manet's *Music in the Tuileries Gardens* or Zandomeneghi's *Place d'Anvers* it reflects the broadly left-wing sympathies of the French Impressionists, and takes its place in the larger tradition of association between Republicanism and horticulture which had developed in France, from the names given after the French Revolution to the months – *Germinal*, *Floréal*, and so on – to the claim by Soulange Bodin, first Secretary of the Horticultural Society of Paris, that modern French horticulture was born in 1789 from a new 'fraternity' of scientists, artists and 'husbandmen'.[26]

Gardens could offer contemplation of the wider landscape, as was already the case in the early nineteenth-century *A View of Florence from the North Bank of the Arno* by François-Xavier Fabre [4], or even be places from which to glimpse the infinite sky, as in Monet's views of his pond reflecting the clouds. In Frédéric Bazille's *African Woman with Peonies* [14], the garden is beyond the painting and left to the viewer's imagination, its close proximity implied by the radiant freshness of the flowers in course of arrangement. But, in an age when artists began to substitute outdoor observation

[fig.8] Pierre-Auguste Renoir
Ball at the Moulin de la Galette,
1876
Musée d'Orsay, Paris

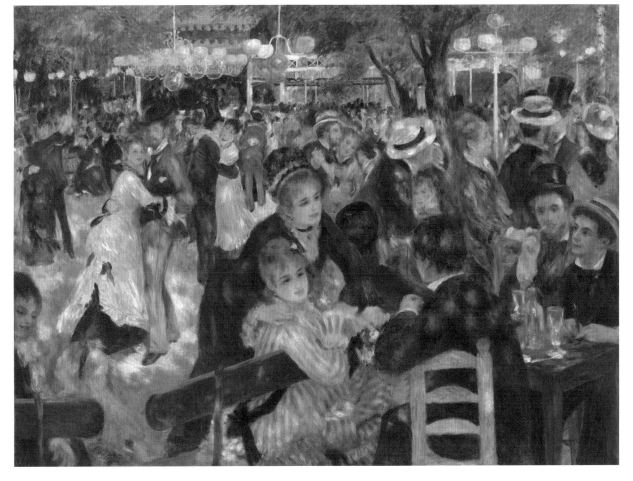

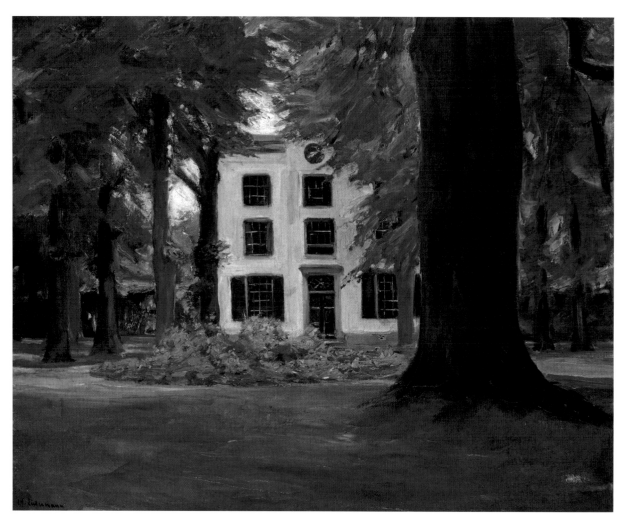

[fig.9] Max Liebermann
Landhaus in Hilversum, 1901
Nationalgalerie, Berlin

for academic studio work, and when Charles Darwin's theory of human evolution demonstrated that 'there had never been a Garden of Eden'[27] and that organisms were affected by their environment, the garden, old or new, acquired an extended range of functions and meanings as well as secular associations. It had become a far more versatile, prominent and expressive artistic motif than ever before. Horticulture, meanwhile, came of age as a science. As plant collectors introduced quantities of exotic species – whose European cultivation was assisted from the 1840s by British gardener and architect Joseph Paxton's invention of glasshouses – so the discovery of hybridisation introduced still more diverse plant forms and colours. In 1845, the new Belgian horticultural journal *Flore des serres et jardins de l'Europe* (all of whose volumes Monet was to acquire at Giverny) even argued that hybridisation was 'the true conquest of our age … the procedure which means that, just like the Creator, man too may create plants virtually at his convenience, and may say, again just like the Creator: you, be born, and be of such and such a form … ! Divine power!

Infinite resource'.[28] Even before Darwin abolished Eden, horticulture in France had already begun to make God seem redundant.

Monet, Degas, Cézanne, and Morisot, like their literary colleagues Edmond Duranty and Emile Zola, certainly knew and were intrigued by the work of Darwin,[29] who was first given recognition in France by the botanical division of its Academy of Sciences. In placing before us the dazzling brilliance of a sunlit garden filled with colourful flowers, as in the American painter Childe Hassam's *Geraniums* [38], or the subtlest nuances of white and grey in snow-covered kitchen gardens, as in, say, Sisley's *Winter at Louveciennes* [58], the Impressionists were powerfully engaging the very sense – sight – which, in the wake of Darwin's theories, was viewed as mankind's foremost 'biological survival mechanism'.[30] Equally, it was the ability to appreciate sweet scent, so central to the character of a flower garden, that was believed in nineteenth-century France to differentiate man from animals.[31] When French Impressionist works were first publically displayed in

Germany at an exhibition at the Galerie Gurlitt in Berlin in 1883, the French poet Jules Laforgue even implicitly invoked Darwin's theory of evolution by jingoistically likening the Germans to one of the most primitive forms of life, *tardigrada*; he felt they needed the 'civilising' effect he saw in the Gurlitt show.[32] His comments were, of course, coloured by French hostility to Germany after the Franco-Prussian War of 1870–1. He also described the 'Impressionist eye' in Darwinian terms, as 'the most advanced eye in human evolution', capable of perceiving and reproducing 'the most complicated combinations of nuances known'.[33]

Garden motifs were prominent in the Gurlitt exhibition, in which Laforgue was closely involved, as well as in early German purchases of French Impressionism. For example, Hugo von Tschudi, the enterprising Director of the Berlin National Gallery, bought Manet's *In the Conservatory*, which was the first French Impressionist work to enter a German public collection, and Liebermann acquired and himself emulated late garden paintings by Manet [fig.9].[34] Garden motifs were likewise favourably noticed at the pioneering exhibitions of French Impressionism held in the United States from the 1880s by the dealer Paul Durand-Ruel.[35] These developments are revealing. Gardens, after all, as shown earlier, are potent emblems of mankind's mastery of nature. If Impressionism was seen by Laforgue as a means to civilise Germany, so too were gardens perceived both as the taming of wild nature, and as a means to promote a civilised society – that ideal so intently pursued in an age when industry, science and technology seemed

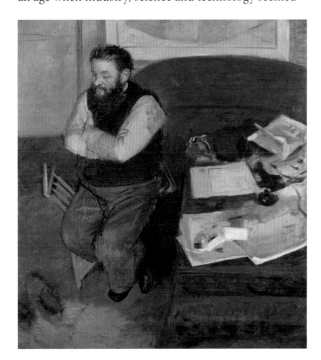

[fig.10] Edgar Degas
Diego Martelli, 1879
National Gallery of Scotland, Edinburgh

to some to promise a better world.[36] In the eighteenth century Jean-Jacques Rousseau had argued that 'the man who having enclosed a piece of land, took it upon himself to declare, *this is mine*, and found people simple enough to believe it, was the true founder of civil society', and cultivation of gardens was seen after both the Napoleonic and Franco-Prussian Wars as a tangible means to 'turn swords into ploughshares'.[37] The garden images in the 1880s of Italian artists such as Filippo Palizzi or Telemaco Signorini who had personally been involved in the battles for Italian unification, Monet's gift to France of his water lily murals as a First World War memorial and Liebermann's concentration after 1914 on motifs of his garden, essentially continue these traditions [28, 36, 94]. Equally, the garden in the nineteenth century became both an emblem of an ideal world and a perceived agent of moral influence.

THE IMPRESSIONIST GARDEN ABROAD

The very character of gardens as one of the most ancient of forms of human engagement with nature makes it only logical that Impressionist gardens also emerged in many countries beyond France. French Impressionist work was exhibited and promoted from the 1880s in other countries, but non-French forms of Impressionism were not simply imitations of work by Monet and his colleagues. In Italy, for example, there was already a vigorous tradition in Naples of painting out of doors (*all'aperto*). The mark, patch or tonal framework (*macchia*) which the Italian Macchiaioli artists made the basis of their art has clear affinities with French Impressionism, yet developed independently before it was modified as Italian artists came into contact with French Impressionism through critics such as Diego Martelli [fig.10].

A telling example of the marriage of native and wider traditions in garden imagery is provided by *Afternoon in the Tuileries Gardens* [fig.11] by the German artist Adolph Menzel, who was admired by Degas, Duranty and Liebermann. Painted following a visit to Paris for the 1867 Exposition Universelle, this is thought to have been prompted by Manet's *Music in the Tuileries Gardens*, but its depiction of the senses also builds on naturalist tendencies already established in Germany, partly under the influence of the English artist John Constable. In the warm, spring sunshine, we are invited to 'hear' the barking dog and bawling child; 'touch' is evoked in the fur being traded by a Turkish visitor and the rough gravel with which the children play; and the red balloon delights the eye. Menzel's evident empathy with children here likewise forms a suggestive sequel

[fig.11] Adolph Menzel
*Afternoon in the Tuileries
Gardens*, 1867
The National Gallery, London

to the symbolic association of children and plants by the Romantic painter Philipp Otto Runge and the child garden (*Kindergarten*) ideal of the progressive Swiss educationalist Friedrich Froebel; in the latter, the child was encouraged to develop independence through sensory engagement with nature and educative play, including dancing and singing.

By the turn of the century Impressionism was not only international, but also recognised as having strong historical precedents, and embracing all the arts. The German art historian Richard Hamann even argued in 1907 that it was a 'way of life'.[38] The Spanish artist Joaquín Sorolla, who admired both Menzel and Monet, certainly saw his distinctive Luminist form of Impressionism as falling heir to the art of his compatriot Velázquez [83–5], and pithily maintained that 'All inspired painters are impressionists, even though it be

true that some impressionists are not inspired'.[39] In France, meanwhile, the critic Camille Mauclair specifically defined Impressionism as including the work of Sorolla and of other foreign painters such as James Guthrie, John Singer Sargent, Théo Van Rysselberghe, John Lavery, and Max Liebermann [43, 52, 75, 90, 94], although he considered their art the result of French influence.[40] In Belgium, the *Vingt* and *Libre Esthétique* groups were openly international, bringing together impressionistic painting from different countries, while in Austria in 1903 the Vienna Secession's exhibition *The Evolution of Impressionism in Painting and Sculpture* presented the movement in explicitly organic terms, tracing both the root *of* Impressionism, and that of other works *in* Impressionism.[41] Such perceptions make it only logical that, following the inclusion of Monet's *The Artist's Garden at Argenteuil* (*A Corner of the Garden*

with Dahlias) [19] in the major *Manet-Monet* exhibition mounted in 1910 by Klimt's agent in Vienna, Klimt's *Italian Garden Landscape* employs the same composition [92]. Klimt may be thought of as the painter of sinuous nudes and golden women, but he loved gardens and their flowers and both this painting and his *Rosebushes under the Trees* [81] have direct and intriguing affinities with the Impressionist garden tradition. If gardens now combined plants from across the world, and horticultural exhibitions presented ever more splendid displays of new floral colours and types, then Impressionist garden painting clearly matched this process.

Impressionist gardens had many forms, including vegetable plots and orchards as well as places for flowers, but their importance was perhaps above all as places of powerful personal and social associations and meanings. It is perhaps no coincidence that the artist's garden, the site both grown and painted by the artist, was born with Impressionism – the movement Zola welcomed as showing 'a corner of creation … through a temperament'.[42] As well as Monet's gardens at Argenteuil, Vétheuil and ultimately Giverny, numerous examples may be cited, ranging from Caillebotte's extensive garden at Petit-Gennevilliers on the Seine, to Sorolla's in Madrid with its Moorish ornament, and Lavery's bougainvillea terraces at his winter residence in Morocco. Internationally, Impressionist gardens could also serve to celebrate collective artistic identity as in the Scandinavian Peder

Krøyer's *Hip, Hip, Hurrah!* [fig.12], which depicts an artists' party in a garden at the artists' colony of Skagen in Denmark. But if artists' gardens were on one level symptoms of the new scientific and bourgeois age, they were also the tangible embodiment of the subjectivity of the 'impression'.

The emotion with which the artist's garden could be invested is poignantly revealed in the critic Gustave Geffroy's description of visiting Caillebotte's garden at Petit-Gennevilliers in spring 1894, just after the artist's death:

… along the flower-beds, in the clearings of the miniscule wood, in the interstices of the stones which form the rocky base of the greenhouse, everywhere, plant-life is opening its buds; the little flowers are shining like children's eyes, sturdy shoots are pushing through the soil. All this little vegetable world, pampered, adored by Caillebotte, is faithful to the rendez-vous given to it. 'You will see my garden in the spring', he said to his friends, at the last Impressionist dinner.[43]

Monet, referring to lily bulbs he had just received from Japan, and 'cases of very expensive seeds that would produce beautifully coloured blossoms', was to quote Caillebotte's words of spring renewal only fifteen days before his own death in 1926, when the journalist Thiébault-Sisson visited him at Giverny.[44] Monet and Caillebotte had been the closest of gardening friends, exchanging tips, and visiting horticultural exhibitions together. In this poignant comment, it is as though Monet now planted his garden with memories as well as seeds.

The Impressionists' passion for gardens gave rise to some of the most memorable and significant paintings of the nineteenth and early twentieth centuries. The following sections explore key aspects of this passion, from its sources and origins in naturalist landscapes and symbolic still lifes, to its mature expression in images of private, public, and vegetable gardens, and its influence on the fresh growth and new blooms created by artists such as Van Gogh, Bonnard, Klimt, and Sorolla.

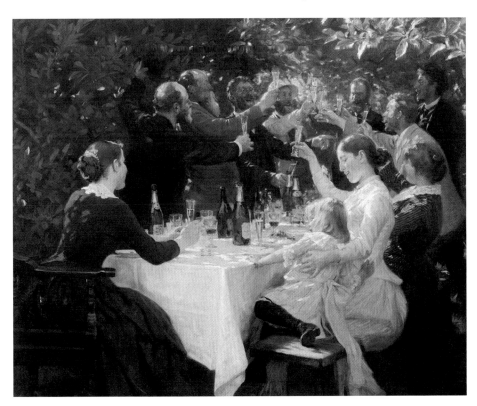

[fig.12] Peder Severin Krøyer *Hip, Hip, Hurrah!* 1888
Göteborgs Konstmuseum, Göteborg

1 *Towards the Impressionist Garden*

As shown, Manet used a Paris park for his pioneering scene of modern life in 1862 – *Music in the Tuileries Gardens* [fig.4] – but the paintings in this section illustrate some of the wider ideas and developments which, already from the start of the nineteenth century, anticipated the Impressionist garden. Perhaps the foremost of these are a heightened interest in the 'pleasant place', where it is good to be – what in antiquity had been called the *locus amoenus* – and a sense that this place might lie on one's own doorstep, rather than far away in exotic lands or in imagined scenes from history or literature.

In the 1760s the writer and philosopher Jean-Jacques Rousseau had complained of 'the tendency which most men have to be happy only where they do not happen to be', arguing that mankind should instead 'live for the sake of living … and … make for himself a walk within reach of his house'. In the nineteenth century, this idea found new impetus in the context of what the art historian Nicholas Green has called a distinctively 'sensual and individualised response to sights, textures and smells'.[1] The sensations of the local environment were to be savoured and enjoyed for their own sake, in the here and now. 'I love especially the spectacle of nature's changing apparel in spring, the tender green of young shoots in the first days of May, and the wonderfully sweet scents exuded by the early blossom', wrote the author of a French guidebook in 1847, in response to the countryside near Paris.[2] A garden, of course, is where seasonal colours, textures and scents, and tastes, can be grouped or concentrated for aesthetic or practical purpose, in arrays of flowers, trees or vegetables, season by season. In 1813, in the Neoclassical painter François-Xavier Fabre's *A View of Florence from the North Bank of the Arno* [4] there is already a striking appreciation of just such a place: the meandering paths and spacious lawns of the English style Cascine Park near Fabre's home in Italy. The picnicking figures in the golden afternoon sunshine (the distant clock-tower marks the precise moment) are not from classical mythology or the Bible, as in earlier landscapes of Italy by Claude or Poussin, but instead are the artist's contemporaries.

Still more local and contemporary is the unassuming little sketch of 1820 by the Romantic landscape painter Paul Huet, which, unlike Fabre's picture, was made direct from nature. This shows the tall, stately trees of the former royal park of Saint-Cloud near Paris, against scudding clouds [7]. Huet called Saint-Cloud 'that enchanting place one talks about when in Italy',[3] implying that, for the painter prepared to depart from convention, there were sights at home every bit as evocative as those favoured by Grand Tour travellers or expatriates like Fabre. This idea gained momentum after John Constable's work won acclaim at the Paris Salon of 1824, and his precept 'I should paint my own places best'[4] found a direct echo in the comment by Huet's fellow painter Charles-François Daubigny that 'there is nothing like the nature in which one lives every day and which truly pleases one. The paintings which result are imbued with a sense of intimacy, and the sweet sensations which you feel there.'[5] Although a more formal exhibition work, Daubigny's 1865 view of Saint-Cloud [11] vividly captures the sensations of the warm sunshine, fresh breeze, and summer lawns where children sit and play; by then, the railway line from Paris had made Saint-Cloud even more local.

Both Huet and Daubigny were closely associated with the artists such as Jean-Baptiste-Camille Corot and Théodore Rousseau who from the 1830s painted in the Forest of Fontainebleau near Paris, using the village of Barbizon as their base. The intimate landscapes (*paysages intimes*) created by the Barbizon artists depict scenery which, like the land around Saint-Cloud, had originally been part of the great hunting grounds of royalty and the aristocracy, and was sometimes called the open garden (*jardin ouvert*) of Paris. Although the Barbizon artists emphasise the way that nature had reclaimed much of these grounds by the nineteenth century, they often created intimate compositions which convey the

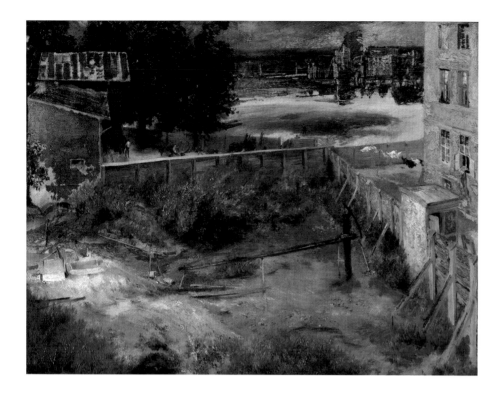

[fig.13] Adolph Menzel
Rear of House and Backyard,
c.1846
Nationalgalerie, Berlin

[fig.14] John Constable *Golding
Constable's Kitchen Garden*, 1815
Ipswich Museums and Galleries
Collection

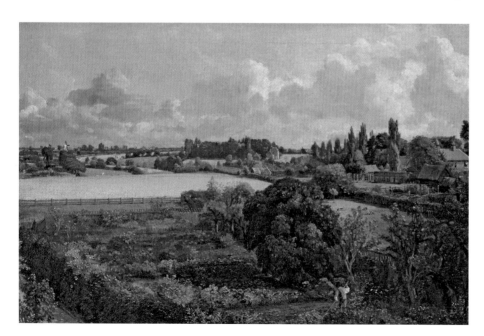

more than four or five brushmarks … a formless harmony of colours'[6] – an antecedent as radical as any for Impressionism, but one whose principles are already evident in the bold pattern of light filtering between the branches in *Orange Tree and Women*. In the meantime, the Neoclassical landscapist Antoine Pierre Mongin chose deliberately unpicturesque motifs for his studies from nature. In *The Curious One* [3] he portrays garden walls and surrounding buildings, but leaves the 'pleasant place' to our imagination, wittily inviting our censure as an inquisitive young man tries to scale the walls to see the ladies within. And in Germany Constable's example influenced the naturalist generation; Adolph Menzel's scenes of the untidy pieces of garden behind tenements in his native Berlin [fig.13] use a free, expressive form of brushwork which already lays important foundations for German Impressionist work.

Constable's views of his parents' garden [fig.14], and his use of his own garden in Hampstead as a place for cloud studies, are in essence a prototype for the Impressionist practice of growing and painting a 'pleasant place' of your own – an artist's garden. Although this practice did not mature until the 1870s, a number of French works of the 1850s and 60s show gardens with strong personal associations, such as Jean-François Millet's *Garden Scene* [8], and the portrait by Manet's tutor Thomas Couture of his wife in the family garden at Senlis near Paris [10]. These continue the Romantic and Barbizon tradition of using nature to express feeling, but also anticipate the theme of the family garden portrayed by artists such as Monet, Morisot, and Eitner.

Of the Barbizon and other artists who developed aspects of Constable's approach, Daubigny was the only one to finish work out of doors, as Monet, Sisley and Renoir were to do when they painted at Fontainebleau at the start of their careers. Daubigny gave the Impressionists strong support, championing their work at the Salon when elected to its jury in the 1860s, and resigning from that jury when it rejected work by Monet in 1870. It was during the 1860s that the new concerns with the local, domestic and personal began to be seen in an ever wider range of garden motifs, from the burst of sunlight and cooling shade of Frédéric Bazille's *The Oleanders* [13], to the smooth, stiff textures of the blue cabbage leaves in the Belgian painter Henri de Braekeleer's *A Flemish Kitchen Garden* [12], and the experiments by Manet and Monet with scenes of multiple figures in gardens. Such works moved even further from Romanticism's quest for the exotic and sublime. However, the exotic and even the imaginary were not completely absent from the emerging Impressionist garden. The delight in sensations

feeling of a garden where nature is enclosed. Woodland scenes (*sous-bois*) are an example of this, especially in works such as Corot's *The Parc des Lions at Port-Marly* [16] which shows light and shade dappling a secluded forest corner. In Italy, awareness of Barbizon practice encouraged artists such as Filippo Palizzi, whose *Orange Tree and Women* [9] is essentially a *sous-bois*. It was, intriguingly, in Palizzi's studio in 1868 that the critic Victor Imbriani noticed a 'small card … no more than a few centimetres wide … on which there was nothing

was fostered as arguably never before by the astonishing variety of garden flowers which came into cultivation after the invention in 1840 of 'Ward cases' – framed glass boxes which allowed the transport to Europe of tropical plants – and, around the same time, of Joseph Paxton's glasshouses, which could over-winter fragile specimens. In France these developments came at an opportune moment, for the departure of foreign troops after the Napoleonic wars had launched an expansion of private garden-making.[7] Gardens became 'worlds in miniature', bringing together flowers and plants from America, Asia and Africa, and a view evolved that the civilising art of horticulture might be a defence against future wars, and a means to build strong citizens and soldiers.[8] By the 1840s, even delinquents in France were being taught gardening in agricultural communities (*colonies agricoles*). One of these was where Pierre Barillet-Deschamps, the chief horticulturalist of the City of Paris under Napoléon III during the 1850s and 60s, was first employed. In Paris, the La Muette greenhouses established by Barillet-Deschamps supplied the thousands of bedding plants and flowers – over 870,000 a year by 1865 – which were required for Napoléon's new parks in the capital, and they became a major training centre for gardeners from all over Europe.[9] By 1850, Barillet-Deschamps's own horticultural establishment at Bordeaux already offered no fewer than 230 varieties of dahlias alone, of which 140 were new that year, a telling indication of the burgeoning 'cult of flowers'.[10]

It was only logical that painters should draw rich inspiration for still life from this new cult and that, given the lowly status of the still-life genre in the traditional hierarchy of genres in painting, they should seek to give it greater significance by introducing landscape, narrative and portraiture elements. Following his exuberant experiments with flower painting in the 1830s [5, 6], Eugène Delacroix, for example, painted a series of works in 1848 where cut flowers are placed in landscape settings. It was in Lyons, however, that flower painters, looking back to Dutch models, began to use more ambitious combinations of flowers with landscapes and figures. The city was one of the foremost European centres of silk production, and a Salon des Fleurs, incorporating work by Netherlandish as well as French artists, was established in its Musée des Beaux-Arts in 1814 to assist fabric designers. A school of highly-skilled flower painters developed, the Lyons *fleuristes*, of whom Jean-François Bony and Simon Saint-Jean, together with Antoine Berjon, and later, Pierre Chabal-Dussurgey, were amongst the most famous. Many of these artists not only designed fabrics themselves, but working from flowers specially grown in the city's Botanical Garden, also created paintings as models for the silk designers. They had a strong predilection for floral symbolism, partly derived from Baroque traditions, but also reflecting the emergence in early nineteenth-century France of a new Romantic language of flowers inspired by Turkish *selams* (greetings).[11] Such symbolism – which was also employed in the planting of gardens[12] – was another means whereby the still life and its variants could be made to carry greater significance. Bony set a still life out of doors in a garden as early as 1804 [1], and the 'gardener-girl' imagery of his younger colleague Saint-Jean [2] is a prime example of this merging of genres – a kind of hybridisation of art itself. The 'gardener-girl' motif, which was subsequently taken up by Gustave Courbet and can be seen in Bazille's *African Woman with Peonies* [14], had its origins in Renaissance and Baroque images of the goddess Flora, and is a vivid reflection of the popular association in the nineteenth century between women, flowers, and gardens. Women were traditionally thought to have greater sensitivity than men to the colours, scents and tactile appeal so evocatively offered by flowers, and they were accordingly described by 1859 as 'the good genii of gardens; it is they who get utilitarian men to bring them to life, and who show them how much a garden may spread charm over life'.[13] Associations of women and flowers in turn underpin much Impressionist garden imagery.

[fig.15] Edgar Degas
Woman Seated beside a Vase of Flowers, 1865
The Metropolitan Museum of Art, New York

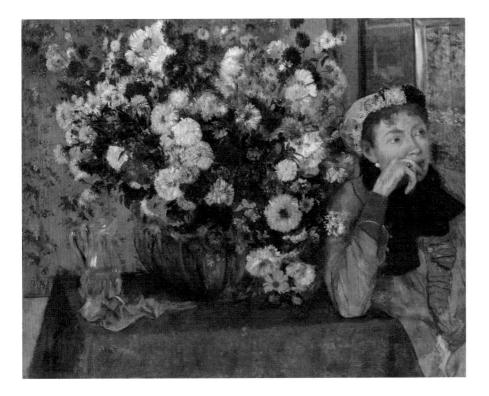

The finest Lyons paintings were exhibited in Paris, where Manet's future friend the poet and critic Charles Baudelaire damned the Lyons school as 'the penitentiary of painting' – a sideways allusion perhaps, by the writer of the iconoclastic *The Flowers of Evil* poems, to the agricultural communities for delinquents, whose discipline was, of course, so different from the artistic freedom to be admired in Eugène Delacroix's brushwork and colour.[14] The work of the Lyons painters has tended to be overlooked in histories of Impressionism, but in the works included here the attention paid to the effects of natural lighting on petals and foliage and the enterprising use of outdoor settings are directly relevant to the Impressionist garden. Degas as well as Bazille studied the collection of the museum in Lyons, and Degas's *Woman Seated beside a Vase of Flowers* of 1865 [fig.15] is, in effect, an updated 'gardener-girl'. The gardening gloves beside the sitter imply that she herself has gathered the splendid bouquet of asters, marigolds and other flowers, whose symbolic meanings complement her meditative mood.[15] As late as 1901, at a period when he was much engaged in still-life painting, Renoir wrote to his dealer Durand-Ruel that he was intending to 'spend two or three days in Lyons' whilst delivering a painting to its museum.[16] It would seem as though, despite his own maturity as a painter, he felt he would benefit from a re-acquaintance with traditions which had earlier inspired him.

It was certainly in floral still lifes that Renoir, Monet, and Bazille honed their painting skills, enjoying the freedom they afforded for evocative effects of colour, light and brushwork. Monet wrote in 1864 to Bazille that he should do a flower picture 'because I believe it's an excellent thing to paint', and Renoir later commented that in flower pictures he could 'experiment boldly with the tones and values' in a way he would not 'dare' in a figurative subject, for fear of 'spoiling everything'.[17] Allusions to the language of flowers nonetheless persist in Bazille's *African Woman with Peonies* and can also be identified in Monet's *Women in the Garden*, the most ambitious garden picture of the 1860s by a future Impressionist [fig.7]. Painted from life near Paris, this work decisively turns the 'gardener-girl' motif into the Impressionist garden, by combining figures with growing as well as cut flowers. The symbolism of the flowers held by the seated woman – modelled by Monet's future wife Camille – makes the picture in effect a love tryst, and it is worth noting that Camille, a Parisian seamstress, was originally from Lyons.[18]

Even in works which to modern eyes may seem pure painting, such as the 1860s still lifes by Monet and Renoir of garden flowers, with their harmonies of colour and suggestive brushwork, there are flowers which, in their day, would have had particular significance for certain viewers. Monet's *Spring Flowers* [fig.16], probably exhibited in Rouen in summer 1864, was surely intended to appeal to the nineteenth-century horticultural elite – the wealthy bourgeoisie who grew gardens for leisure and might purchase such a picture. In addition to showy peonies, red pelargoniums, forget-me-nots and guelder-roses, the painting includes hydrangea (*Hydrangea macrophylla*), introduced from Japan in 1845, Persian, rather than common, lilac, and what appears to be *Weigela amabilis*, the small pinky-white tubular flowers near the centre of the work. This last species, also from Japan, was cultivated in the 1850s by the horticulturalist Philippe André de Vilmorin near Paris, and it can reasonably be assumed that it would have been grown in Monet's home town of Le Havre, which he visited in early summer 1864. The 'Practical Circle for Horticulture and Botany' of Le Havre noted with praise the 'numerous gardens … as beautiful to see as a group as to visit individually', some with 'immense greenhouses' containing 'plants from all regions of the globe', of the Ingouville quarter where Monet's aunt lived.[19] It was her fine standard roses that Monet would portray in 1866 in some of his earliest known garden paintings, and *Spring Flowers* may conceivably include specimens

[fig.16] Claude Monet
Spring Flowers, 1864
Cleveland Museum of Art, Ohio

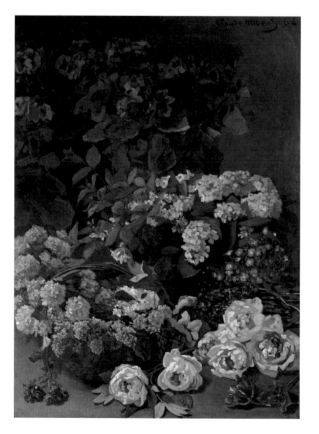

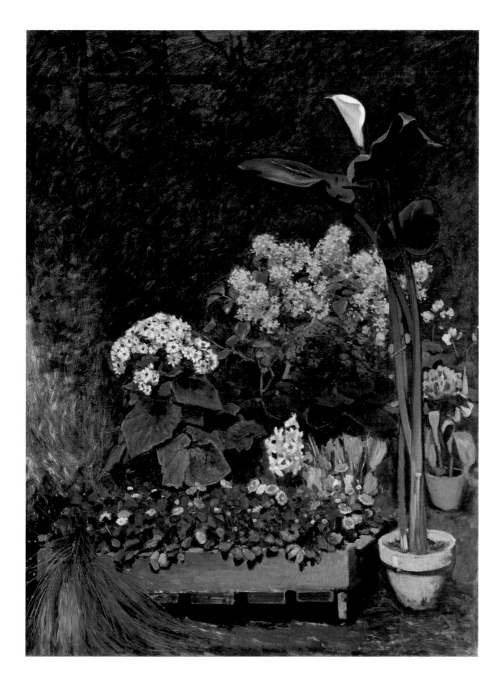

[fig.17] Pierre-Auguste Renoir
Spring Flowers, 1864
Kunsthalle, Hamburg

in Montmartre [see 21]. Even in Renoir's *Spring Flowers* [fig.17], painted the same year as the work by Monet, common garden flowers such as the daisy and crocus are given as much, or even more, prominence as a hothouse arum lily, a showy *Keizerskroon* tulip, cineraria, and, near the centre, a hyacinth whose size and shape of bloom suggest *L'Innocence*, a variety only introduced the previous year. Renoir gives his floral mixture no airs and graces: the pots are still smeared with earth. Yet it too updates an earlier tradition – the 'preparations for a celebration' motif painted by Lyons artists such as Bony. Having begun his career as an artisan painter of flowers on porcelain, it is possible that Renoir in fact learnt some of his skills from the widely-used flower-painting manuals by the Lyons flower painters, such as that published by the Gribbon brothers.

To emphasise flowers above all else in charting steps towards the Impressionist garden would, however, be a mistake, despite their importance for the themes of sensations and women and gardens. Neither Filippo Palizzi's sunlit orchard nor Daubigny's view of Saint-Cloud features flowers; instead, these local landscapes have intriguing political overtones – Italian nationalist in Palizzi's case and Republican in Daubigny's [9, 11]. As such, they look forward to the role of the 'pleasant place' in certain Impressionist gardens as a vision of a better world implicitly contrasted with the present one. The prominence Daubigny gives to children amongst the day-trippers at Saint-Cloud also anticipates the association of gardens and a child's receptivity to sensations in works by Monet, Morisot, Mary MacMonnies and others as explored in later sections. Both Palizzi's orchard and De Braekeleer's cabbage garden, meanwhile, like Millet's kitchen garden (*jardin potager*) [8] celebrate the possibility of the 'pleasant place' even in the working garden – a central theme for Pissarro, and also one portrayed by Gustave Caillebotte. The very variety of the pre-Impressionist 'pleasant place', and its interpretation by both French and foreign artists such as Palizzi and De Braekeleer, is, in fact, one of its most direct links with the mature Impressionist garden and its successors.

from her garden or greenhouse, since some of its flowers are actually summer blooms. *Spring Flowers* is, in effect, the Impressionist equivalent of the earlier magnificent bouquets of Bony and Saint-Jean and those of Delacroix, and anticipates Monet's cultivation of select flowers in his own gardens. It is possible to understand why he later said that gardening was 'a skill I learnt in my youth', and that 'I perhaps owe it to flowers that I have become a painter.'[20]

Compared with Monet's *Spring Flowers*, or Bazille's *African Woman with Peonies*, the wild flowers of Renoir's *Flowers in a Vase* [15] are richly revealing, a portent of his later appreciation of his semi-wild garden

1 Jean-François Bony *Spring*, 1804
Musée des Beaux-Arts, Lyons

Bony was a leading member of the celebrated Lyons school of flower painters. By placing a still life out of doors in a garden, he looks towards the Impressionists' interest in effects of natural light. In the morning sunshine, the flowers seize the attention, and a statue of a warrior goddess is given a secondary role. The flowers include roses, lilies, poppies, delphinium and striped parrot tulips, whilst two ladybirds, traditionally associated with good fortune, have settled on a hollyhock leaf.

2 Simon Saint-Jean *The Gardener-Girl*, 1837
Musée des Beaux-Arts, Lyons

Bought in 1838 by King Louis-Philippe, *The Gardener-Girl* sealed Saint-Jean's reputation as the principal Lyons flower painter of the generation after Bony. The flowers which the gardener-girl has gathered are richly symbolic, reflecting Saint-Jean's desire to prove himself to his new wife and her father. Roses, signifying beauty and love, occupy the heart of her bouquet, whilst a tulip – the emblem for a declaration of love – points the way up the garden steps. An acanthus, the symbol of art, curls over the girl's arm.

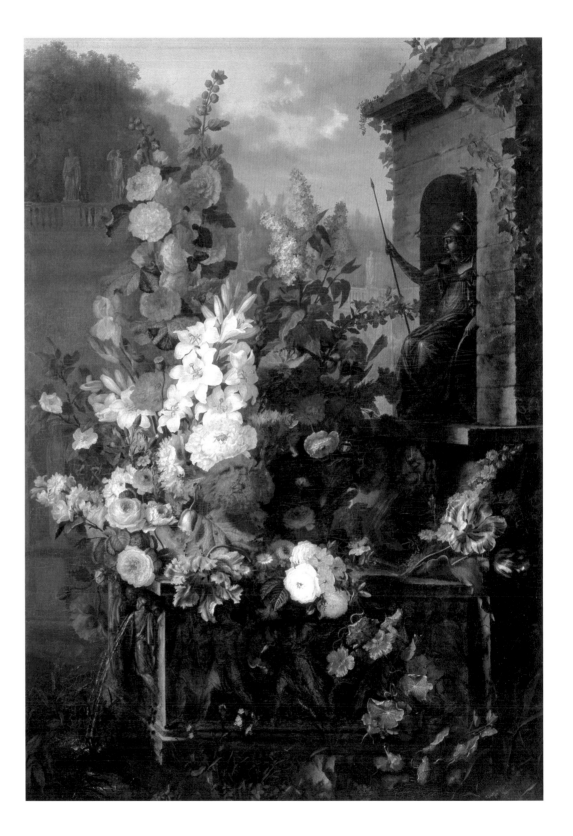

3 Antoine Pierre Mongin
The Curious One, 1823
The Cleveland Museum of Art, Ohio

A young man scales a wall to peer into the garden of a girls' school. The name of the school's director – Mrs Watchful – is written on the wall, and wittily draws attention to Mongin's own watchfulness, as he renders with loving care the rough stone and plasterwork, and the fall of light and shadow. The garden becomes a modern, secular version of the traditional enclosed garden of the Virgin Mary.

4 François-Xavier Fabre
A View of Florence from the North Bank of the Arno, 1813
National Gallery of Scotland, Edinburgh

The French painter Fabre evokes the pleasures of the here and now – a key theme later of the Impressionists. Picnickers enjoy the Cascine Park near Florence, as the clock on the distant Palazzo Vecchio stands at ten to four and the afternoon sun lights up the grass and sparkles on the river. Created in 1737, the Cascine Park had recently been opened to the public by Napoleon's sister the Duchess of Tuscany, and Fabre's image reminds us that Italy itself was often called the garden of Europe.

5 Eugène Delacroix *A Vase of Flowers*, 1833

National Gallery of Scotland, Edinburgh

Delacroix's deftly-handled brushwork marked a new direction in still life, and was much admired by the Impressionists. This was painted at his friend Frédéric Villot's home at Champrosay near Fontainebleau, and portrays carnations and some of the new anemone dahlias developed a few years previously in 1826. The virtuosic rendering of their vibrant colours and waxy textures finds a sequel in Monet's and Caillebotte's paintings of the dahlias they cultivated later at Argenteuil and Petit-Gennevilliers.

6 Eugène Delacroix *Still Life with Flowers*, 1834
Belvedere, Vienna

One of Delacroix's more ambitious flower subjects, this rich array of some twenty different species and cultivars is casually arranged, and surrounded by scattered fruits. The sensitive brushwork makes us feel we might almost stroke the silky pink tulip at the crown, and breathe the sweet scents of the white rose and the orange and yellow lilies. The painting's first owner was Delacroix's friend the writer and garden-lover George Sand.

7 Paul Huet
Trees in the Park at Saint-Cloud, c.1820
The National Gallery, London

The historic park of Saint-Cloud Palace near Paris was one of the earliest public gardens in France, opened after the Revolution of 1789. Huet called it 'enchanting' and in this breezy sketch gives prominence to its soaring, ancient trees, which almost dwarf a small formal fountain. Both this emphasis on nature's freedom, and the idea that beauty could be found close to home, find echoes especially in Renoir's garden painting.

8 Jean-François Millet
Garden Scene, 1854
The Metropolitan Museum of Art, New York

Millet painted this vigorous little sketch in his native village of Gruchy in Normandy, whilst settling his mother's estate there. The view shown – down the garden terraces to the sparkling sea and sky – may well have evoked poignant memories of his early life. He certainly remembered his great-uncle working the land, as does the peasant digging in the foreground. This sense of the garden as a place of emotional attachment reaches maturity in Impressionist family gardens.

9 Filippo Palizzi
Orange Tree and Women, 1860
Galleria Nazionale d'Arte Moderna, Rome

The Italian artist Palizzi visited France in 1855 and was familiar with the work of the Barbizon School painters. However, *Orange Tree and Women* is more than just a copy of a French example. Showing an orchard near Sorrento, its strongly-contrasted light and shadow was to become a hallmark of Italian Impressionism. Palizzi's motif of Italian soil giving forth its fruits was perhaps symbolic: he supported Garibaldi's campaign for a unified Italy, and the woman's red scarf recalls the red shirts worn by Garibaldi's men.

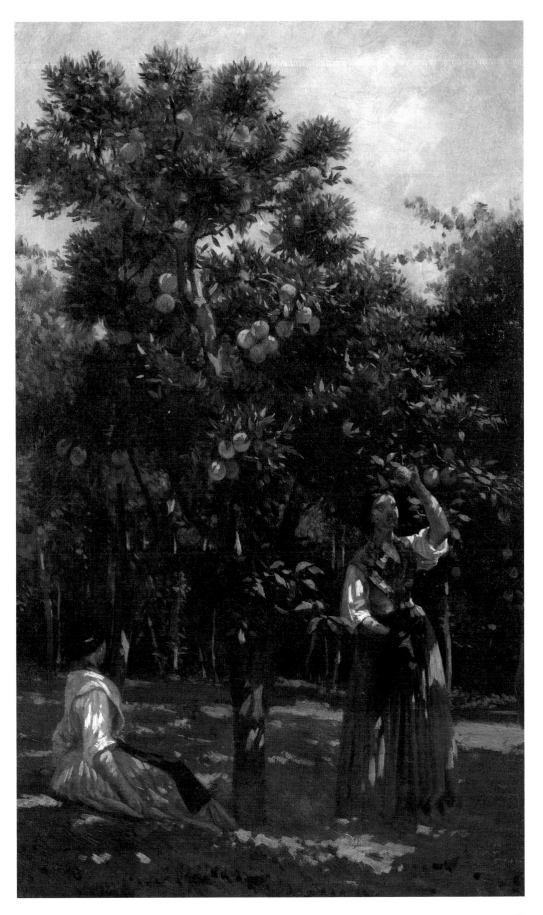

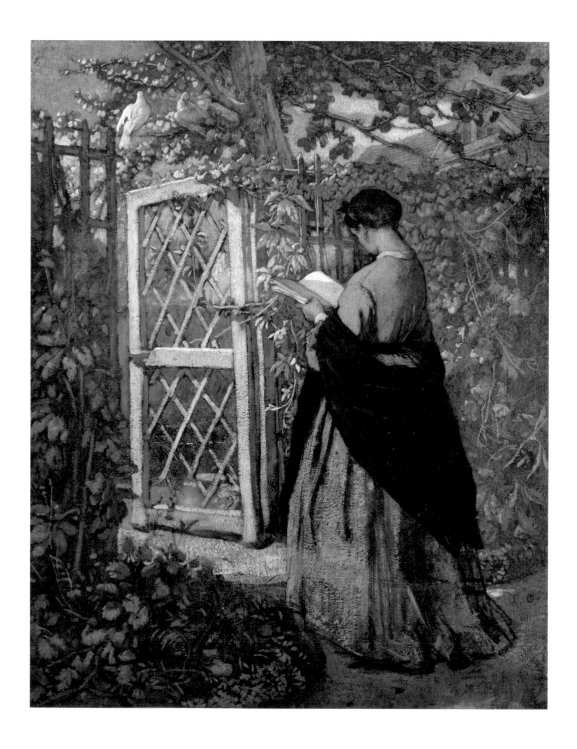

10 Thomas Couture *The Reading*, 1860
Musée national du Château de Compiègne

Couture taught Manet, and his tactile brushwork, outdoor practice, and modern-life subjects influenced Impressionism. This is one of several paintings he made in the garden of his family home at Senlis in northern France. His new wife Marie-Héloise Servent strolls amidst vines and flowers as she reads; she was expecting their first child.

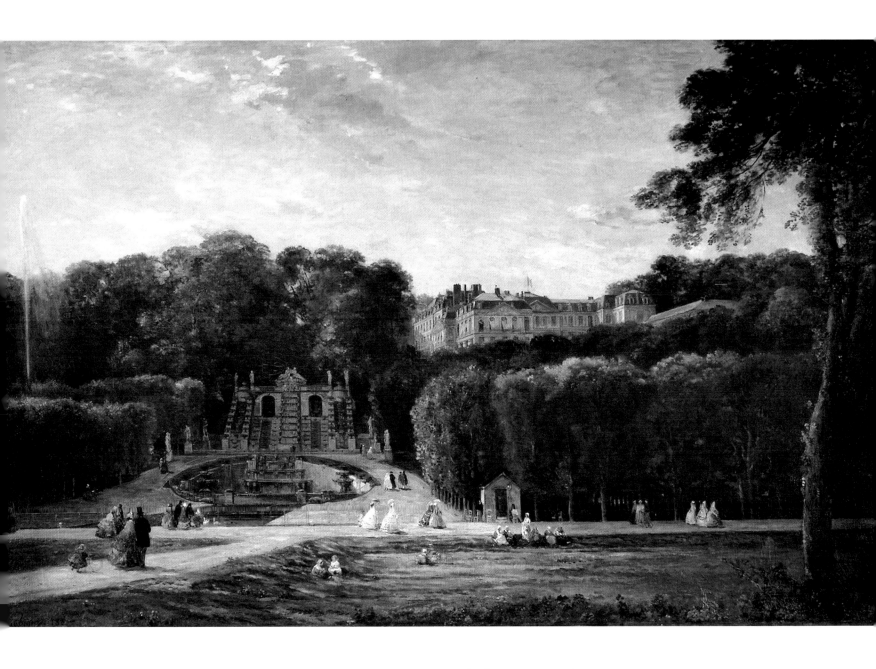

11 Charles-François Daubigny
The Cascade at Saint-Cloud, 1865
Musée des Beaux-Arts et d'Archéologie de Châlons-en-Champagne

Napoléon III commissioned this grand formal work as part of a series
intended to record the great imperial parks and châteaux. However,
Daubigny relegates to the shadows the historic monuments of regal
and aristocratic power at Saint-Cloud – its great baroque fountain and
Cascade – and instead gives prominence to the luminous sky and the day-
trippers strolling in the sunshine. Saint-Cloud was easily accessible from
Paris by rail, and had become a place of popular leisure.

12 Henri de Braekeleer *A Flemish Kitchen Garden: La Coupeuse de Choux*, c.1864

Victoria & Albert Museum, London

The Antwerp painter De Braekeleer finds a subtle poetry in the harvesting of the season's first winter cabbage in the kitchen garden. The pale sunlight turns the magnificent Savoy cabbages a delicate silvery blue, and gilds the woman's dress; flowers beyond add vibrant notes of pink and red. We can see why De Braekeleer was praised for the sensuality of his colour.

13 Frédéric Bazille *The Oleanders*, 1867

Cincinnati Art Museum

Bazille was one of Monet's and Renoir's closest early colleagues before his premature death in the Franco-Prussian War in 1870. Here he captures the summer brilliance of the terrace of his family's estate at Méric near Montpellier. Although unfinished, the scene clearly points the way to the flower gardens of mature Impressionism. The rich pink and cream oleanders bear witness to the success of the fungus treatment for these plants invented by Bazille's father, a prominent local agriculturalist.

14 Frédéric Bazille *African Woman with Peonies*, 1870

Musée Fabre, Montpellier Agglomération

Traditional floral symbolism is combined with a sense of light and colour which stand on the very threshold of Impressionism. The laburnum in the model's left hand represented magic and spells, but is offset by the showy pink, red and white peonies – flowers said to annul spells. Good fortune is thus assured for Bazille's sister-in-law Suzanne Tissié, for whom he painted the picture. She gave birth to a son in May 1870, and this event is announced by the iris in the vase, the flower of the Greek messenger goddess.

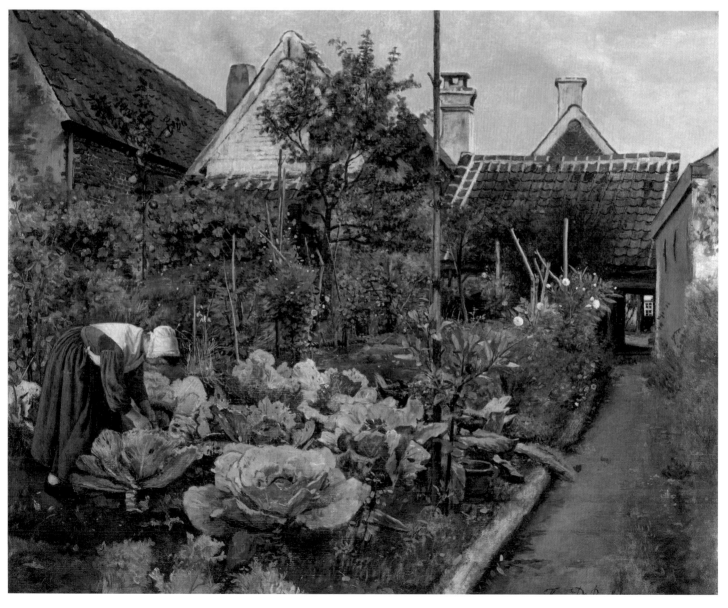

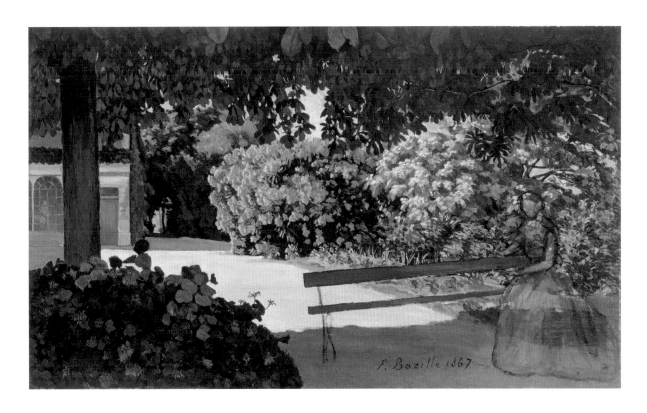

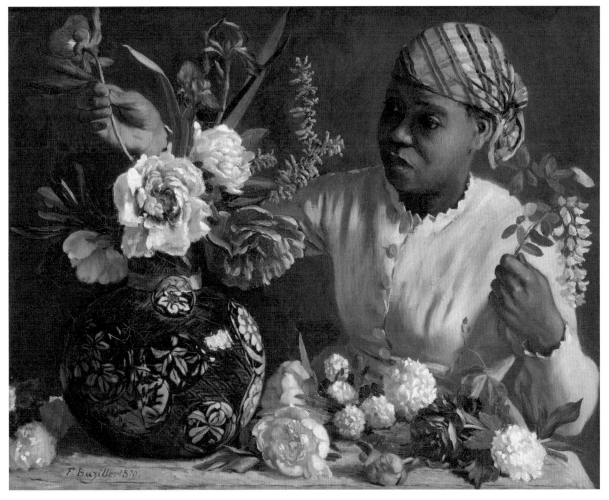

15 Pierre-Auguste Renoir
Flowers in a Vase, c.1866
National Gallery of Art, Washington DC

A souvenir of a stroll in the fields, perhaps with friends near Fontainebleau, the armful of wild flowers celebrates the pleasure of being in the garden of nature. Corn poppies, chamomile, and ragwort jostle in an earthenware vase with cornflowers or round-headed rampion, the ball-like heads of wild parsley, and small yellow flowers, possibly Spanish broom, which droop near the handle of the jug.

16 Camille Corot
The Parc des Lions at Port-Marly, 1872
Museo Thyssen-Bornemisza, Madrid

The girl with a sturdy walking stick and the straw-hatted boy on a donkey are the children of Corot's friend the Paris stockbroker Georges Rodrigues Henriques. As they take the air in the family park near Versailles, their sibling relationship is echoed by the pair of trees at the centre. The Impressionists much admired Corot's effects of dappled light filtering through foliage, but this picture also anticipates the intimate association of children and gardens to be found in the art of his pupil Berthe Morisot.

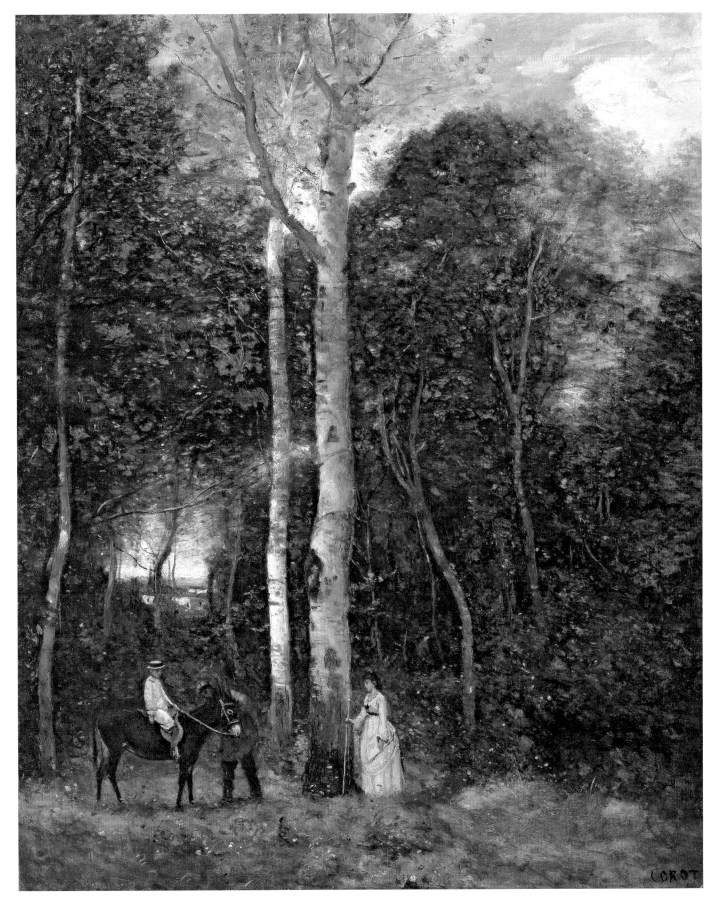

COROT

2 Flower & Leisure Gardens of Mature Impressionism

The notion that flowers should be grown in a dedicated pleasure-garden, separate from useful vegetables, did not truly come of age until the era of Impressionism. Flowers had formed part of 'decorative' villa gardens created by the Roman, Tuscan, and Venetian aristocracy in the early Renaissance, and floral gardens had in turn become more widely cultivated in Italy.[1] But in France before the mid-nineteenth century, it was almost exclusively in the great royal gardens, such as Versailles or the Empress Joséphine's rose garden at Malmaison, and those of the aristocracy, that flowers were given dedicated space – and where the concept of the garden as a place for leisure developed. In rural and urban gardens, flowers were typically grown alongside vegetables, for medicinal use or for cutting for the house, and a similar situation prevailed in Germany and Austria.

By the 1860s, however, growing and enjoying flowers in a decorative or leisure garden (*jardin d'agrément*) had become a favourite pastime in France, as the petits bourgeois who laboured each day in government, commerce, manufacture and industry abandoned crowded city centres to live in houses with gardens in the suburbs, former villages now extended by new building, where they could seek something of the closeness to nature enjoyed by their parents and grandparents. By the 1870s, the decorative or leisure garden was also found in rural areas in France[2], as illustrated in Armand Guillaumin's *The Nasturtium Path* [26]. In Britain and America, meanwhile, practical treatises on popular horticulture such as those of J. C. Loudon and A. J. Downing fuelled the rise of 'leisure horticulture' amongst the working as well as the middle classes.[3]

Hand in hand with these developments, and partly influencing them both in France and beyond, was Baron Haussmann's bold and influential transformation of Paris into a city of gardens as part of Napoléon III's scheme of urban renewal during the Second Empire (1852–1870).[4] Both the Paris gardens and the older landscape gardens in Britain were in turn studied by Frederick Olmsted before he created 'the first real park' in the United States, Central Park in New York.[5] Opened in 1857 as a place for the citizens' recreation and moral improvement, the park is portrayed in William Merritt Chase's *In the Park* [56].

The paintings in this section, covering the period from 1870 to 1900, fall heir to these developments. In seeking to paint modernity, the Impressionists were perhaps almost inevitably attracted to flower and leisure gardens. What the novelist George Sand called 'the decorative garden'[6] – the modern flower garden – had, after all, been central to Haussmann's embellishment of Paris. The Parc Monceau, shown in several paintings by Monet of 1878 [49, 50], was the jewel in the crown, and exotic and rare plants continued to be grown in its ornamental borders and beds after the Third Republic came to power in 1870. Whilst some of these appear in Monet's paintings of the park, it was in his own private garden at Argenteuil that he gave full attention to the decorative flowers such as pelargoniums, dahlias, and fuchsias which Haussmann's chief gardener Barillet-Deschamps had popularised [18, 19].

Outside France, meanwhile, parks and gardens were painted by non-French artists who developed their own native forms of Impressionism. In the early 1870s the Austrian painter Fritz Schider created a series of high-keyed, broadly brushed studies of contemporary figures in the English Garden in Munich, from which *The Chinese Tower at the English Garden in Munich* [48], more subdued in tone, was developed. His evocation of diverse forms of leisure – taking tea, listening to music, making conversation, and watching the play of sun and shadow – parallels the evolving French Impressionist emphasis on sensations. The Italian Marco Calderini, painting some years later, turned the Royal Gardens in Turin into a place of almost elegiac poetry, informed by respect for the Barbizon tradition of painting as feeling [55]. By the 1880s, numerous foreign artists who came to train in Paris were painting in impressionistic modes in the city's public parks and gardens, or the gardens

Detail from
Frederick Childe Hassam
Geraniums [38]

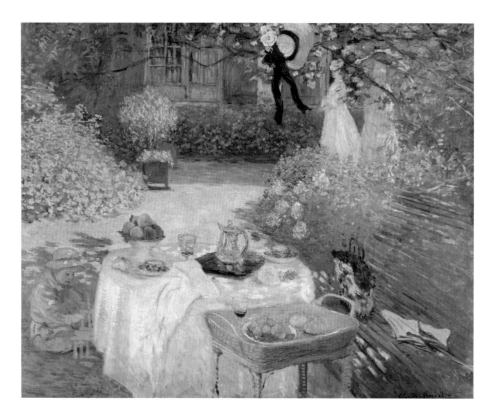

[fig.18] Claude Monet
The Luncheon, 1873
Musée d'Orsay, Paris

of houses in the surrounding countryside. In 1879, for example, John Singer Sargent merged the Whistlerian Nocturne tradition with the Impressionist garden of sensations in his view of the historic Luxembourg Gardens at twilight, and in the 1890s his compatriot Maurice Prendergast also painted there [52, 53]. Frederick Childe Hassam, another American, created a series of luminous paintings of the flower-filled garden of the house he rented at Villiers-le-Bel [37, 38]. And, by 1901, under the stimulus of the francophile Director of the Hamburg Art Gallery, Alfred Lichtwark, the German Impressionist Ernst Eitner was using his garden near Hamburg to capture the brilliance of sunlight on his family breakfasting outdoors [77].

THE PUBLIC, THE PRIVATE & THE DECORATIVE

Whilst the gardens portrayed in this section fall into two broad categories – private gardens and public parks – there were subtle connections between these, just as happened in the New Town area of Edinburgh or in Bath in the eighteenth and nineteenth centuries. Although the Parc Monceau, for example, was a public garden, each of the mansions built around it in the 1860s had its own gate into it. After hours, it was again the private garden it had been when it was originally created by the Orléans family in the eighteenth century. This transformation was vividly evoked in Emile Zola's 1872 novel *La Curée* (*The Rush for the Spoils*), which was set in one

of the mansions. For Monet in 1878, the Parc Monceau was literally a surrogate for the private gardens he had cultivated and painted at Argenteuil before creditors had chased him from his home there.

Conversely, the private garden could have elements more reminiscent of a public park. The French artist James Tissot, who settled in Britain, modelled the garden of his London house on the Parc Monceau [23], whilst the decorative display beds in Monet's gardens at Argenteuil [18, 19] were a miniature version of the kind of floral culture seen in the Paris parks. A similar effect of a miniature park where tall plants such as standard roses were exhibited in display beds (*corbeilles*) can be seen in the traditional landscape painter Henri Harpignies's view of his own garden at Saint-Privé [33]. Such emphasis on decoration in part answered the new role of the private garden in the nineteenth century as an outdoor salon, an attractive space for receiving friends. Indeed, in 1867 the French horticultural historian Arthur Mangin called the private garden 'the true temple of hospitality', where the owner's 'first pleasure and duty' on the arrival of a guest was to 'give him the honours of the garden, take him for a walk along the paths'.[7] Monet followed this tradition at Giverny in the early twentieth century, where he welcomed friends such as the former premier Georges Clemenceau, but Monet's first wife Camille can already be seen walking with a female friend in the background of *The Luncheon* of 1873 [fig.18], which depicts his first house and garden at Argenteuil.

Impressionist paintings of private gardens in this sense invite the viewer to be the painter's guest: to share his or her private life on equal terms, or, alternatively, to accompany the painter on a visit to the garden of a friend. This intimacy is often underlined by the accessibility of the composition, with a path opening before the viewer, or flowers and plants seemingly spilling out of the painting into our space. The American Charles Courtney Curran even implicitly places us in a boat with his bride and cousin amid the lotuses on their family estate [35]. Such effects represent a further shift away from Romanticism's sense of the smallness of mankind in the face of nature's grandeur, and also complement the interests of the private middle-class patrons who typically bought Impressionist works.

The private garden could in fact be as much a place of social encounter as the public park, as illustrated by the wittily-composed gathering of friends in Manet's *The Croquet Party* [17], in which the game portrayed is one also of personal relationships. Equally, the logic of the garden as a form of decorative nature – whether public or private – is followed through in the Impressionist use

from the mid-1870s of flower- and leisure-garden motifs as mural decorations. Monet displayed his painting *The Luncheon* as a 'decorative panel' at the 1876 Impressionist exhibition, and also painted murals in the same year for the Château de Montgeron which showed its gardens and grounds. Renoir likewise painted murals of garden flowers for his friend the diplomat Paul Bérard's château at Wargemont in the late 1870s and early 1880s.[8] Whilst such schemes reinvented the Rococo tradition of park and garden themes in decoration, they now replaced its fantasy imagery with contemporary, observed nature. Gustave Caillebotte's murals of the early 1890s, showing flowers from his garden at Petit-Gennevilliers [39, 40], and Monet's later water lily murals, donated by him to the French State and now in the Orangerie in Paris, are their sequel.

Renoir's interest in the decorative was surely encouraged by his experience of painting in the neglected garden of the studio he had taken in 1876 at an old mansion on the rue Cortot in Montmartre – the garden shown in his *Woman with Parasol in a Garden* [21]. With its 'vast uncultivated lawn … strewn with poppies, convolvulus and daisies', the garden would have vividly embodied the 'multicoloured' quality that Renoir admired as creating a 'decorative' effect in Delacroix's art; its 'irregular' or 'landscape character', again recalling eighteenth-century models, would also have offered a striking contrast to the 'regularisation' beloved of Haussmann.[9] It is perhaps no coincidence that, just as Monet chose to paint a curving side-path at the Parc Monceau, rather than Haussmann's arterial *allées* there, so Renoir, following his stay at rue Cortot, began to formulate his vision of a 'Society of Irregularists', with the 'irregular', free growth of nature as its guide.[10]

The French Impressionists typically preferred to paint the old, historic parks of Paris, such as the Parc Monceau or the Tuileries, rather than Haussmann's new gardens. These older gardens were frequented by the wealthier classes, whose patronage the Impressionists hoped to obtain, but must also have been attractive as places where the trees had largely escaped the felling for firewood which ravaged so many other parks in Paris during the Prussian siege of 1870. An associate of the Impressionists, the Italian artist Federico Zandomeneghi nonetheless painted the Place d'Anvers [54] – one of the new 'little gardens of the people', as they were termed in the Italian horticultural press, which Haussmann had planned for the poorer quarters of the city.[11] However, Zandomeneghi takes a dynamic, angled view so that, despite the straight paths and the geometry of the flower beds, the effect is one of intimacy. The Place d'Anvers

becomes in all but name the private garden of the nursemaids, children and lovers who form decorative notes of colour in its sun and shadow.

THE ARTIST'S GARDEN

Amongst the various flower and leisure gardens painted by the Impressionists from about 1870, it is the artist's garden – the garden both cultivated and painted by an individual artist – which comes to the fore as an essentially Impressionist invention. It is where perhaps the most direct and subtle development both of the Barbizon delight in local nature as a 'pleasant place', and of the celebration of nature's sensations in the floral paintings of the Lyons school, and of Delacroix and Bazille, can be found. It can also be viewed as a logical sequel to what the poet Baudelaire had identified as one of Delacroix's cardinal characteristics, his 'love for the home – both sanctuary and den … As others seek privacy for their debauches, he sought it for inspiration'.[12] For the Impressionists, the privacy of the artist's garden was, after all, what made it a prime artistic laboratory, a place for dedicated investigation of the effects of colour, light and atmosphere on figures, flowers and plants. Removed from the noise and bustle of the streets, and the exposure to public gaze which painting out of doors could otherwise entail, its privacy and ease of accessibility invited artistic experiment. The same motif could be explored under different lighting or weather conditions, just as a particular model could be observed in different scenarios, as in Morisot's paintings of her young daughter Julie playing with various toys in the garden of her summer home at Bougival [29, 31].

The nature offered by the artist's garden was also one, of course, whose layout and character had been devised or selected by the artist, and as such it realises the ideal of 'a corner of creation seen through a temperament' which the writer and critic Emile Zola had set out as the goal of modern art in an 1868 Salon review.[13] Monet's individuality is vividly evident from the way he planted not only conventionally decorative beds at Argenteuil [18], but also a free hedge of dahlias [19], in which can be recognised the quest for nuance and variety of floral colour he would gratify at Giverny, where he settled in 1883. Caillebotte's garden at Petit-Gennevilliers, started in 1884, was likewise a place for experiment with colour, but there each bed was dedicated to a single species [41]. His form of horticulture in this sense has much in common with the passion for collecting which the writer and aesthete Edmond de Goncourt displayed in his garden of choice specimens at Auteuil at this period.

Even Renoir's semi-wild garden at rue Cortot reflects

[fig.19] Auguste Renoir
*Portrait of Monet Painting in his
Garden at Argenteuil*, 1873
Wadsworth Atheneum, Hartford

his personal preference; it was, in effect, the embodiment of his condemnation of 'gardens that are so trimmed up that artists have no place there, for artists can only work where nature is left some freedom'.[14] Renoir's portrait of Monet painting the dahlias in his garden at Argenteuil [fig.19] – perhaps the archetypal image of the Impressionist artist's garden – is as revealing of his own tastes as of his colleague's: the background houses and the low straight fence (features absent from Monet's own image of his dahlias) serve to throw into prominence the free, irregular growth of the flowers, and, implicitly, Monet's artistic skill in capturing this.

Monet's artist's gardens at Argenteuil, at the Maison Aubry from 1871, and the Pavillon Flament from 1876, are amongst the earliest in Impressionism. As well as Renoir, Pissarro, Manet and Sisley all visited him at Argenteuil, and Renoir and Manet also painted in friendly rivalry in his garden there.[15] The artist's garden in the 1870s was, therefore, perhaps less private than might be expected, forming a sequel as much to the colonies of artists who had painted in the Forest of Fontainebleau, as to the Romantic cult of the individual. The gatherings of like-minded artists in Monet's garden can certainly be situated in the context both of the

Impressionist exhibitions held from 1874, as attempts to regenerate French art, and of the popular conception of gardens as emblems of national renewal in the aftermath of the events of 1870–1 (the Prussian siege of Paris, the loss of Alsace-Lorraine to the Germans, and the bloodbath of the Paris Commune). In 1876, for example, the critic and early supporter of the Impressionists, Edmond Duranty, called their art not only 'a little garden', but also a 'young branch … on the trunk of the old tree of art' – a metaphor suggestively echoing Livy's description of the 'regrowth' of Rome after its sacking by the Gauls in antiquity, and thereby alluding to the hopes for Parisian renewal after the Prussian siege and the Paris Commune.[16]

With young children to bring up, it is hardly surprising that artists such as Monet or Morisot used their gardens as motifs in the 1870s and 80s. However, the theme of the family, like that of the child, was also highly topical in France in these post-war years, after the unnatural role felt to have been played by the *pétroleuses* – the female supporters of the Paris Commune whose paraffin-throwing had reputedly been responsible for the destruction of the Hôtel de Ville and other great buildings in Paris in 1871. Families, mothers and children were the hope of the future,[17] a resonance underlined by gardens themselves, with their traditional peace-building associations. Such connotations help explain why, in France at least, the artist's garden was also often a family garden in the 1870s and 80s, with figures as well as plants and flowers, and the two sometimes even correlated. The term *plante humaine* (human plant) was applied by the critic Octave Mirbeau to Pissarro's figures,[18] but already comes to mind in Morisot's image of her daughter Julie amongst the flowers in *Child amongst the Hollyhocks* [29], or Monet's of his son Jean alongside his splendid potted *Epiphyllum* (a type of cactus) in *The Artist's House at Argenteuil* [18]. In turn, in the Belgian painter Léon Frédéric's *The Fragrant Air* [47], the child's association with the roses can be recognised as not only an example of the increasing proximity of Impressionism to Symbolism by the 1890s, but also a poignant reflection of Frédéric's sympathies with the Belgian socialists' aspirations for better working conditions; the wild rose above the girl's head was a socialist emblem.

A vision of the 'pleasant place' as a better world seems to have been a recurrent feature both of the artists' gardens of Impressionism, and of other forms of Impressionist leisure garden. In the Italian painter Odoardo Borrani's image of girls winding wool [27], the harmony of red flowers and plants related to the *Arum italicum* complements the Garibaldi red of the figures'

costumes, speaking of his hopes for the new united Italy; in Monet's, Morisot's and Mary MacMonnies's images of children playing in their rented gardens, both the harmony of child and cultivated nature and the freedom of the child's form of play, reflect the spread of the progressive educationist Friedrich Froebel's ideas. Froebel's 'gospel' was taken up particularly by the Republicans in France, with whom the French Impressionists broadly sympathised.[19]

The concept of a better world takes us back to the idea of decoration. For in decorative panels such as Monet's *The Luncheon* [fig.18] or Caillebotte's *Nasturtiums* and *Daisies* [39, 40], the painted garden – whether in terms of a reinvented Eden, a perpetuation of summer, or a celebration of native soil – was implicitly intended to influence those who used the room it adorned. The Impressionist garden as decor for living and as living decor – is, however, a theme which reaches its full fruition only after 1900 in Monet's water lily murals, in garden panels by Bonnard and Vuillard [figs 23, 24], and in the styles developed by artists such as Van Rysselberghe in Belgium or Gustav Klimt in Austria who took Impressionism in new decorative directions [75, 81, 92]. Equally, the concept of the garden as an outdoor room already evident in the imagery of outdoor meals and domestic activities of Odoardo Borrani and Albert André [27, 46] leads at the *fin-de-siècle* to new forms of intimate and symbolic garden imagery in which not only house and garden, but also garden and mind are more closely interlinked.

Private Gardens

17 Edouard Manet *The Croquet Party*, 1873
Städel Museum, Frankfurt am Main

Croquet was very fashionable in 1870s
France. This game takes place in the Paris
garden of Manet's colleague Alfred Stevens.
A friend called Alice Legouvé prepares to hit
the ball, watched by Stevens, seated on the
ground, and his lover Victorine Meurent.
However, Manet leaves it to us to decide
where Victorine's gaze actually rests – on
Alice alone? Or partly on Stevens's rival Paul
Roudier, a little distance beyond? Manet's
wit is as bold as his brushwork.

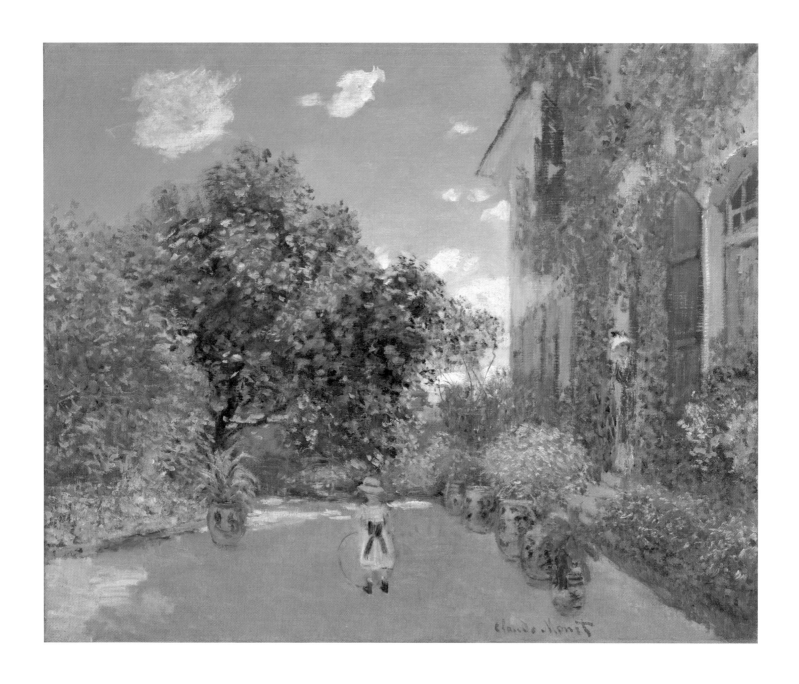

18 Claude Monet *The Artist's House at Argenteuil*, 1873
The Art Institute of Chicago

Monet invites us into the tranquil little world of his first garden at Argenteuil, glowing with colour and reflected light. His wife watches from the house as his son Jean plays with a hoop. Nasturtiums fill the circular display bed; fuchsias, marguerites, and lobelia, cornflower or love-in-a-mist are probably the flowers growing near the house. But in the blue and white pot in the foreground, with Monet's signature proudly placed beneath, is the garden's most exotic plant – an *Epiphyllum*, a type of Mexican cactus, in flamboyant red flower.

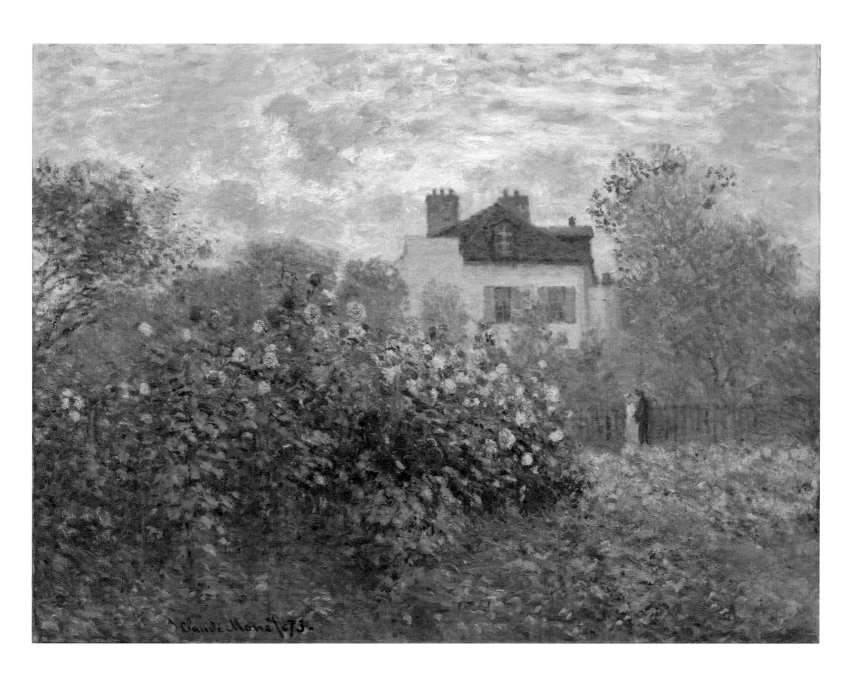

19 Claude Monet *The Artist's Garden at Argenteuil*
(A Corner of the Garden with Dahlias), 1873
National Gallery of Art, Washington DC

Once again, Monet celebrates his horticultural success. This mass of dahlias at
their prime in another part of his first Argenteuil garden includes bright scarlet
cactus specimens – perhaps *Dahlia juarezii*, first listed in 1864 – whilst the pinkish
flowers suggest the giant *Dahlia imperialis*, only recently cultivated outdoors in
northern France. In place of Delacroix's cut, single dahlias, Monet now grows the
new double types, and captures their splendour in the fresh morning light.

20 Paul Cézanne
The Pool at the Jas de Bouffan, *c.*1876
Sheffield Galleries & Museums Trust

The Jas de Bouffan was Cézanne's family estate in Provence, but here he allows its structure to merge with the countryside beyond. A shrub with pink flowers softens the geometry of the foreground pool and guides the eye to the light tones of a ripe cornfield. The effect brings to mind utopian ideals of the period, which likened the whole of France to a 'vast garden'.

21 Pierre-Auguste Renoir
Woman with Parasol in a Garden, 1875–6
Museo Thyssen-Bornemisza, Madrid

Renoir rented a studio in Montmartre in 1875–6 whose semi-wild garden was filled with poppies, convolvulus and cornflower. Although the bending figure suggests a gardener, his efforts are plainly unequal to this abundant growth, whilst the woman with her parasol might almost be some bloom herself. As the flowers cascade towards us, we are reminded of Renoir's evocative comment that a picture should 'seize you, enfold you, carry you away'.

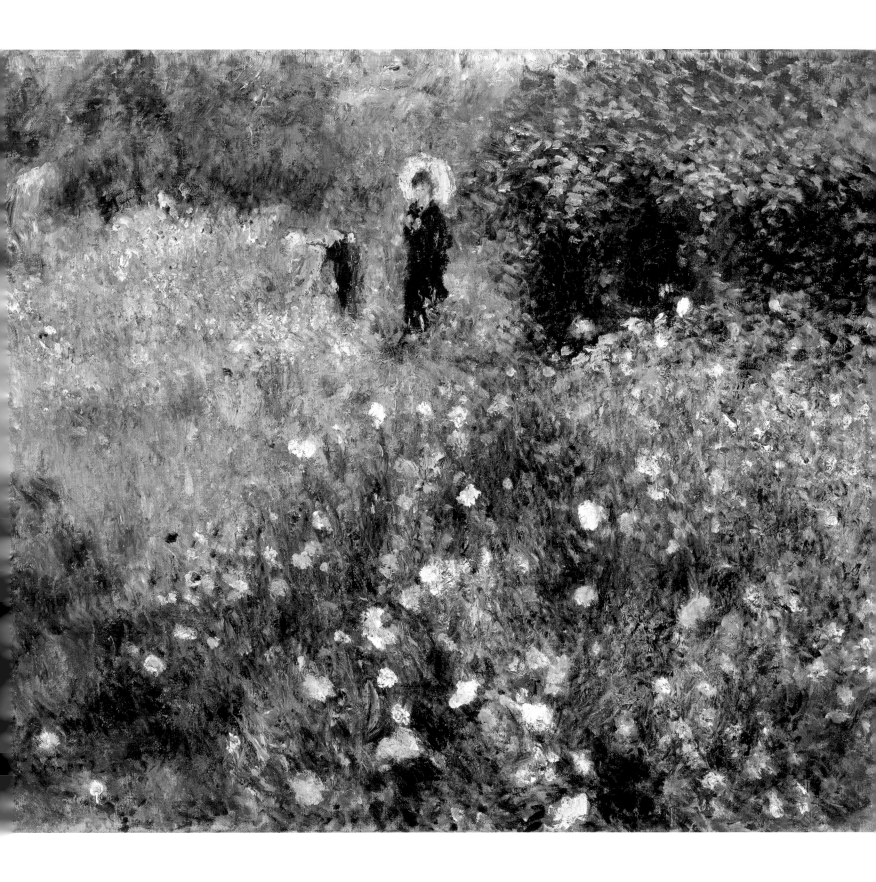

22 Joseph Bail
The Artist's Sister in her Garden, 1880
Musée des Beaux-Arts, Lyons

Bail won much success at the Paris Salon for still lifes and interiors influenced by Dutch genre painting. Here, however, he is outdoors in the garden of his family's summer residence at Bois-le-Roi near Fontainebleau. His thirteen-year-old sister Amélie might almost be one of the flowers. The brilliant blue of her parasol joins yellow blossoms and scarlet oriental poppies to place a joyous burst of colour at the heart of the tranquil scene. Use of a range of bright colours was a feature of Impressionist garden paintings.

23 James Tissot
Holyday, c.1876
Tate, London

Degas invited Tissot to contribute to the first Impressionist exhibition in 1874, but he declined, having patronage in London. His garden in St John's Wood, with its colonnaded pool, was nonetheless modelled on the Parc Monceau in Paris. Elegant young women flirt and take tea with cricketers wearing the caps of a local club, reminding us that 'holy' is old English for health. Yet the leaves are beginning already to turn. Tissot seems to express some private regret, perhaps for the Paris he was now enjoying at second hand.

24 Marie Bracquemond
On the Terrace at Sèvres, 1880
Association des Amis du Petit Palais, Geneva

Bracquemond exhibited with the Impressionists from 1879. Her sister Louise modelled both the women seated here with an unidentified companion in the artist's hillside garden at Sèvres. The white rose worn by Louise at the right is a traditional emblem of silence and innocence, and although the figures share each others' company, no-one speaks; in the warm light of late afternoon, each is caught in a moment of introspection and reflection.

25 Henri Fantin-Latour
Nasturtiums, 1880
Victoria & Albert Museum, London

These double nasturtiums are growing on stakes in a pot – an Impressionist garden in miniature. The complex petal structure of nasturtiums was often used as a subject for training flower painters, and *Nasturtiums* was purchased by the South Kensington Schools of Design as a model for its students. However, Fantin-Latour also captures the vigour and impatience of the nasturtiums' growth.

26 Armand Guillaumin
The Nasturtium Path, 1880
Ny Carlsberg Glyptotek, Copenhagen

Guillaumin was employed as a railway clerk, but contributed to most of the French Impressionists' group exhibitions in Paris. His love of brilliant colour finds expression in a rustic cottage garden in the Ile-de-France, where the flowers glow even in the shadows. Nineteenth-century scientists believed that nasturtiums contained phosphorus and therefore emitted light.

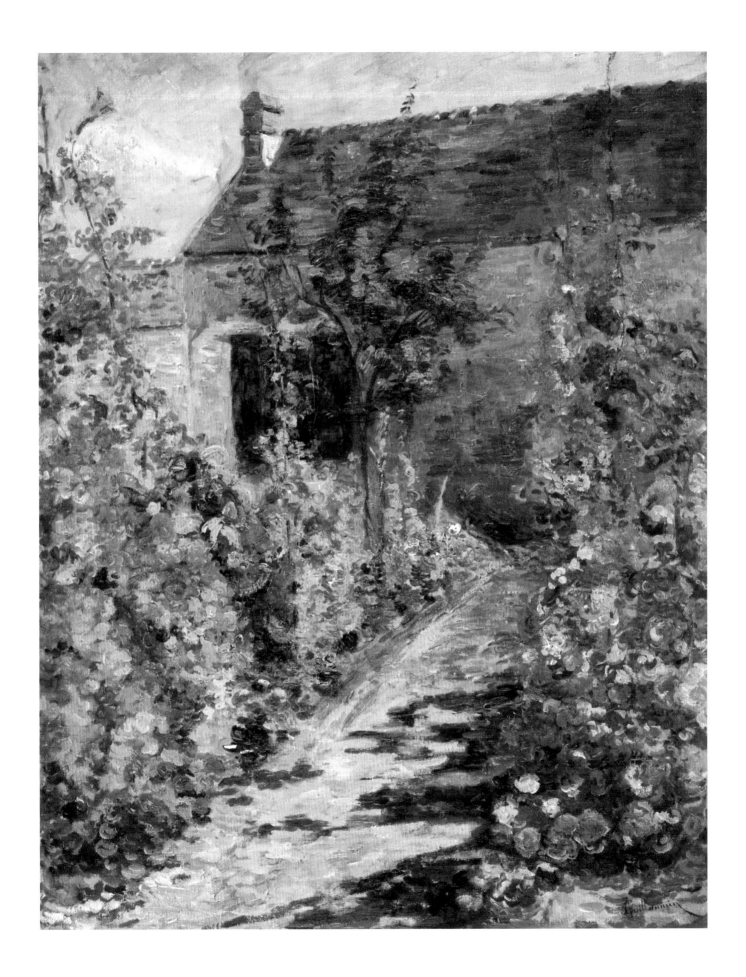

27 Odoardo Borrani
*Girls Winding Wool, c.*1880
Galleria Nazionale d'Arte Moderna, Rome

Green leaves, red flowers, white wool: the three colours of the Italian flag sing out from this tiny urban garden, reminding us that the Italian Impressionist Borrani had fought under Garibaldi for the unification of Italy, achieved only in 1871. The distinctive heart-shaped leaves of arum plants, commonly found in the Italian countryside, are also much in evidence. The girl who stands so erect at the right is almost like *Arum italicum*, her blouse its red fruit – and an echo of Garibaldi's red shirts.

28 Filippo Palizzi *The Roses of my Terrace*, 1881
Galleria Nazionale d'Arte Moderna, Rome

Palizzi, who was a pioneering Italian Impressionist and supporter of the struggles for a unified Italy, has settled into a comfortable life at home in Naples. In one of the last open-air studies of his career, he takes a palpable pride in the vigour of his roses and pot plants. Viewed from below, they seem taller even than the nearby houses.

29 Berthe Morisot *Child amongst the Hollyhocks*, 1881
Wallraf-Richartz Museum & Fondation Corboud, Cologne

Dwarfed by the soaring hollyhocks in the garden of the family holiday home at Bougival, Morisot's daughter Julie plays with a toy horse and cart. The child's world of fantasy contrasts with the adult world of work represented by the line of washing glimpsed beyond the gate, but Morisot's fleeting, delicate brushstrokes unite both in a larger, decorative harmony. The hollyhocks are probably some of the fine florist's varieties, prized for their double blooms and subtle colours.

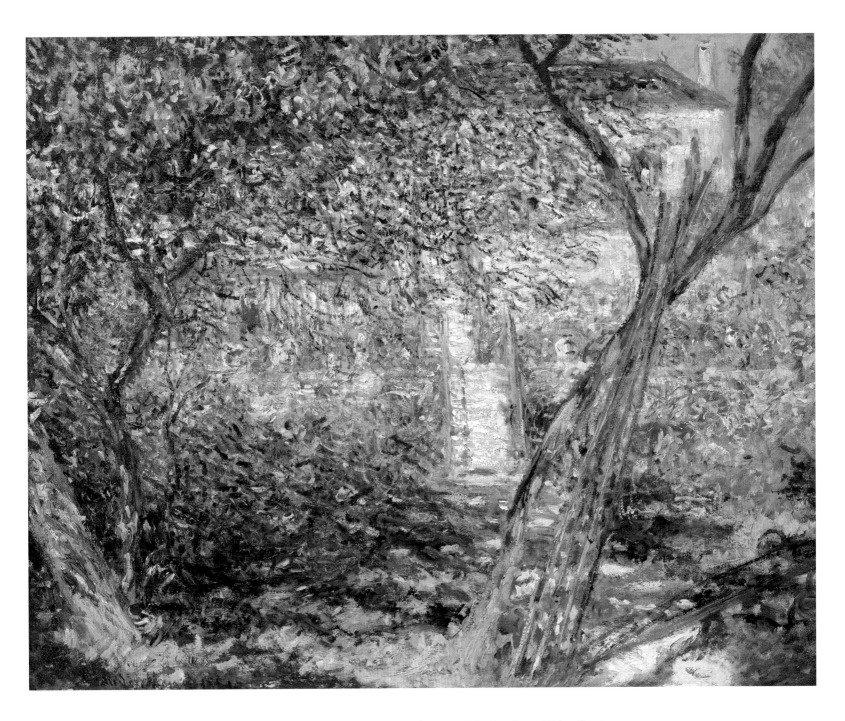

30 Claude Monet *The Garden at Vétheuil*, 1881
Private Collection

Monet lived in the quiet village of Vétheuil on the Seine from 1878 to 1881. The stakes placed against a tree in his steeply terraced garden there cast decorative shadows which complement the orange gladioli and the blue and white Delft pots shimmering in the sun beyond. The garden was separated from the house by the main road at Vétheuil, and ran down to the river.

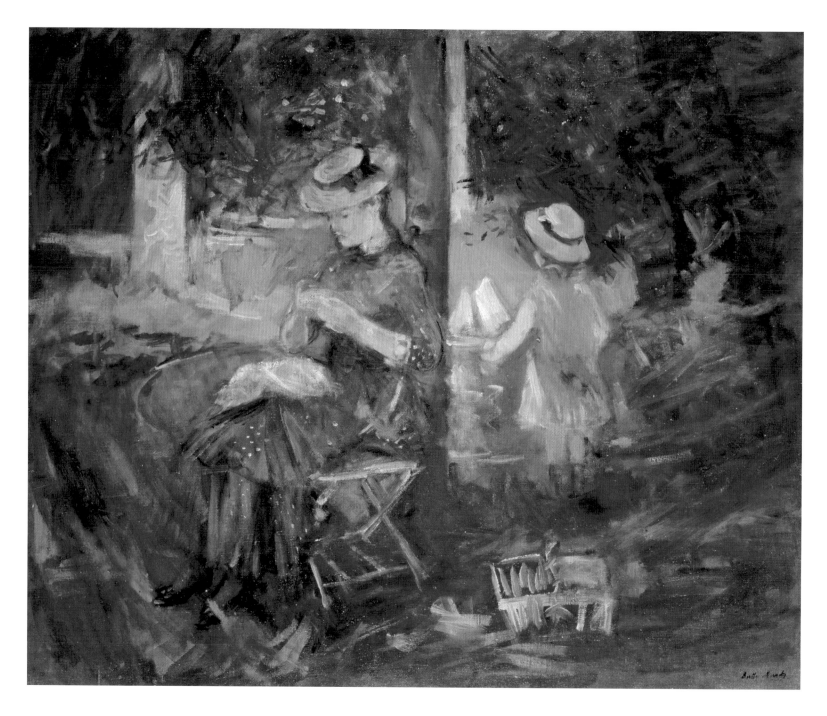

31 Berthe Morisot

A Woman and Child in a Garden, c.1883–4

National Gallery of Scotland, Edinburgh

Morisot gives us another privileged glimpse of her holiday garden at
Bougival. The woman so engrossed in her sewing, on a camp-stool under
a tree, is her niece Paule Gobillard; the straw-hatted child following the
progress of a toy boat on the pond is the artist's daughter Julie. Although
compositionally unresolved, and still a rough sketch, the picture provides
a vivid sense of the Bougival garden as a place for delight in the
pleasures of the moment.

32 Edouard Manet *The House at Rueil*, 1882

National Gallery of Victoria, Melbourne

Manet rented a modern house at Rueil near Versailles for a summer
break in 1882. Already crippled by the disease which killed him the
following year, he made the best of his physical limitations by painting
from a chair in its garden. His friend Théodore Duret was astonished
at the results, calling them 'luminous and seductive'. *The House at
Rueil* was quickly purchased by the Paris Opera singer Jean-Baptiste
Faure, and the German Impressionist Max Liebermann later bought
other Rueil works.

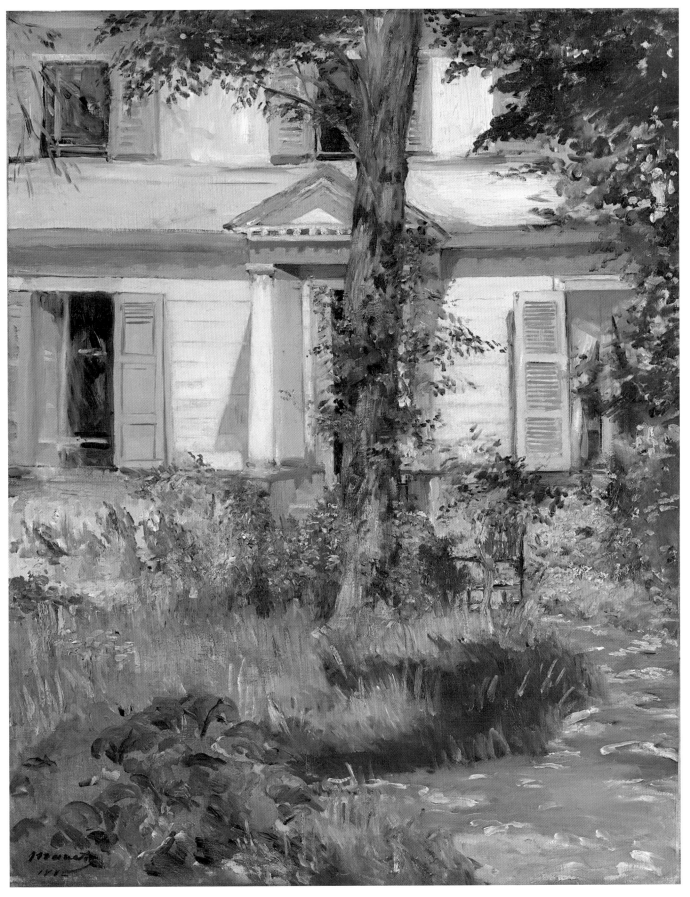

33 Henri Harpignies
The Painter's Garden at Saint-Privé, 1886
The National Gallery, London

A colleague of Daubigny, Harpignies painted many motifs in the forest of Fontainebleau. In later life, however, he kept a much-admired terraced garden at La Trémellerie, his home in the village of Saint-Privé near Fontainebleau. With its luminous sky and a view to the adjacent wood, *The Painter's Garden at Saint-Privé* combines an almost classical sense of order with colour and brushwork influenced by Impressionism.

34 Ernest Quost
Morning Flowers, *c*.1885
Musée municipal des Beaux-Arts, Bernay (Eure)

Quost was advised to exhibit with the Impressionists by their colleague Ernest Rouart, but chose instead to send his work to the Paris Salon. His skill as a flower painter was nonetheless greatly appreciated by Van Gogh. *Morning Flowers* captures the hour when dew still covers the garden and birds look enquiringly for crumbs. Morning glory, convolvulus, asters, and the leaves of nasturtiums weave a decorative screen across the foreground, and a pink rose blooms beside the house.

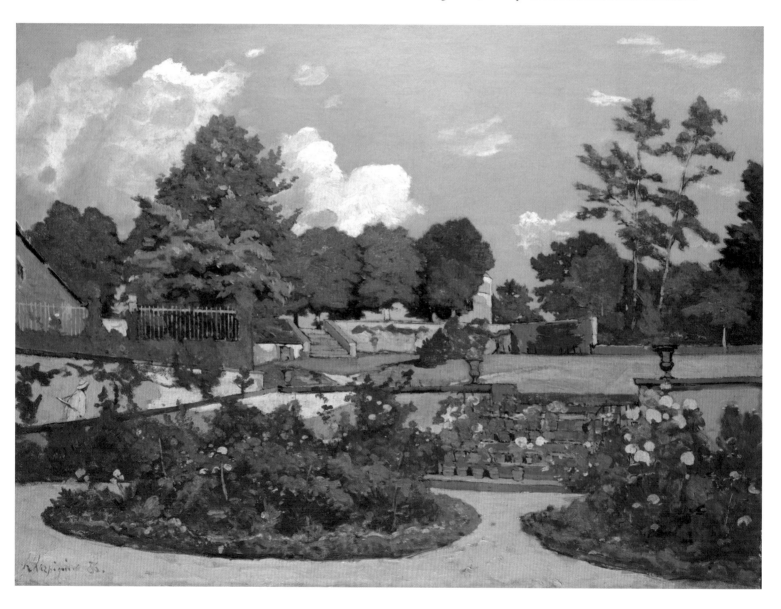

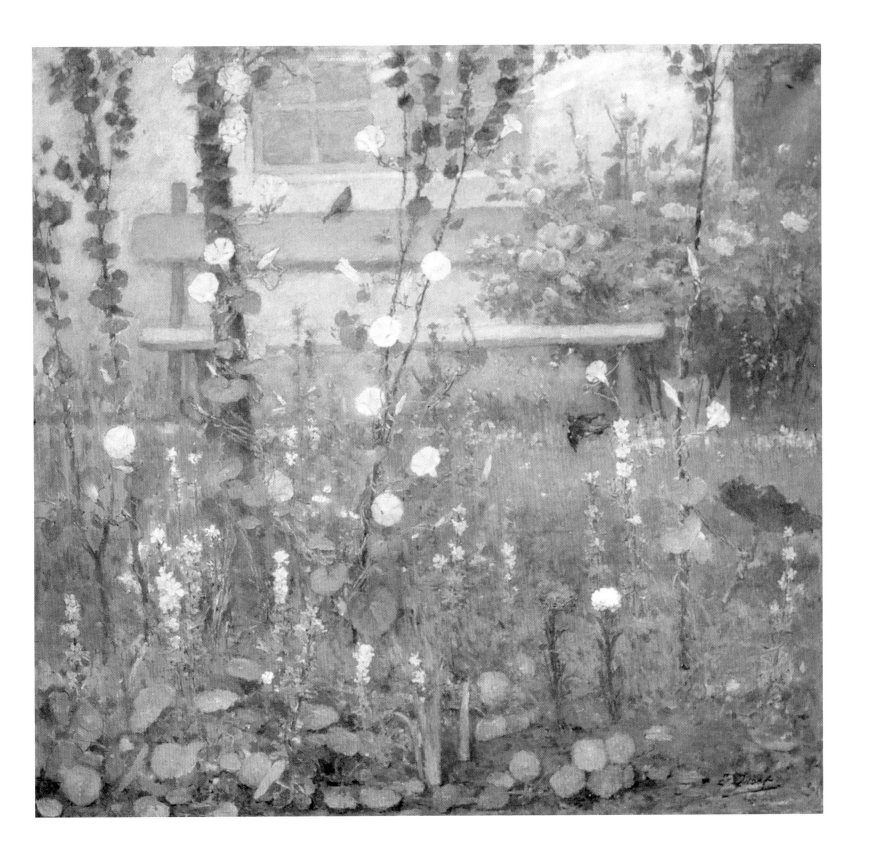

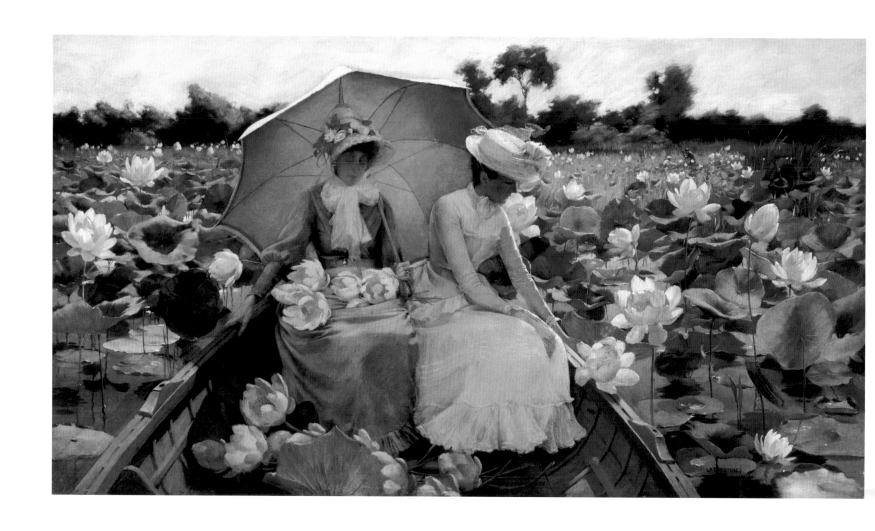

35 Charles Courtney Curran *Lotus Lilies*, 1888

Terra Foundation for American Art,
Daniel J. Terra Collection, Chicago

Lake Erie in Ohio has here become a luminescent
garden. Blooms of *Nelumbo lutea*, the American
lotus, reach as far as the eye can see, encircling
Curran's new bride Grace Winthrop and her cousin
Charlotte Taylor in their boat. Grace's wedding
bouquet had been made from these sweetly-scented
flowers, which still grow today on Lake Eyrie and are
related to the sacred lotus. Now, haloed by her leaf-
green parasol, she becomes the finest of Lake Eyrie's
blossoms, and the object of Curran's veneration.

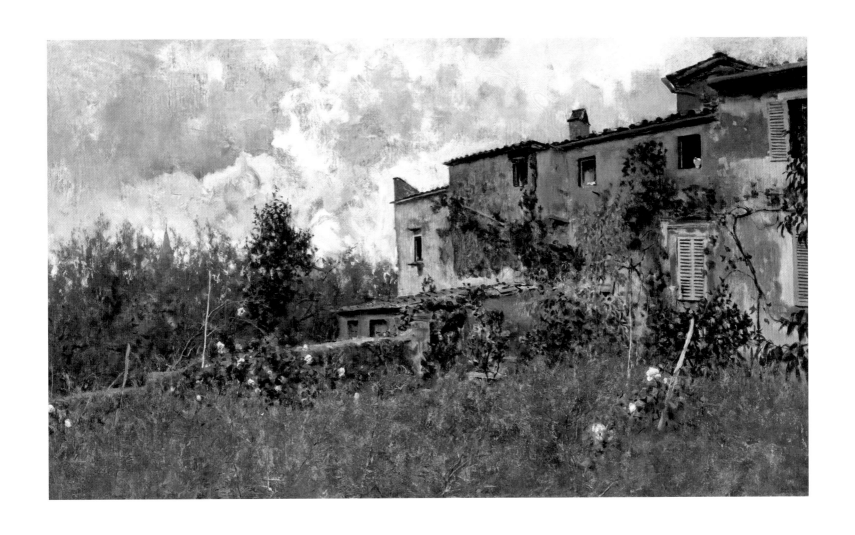

36 Telemaco Signorini *Summer Rain*, 1887
Galleria Nazionale d'Arte Moderna, Rome

Signorini was the most cosmopolitan of the
Italian Impressionists, painting in Paris, London
and Edinburgh amongst other European cities.
In *Summer Rain*, however, he is on native
soil, in an old hilltop garden at Settignano
near Florence. Despite his unpromising
subject – a passing shower, untidy grass, and
roses in need of pruning – he creates a vivid
sense of atmosphere and place, reflecting the
Italian Impressionists' belief that 'everything is
beautiful' in nature.

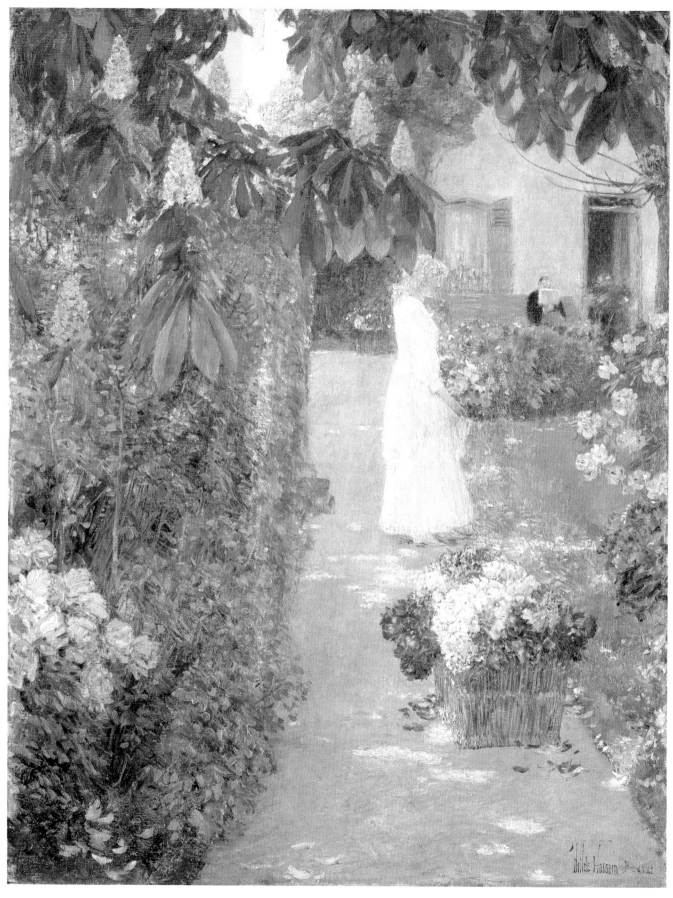

37 Frederick Childe Hassam
Gathering Flowers in a French Garden, 1888
Worcester Art Museum, Massachussetts

It is early in the morning, the time for
cutting flowers, in the garden at Villiers-le-Bel
near Paris of the Blumenthals, friends of the
American painter Hassam. Sun is beginning
to penetrate the shade, and the woman in her
shimmering dress becomes the focal point in
a decorative play of stately chestnut candles,
freshly-opened leaves, and dancing flecks
of light.

38 Frederick Childe Hassam
Geraniums, 1888–9
The Hyde Collection, Glens Falls, New York

Hassam's wife Maude sews beside the tender
geraniums in the garden at Villiers-le-Bel.
Filtered through an unseen glass awning, the
sunshine creates its own embroidery of dappled
light and shade, to which the flowers – properly
known as pelargoniums – add notes of glowing
colour and further patterns of shadow. Popular
both in France and in Hassam's home of New
England, pelargoniums were grown in pots to
facilitate wintering indoors.

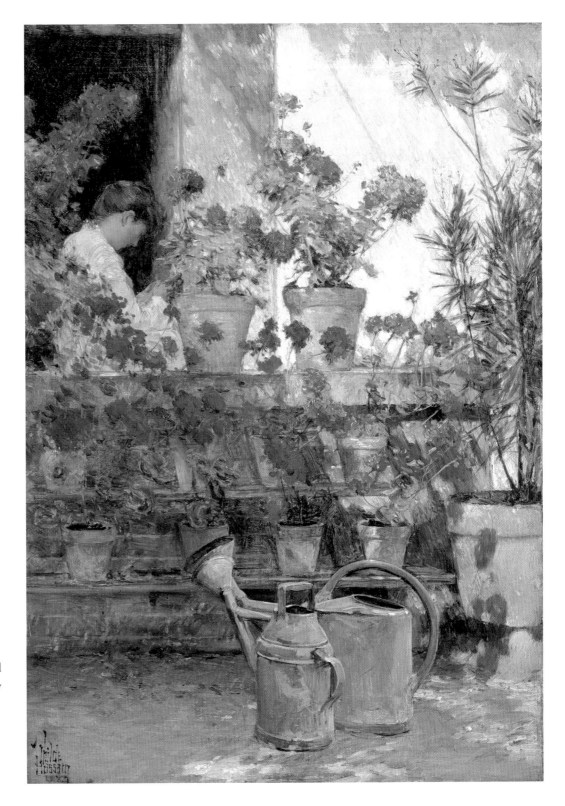

39 Gustave Caillebotte *Nasturtiums*, 1892
Private Collection

40 Gustave Caillebotte *Daisies*, 1892
Private Collection

Nasturtiums and *Daisies* are thought to be panels for the scheme of murals for Caillebotte's home at Petit-Gennevilliers on which he was working when he died in 1894. The close-up viewpoint recalls Japanese floral prints and contributes to the flat, decorative effect. The nasturtiums, flowers originally from Peru, are a traditional climbing variety, whilst the daisies are a type of marguerite, a flower cultivated in European gardens since 1699.

41 Gustave Caillebotte
The Dahlias, Garden at Petit-Gennevilliers, 1893
Private Collection

In contrast to the mixtures of plants grown by Monet at Giverny, Caillebotte kept each species in a dedicated bed in his garden at Petit-Gennevilliers. Yet his dahlias are not mere botanical exhibits. Placed right at the forefront of the picture, they burst from the canvas like red and yellow fireworks. This effect cleverly integrates our world with that of the painted garden, where Caillebotte's mistress Charlotte Berthier strolls with his dog near his house and greenhouse.

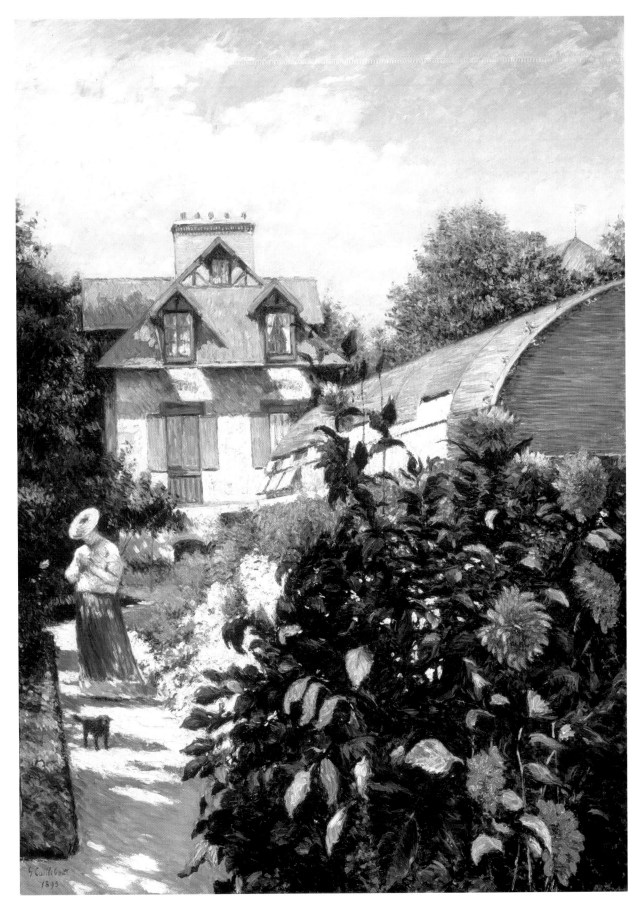

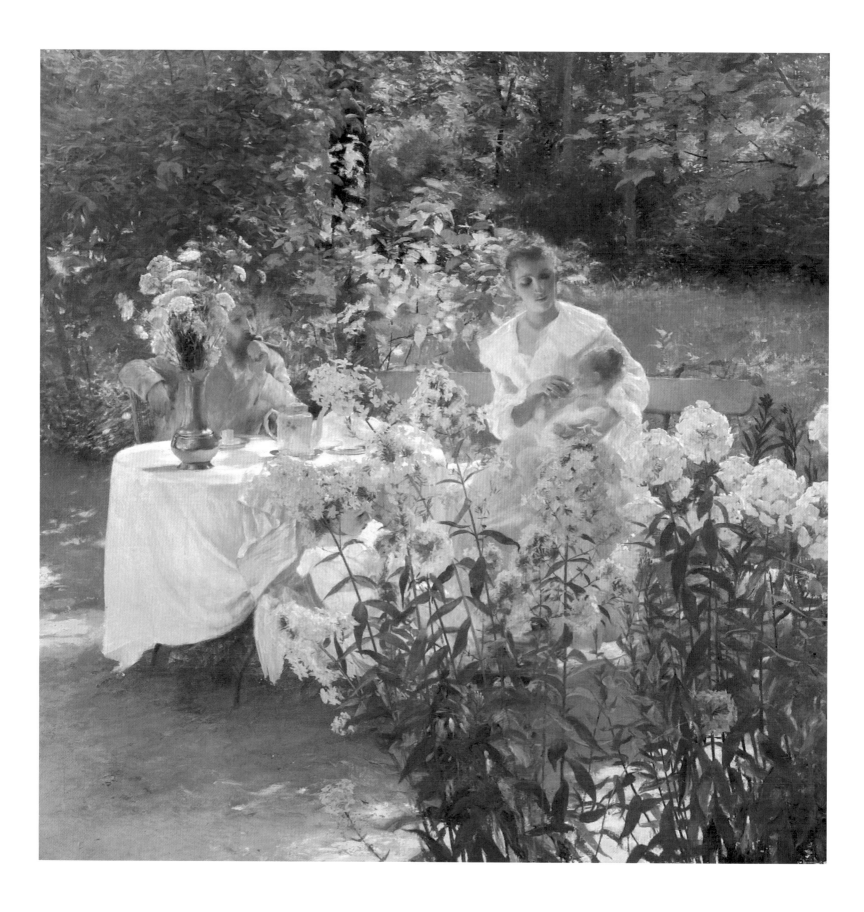

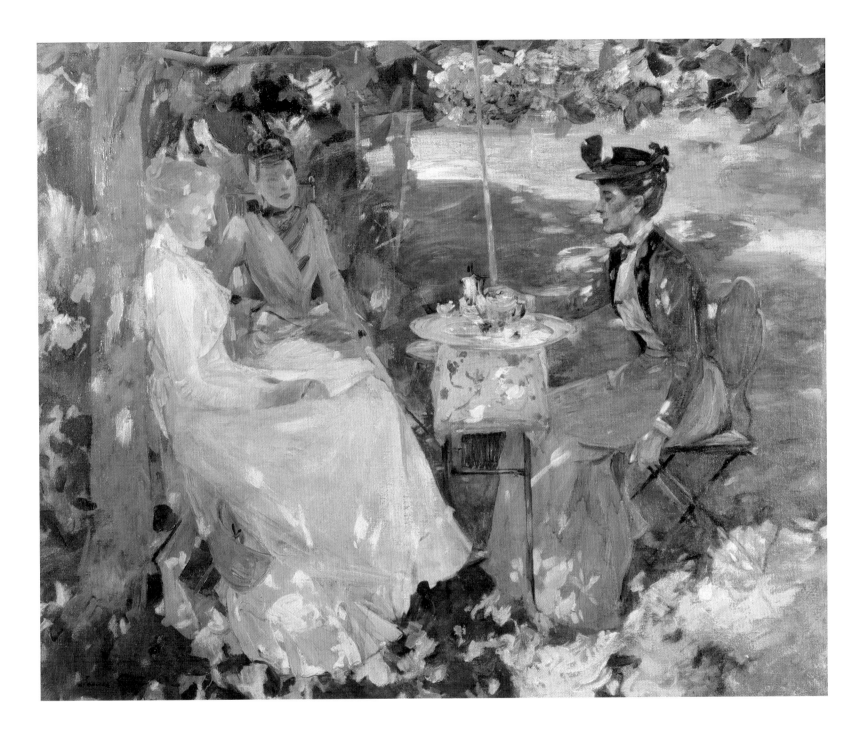

42 Gaston La Touche *Phlox*, 1889

Musée de La Roche-sur-Yon

La Touche was a friend of Manet and Degas. In his intimate family garden near Saint-Cloud, he weaves a dazzling harmony of whites – the phlox, the costumes, and the tablecloth. White, of course, is the colour of innocence, and this symbolism is complemented by the glass of water his wife gives their child. Although phlox were fancy plants, normally grown for contrast with collection plants such as roses, they are valued here in their own right.

43 James Guthrie *Midsummer*, 1892

Royal Scottish Academy (Diploma Collection), Edinburgh

The Scottish painter Guthrie captures the magical light of long summer days in his native land in a sympathetic portrait of Maggie Hamilton, a fellow artist, and two companions thought to include her sister. They are taking tea in the garden of Maggie's home, Thornton Lodge, in Helensburgh near Glasgow. Guthrie had recently visited Paris and had become attracted there to the Impressionists' contrasts of light and shade, and their subtle use of luminous colour.

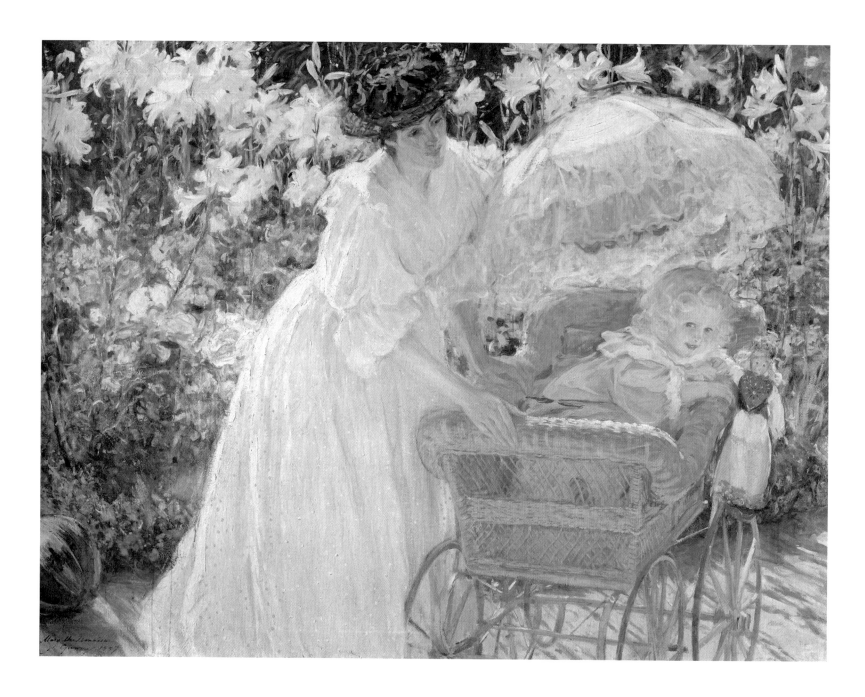

44 Mary Fairchild MacMonnies *Roses and Lilies*, 1897
Musée des Beaux-Arts, Rouen

Dazzling summer light fills the garden of the Villa Bêsche, the first house at Giverny of the American artist Mary MacMonnies. The infant in the dress as pink as the roses is MacMonnies's daughter Berthe, whilst the artist herself is shown in white like the lilies. Together with a number of other American artists, MacMonnies and her sculptor husband Frederick were attracted to Giverny by its association with Monet.

45 Mary Cassatt *Summertime*, 1894
Terra Foundation for American Art, Daniel J. Terra Collection, Chicago

A woman and child are boating on the pond in the garden of the Château de Beaufresne, the dilapidated mansion Cassatt had recently purchased near Beauvais. Looking down at the water, their attention is captured by its flickering, hypnotic shimmer. Cassatt had recently included a motif of women and ducks in a mural of *Modern Woman* for the Chicago World's Fair, but now she creates a more intimate version, a souvenir of summer's pleasures. It forms part of wider Impressionist interest in the shifting effects of light on water.

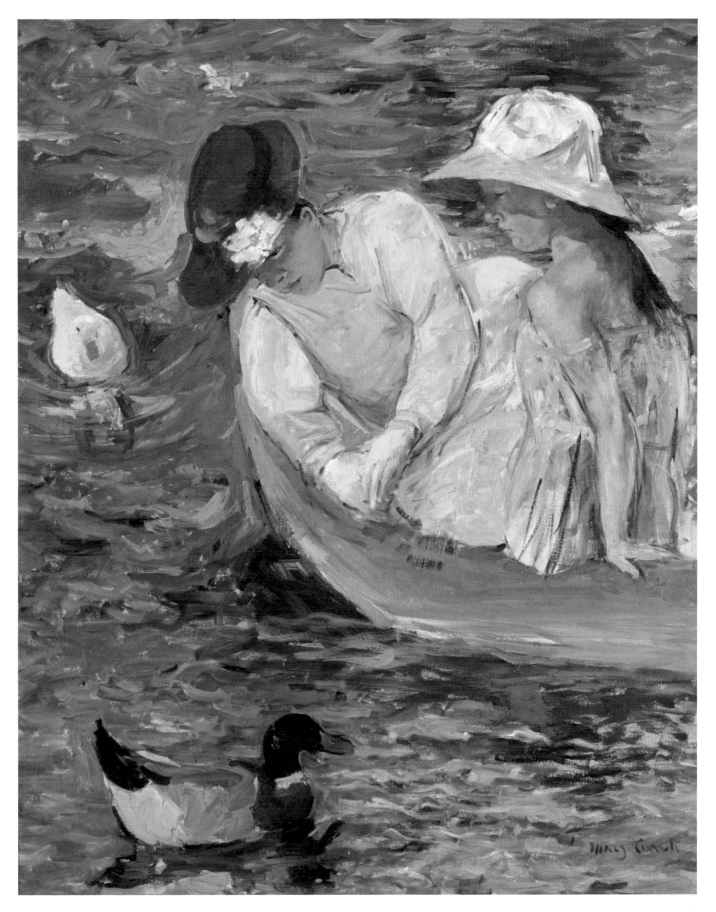

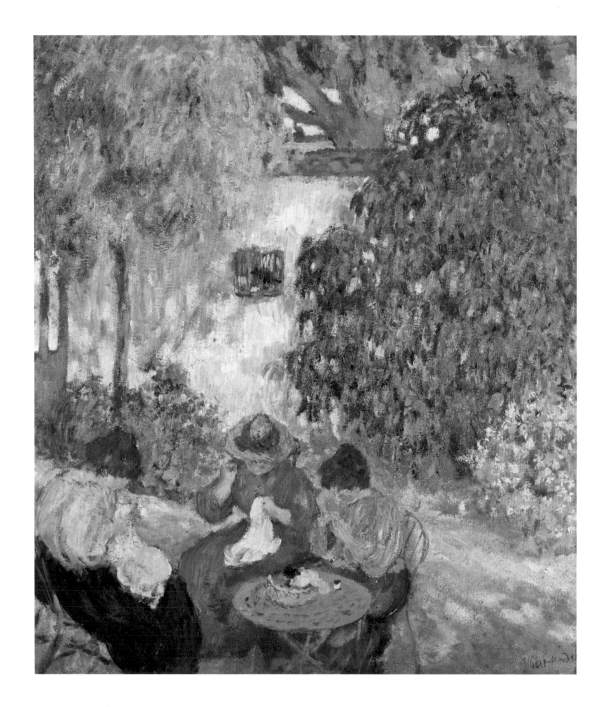

46 Albert André *Women Sewing, c.*1898

Carmen Thyssen-Bornemisza Collection,
on loan to the Museo Thyssen-Bornemisza, Madrid

André began his career as a silk designer in Lyons but turned with Renoir's encourage-
ment to painting. His close-toned image of women sewing in the shade beside the trees
and shrubs of the family garden at Laudun near Avignon has much in common with
the *intimisme* of his colleagues Bonnard and Vuillard, and looks towards the more
decorative character of many Impressionist gardens in the twentieth century.

47 Léon Frédéric
The Fragrant Air, 1894
Private Collection

Fragrance is notoriously ephemeral. And so too was life for many children in Frédéric's native Belgium, where industrialisation had brought pollution and disease. In this sense, the ruddy-cheeked infant is as precious as the rose she so dreamily smells – *Rosa sericea*, a four-petalled rarity. The rose like a star above her head, meanwhile, is a dog rose, the emblem of the socialists, whose election victories in 1894 had brought new hope to many Belgians. This message is reinforced by the spring flowers – including a tulip, wild daffodils and grape hyacinths – which grow amongst the extraordinary mass of blowsy cabbage roses.

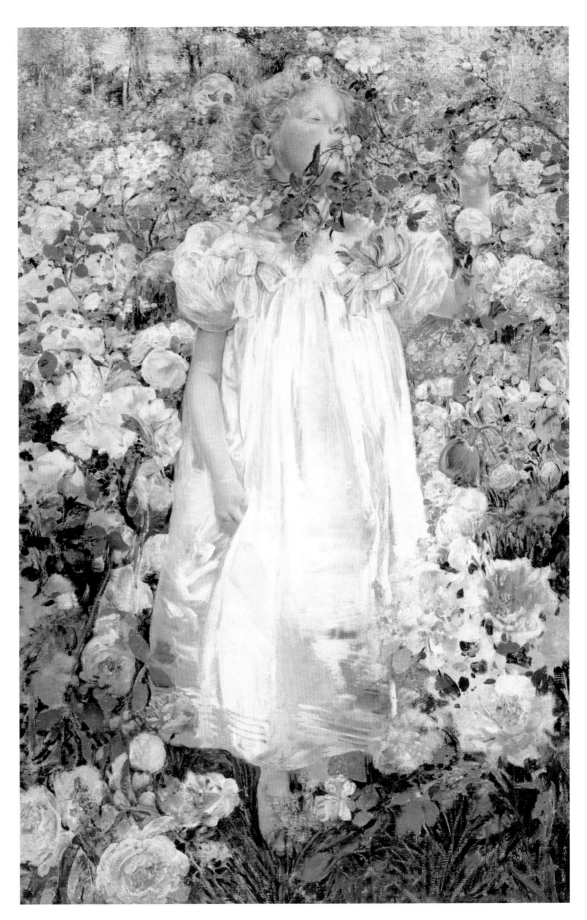

Public Gardens

48 Fritz Schider
The Chinese Tower at the English Garden in Munich, c.1873
Kunstmuseum, Basel

The ornate Chinese Tower is one of the attractions of Munich's historic English Garden. However, the Austrian artist Schider gives prominence instead to the shifting patterns of sunlight in this park. It picks out the fingers of a harpist at an outdoor café, and a child's glance of fear as a beggar-woman passes; it makes the silver gleam, and draws the eye to children dancing on the grass. These effects, and the theme of modern leisure, contributed to the emergence of Impressionism beyond France.

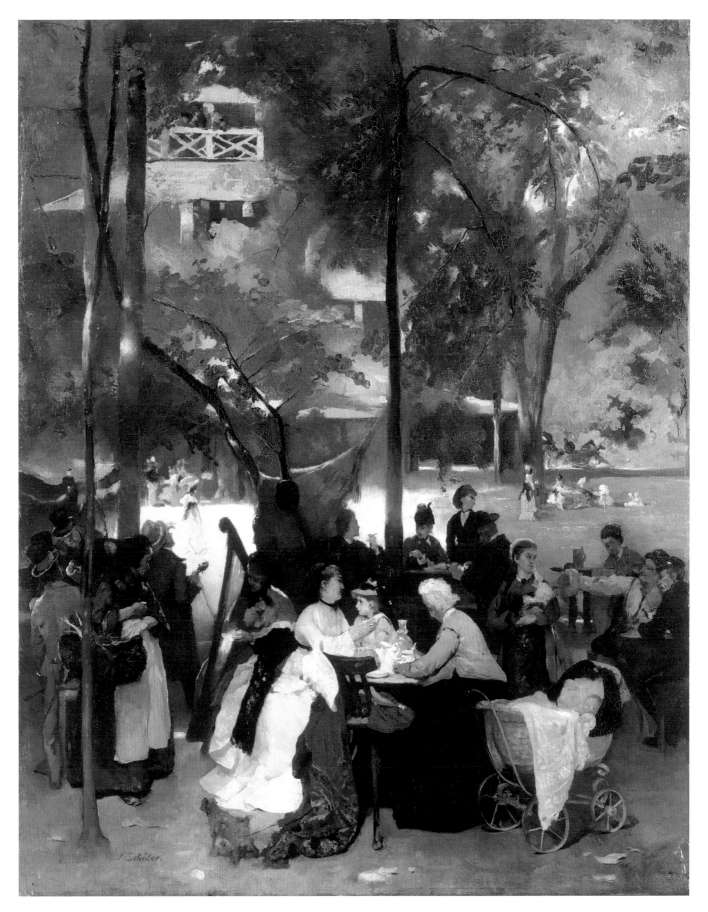

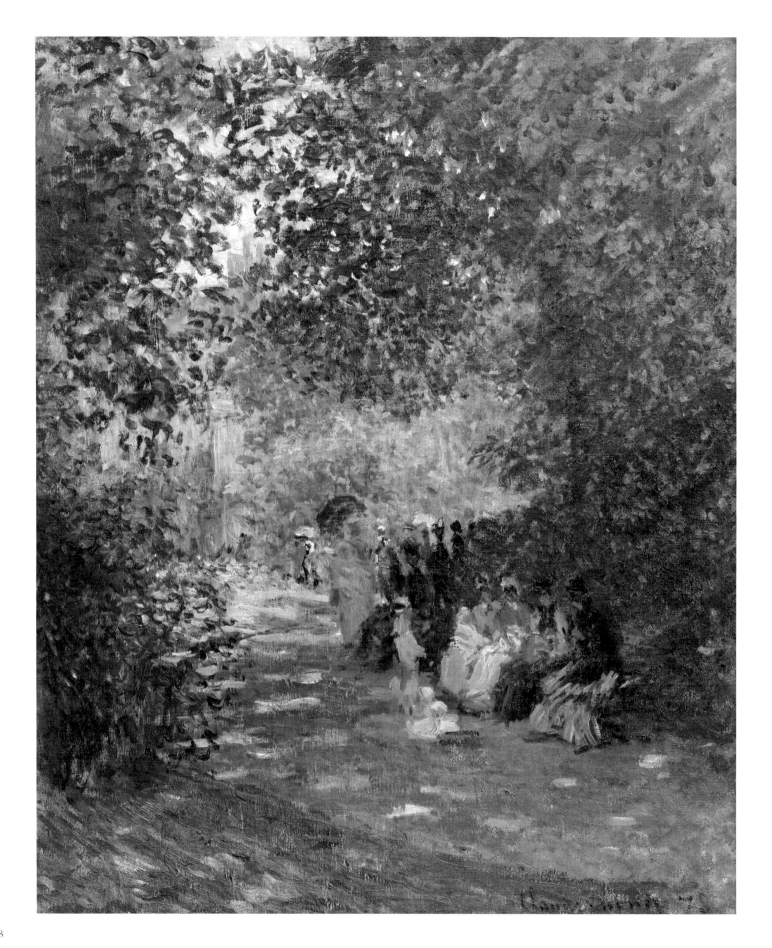

49 Claude Monet
The Parc Monceau, 1878
Private Collection

50 Claude Monet
The Parc Monceau, 1878
The Metropolitan Museum of Art, New York

The Parc Monceau was the jewel in
the crown of the Paris public gardens.
Established by the Duc d'Orléans a century
before Monet's pictures, it had been opened
to the public by Napoléon III in 1862. Monet
includes in the background some of the elite
private mansions built by Napoléon, but he
provides a fleeting glimpse only of the park's
celebrated floral displays, and no sign at all
of its grand arterial drives, also constructed
by Napoléon. He concentrates instead
on the decorative play of strong Parisian
sunshine and deep shadow, and the figures
relaxing under the tall, mature trees. His
creation of two versions of the motif – one
with more emphatic tonal contrasts, the
other with softer harmonies – anticipates his
interest in painting 'series' of works, such as
those of Rouen cathedral and the water lilies
at Giverny.

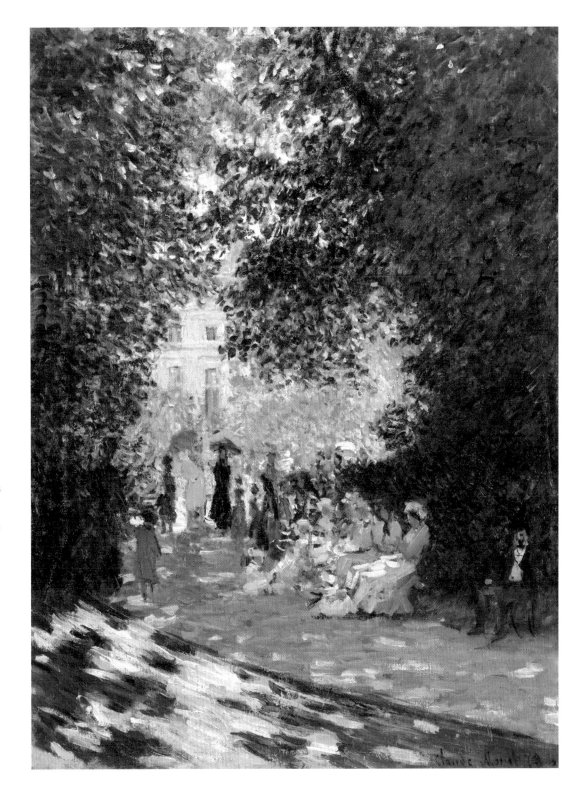

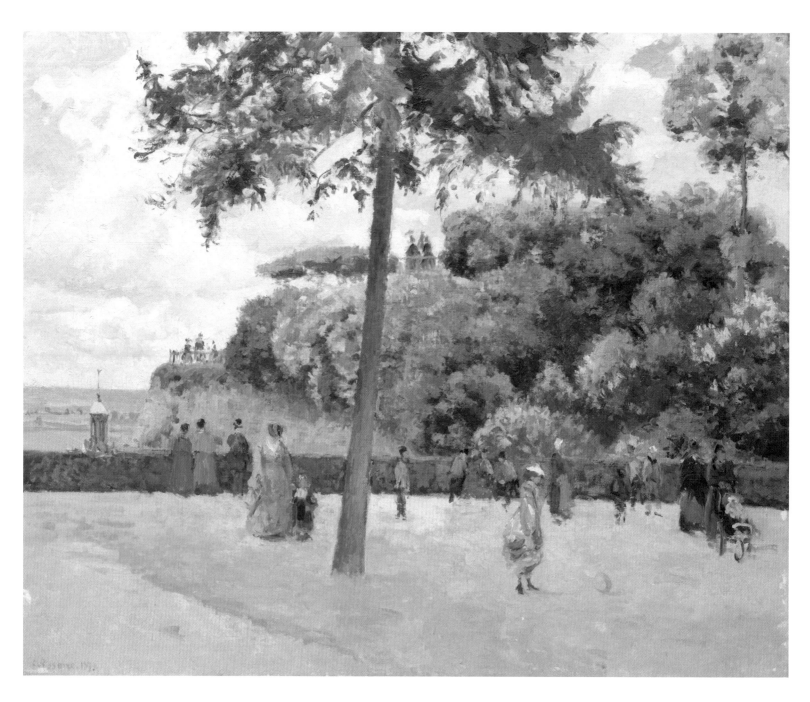

51 Camille Pissarro

The Public Garden at Pontoise, 1874

The Metropolitan Museum of Art, New York

Originally in private hands, the Pontoise public garden was noted for
its view across the Montmorency plains to Paris. However, Pissarro
delights in the children playing, people strolling, and spectators enjoying
the view from special railed platforms on the park's rocky outcrop.
The flowering shrubs add notes of colour and are probably lilac, which
tolerates drier soil.

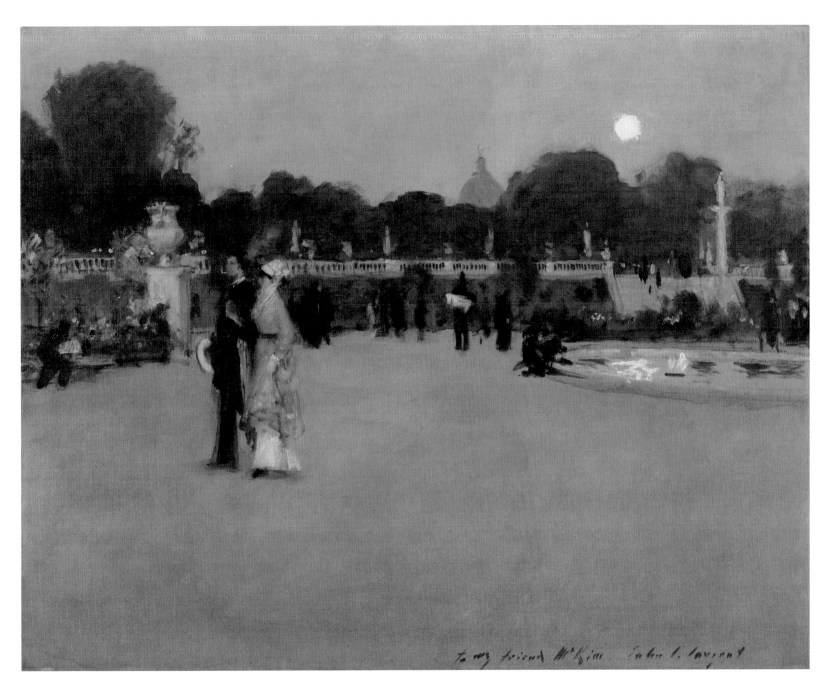

52 John Singer Sargent *The Luxembourg Gardens at Twilight*, 1879
Minneapolis Institute of Arts

The American painter Sargent knew the Luxembourg Gardens well, as his studio was nearby. Created in the seventeenth century, the Gardens are one of the great formal parks in Paris. Although Sargent's twilight harmonies recall the nocturnes of his early mentor Whistler, he had recently met Monet and takes a thoroughly Impressionist delight in the incidents of modern life – the children still sailing their boats despite the lateness of the hour, and the well-dressed couple strolling at the centre.

53 Maurice Prendergast
The Luxembourg Gardens, Paris, 1890–4
Terra Foundation for American Art,
Daniel J. Terra Collection, Chicago

Prendergast makes the Luxembourg's visitors
a subject in themselves, in a simple *pochade*
– a rapid oil sketch. He captures the mood of
approaching autumn, and the nursemaids relaxing
and conversing as their charges play. Already
evident is the feeling for decorative simplification
which became a feature of the lively city park
scenes he painted later in his native America.

54 Federico Zandomeneghi
The Place d'Anvers, 1880
Galleria d'Arte Moderna Ricci Oddi, Piacenza

The Italian artist Zandomeneghi captures a
moment in the life of a Paris square – one of
the 'little gardens of the people' recently created
in working-class districts. Children skip and
invent little worlds of private fantasy; nursemaids
chatter; lovers flirt; a toddler is caught short.
Zandomeneghi exhibited with the French
Impressionists, and he treats artistic convention
with freedom. The line of trees becomes a bold
rhythmic pattern, and the shadows shimmer in
blue, pink and lilac.

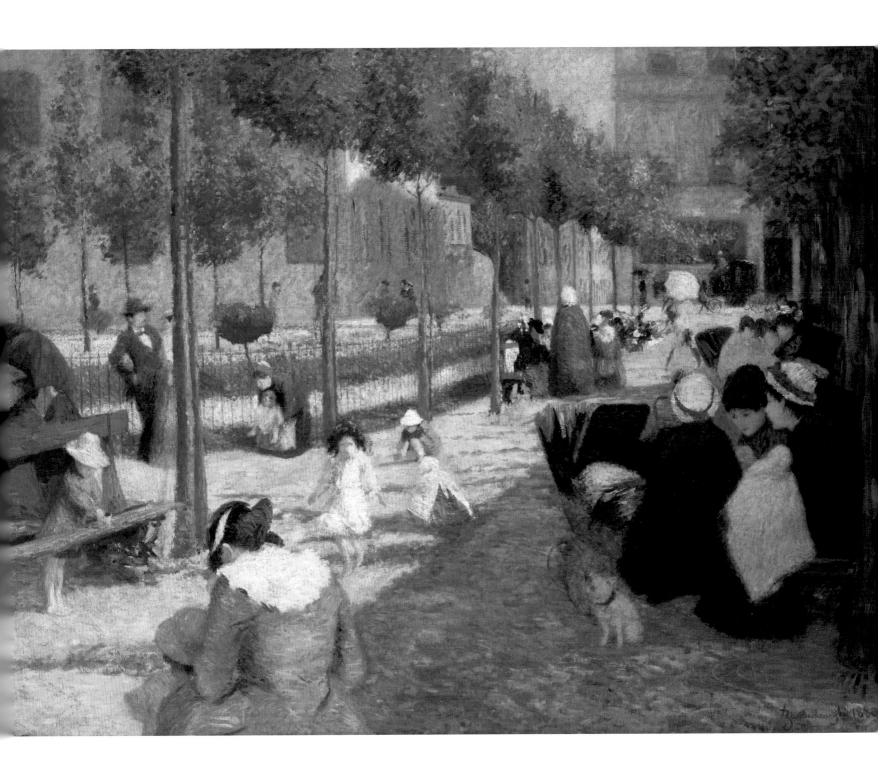

55 Marco Calderini *Winter Sadness*, 1884
Galleria Nazionale d'Arte Moderna, Rome

Winter Sadness belongs to the Turin Impressionist Calderini's series of seasonal paintings of the Royal Gardens of Turin. The bare, static trees, still water, and stone memorial urns are thought to convey his sense of loss at the death of his friend the artist Francesco Mosso. A quiet note of hope is nonetheless perhaps offered by the blue sky, reflected in the pool. These details anticipate the merging of Impressionism with aspects of Symbolism.

56 William Merritt Chase *In the Park. A By-path*, *c*.1890

Carmen Thyssen-Bornemisza Collection,
on loan to the Museo Thyssen-Bornemisza, Madrid

Visiting Paris regularly through the 1880s, the American painter Chase
developed a close familiarity with French Impressionism. His striking
composition with its bold, empty foreground was probably influenced
by the art of Degas and Japanese prints. However, it also vividly captures
the character of his motif – Central Park in New York – as a piece of
American wilderness reinvented in the city. The figures are his wife and
their daughter Alice.

57 Paul Gauguin *Skaters in Frederiksberg Gardens*, 1884

Ny Carlsberg Glyptotek, Copenhagen

Gauguin was initially influenced by Pissarro but in the early 1880s
he began to develop more expressive forms of painting. In *Skaters in
Frederiksberg Gardens*, one of three views he painted of Copenhagen
parks, the vivid reds and greens of the fallen leaves emphasise the coldness
of the ice, and the leaning tree draws attention to the movements of the
skaters, one of whom has fallen over. In contrast to Gauguin's later sun-
drenched views of Tahiti, we have a reminder here of winter in the north.

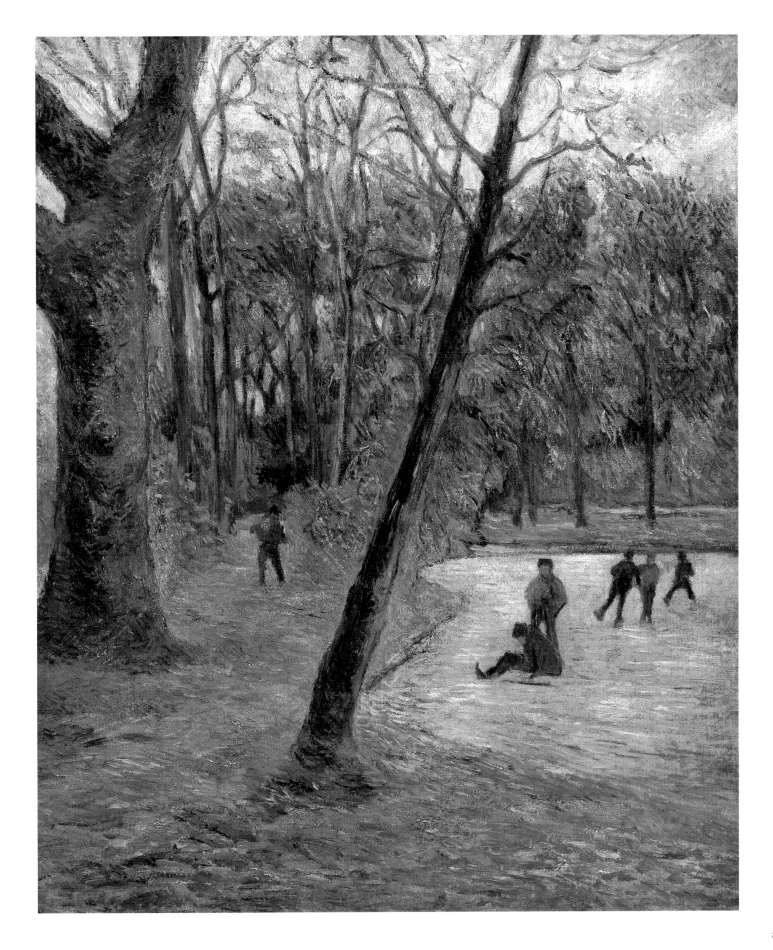

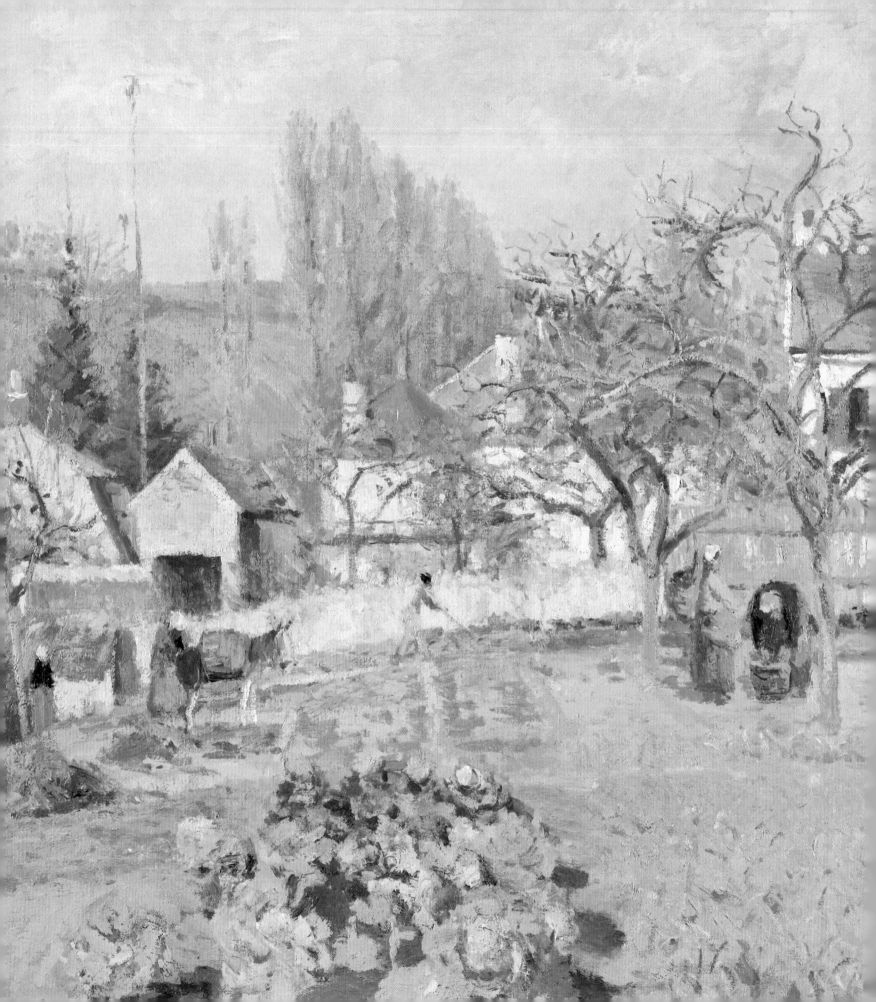

3 Kitchen, Peasant & Market Gardens from 1870

As places for growing food, kitchen gardens and orchards represent some of the oldest forms of horticulture. In the era of Impressionism, many of these gardens were still as they must have been for centuries with mixtures of different seasonal crops to feed a family, perhaps with some surplus for a local market, together with some fruit trees, and a few flowers for cutting or even, like nasturtiums, for eating in a salad. Although the ravages caused by the vine louse *phylloxera* led to many new orchards being planted in northern France in the second half of the nineteenth century, as replacements for vineyards, orchards like Monet's at Giverny were already traditional features both in Normandy and the Ile de France. Alfred Sisley's views of gardens filled with fruit trees at Louveciennes [58], meanwhile, bear witness to the character of this small town near Paris of which Renoir's son Jean recalled that 'most of the population … was made up of prosperous market-gardeners'.[1] Beyond France, the traditional farm garden (*Bauerngarten*), mingling vegetables and flowers, remained common in Germany and Austria, and in the nineteenth century was depicted in the 'Herb and Turnip' (*Kraut und Rüben*) paintings of the Austrian 'atmospheric impressionists' led by Jakob Emil Schindler; Klimt's peasant garden subjects [fig.20] have their origins in such works.[2] In the east of Scotland, where Arthur Melville painted *A Cabbage Garden* in 1877 [61], centuries of importing seed from the Low Countries had likewise established a strong tradition of useful horticulture. Melville's image is in fact one of the earliest of many cabbage paintings in Europe and the United States at this period – including that by the Belgian James Ensor [66] – which parallel French Impressionist interest in the kitchen garden (*jardin potager*).

By the 1860s and 70s some vegetable gardeners had began to employ the new scientific techniques of cultivation – notably chemical forms of fertiliser and pest control – which the novelist Gustave Flaubert cruelly mocked in his story of Bouvard and Pécuchet,

two Parisian bank clerks who take up horticulture as a retreat from city life. But, as the art historian Richard Brettell has shown, such techniques were actually slow to be adopted in the Pontoise region painted by Pissarro,[3] and his peasant and kitchen garden subjects there and at Eragny were, in a real sense, the direct opposite of the modern floral horticulture of the Paris parks or Monet's flower gardens. There are, in fact, relatively few Impressionist images of the new, large-scale commercial gardens which came into being in the later nineteenth century; even Alfred Sisley's *The Fields* [60], which shows a market garden, includes a tall, established tree which anchors the scene in its wider rural environment.

Most of the images in this section are thus of old-fashioned gardens, illustrating what Denis Diderot's great eighteenth-century *Encyclopédie* had termed *nature employée* (nature turned to useful ends).[4] Lacking intentionally aesthetic qualities, the artistic inspiration such gardens offered was that of the found motif: the corner of nature whose qualities of structure, colour, design or content answered to an individual artist's particular interests and sympathies, or provided a stimulus for creating beauty. Camille Pissarro, the principal French Impressionist painter of *nature employée*, summed up this situation in a comment of 1899 about his own environs at Eragny, the village some 100 kilometres north-west of Paris, where he lived from 1884 until his death in 1903: 'one extraordinary motif is the garden at the foot of the stairs to the studio. It's an extraordinary spot, I think. The number of beautiful motifs I've found in the garden!! And there are more.'[5] As shown in his *The Artist's Garden at Eragny* [62], Pissarro's garden, kept by his wife Julie, was very much in traditional peasant mode, with flowers firmly subordinate to cabbages, lettuces and other vegetables. Whilst in terms of ownership it was an artist's garden, it was thus inherently different from Monet's at Giverny. As found motifs, kitchen, peasant and market gardens are, in fact, on one level simply variants of the wider landscape. Yet, in contrast to the scenes of wild

Detail from
Camille Pissarro *Kitchen Gardens at L'Hermitage, Pontoise* [59]

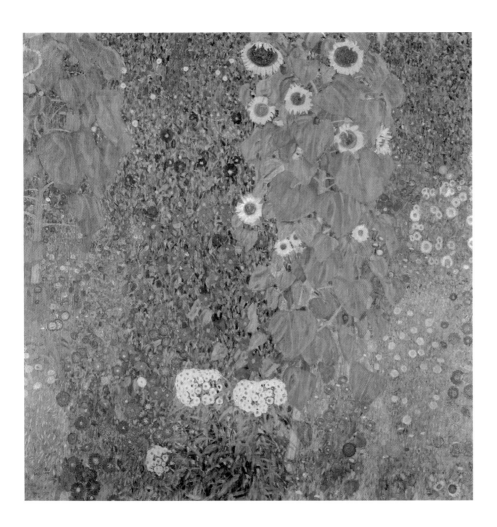

[fig.20] Gustav Klimt *Farm Garden with Sunflowers, c.*1907 Belvedere, Vienna

it's not everyone who can make a good cabbage soup with salt pork', whilst in 1891, implicitly thumbing his nose at the classical landscape tradition of Claude and Poussin, he asked 'What would the Gothic artists say, who so loved cabbages and artichokes, and knew how to make of them such natural and symbolic ornaments?'[7]

Kitchen gardens and orchards had, of course, formed part of medieval Labours of the Months imagery. But with the exception of works such as John Constable's view of his father's kitchen garden [fig.14], they had rarely been portrayed in their own right prior to Impressionism. Jean-François Millet and Henri de Braekeleer had made kitchen gardens a setting for domestic activities [8, 12], but these were essentially born of the Realist principle that, as De Braekeleer's admirer James Ensor later put it, 'everything is material for painting'.[8] The critic Théodore Duret still defended Pissarro's kitchen garden subjects in 1878 on this principle: 'Just imagine, he has descended to painting cabbages and lettuces, and I think even artichokes too. Yes, in painting the houses of certain villages, he has also painted the kitchen gardens which adjoined them, and in these gardens there were some cabbages and lettuces and along with all the rest, he has reproduced them in his picture.'[9]

To reduce Impressionist vegetable and orchard imagery to a by-product of a Realist approach, however, is surely too simplistic. A key stimulus to Pissarro's interest in the peasant gardens at Pontoise [59, 64] – and, in consequence, that of Paul Cézanne [63], Armand Guillaumin and other artists who came to paint alongside him there in the 1870s – appears, after all, to have been Daubigny, that independently-minded artist who was prepared to create finished works on the spot, rather than simply sketching out of doors, and who believed in the stimulus of nature in which one lives every day, with its attendant personal associations. As part of these interests, he had already painted a traditional garden in the old Hermitage quarter of Pontoise, not far from his home in Auvers, before Pissarro first settled there in 1866. This clearly inspired him as a place which – being cultivated for winter cabbages through to autumn fruits – registered the immediacy of time and season in atmosphere, light, and colour. Equally, as a found motif reflecting the artist's preferences, it enabled the expression of 'temperament' which Zola had described in 1868 as essential in 'modern art'.[10]

Requiring the artist to make something out of nothing (as the Impressionists' contemporaries would have viewed it), kitchen, peasant and market garden subjects were even, perhaps, actively conducive to artistic innovation. It was certainly a kitchen garden

nature painted by the Romantic generation, or even the forest subjects favoured by the Barbizon artists, their character as productive nature speaks of the work inherent in their creation and maintenance, and, in some cases, the moral or social implications of that work. Equally, the very functionalism of their layout challenges the tradition both of the historical landscape (*paysage historique*), serving as a complement to figural narrative, and of the Barbizon intimate landscape (*paysage intime*) with its emphasis on a corner of nature in harmony with the artist's soul.

Pissarro's attraction to vegetable gardens and orchards was certainly felt by many of his contemporaries to be a step too far. At the Impressionists' first group exhibition of 1874, the otherwise sympathetic critic Jules Castagnary noted his 'deplorable predilection for market gardens', whilst even in 1886, the year of the last Impressionist exhibition, adherents of the emerging Symbolist movement mocked him as 'an Impressionist market-gardener specialising in cabbages'.[6] Pissarro's responses were appropriately down-to-earth: of the Symbolists, he joked 'in truth, perhaps they don't like cabbages because …

that the early supporter of the Impressionists Edmond Duranty made the subject of paintings by a fictitious proto-Impressionist artist, Louis Martin, in a short story of 1872. This artist sought 'independence of methods…frankness of impression…sincere naivety of…view',[11] and by painting *nature employée*, Duranty seems to imply that Martin is released from conventions and constraints so that originality and honesty replace tradition and artifice. If the kitchen garden itself was old-fashioned and, as a motif, cautious and even conservative, the art to which it gave rise might be the very opposite.

THE MODERN ART OF KITCHEN GARDENS

Artistic innovation is certainly already apparent in a group of paintings of vegetable gardens of 1874, the year of the Impressionists' first group exhibition, whose planning is mentioned in Duranty's story. Pissarro's *Kitchen Gardens at L'Hermitage, Pontoise* [59] shows traditional peasant cultivation of varied crops, where a donkey is being loaded with produce for a local market, and Sisley's *The Fields* [60] an extensive commercial garden near Louveciennes, with rows of plants which will later be harvested for transport by cart or train to the great market of Les Halles in Paris. Both paintings are prime examples of the new luminous palette and atmospheric effects of mature Impressionism, in which shadows are made blue and lilac through reflected colours, and broken, comma-shaped brushstrokes evoke the vivid sensations of the season – early autumn in Pissarro's picture, with its golden light and lingering warmth, and early summer in Sisley's, where little puffy clouds scud across the sky and the light is clear and bright. Daubigny's orchard scene of 1874 [68], though more subdued in colouring, likewise projects a vivid sense of season and atmosphere, probably now partly influenced by his younger Impressionist colleagues. Bright yellow flowers grow amongst the trees in spring blossom, and the tactile brushwork conveys a sense of immediacy.

Van Gogh admired Daubigny's orchard pictures [68], and took their sense of personal response to nature's moods to its logical conclusion in his own orchard scenes in the south of France of 1888 [69]. He intended these to convey the gaiety he associated with Japanese art, but also to be elements in triptychs or decorations for his Yellow House at Arles, where he hoped to form his own fraternity of artists who would take Impressionism in a new direction.[12] Already in 1877, however, in *The Côte des Boeufs at L'Hermitage* [64] Pissarro treats a Pontoise orchard garden on a monumental scale, and with a sense of the almost two-dimensional, decorative

effect created by a screen of tall poplars just beyond the little peasant small-holding with its cluster of young trees in pink blossom. In place of the scene of autumnal activity in his 1874 picture, the *Kitchen Gardens at L'Hermitage, Pontoise* – where the harvesting of vegetables is accompanied by ploughing for next year's growth – there is an almost meditative mood, and the canvas is correspondingly worked and reworked. Its layers of paint clearly indicate the shift now emerging in Impressionist technique, as work begun on the spot was taken back to the artist's studio for further development. It was in the tranquillity of the studio that Pissarro now felt he could best pursue the qualities of 'synthesis' and 'harmony' he so much valued.[13] Two motionless figures, at first barely visible amongst the trees at the left, stare out from his picture, as if inviting the viewer in turn to stand and contemplate, even to pay respect, perhaps, to the orchard as one of the oldest forms of garden, whilst also looking to the future, as the young flowering trees replace older stock.

Cézanne's 1881 view of the Hermitage kitchen gardens at Pontoise [63] also reaches out to new ways of painting. Showing exactly the same motif as a picture of about 1867 by Pissarro which Zola had praised for its creation of 'vitality' from 'nothing more' than 'a plot of land' and 'a stand of tall trees',[14] Cézanne now excludes all human activity, and even the orchard is reduced to a few scattered indications of trunks and branches. Yet despite being incomplete, his painting has an almost elemental quality; its mosaic of interlocking shapes pares the motif to its essence, as if to re-assert the transformative power of artistic vision admired by Zola in Pissarro's version of the scene, and which arguably lies at the heart of the Impressionist vegetable or orchard garden.

It is the artist's searching gaze, scanning a kitchen garden in its larger landscape environ as if to assess its potential for painting, which the Norwegian artist Christian Krohg certainly captures in his striking portrait of his Swedish colleague Karl Nordström on the balcony of his room at Grez-sur-Loing, the artistic colony south-west of Paris which attracted many international painters in the late nineteenth century [65]. The small rectangular plots, each for a different crop, which period horticultural manuals recommended for kitchen gardens are clearly seen,[15] but the elevated viewpoint and angled line of vision – echoed in Nordström's gaze – transform these into an almost abstract design, just as their geometry is softened by the delicate haze of spring sunshine. Both Krogh and Nordström had been impressed at the Impressionist exhibitions in Paris by Caillebotte's unconventional viewpoints – new ways of

looking which are notably evident in Caillebotte's *Yerres, in the Kitchen Garden, Gardeners Watering Plants* (before 1879, Private Collection), one of the most ambitious kitchen garden scenes of Impressionism in the 1870s. This shows the walled kitchen garden of his parents' estate in the Brie, with the rows of slightly raised cloches creating an almost decorative effect as the gardeners work in a disciplined partnership, one pouring water, the other fetching it.

By the 1890s, yet another example of the artist's transforming vision is offered by Bonnard's *The Large Garden* [67] – a painting which looks with nostalgic eyes at the orchard of his childhood, and offers a further stage in the emergent trend to the decorative. Once again, however, it is the invitation to artistic liberty afforded by the ordinariness of the motif – gathering of apples, bringing in of washing – which plays a key role. Within the frieze-like composition, our attention is seized by the children's innocent, playful delight in the irregularly scattered golden apples, and the varied sensory attractions of lush grass, smooth linen and ripe fruit. Bonnard was later to recall his discovery of Impressionism at the first public exhibition of Caillebotte's collection of Impressionist works in 1897, but his very choice of motif in *The Large Garden* already seems to announce the freedom he said Impressionism taught him.[16]

IDEALS AND POLITICS

Despite the stylistic and compositional boldness of their handling, it would be a mistake to view meaning as unimportant in Impressionist images of vegetable or orchard gardens. For, at least in France, the *nature employée* of such gardens had strong Republican and utopian associations, and the inspiration which the Impressionists drew from them is richly suggestive in light of their mainly Republican sympathies and their desire to reform French art. Agricultural workers had, after all, formed the major element in the Third Estate which had risen against the aristocracy in the Revolution of 1789, and following the battle of Waterloo it was domestic horticulture which Etienne Soulange Bodin, the first General Secretary of the Paris Horticultural Society and author of the strongly Republican *Historical Coup d'Oeil upon the Progress of French Horticulture Since 1789*, had evoked in his famous comment that 'it would have been better for both parties that they stay at home to cultivate their cabbages'.[17] Pierre-Joseph Proudhon, the utopian socialist much admired by Pissarro, had similarly argued that the 'earth must become, through cultivation, like an immense garden' – an ideal revived in the anarchist Peter Kropotkin's vision

of the 'working in common of the soil' as the means to perfect society.[18] Pissarro sympathised with anarchism and although he wrote in the 1890s of Kropotkin's ideas as 'a beautiful dream', he nonetheless still felt this should be cherished.[19] Daubigny, meanwhile, whose portrayal of kitchen gardens at Pontoise anticipates Pissarro's practice there, was a strong Republican.

These associations between fruit and vegetable gardening and left-wing ideals also surely explain Duranty's choice of kitchen garden subjects for his fictitious painter Martin. For Duranty was a warm admirer of Diderot, the eighteenth-century originator of the phrase *nature employée*, who, like Voltaire, was seen by Republicans in late nineteenth-century France as a spiritual forefather for their beliefs in individual liberties. (Monet, interestingly, had a copy of Albert Collignon's detailed *Life, Works and Correspondance* of Diderot in his library at Giverny.)[20] After the 'Republican Republic' came to power in France in the late 1870s, the reference to work inherent in the concept of *nature employée* was particularly topical: Gambetta, the Republican politician admired by Manet, called the Republic 'the workers' friend'.[21] Caillebotte's sympathetic depiction of the work of the gardeners on his family's estate at this period takes its place in this context, just as the Impressionists' emergence as an organised group in 1874 had itself been a direct consequence of Monet's positive response to the Republican journalist Paul Alexis's call for an association of artist-workers.[22] In its day, French Impressionist kitchen, peasant and market garden imagery would have held as much significance as the symbolic flowers earlier portrayed by the Lyons painters, or Renoir's and Monet's preference for old Parisian gardens over Haussmann's new parks. Impressionist kitchen and vegetable gardens are perhaps as much a vision of a better world as the flower and leisure gardens discussed earlier. They show work as no longer the harsh toil of the peasants depicted by Millet and Courbet, but something instead made pleasurable by the vibrant sensations of the different seasons – whether spring breezes, summer heat, autumn sunshine, or winter's poetry of grey and white.

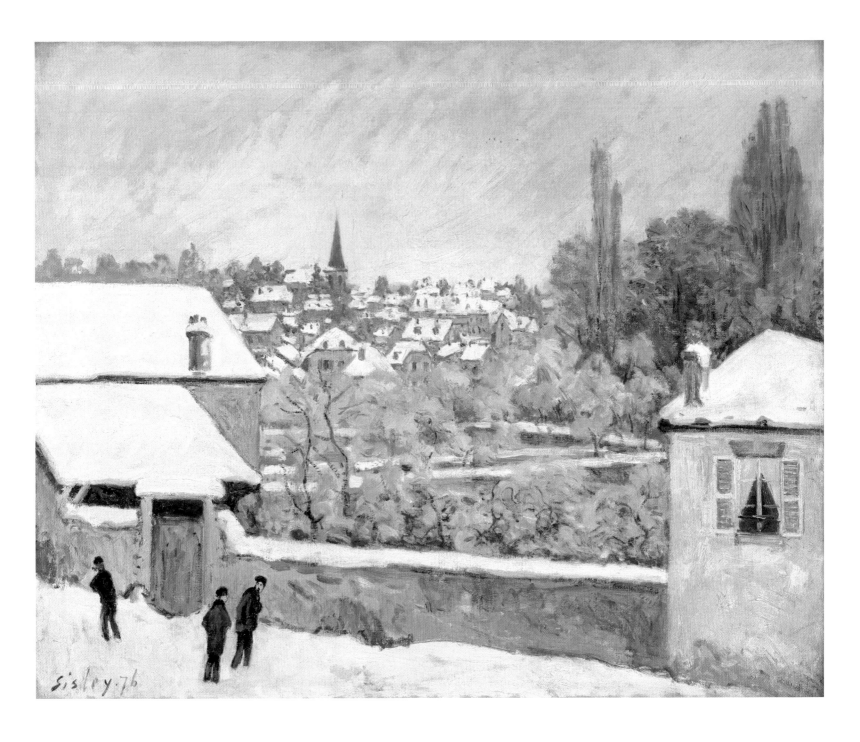

58 Alfred Sisley, *Winter at Louveciennes*, 1876

Staatsgalerie, Stuttgart

Snow clothes the village of Louveciennes near Paris. In the frozen gardens, the twisted forms of fruit trees are blurred by its soft thick mass, and the zigzag of the snow-topped walls guides the eye to the distant church spire. The subtle harmony of restrained colouring integrates the snow into the scene as a natural part of the design. The seasons will take their course, and the snow will be replaced by the white of springtime blossom.

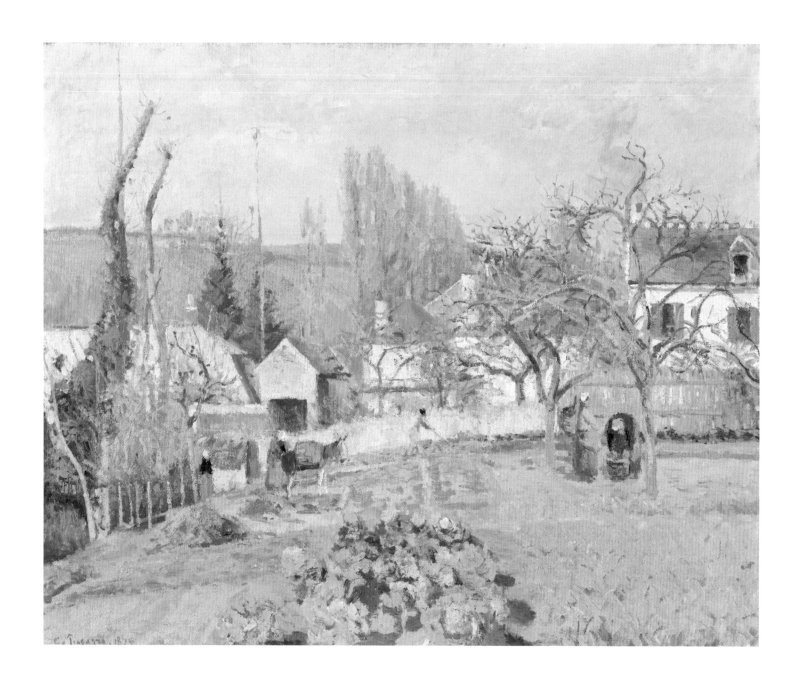

59 Camille Pissarro
Kitchen Gardens at L'Hermitage, Pontoise, 1874
National Gallery of Scotland, Edinburgh

Pissarro frequently painted the traditional peasant gardens of
L'Hermitage, his home during the 1870s in the market town of Pontoise
in northern France. Cabbages in the foreground lead the eye to a figure
ploughing at the centre, whilst a donkey is loaded for market, and two
women fill baskets, perhaps with fruit. The soft yellows, browns and blue-
greens of the gardens harmonise with their surroundings, creating
a closely-knit pictorial unity.

60 Alfred Sisley *The Fields*, 1874
Leeds Museums & Galleries (Leeds Art Gallery)

These are market gardens near Paris, where commercial horticulture was increasingly replacing the traditional peasant gardens painted by Pissarro at Pontoise. Sisley nonetheless includes an old, spreading tree at the left, which speaks of continuity. The gently ascending rows of vegetables draw the eye to the bright summer sky and there is a sense of the slow but steady maturing of the crops in accordance with the seasons.

61 Arthur Melville *A Cabbage Garden*, 1877
National Gallery of Scotland, Edinburgh

Late summer weeds are being removed from a plot of maturing drumhead cabbages. East Lothian, the home of the Scottish painter Melville, had a long tradition of domestic horticulture, encouraged by seed imported from the Low Countries, and the first Scottish gardening book, *A Scots Gard'ner*, was written in the county in 1683.

62 Camille Pissarro
The Artist's Garden at Eragny, 1898
National Gallery of Art, Washington DC

Although brought up in the West Indies, Pissarro ultimately settled in Eragny near Rouen, where he lived with his family from 1884. The figure apparently planting seeds is almost certainly his wife Julie, who tended the large garden there – an essential source of food for the family. The leaves and flowers shimmer like jewels beneath the high midday sun, and the presence of sunflowers and dahlias suggests it is August or September. Julie is taking advantage of the sun-warmed soil to give her seeds a good start.

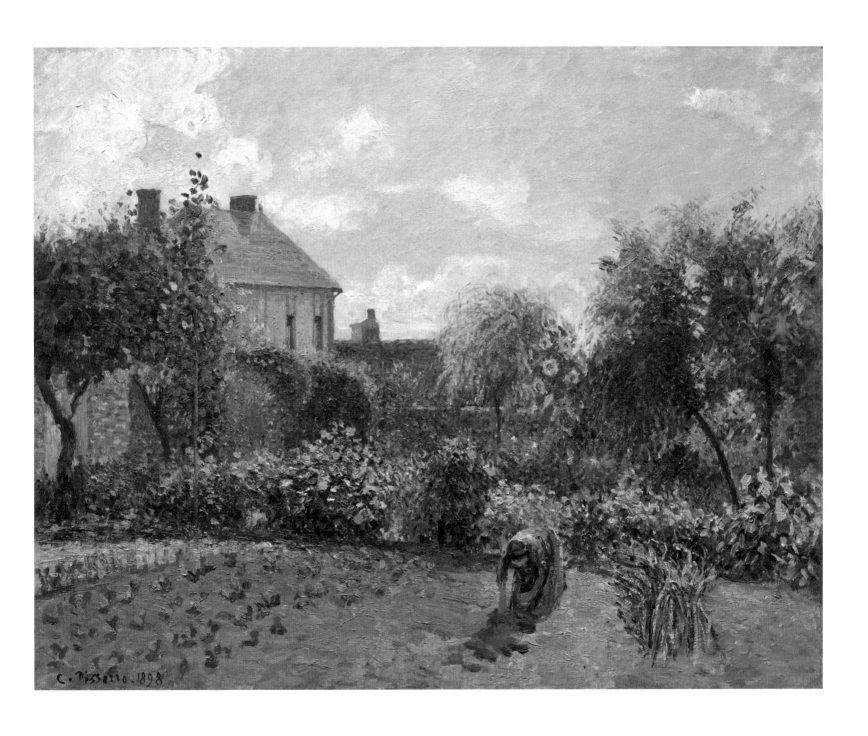

63 Paul Cézanne
The Hermitage at Pontoise, 1881
Von der Heydt-Museum, Wuppertal

Cézanne often painted with Pissarro, and in summer 1881 lived close
to him in Pontoise. However, his own distinctive style is already apparent
in this unfinished view of ancient kitchen gardens behind their homes.
He alters the perspective of the central path or low wall, turning it into an
almost abstract vertical, and the gardens in turn become a flat design of
horizontal strokes – an emerald foil to the mosaic of buildings on
the hillside.

64 Camille Pissarro
The Côte des Boeufs at L'Hermitage, Pontoise, 1877
The National Gallery, London

A haze of pink blossom crowns a young orchard near Pissarro's home at
Pontoise. Yet, although Pissarro evokes the fleeting sensations of spring
– scudding clouds, warm sunshine, a fresh breeze – the canvas is thickly
encrusted with successive layers of paint and the two motionless figures
looking out at the left add a contemplative note. The screen of tall poplars
produces an almost decorative effect, and with its large scale, the painting
has something of a mural character.

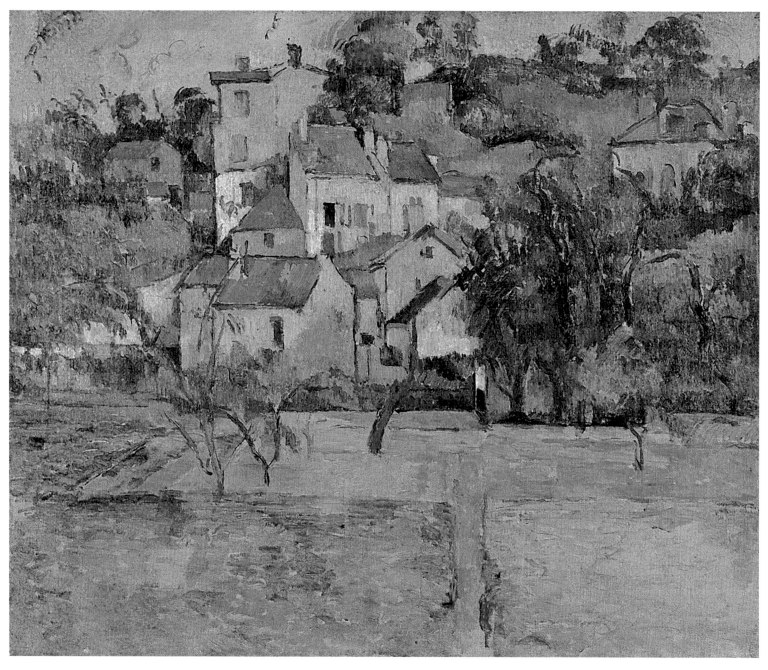

65 Christian Krohg
Portrait of Karl Nordström, 1882
The National Museum of Art, Architecture
and Design, Oslo

The Swedish artist Nordström looks out
across the sunlit kitchen garden of the Hôtel
Laurent at Grez-sur-Loing in northern
France. He had just arrived at Grez with
his Norwegian colleague Krohg, and
Krohg's picture recalls the balcony motifs
by Caillebotte which the two artists had
admired at Impressionist exhibitions in
Paris. Leaning back slightly, Nordström
appraises his new surroundings; the Hôtel
Laurent's orderly garden was in fact to
become one of his principal subjects in Grez.

66 James Ensor
The Garden of the Rousseau Family, 1885
The Cleveland Museum of Art, Ohio

Ensor is often remembered for his fantastical
scenes of Carnival in his native Belgium. But
he initially worked in a form of Impressionism,
often painting at the home in the Brussels
suburb of Watermael of his friends Mariette
Rousseau and her husband. *The Garden of
the Rousseau Family* was probably created for
Mariette, a botanist's daughter and amateur
scientist. The two freshly-cut cabbages might
almost be some giant pair of eyes – a witty
allusion, perhaps, to Mariette's pleasure in her
microscope.

67 Pierre Bonnard *The Large Garden*, 1895–6
Musée d'Orsay, Paris

Children of Bonnard's sister gather apples in
the lush green orchard of his family home at Le
Grand Lemps in the Dauphiné. The frieze-like
composition, with its dog and maid in profile,
reflects the origins of *The Large Garden* as
one of the panels in a set of mural decorations
inspired by Le Grand Lemps. The child joyously
skipping to the right would have led the eye to
the next panel. Bonnard loved Le Grand Lemps,
and vividly evokes the evening hour when the
apples become balls of burnished gold.

68 Charles-François Daubigny
Orchard in Blossom, 1874
National Gallery of Scotland, Edinburgh

Daubigny often painted the orchards near his home at Auvers in
the Oise and was an early supporter of the Impressionists, whose
first exhibition was held the same year that he completed *Orchard in
Blossom*. The picture's bright shafts of sunshine are clearly influenced by
Impressionism and emphasise the delights of the springtime orchard.
Two figures relax beneath the trees, and another appears to gather the
flowers which grow in yellow drifts amidst the grass.

69 Vincent van Gogh
Orchard in Blossom (Plum Trees), 1888
National Gallery of Scotland, Edinburgh

Van Gogh painted his famous series of views of what he called 'a
Provençal orchard of outstanding gaiety' at Arles in 1888. The bright
colours here reflect his admiration for Impressionist painting and
Japanese prints; he also greatly admired Daubigny's vigorously brushed
orchard views. However, whilst Daubigny shows an aging orchard,
Van Gogh's is well maintained, with tidily-pruned branches and trunks
coated with whitewash to deter insects. He also contrasts nature with
the industrial chimney in the background.

4 *Fresh Growth & New Blooms in Late Impressionism*

When Berlin's Gurlitt Gallery mounted its pioneering exhibition of French Impressionist art in 1883, Alfred Lichtwark, the future director of the Hamburg Art Gallery, was much impressed by a recent picture by Monet called *L'Allée*, which showed the park of La Grande Jatte in north-eastern Paris [fig.21]. It is tempting to imagine that what Lichtwark called this painting's 'dark walls of foliage between the cool shaded path, and the bright tops of the trees, on which a golden shimmer lies'[1] still lingered in his mind when, some twenty years later, he advised on the design of the German Impressionist Max Liebermann's garden at Wannsee near Berlin, with its shaded birch-tree path (*Birkenallee*) visible in *The Artist's Granddaughter with her Governess in the Wannsee Garden* [94]. Between the early 1880s and early 1910s, when Liebermann painted this picture, however, Impressionism underwent substantial changes and in turn acted as a springboard for new styles and approaches by artists both in France and beyond. This chapter considers some of the ways these found expression in – and were given impetus by – garden motifs.

Even as *L'Allée* was being admired in Berlin in 1883, Monet was beginning to cultivate his garden at Giverny, which was to shift his art in distinctive new directions and also influence Liebermann and other 'artist-gardeners'.[2] Equally, by 1886, a very different image of the park of La Grande Jatte was bursting on the European art world, first in Paris at the final group exhibition of the French Impressionists, and subsequently in exhibitions in Brussels and Vienna: Georges Seurat's now celebrated Neo-Impressionist work *A Sunday on La Grande Jatte* [fig.22]. This too would have important repercussions for the works in this section. Its boldly-stylised, almost hieratic figures and broad zones of sun and shadow were composed of tiny juxtaposed dots of divided colour inspired by the chemist Eugène Chevreul's scientific theory of colour harmony, which systematised Impressionist technique. Regular dots of yellow placed beside blue, for example, blended in the eye of the viewer to

read as green grass. Pissarro, who had himself begun to adopt Seurat's technique, wrote that 'Impressionism begins again in a completely new phase.'[3] With its figures each absorbed in his or her form of personal relaxation, Seurat's picture was, in effect, a manifesto not only for Neo-Impressionism, but also for the anarchist vision of society which he and Pissarro shared. For, as the art historian Albert Boime has shown, it presents La Grande Jatte – like the Parc Monceau a former garden of the Orléans family opened to the public by Napoléon III – as a veritable utopian paradise, enjoyed on the day of rest by all social classes, and imbued with the anarchist ideal of individual liberty.[4]

Monet, like Renoir, had chosen not to exhibit at the final Impressionist exhibition. As well as beginning his new garden, he was investigating new effects of light and nature on the Riviera and Normandy coasts. But when he began to create his famous water garden at Giverny in the 1890s, it was, revealingly, at a period of close contact with one of his strongest supporters, the anarchist writer Octave Mirbeau, himself an avid gardener. Mirbeau published one of the first accounts of Monet's Giverny garden, in 1891, evoking the painter 'in his shirt sleeves, his hands black with earth, his face haloed with the sun, happy to be growing seeds, in his garden constantly dazzling with flowers', and likening Monet's art itself to 'growth'.[5] Monet in turn reinforced this utopian vision by allowing a photograph of himself in working clothes and rustic clogs in his orchard at Giverny to illustrate Maurice Gillemot's important article of 1898 on his paradise.[6]

The expressive and decorative possibilities of colour, the search for a more perfect world, and the sense that, as the francophile poet and supporter of the Vienna Secession Hugo von Hofmannsthal wrote in 1906, a garden is the 'silent biography' of its creator,[7] are recurrent themes in this section. Whilst Neo-Impressionism and Monet's paintings of his garden at Giverny are two examples of fresh growth and new blooms in

Detail from Gustav Klimt
Rosebushes under the Trees [81]

[fig.21] Claude Monet *L'Allée*, 1878 (w.464), lost/destroyed

[fig.22] Georges Seurat *A Sunday on La Grande Jatte*, 1884–6
The Art Institute of Chicago

Impressionism, there were many others, including *Stimmungsimpressionismus* (literally 'mood Impressionism') which emerged in late nineteenth-century Germany and Austria at the hands of artists such as Leo von Kalckreuth, Fritz von Uhde, Ernst Eitner and Max Liebermann [71, 76, 77, 94]. The Romantic colour theories of Goethe, placing emphasis as much on subjectivity as science, were important here, as Kalckreuth's vivid evocation of the intensity of a child's perception of the colours of the rainbow in his garden illustrates [71].

Symbolism, however, with its emphasis on subjective experience, dream, and what the poet Stéphane Mallarmé called 'suggestion', also helped reshape the Impressionist garden. In this context, Edmond de Goncourt's description of his garden at Auteuil on the outskirts of Paris, published in 1881 as part of his influential book *The House of an Artist*, is of particular interest. Presenting his garden as his 'intimate and particular pleasure', he wrote of it subjectively as both an asylum from the ugly modern city and a place where he could live out his dreams of life as it had been in the eighteenth century. His text recounts his discriminating selection of rare plants and shrubs to complement the 'superb group of immense trees' already present in his garden, a relic of the former eighteenth-century Montmorency park:

For a colourist man of letters, there was a painter's garden to be made, a palette of greens to be deployed on a large scale, ranging from deep greens to tender greens, passing through the blueish greens of the junipers, the bronze greens of the cryptomerias, and all the varied

mixtures of hollies, spindle-trees, aucubas …

In turn, in late summer, came 'the hour of the intense, brutal, decimating note of the geraniums, those flowers which seem painted with the *minium* [red lead], which is applied to iron [to prevent it rusting]'.[8]

Plants, and De Goncourt's arrangement of their colours, were here an explicit reflection of his individual taste and personality. Equally, his reinvented park – different from that of Seurat, yet sharing its emphasis on colour – was but an extension of the famous Japanese and Rococo art collections which decorated his house. These ideas find direct echoes in Monet's collections of rare water lilies, roses, and peonies, and his portrayal of his Japanese water garden in his water lily murals for the Orangerie in Paris. It is clear why the Goncourt Academy, dedicated to preserving De Goncourt's name after his death, held one of its meetings at Monet's home in Giverny in 1915. Meanwhile, in the late nineteenth century, Lichtwark's reading of De Goncourt's book inspired him to visit the writer in his garden at Auteuil, and the contrast there of red geraniums against green shrubs was later to be found in the garden Lichtwark helped Liebermann create at Wannsee.[9]

If De Goncourt wrote of his garden in terms of a passionate relationship – 'the garden seizes you, keeps you, retains you' – it was Baudelaire's famous description of a similarly intimate liaison, that of synaesthesia, where sights are 'heard' or colours 'smelt', that had a special place in Symbolism.[10] In J.-K. Huysmans's Symbolist novel *A Rebours* (*Against the Grain*) published in 1883,

and read by both Monet and Pissarro, the reclusive hero Des Esseintes even plays harmonies of different hues on a colour organ. Such inherently subjective effects took the Impressionist emphasis on sensory experience into a new emotive realm. Mirbeau now wrote of Monet's 'intoxicating pictures that can be inhaled and smelled'.[11] And in answer to criticisms that Seurat's pointillist brushwork and scientific colour were merely mechanistic, his early supporter Félix Fénéon in turn maintained that every Neo-Impressionist was a painter who 'proudly flaunts his individuality … through his own distinctive interpretation of the emotional significance of colour, and the degree of sensitivity of his optic nerves to varying stimuli'.[12]

As places where the everyday world could, at least temporarily, be left behind for the horticultural wealth of flowers, trees, fruits and vegetables available by the late nineteenth century, gardens were perfect subjects for these new preoccupations. As ordered nature they likewise answered to the Symbolist concern with the decorative, famously expressed in 1890 by Maurice Denis: 'a picture … is essentially a flat surface covered with colours arranged in a particular pattern'.[13] Fresh growth and new blooms in Impressionist painting include not only Monet's water lily murals for the Orangerie in Paris, but also, for example, Liebermann's decoration of his garden loggia with scenes inspired by the garden frescoes of the Villa Livia in Rome, and Bonnard's and Vuillard's depictions of gardens in murals for the homes of private patrons. These now integrate real and painted worlds in richly intimate ways, including allusions to the artists or portraits of their patrons, and creating subtle visual harmonies with their architectural settings.

THE SPREAD OF IMPRESSIONISM

Given these and other developments, there is a real sense in which the Impressionist garden reached its full potential only after, rather than during, the period of the French Impressionist exhibitions which were held from 1874 until 1886. It was, after all, only in the late nineteenth century that Impressionism began to become an international phenomenon, with contacts between its forms in different countries fostered by major exhibitions, including Durand-Ruel's of French Impressionism in America, and by new opportunities for travel and the purchase of French art by, amongst others, Lichtwark and the radical director of the Berlin National Gallery Hugo von Tschudi.

The display in Paris in 1897 of Caillebotte's bequest to the French nation of his collection of Impressionist paintings, for example, brought works such as Monet's *The Luncheon* [fig.18] to wider attention for the first time, inspiring Bonnard amongst others [see 88, 93]. Influential French Impressionist exhibitions were also held in Germany in the 1890s and in Brussels in 1904. Liebermann collected and was inspired by garden works by Manet and Monet; and in 1903, the Vienna Secession's ambitious *The Evolution of Impressionism* exhibition

[fig.23] Edouard Vuillard
The Terrace at Vasouy, the Lunch,
1901, reworked 1935
The National Gallery, London

[fig.24] Edouard Vuillard
The Terrace at Vasouy, the Garden, 1901, reworked 1935
The National Gallery, London

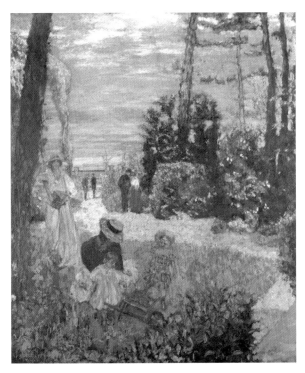

placed the movement in a historical continuum starting with Tintoretto and including Seurat's *A Sunday on La Grande Jatte*.[14]

Seurat's innovations found direct echoes in the styles developed by artists such as Théo Van Rysselberghe in Belgium, Gustav Klimt in Austria, Henri Martin, and Henri Le Sidaner [75, 81, 91, 97]. In Klimt's *Rosebushes under the Trees* [81], however, the dots of colour are now alive, as the pale rose-heads and glowing orbs of the fruit upon the trees. De Goncourt's sense of his garden as a palette finds a sequel here; and also Monet's planting of blue and mauve irises in his orchard at Giverny, as if he wished to transmute the shadows under the trees into living, growing colour.

New names in turn made their appearance in Paris, such as that of the Spaniard Joaquín Sorolla, whose blockbuster exhibition there of five hundred works in 1906 was said by the French critic Camille Mauclair to 'magnetise the viewer' with the 'triumphant pagan joy' of its virtuosic Impressionism, sometimes called Luminism [83–5].[15] This was surely one of the events against which Monet sought to take his measure in his great display of subjects from his water garden at Giverny in 1909, a display treated by the critic Roger Marx as evidence of Monet's own 'hypnosis' before the shimmering surface of his pond.[16] The living dots of colour created by its red, pink, and yellow water lilies not only implied synaesthesia, for many of these flowers were scented, but were also quite literally new blooms, recently developed through the hybridisation of exotic and native species [78–80]. As well as the wealth of art exhibitions which helped spread and diversify Impressionist approaches, and the articles which brought Monet's garden to wide attention in the 1890s and 1900s, ever more ambitious horticultural exhibitions and displays took place at this period: the Japanese gardens and the 2,500 rose species at the 1889 Paris Universal exhibition and the 'Floral Paradise' at its successor in 1900; the huge garden exhibition at Hamburg in 1899; and Joseph Maria Olbrich's colour gardens in his influential garden exhibition at Darmstadt in 1905, for example.

If the new directions in Impressionist garden painting were indeed diverse, some features and trends nonetheless stand out. Gardens were now – perhaps above all else – places of association, whether personal, as in the case of Van Gogh [72, 73], or shared, as in the Neo-Impressionist-cum-anarchist vision of the park as an emblem of an ideal society. They often involve wider geographies – especially of the south, the age-old site of longing, desire or abundance. That 'other land' of the past is also invoked: what Mallarmé called 'old gardens reflected by the eyes', and Klimt's contemporary Hugo von Hofmannsthal 'that other garden, where I was before', a place part remembered, part dreamt, yet filled with the potent, sensory presences of colour, shape and scent.[17] At the same time, and partly prompted by Monet's example, there was a veritable explosion of artists' gardens, from Giverny and Wannsee to the gardens of Bonnard or Sorolla. These features and trends were closely inter-linked, and repay closer examination.

GARDENS OF THE SOUTH, GARDENS OF THE PAST

Renoir had visited Italy in 1881 and Algeria in 1882, and settled at Cagnes on the Riviera in his later years, delighting in his garden of roses and olives which formed the setting for paintings of a mythical golden age. Already in 1888, however, following his experience of Impressionism and Neo-Impressionism in Paris, Van Gogh sought still brighter colours in Provence, associating the public garden at Arles with both Japan and the garden of the Renaissance poets Boccacio and Dante [fig.25]. Equally, he saw the garden of the asylum at Saint-Rémy, with its pockets of deep, mysterious undergrowth, in terms of Le Paradou, the southern 'garden of love' evoked in Emile Zola's novel *The Sin of Abbé Mouret* [73]. Van Gogh's paintings of these gardens are effectively projections of his own desires for love,[18] just as his colleague Gauguin was shortly to seek Eden in Tahiti.

In turn, in Austria in 1897, the artist Johann Krämer – a founding member of the Vienna Secession who had likewise studied Impressionism in Paris – evoked the drowsy heat of a garden sketched at Taormina in Sicily [74]. His image contributes to a group of Germanic pictures of southern gardens which reinvent not only Impressionism, but also Goethe's Romantic longing for the perfect 'land where the lemon trees grow'. Klimt, for example, transplants to Italy [92] the hedge of flowers composition of Monet's *The Artist's Garden at Argenteuil* [19], which had formed part of the *Manet-Monet* retrospective in Vienna in 1910, and his compatriot Marie Egner evokes the last precious days of summer in another Italian garden [86]. These works form a Germanic counterpart to the mood of Bonnard's *Resting in the Garden*, painted at St Tropez about 1914 [93], where the figure in the pose of an antique sculpture reminds us that the south was a focus also for French cultural identity – *latinité*.[19]

The theme of southern gardens was complemented by a revival of interest in the Italianate or formal garden tradition, which may be viewed as part of wider trends in garden design at this period, including the German 'Garden-Reform' movement and Gertrude Jekyll's work

in Britain and France. Sorolla painted in the Spanish royal gardens, and Le Sidaner took inspiration from the terraced garden of Isola Bella in Italy when designing his garden at Gerberoy near Beauvais in the 1900s [97]. Le Sidaner's friend Henri Martin incorporated an Italianate pergola and pool in his garden in the Lot [89, 91]. In paintings by Le Sidaner and Martin, Neo-Impressionism's technical discipline, although freely interpreted, was thus linked to formal horticulture, as also in their Belgian colleague Van Rysselberghe's image of the park of Sans Souci near Potsdam [75]. Here, the

paintings was bought by the Berlin collector Robert von Mendelssohn in 1904 [fig.26]. Monet's roses, meanwhile, were trained on supports, so that their scent filled the air [95, 96], just as he had found 'delicious perfume … everywhere' in the south; his carpets of living colour in the orchard likewise echoed the effect of the violets under lemon trees he had so admired in Bordighera in 1884.[22] The example of Giverny, however, takes us to the flowering of the artist's garden in late Impressionism – one of the most revealing examples of the subjective and the individual.

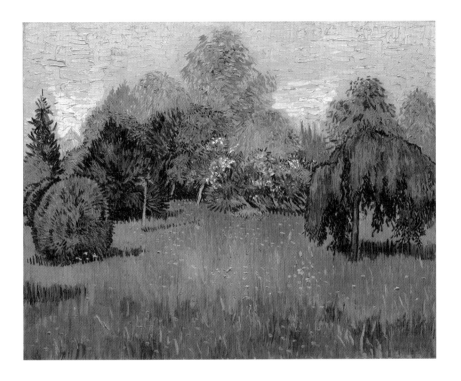

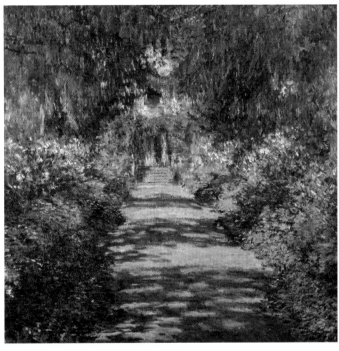

[fig.25] Vincent van Gogh
The Garden of the Poets, 1888
The Art Institute of Chicago

[fig.26] Claude Monet
*Main Path through the Garden
at Giverny*, 1901–2
Belvedere, Vienna

water of a Sans Souci fountain, refracted by the autumn light, itself embodies the colour division of the technique employed, whilst the autumnal moment complements this theme of metamorphosis – much as Hofmannsthal used the ever-falling droplets of a fountain as a metaphor of transience and change.[20] It is perhaps not surprising that Van Rysselberghe's Neo-Impressionism was warmly welcomed by the Vienna Secessionists who gave it a dedicated exhibition in 1899.

Even Monet's garden at Giverny reflects something of the lure of the south, for its profusion of floral growth and intense warm colour in the central formal path (*allée*) – planted with red and pink cactus dahlias, and fiery nasturtiums – can be seen as a direct response to his visits to the French and Italian Riviera.[21] Given the Germanic tradition of longing for the south, it is perhaps only logical that one of Monet's glowing *allée*

THE ARTIST'S GARDEN RENEWED

As shown earlier, the artist's garden had been a source of motifs in mature Impressionism. However, from the early twentieth century the sense of the artist's garden both as a reflection of its creator's personality, and as equivalent to a painting, becomes more prominent. Liebermann wrote that 'the artist creates the world after his own image'; Monet called his Giverny garden his 'most beautiful work of art'.[23] Although the garden area near the house at Giverny was arranged, like Caille-botte's, in rectangular plots like those of a traditional vegetable garden, Monet's water garden, with its mean-dering paths, irregularly-shaped pool, and backdrops of rambling roses and weeping willows, was most subtly composed. It was here that he realised the decorative potential of his garden in creating his water lily murals for the Orangerie in the Tuileries Gardens. Monet's

hugely successful water lily painting exhibition in Paris in 1909, of which three works included here formed part [78–80], must have provided a powerful foretaste of the sense of being surrounded by flowers, water, and reflections of clouds and foliage which is experienced in the elliptical rooms containing the Orangerie murals. As much as Watteau's *Embarkation for Cythera* – Monet's favourite painting in the Louvre – it is Delacroix's Luxembourg Palace mural in Paris of the Elysian Fields, the eternal, celestial garden of the gods, which the Orangerie scheme reinvents: garden, sky and time are made as one, for perpetuity. Given to the French nation as a First World War Memorial, it is also a sequel to De Goncourt's delight at the 'great calm of nature' in his Auteuil garden, a place of healing after 'great worries'.[24]

In Germany, both Kalckreuth's garden at Höckricht, and the artists' gardens of Eitner and Liebermann on which Lichtwark advised, were modelled on the traditional German farm garden (*Bauerngarten*) [71, 94]. This, of course, was the kind of garden also painted by Klimt in Austria [81]. Once again, the garden unites past and present, and the rectangular beds, straight paths, and square of lime trees shown in Liebermann's *The Artist's Granddaughter with her Governness in the Wannsee Garden* [94] are *Bauerngarten* features.[25] In painting their artists' gardens Liebermann and his colleagues correspondingly emphasised homeliness (*Wohnlichkeit*), showing the garden's outdoor rooms being enjoyed by family members, and as a place of views both from and to the house.[26] Since the distant view (*Fernbild*) was seen at this period in Germany as a metaphor of harmony, a picture such as Liebermann's *The Artist's Granddaughter with her Governness in the Wannsee Garden* is, of course, as much an image of a better world as Seurat's *A Sunday on La Grande Jatte* or the gardens of the south discussed above.

Sorolla, Le Sidaner, Martin, and Lavery also create effects of domesticity in their artists' gardens, but more typically emphasise a sense of intimate enclosure. The garden is a 'pleasant place' for taking meals, or sitting, perhaps dreaming, amidst the flowers. Le Sidaner, influenced by the British garden designer Gertrude Jekyll's ideas, developed colour-themed outdoor rooms in his garden at Gerberoy; his *Rose Pavilion, Gerberoy* [97] also shows how the Impressionist garden remained vigorous even into the 1930s.[27] Bonnard continued the Impressionist garden tradition into the 1940s, but deliberately kept his gardens at Vernonnet near Giverny and Le Cannet in the south of France in a semi-wild state, just as Cézanne had treated Provençal nature as a virtual garden. Their artists' gardens are both expressions of

personal taste and heirs to Renoir's ideal of irregularity.

In his essay of 1906 on gardens, Hugo von Hofmannsthal described 'wild' gardens, like 'old gardens', as 'always imbued with soul'. However, he also looked to the future, noting that gardens were 'signs that one era leaves behind for those to come'.[28] From this point of view, garden paintings are perhaps the ultimate sign. The examples in this section speak intimately and directly of their artists' ideals and visions, and already begin to map the passage from Impressionism to developments which would integrate colour and emotion still more openly – Fauvism, Expressionism and even Italian Futurism, whose exponents took much interest in Impressionism's evocation of time and change.[29]

70 Henri Le Sidaner
An Autumn Evening, 1895
Carmen Thyssen-Bornemisza Collection,
on loan to the Museo Thyssen-Bornemisza, Madrid

Le Sidaner creates a rural counterpart to Sargent's twilight Parisian garden of fifteen years earlier. However, his picture now reflects the merging of Impressionism with aspects of Symbolism – the movement which preferred ambiguity and suggestion to certainty and precision. The solitary woman is thought perhaps to be Le Sidaner's wife, but as the light fades, it is left to the viewer to decide where she is going, and what lies in the garden beneath her.

71 Leopold Graf von Kalckreuth
The Rainbow, 1896
Neue Pinakothek, Munich

Sunshine after rain illuminates the wife and son, Johannes, of the German Impressionist Kalckreuth in the family garden at Höckricht in Silesia. Kalckreuth's placing of the figures with their backs to us invites us to see the pristine garden through their eyes. Spring bulbs, reddish-brown flower pots, shimmering pear-blossom, red and blue costumes, and red roof and blue sky, combine to echo the colours of the rainbow, creating a larger harmony.

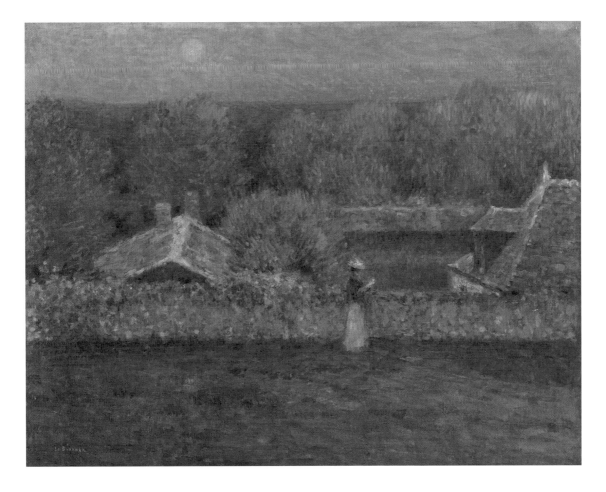

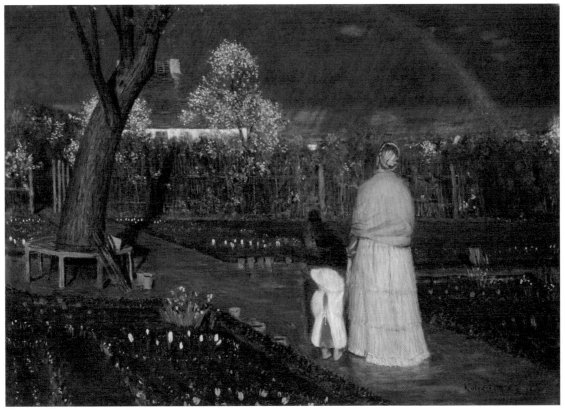

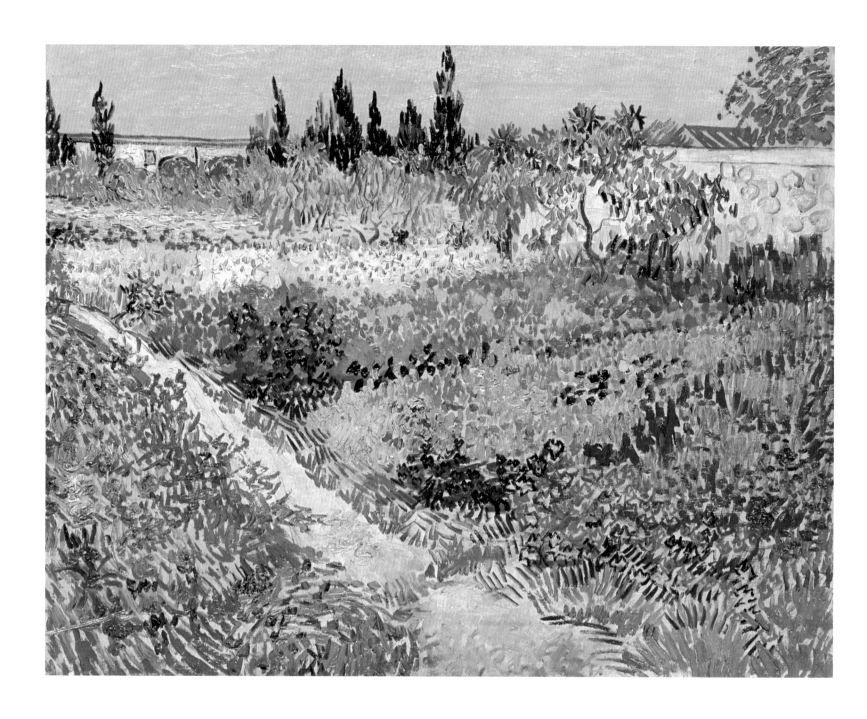

72 Vincent van Gogh *Garden with Path*, 1888

Gemeentemuseum den Hague

Garden with Path is one of two studies made by Van Gogh
in July 1888 of a traditional garden near Arles. He was much
interested in reports of Monet's recent strongly-coloured works
on the Riviera, and was also familiar with Seurat's innovative
dots of colour. However, he deploys a rich variety of jabs, zigzags
and short, stabbing strokes to evoke the flowers, vegetables and
olive trees as they shimmer in the hot southern sun.

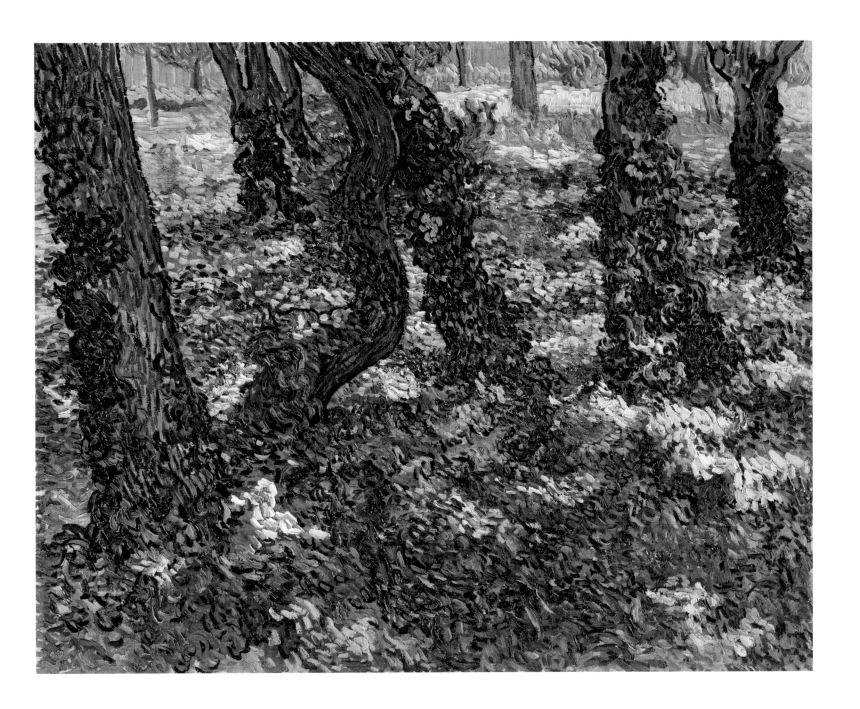

73 Vincent van Gogh *Undergrowth*, 1889

Van Gogh Museum, Amsterdam (Vincent van Gogh Foundation)

Van Gogh's close-up view of tree-trunks and ground covered with ivy and periwinkle at first seems radically different from his colourful *Garden with Path* of the previous year. Painted in the grounds of the sanatorium at Saint-Rémy-de-Provence, to which he had admitted himself, it brings to mind his comparison between the grasp of ivy on oak and the grip of mental illness on himself. Yet there are glimpses of sunlight between the shadows, perhaps suggesting his hopes of better health.

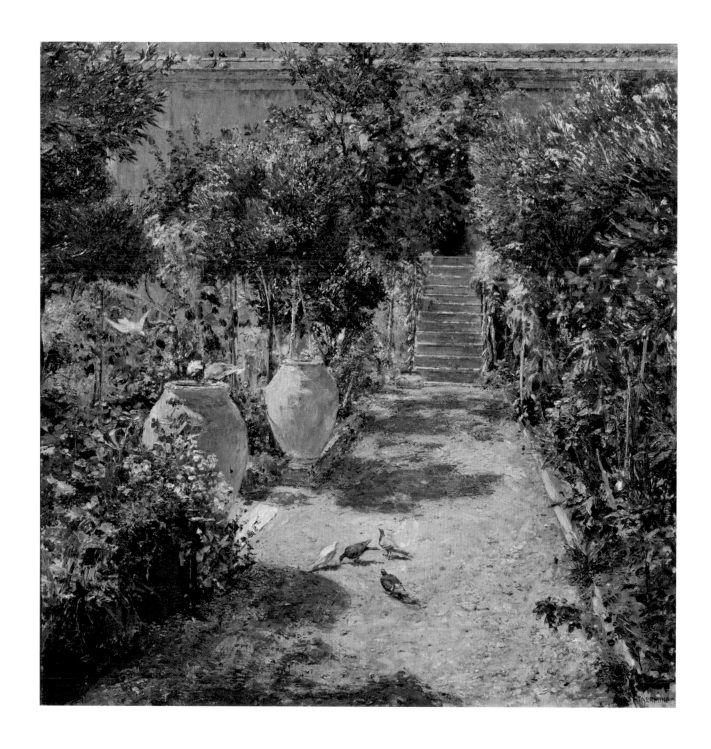

74 Johann Viktor Krämer *In the Sunshine*, 1897
Belvedere, Vienna

Krämer studied in Paris, and as a founding member of the Vienna
Secession, helped to bring Impressionist approaches to his native Austria.
In the Sunshine, with its citrus trees and sunflowers, was painted from
sketches made at Taormina in Sicily. It combines the Germanic tradition
of longing for the south with atmospheric effects of dazzling sunshine and
luminous shadow, and its composition is reminiscent of Monet's Vétheuil
garden views with their central path and steps.

75 Théo Van Rysselberghe
Fountain in the Park of Sans Souci Palace near Potsdam, 1903
Neue Pinakothek, Munich

Sans Souci, the 'German Versailles', was created in the eighteenth century by Frederick the Great. Van Rysselberghe's inspiration from its formal pools and statuary is part of a revival of interest in the early twentieth century in formal garden design. His technique of contrasted dots or flecks of colour has affinities with Seurat's pointillism and aptly evokes the refraction of the fountain into rainbow droplets by the low autumn sun.

76 Fritz von Uhde *The Artist's Daughters in the Garden*, 1903
Wallraf-Richartz Museum & Fondation Corboud, Cologne

Uhde's garden at Perchau near Munich is plain in the extreme – grass,
a path and saplings. His daughters Anna, Amalie and Sophie are its
'blooms', caught in a shaft of sunshine. Whilst the empty chair in the
shadows is perhaps a reminder that the daughters had lost their mother,
who died at Sophie's birth, there is a sense of hope and promise as the
sunlight sparkles on the foliage. We can see why German Impressionism is
also called 'mood Impressionism'.

77 Ernst Eitner *Spring*, 1901
Hamburger Kunsthalle

Eitner was a protégé of the Director of the Hamburg Art Gallery, Alfred
Lichtwark, who much admired French Impressionism. A portrait of
Eitner himself with his wife and son in the dappled light and shade of
their garden at Fühlsbüttl near Hamburg, *Spring* combines the innocence
of childhood with seasonal renewal, and delight in the open-air life. It
takes up a favourite Impressionist theme of families and friends eating out
of doors, seen also in the work of Guthrie, La Touche and Lavery.

78 Claude Monet *The Water Lily Pond*, 1904

Denver Art Museum

Monet created the pond in his Giverny garden in 1893, but enlarged it in 1900–3, to accommodate greater numbers of the colourful new hybrid water lilies in which he took such pleasure. Using a 'series' of canvases through the day, he followed the unfolding of these flowers, which respond to light. The 1904 picture [78] includes a glimpse of the pond's distant bank but the two later pictures [79, 80] concentrate on its surface effects, where the flowers float amidst reflections of the insubstantial clouds and the surrounding foliage, and depth and distance merge. This mobile, ever-changing harmony of vapour, water and colour was explored in many of Monet's subsequent water garden works. The 1907 picture is a delicate harmony of pinks, lilacs and greens, whereas the 1908 work offers bolder, starker contrasts. The shaft of brightness at their centre creates a mysterious, watery echo of the garden paths of his earlier Parc Monceau and Vétheuil paintings.

All three paintings were included in Monet's famous *Paysages d'eau* (Waterscapes) exhibition in Paris in 1909, which pointed the way to the large ensemble of water lily murals he gave to France as its First World War Memorial at the Orangerie in Paris.

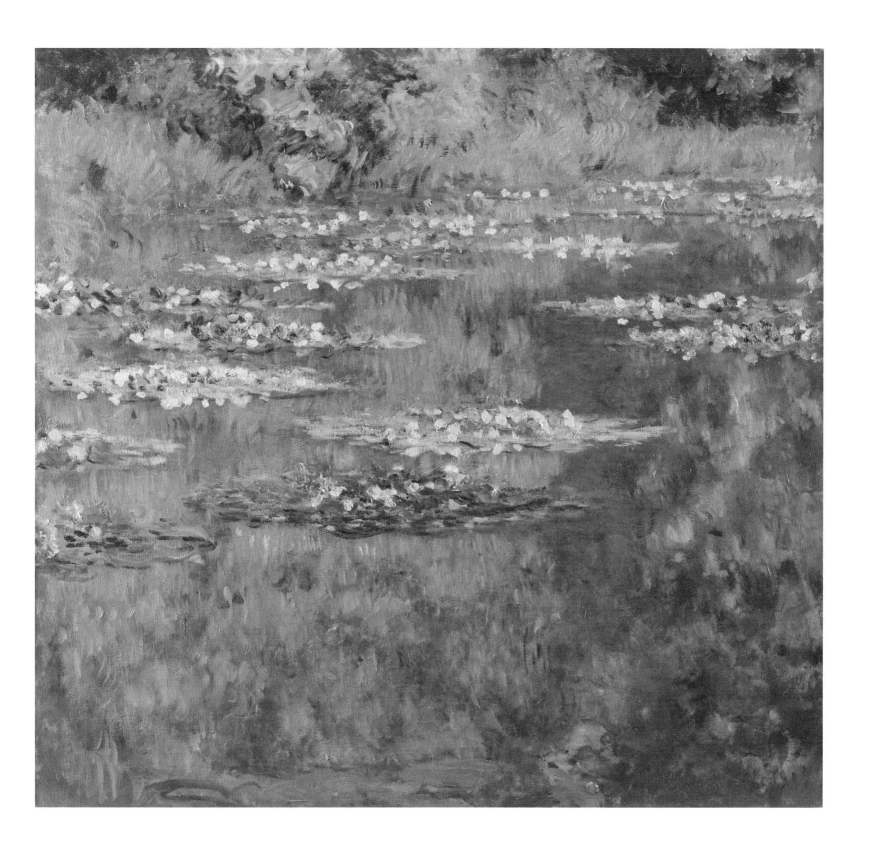

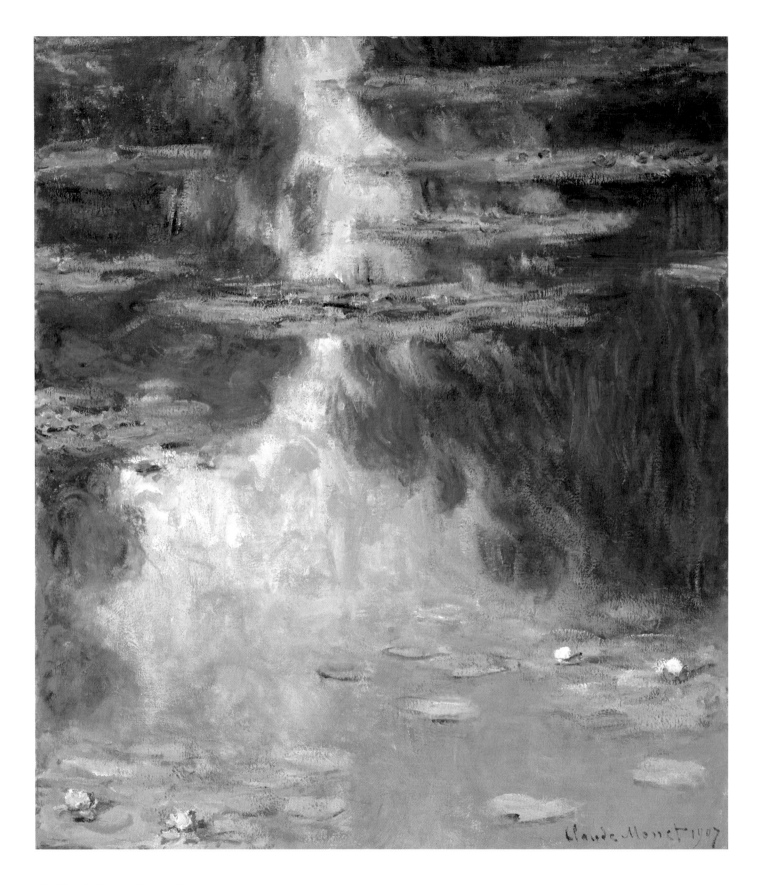

79 Claude Monet *Water Lilies*, 1907

The Museum of Fine Arts, Houston

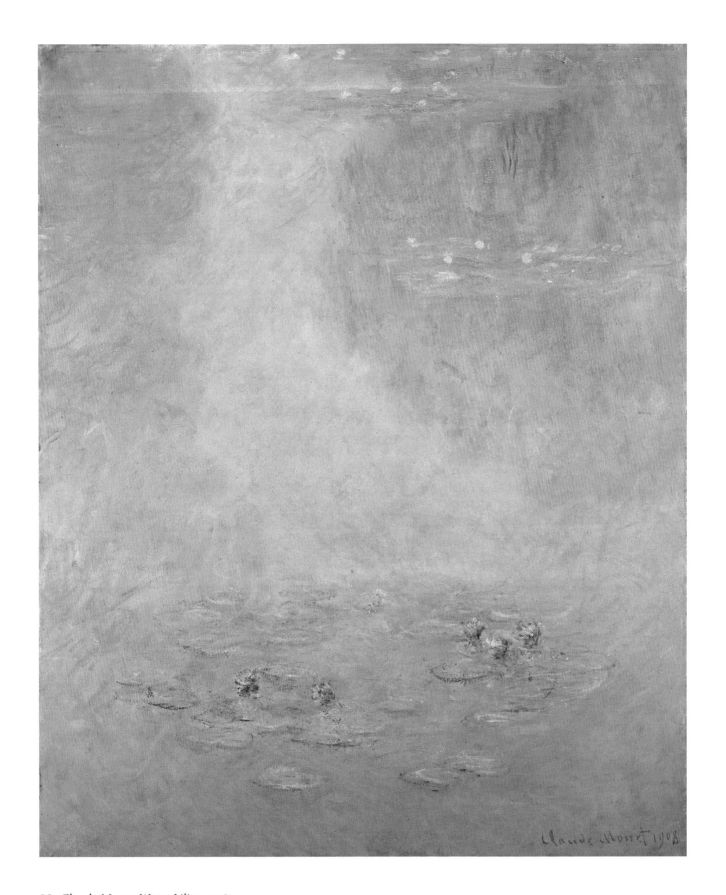

80 Claude Monet *Water Lilies*, 1908

Amgueddfa Cymru – National Museum Wales, Cardiff

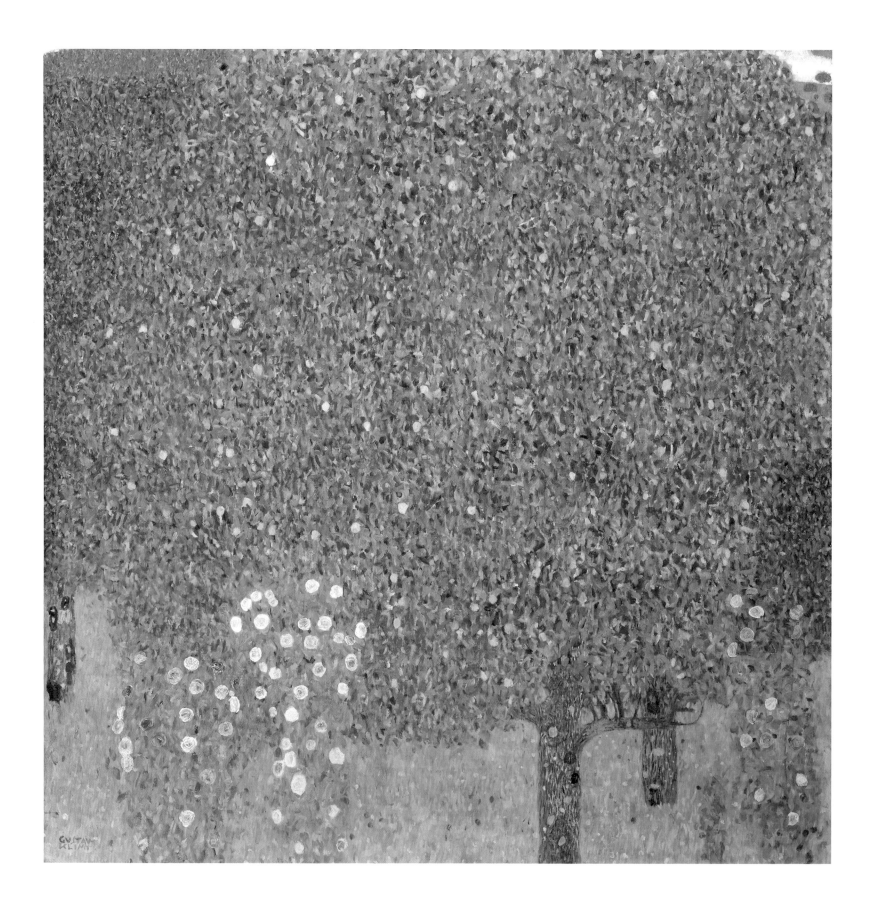

124

81 Gustav Klimt
Rosebushes under the Trees, 1904
Musée d'Orsay, Paris

Klimt greatly admired Monet's water lily
pictures and his use of a square format
echoes practice by Monet. However, he did
not paint his own garden. Instead, he took
inspiration from traditional Austrian farm
gardens, where roses were often grown
beneath the fruit trees. In *Rosebushes under
Trees*, painted in the garden of the Litzlberg
Brewery on the Attersee, the trees fill the
canvas almost completely, creating an
intricate, decorative network on which the
pale roses and golden fruits shimmer.

82 Paul Cézanne
The Big Trees, c.1904
National Gallery of Scotland, Edinburgh

These ancient trees, rooted in the red
earth of Cézanne's native Provence and
sculpted by the mistral, might almost be
symbols of his sense of strong attachment
to the region. We do not know their exact
location, but the subject is reminiscent of
the views he had painted some years earlier
in the semi-wild estate of the Château Noir
in Provence. In this painting, the glimpses
of sunlight between the trees create a
greater sense of air and space.

83 Joaquín Sorolla y Bastida
The Garden of Sorolla's House, 1920
Museo Sorolla, Madrid

The Spanish artist Sorolla was a friend of Sargent and Monet, but developed a distinctive personal form of Impressionism, sometimes known as Luminism. One of his very last works, this painting vibrantly evokes the dappled sun and shade of his garden in Madrid. The chair is where he loved to sit beside the low white wall with its flowers and blue Valencian tiles, and beyond the mature foliage, we glimpse his colonnaded house.

84 Joaquín Sorolla y Bastida
Skipping, 1907
Museo Sorolla, Madrid

Sorolla first began to paint gardens at La Granja de San Ildefonso, the hilltop residence of the Spanish monarchy, on a visit to help his daughter Maria recover from tuberculosis. With its carefree children passing in and out of zones of brilliant sunshine as they skip around a small formal pool there, his picture might almost be a vision of the health and energy sought by Maria. The high horizon and short shadows form a strongly decorative design.

85 Joaquín Sorolla y Bastida
The Reservoir, Alcázar, Seville, 1910
Museo Sorolla, Madrid

One of twenty works Sorolla painted in 1910 in the gardens of the ancient Moorish Alcázar in Seville, *The Reservoir* contrasts the delicate patterns of early spring flowers with a dark hedge and trees and their deep, still reflection. The large shrub against the dazzling wall may be mimosa or acacia, and the plants in pots around the pool are probably succulents requiring special care, such as *Crassula sp* or *Aeonium sp*.

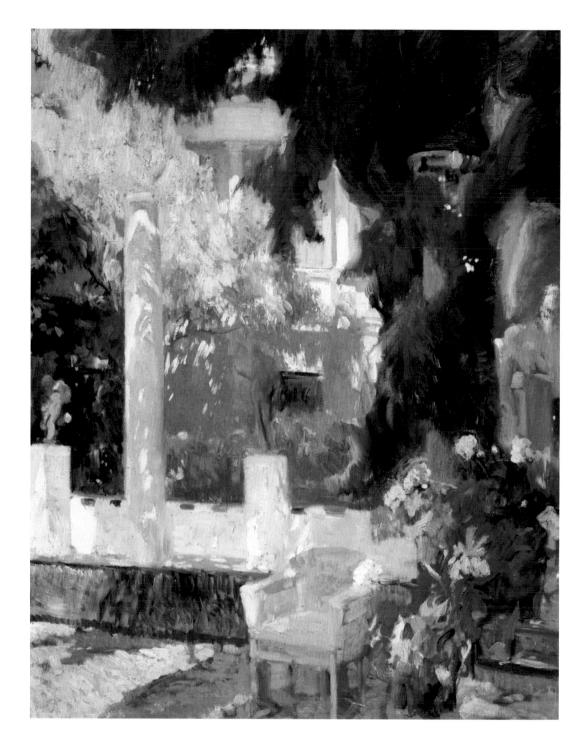

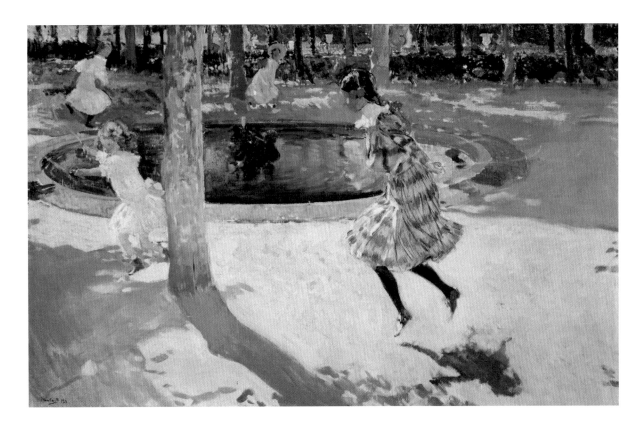

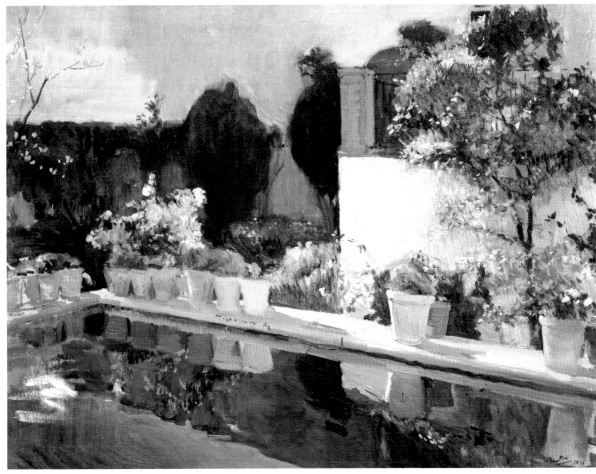

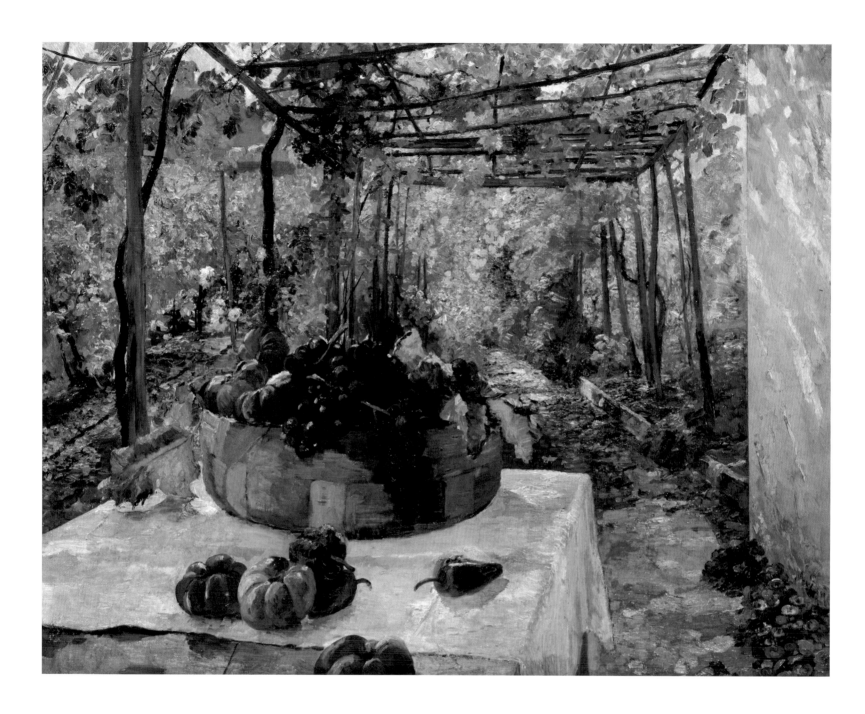

86 Marie Egner *In the Pergola*, c.1912–13
Belvedere, Vienna

The Austrian artist Marie Egner's love of subtle colour was encouraged
by study in London in 1887–8 with the Scottish watercolourist Robert
Weir Allan, who admired Impressionism and was also mentor to Arthur
Melville. *In the Pergola* was painted in Italy, and contrasts the last fruits of
summer – luscious grapes, and red and golden gourds – with the hint of
autumn chill which accompanies the withering of the vine leaves. Egner
has added a strip of canvas at the right to balance the composition.

87 Gaetano Previati *Mammina*, c.1908
Galleria Nazionale d'Arte Moderna, Rome

A mother lifts up her child to admire the beauty of a flowering shrub,
perhaps a lilac. Reaching out towards its blossoms, the child is captivated,
and the shrub seems almost to radiate colour in the warm evening sun.
Previati, an Italian artist, used a distinctive technique of linear threads of
contrasted colour, sometimes known as Divisionism.

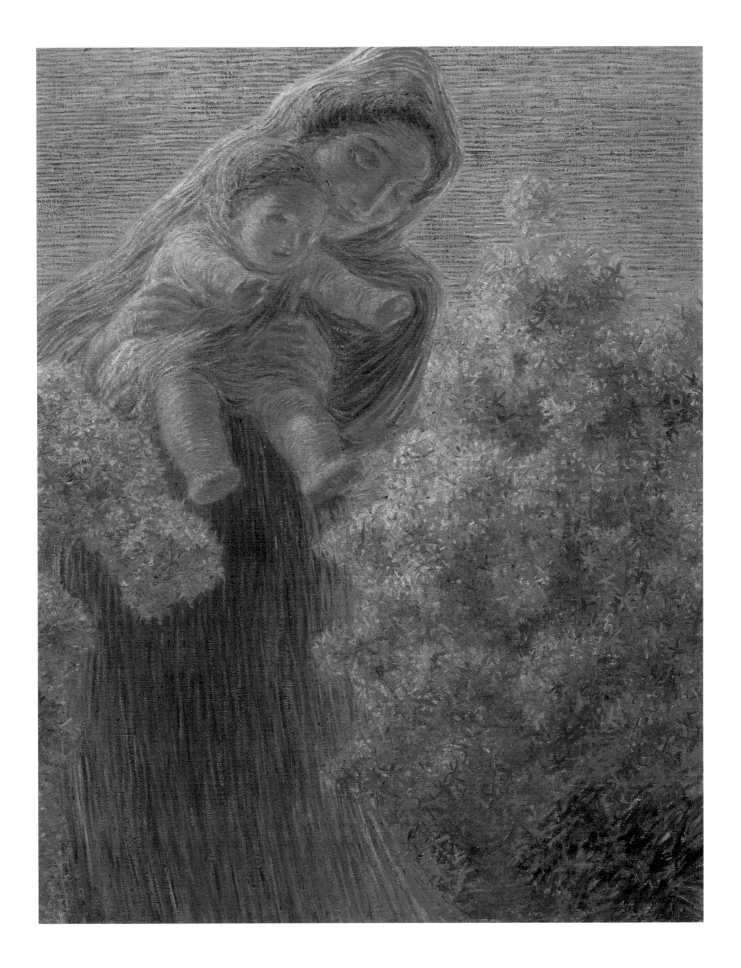

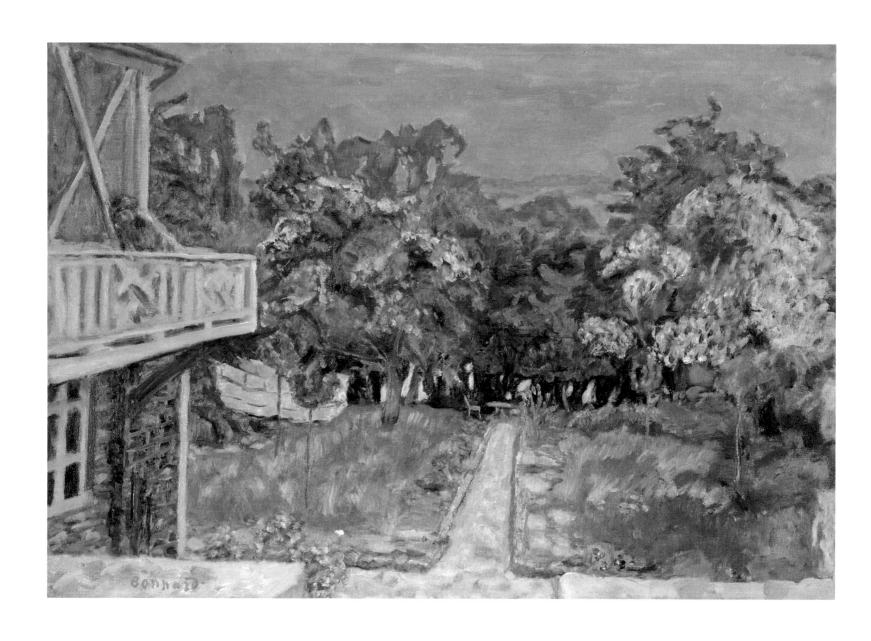

88 Pierre Bonnard *Blue Balcony*, *c.*1910

The Samuel Courtauld Trust, The Courtauld Gallery, London

Bonnard breaks all the rules. The path in his garden at Vernon near
Giverny leads not to some focal point, but a broad mass of trees. We
would hardly guess that the touches of distant blue are the River Epte.
Bonnard does not simply copy nature; for him, it was the starting point
for a very individual interpretation of a scene. Here, his high viewpoint
leads the eye from the pale blue balcony to the veil of blossom on the
trees, and the tablecloth hanging out to dry.

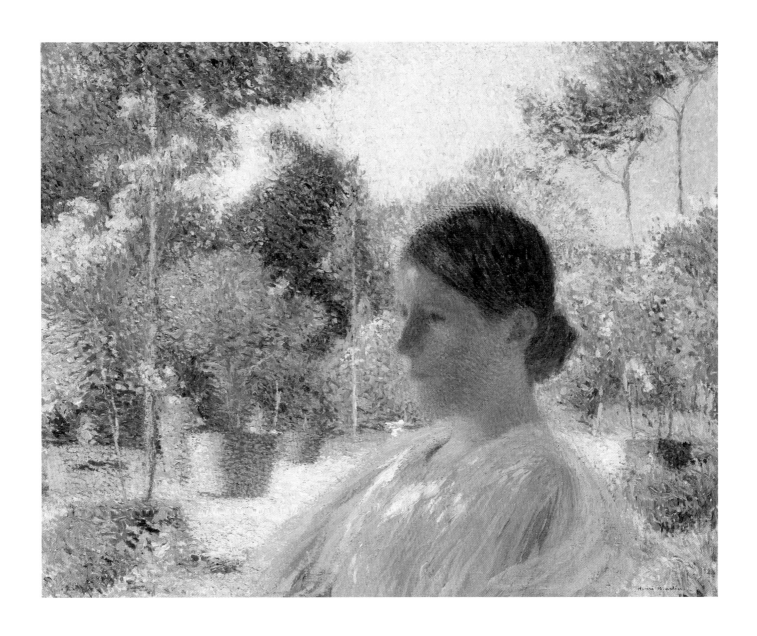

89 Henri Martin *In the Garden*, *c.*1910

Palais des Beaux-Arts, Lille

Martin initially painted historical and Symbolist allegories before
developing a form of Impressionism influenced by his friend
Seurat's pointillist technique. Here he paints the crossing of the
paths in the Italianate garden which he developed from 1900
at Marquayrol in south-western France. Silhouetted against its
oleanders and foliage, almost like some living classical bust, is one
of the models for his murals for important public buildings in
Paris and Toulouse.

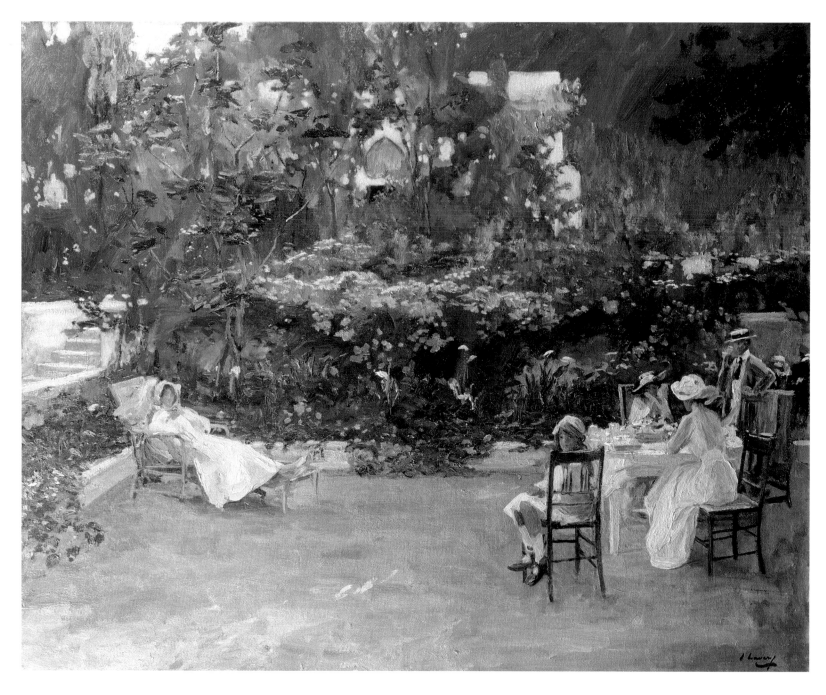

90 John Lavery *My Garden in Morocco*, *c.*1911
Private Collection

Originally from Belfast, Lavery absorbed Impressionist ideas in Paris and
Grez-sur-Loing. The garden of the house he bought in 1903 above the Straits
of Gibraltar provided an intimate retreat for painting and for entertaining
friends. A mass of pink bougainvillea flowers, crowned by a glimpse of
Lavery's studio, creates the effect almost of some decorative stage-set. His wife
Hazel relaxes on a chaise-longue as his two daughters take tea with friends
who may include Walter Harris, the Moroccan correspondent of *The Times*.

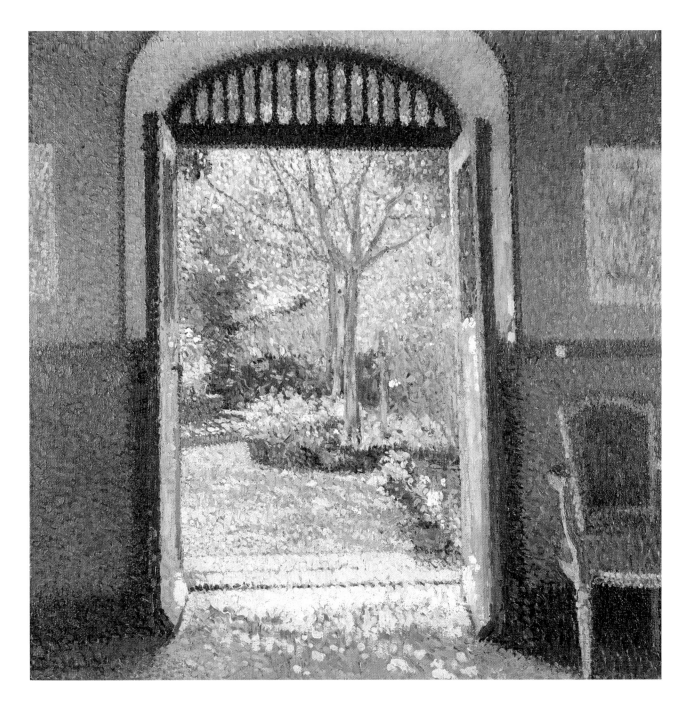

91 Henri Martin *Garden in the Sun*, *c.*1913
Musée de la Chartreuse, Douai

The midday garden with its oleander and potted pelargoniums
is framed by the open door at Marquayrol, Martin's farmhouse
in the village of Labastide-du-Vert in the Lot. So bright is the
southern light, however, that it floods into the cool interior
like a powerful, unrestrained tide. Touches of pink, yellow and
cream embroider an intricate pattern at our feet, whilst the
room is suffused with reflected light.

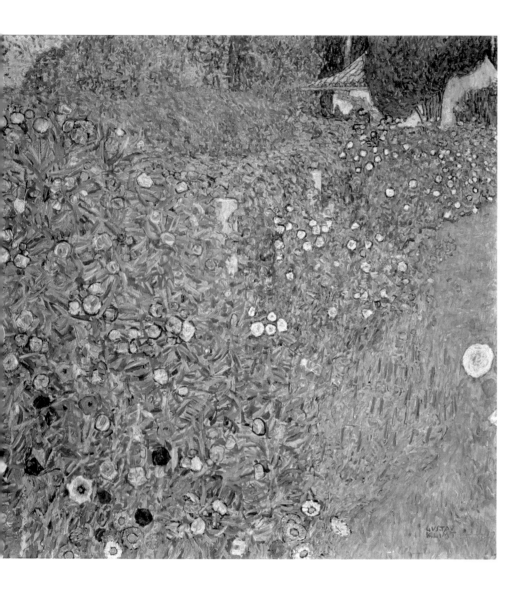

92 Gustav Klimt *Italian Garden Landscape*, 1913
Kunsthaus Zug, Stiftung Sammlung Kamm

Klimt loved flowers, and the garden here seems almost to enfold the little white house. Painted on a visit to Lake Garda, the scene is similar in composition to Monet's *The Artist's Garden at Argenteuil* [19], which had been exhibited in Vienna in 1910. The pink and white flowers thrusting towards us at the left are sweet-scented rosebay; other flowers include bright corn poppies, kingfisher daisies and French lavender, which vibrates against the green grass.

93 Pierre Bonnard *Resting in the Garden*, *c.*1914
The National Museum of Art, Architecture and Design, Oslo

The garden is that of the Villa Joséphine at Saint-Tropez, which Bonnard rented in January 1914. However, he did not paint directly from nature, but from memory and rapid sketches, and he evokes a mood of relaxation in late summer. Plums ripen on the tree, a bowl of cherries tempts us, and the garden merges into a vista of shimmering colour. The pose of the unidentified resting woman recalls that of antique statuary, and even the cat closes its eyes.

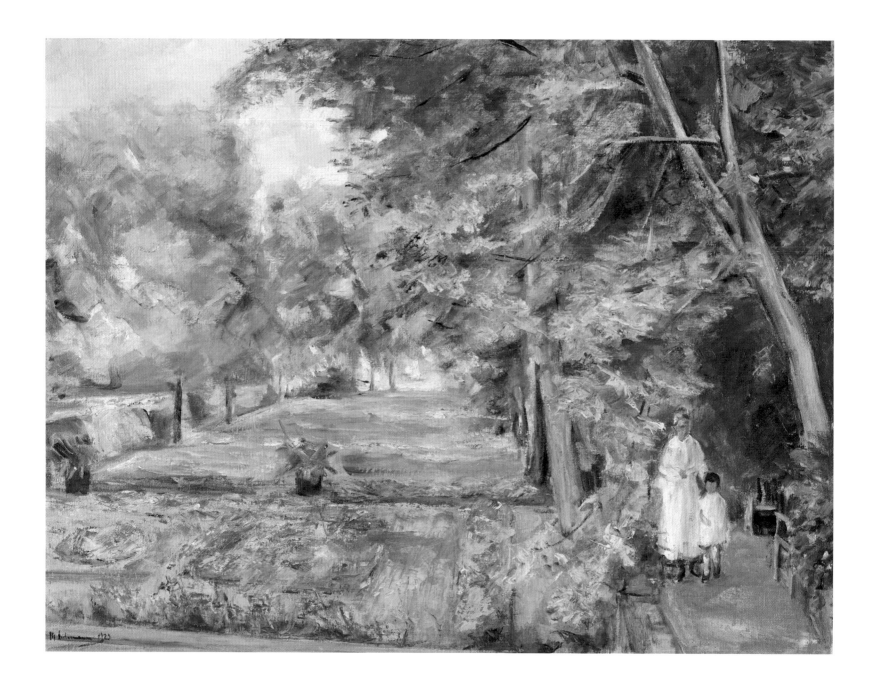

94 Max Liebermann *The Artist's Granddaughter with her Governess in the Wannsee Garden*, 1923

Carmen Thyssen-Bornemisza Collection,
on loan to the Museo Thyssen-Bornemisza, Madrid

The German Impressionist Max Liebermann looks out from his house at Wannsee near Berlin. Bright red flowers fill beds in the foreground; hedged garden rooms lie to the left; at the right is an avenue of birch trees. Guided by the gleam of sunshine on the lawn and the figures' white costumes, the eye travels down to the silvery lake with its boats. Liebermann prized imagination in art, and as the shadows lengthen, his garden becomes, like Bonnard's, a place in which to dream.

95 Claude Monet *The Water Lily Pond*, 1918–19

Musée d'art et d'histoire, Geneva

An intimate corner of Monet's garden at Giverny provides a glimpse of the artist's pond within its larger setting. The reds and pinks of the water lilies are picked up in the pink-brown path and the colours of the rambler roses trained over supports on the bank. These roses included specimens of *Belle Vichysoisse*, which has clusters of tiny pink perfumed flowers, and today is found only at Giverny.

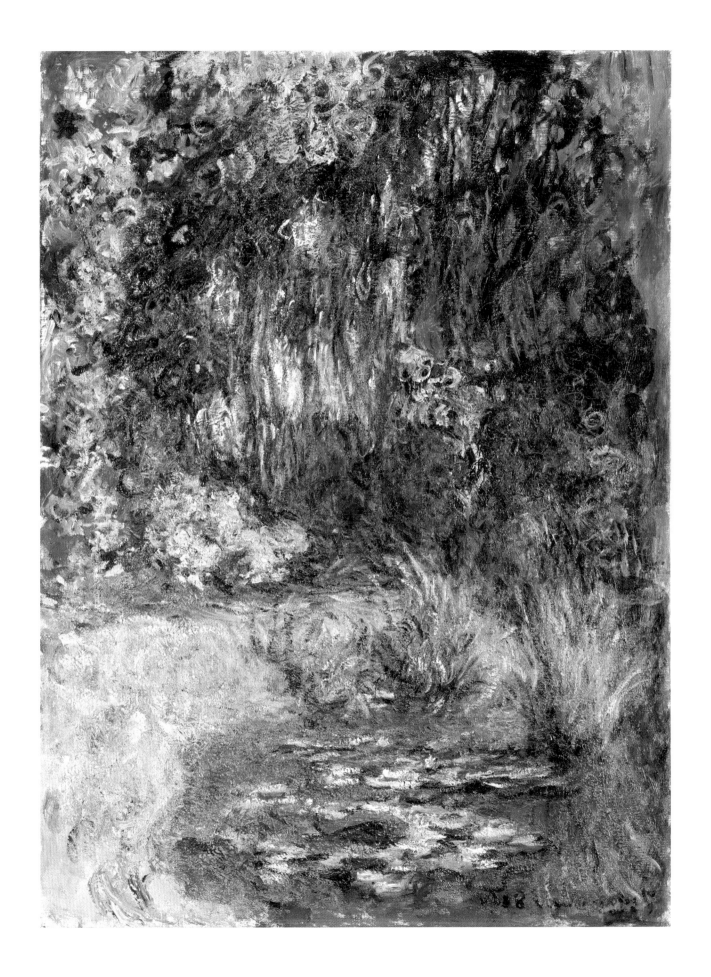

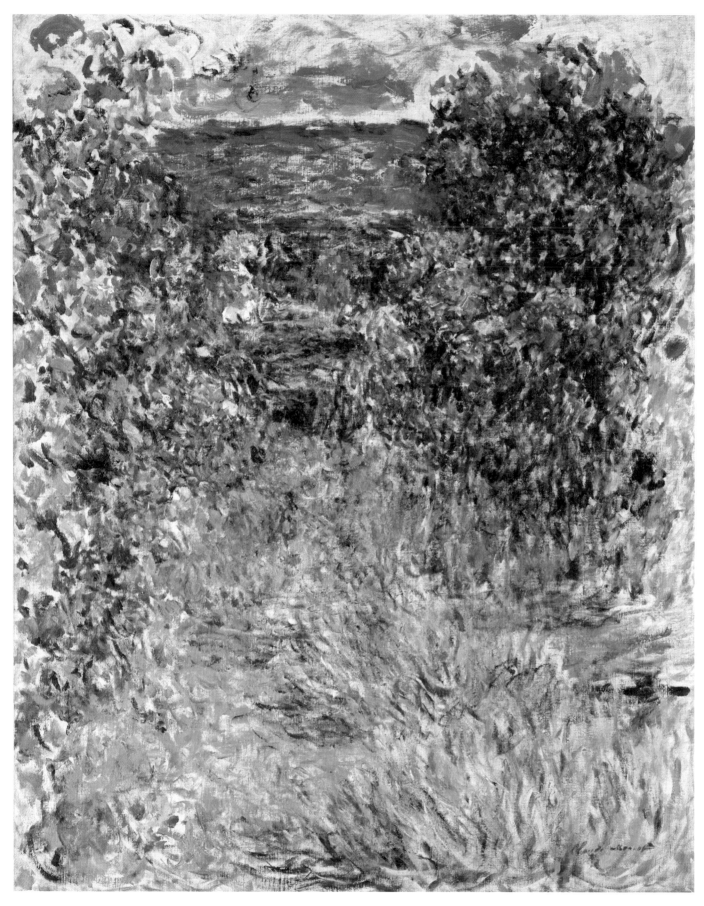

96 Claude Monet

The House among the Roses, 1925

Carmen Thyssen-Bornemisza Collection,
on loan to the Museo Thyssen-Bornemisza, Madrid

Painted whilst Monet was working on his
water lily murals for the Orangerie in Paris,
The House among the Roses celebrates his
rose garden at Giverny. It is one of a series
of views he produced in his final years of his
slate-roofed house framed by roses cascading
over pillars, with his iris-planted lawn in the
foreground. Although unfinished, its energetic
brushwork speaks visibly of the 'second youth'
Monet said he experienced when he finally
began to feel improvement in his sight after his
cataract operations.

97 Henri Le Sidaner *The Rose Pavilion,*
Gerberoy, 1936–8

Fondation Surpierre, on loan to the Wallraf-Richartz
Museum & Fondation Corboud, Cologne

Le Sidaner developed his much-admired garden
near Beauvais from 1902, creating dedicated
areas for different colours and types of plants.
In the rose garden area he grew only pink
and red varieties, and in this picture their
ebullient profusion allows only a glimpse of the
red-roofed pavilion he had built as a summer
studio. The effect is almost that of millefleurs
in a tapestry.

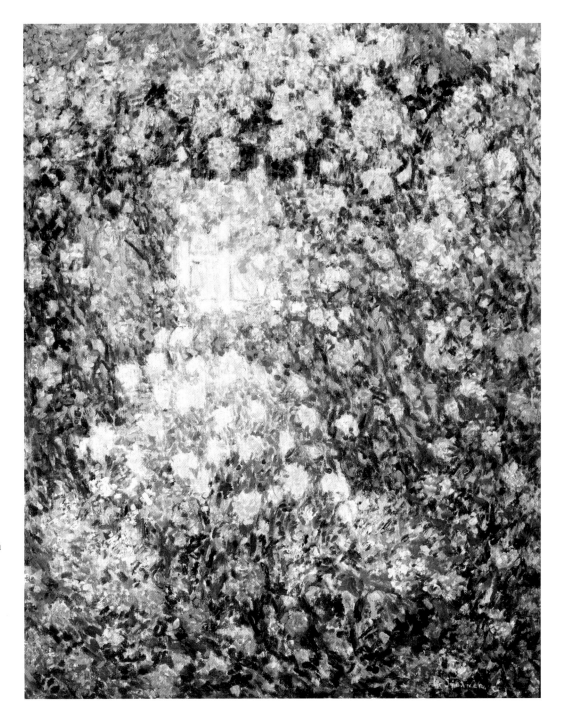

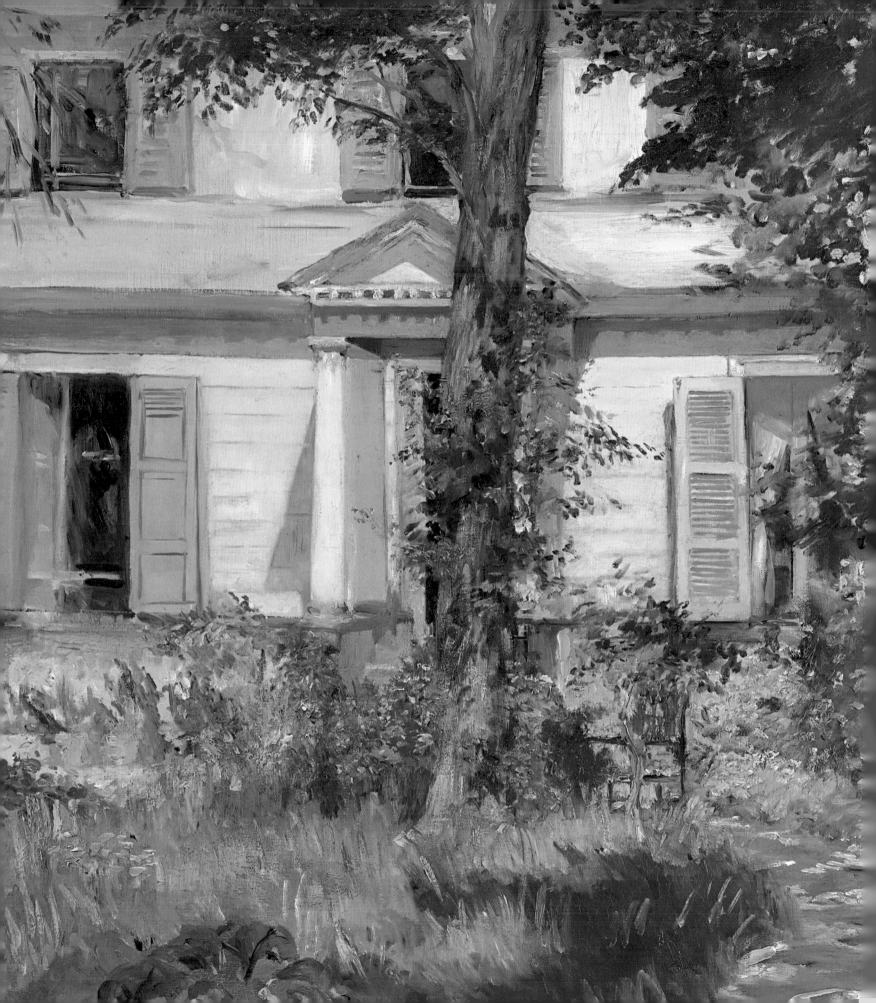

Catalogue

We are most grateful to David Mitchell of the Royal Botanic Garden Edinburgh who has provided botanical information and assisted with identification of plants in the paintings.

All foreign language translations are by the author unless otherwise indicated.

Detail from Edouard Manet
The House at Rueil [32]

1 Jean-François Bony 1760–1825
Spring, 1804

Oil on canvas 190 × 137cm
Musée des Beaux-Arts, Lyons

This virtuosic display of spring and early summer flowers in a terraced garden is one of the first examples of what, by the 1850s, became known as a *fouillis* – a cut-flower arrangement in an outdoor setting.[1] The origins of the *fouillis* lie in Dutch Baroque art and it was taken up by the nineteenth-century Lyons *fleuristes* (flower painters) of whom Bony was an early leading member. With its natural lighting and setting, the *fouillis* contrasts with the more formal representation of single flower species against plain backgrounds which became the trademark of the great flower painter Pierre-Joseph Redouté, and it offers an important antecedent for the Impressionists' paintings of flower gardens.

The Lyons *fleuristes* worked from flowers in their city's Botanical Garden, creating models for the designers of the famous Lyons silks. Bony was professor of flower design at the Ecole des Beaux-Arts in Lyons from 1809–10 and also designed textiles and embroideries including the robes worn by the Empress Joséphine at her coronation.[2] Though its architectural features are by another hand, *Spring* is one of his principal paintings. Its theme of flowers awaiting formal arrangement for a celebration was much favoured by Lyons artists and was taken up by Delacroix, Renoir and Monet.

The specific celebration anticipated in Bony's painting is not known, but, given its date, the way its flowers take precedence over the statue at the right of a warrior goddess suggests an allusion to the new era of peace (albeit short-lived) which followed the Treaty of Amiens of 1802 and led to Napoleon's consecration as French Emperor in December 1804. Similarly, the trough containing the flowers is made from an antique sarcophagus through which pure clear water flows into the garden; what was originally associated with death thus now supports life.

Whilst some of the flowers were probably intended to display Bony's artistic skill, like the delphiniums, and the lilac at the upper right with its shimmering, multiple florets, others symbolically complement the themes of renewal, purity, and putting behind of the past. The hollyhocks at the upper left, for example – flowers traditionally associated with death in Baroque flower painting – are partly placed in shadow so that the white Madonna lilies, scarlet and pink poppies at the centre, and pink and white roses at lower right (perhaps a variety of *Rosa gallica* and *Rosa centifolia* respectively) seize our attention, seen in full sunshine. Lilies, of course, are a traditional symbol of purity, whilst poppies are the flower of forgetfulness. Roses – a particular speciality of the Lyons horticulturalists – are associated with the birth of Venus, goddess of beauty, and blue and white morning glory beside the flame tulips at the edge of the sarcophagus evoke the start of a new day. In turn, the nasturtiums tumbling towards us suggest an extension of the garden into our world.

Spring was exhibited at the Paris Salon in 1809 and entered the Museum of Fine Arts in Lyons in 1844, where it would have been known by Morisot's tutor Joseph Guichard, who came from Lyons, as well as by Bazille and Degas, who visited the museum in the 1860s.

1. For the *fouillis*, see Gifu 1990, p.166.
2. For Bony's career, see Hardouin-Fugier/Grafe 1978, p.31; M. Audin and E. Vial, *Dictionnaire des artistes et ouvriers d'art du Lyonnais*, vol.1, Paris 1918, p.115; and Lyons 1982, p.111.

2 Simon Saint-Jean 1808–1860
The Gardener-Girl, 1837

Oil on canvas 160 × 118cm
Musée des Beaux-Arts, Lyons

The Lyons flower painter Saint-Jean is said to have taken two days to paint a single rose; one for its centre and the other for its petals.[1] This may seem far removed from the Impressionist concern with the fleeting moment – the poet Baudelaire certainly criticised Saint-Jean's 'excessive minuteness'[2] –yet *The Gardener-Girl*, showing a woman with two newly-picked bouquets ascending steps from a garden, can be recognised as a fascinating staging-post towards the horticultural imagery of Monet and his colleagues. Using Bony's motif of cut flowers seen out of doors, Saint-Jean adds a female figure, who is implicitly herself one of the flowers, yet also the agent of their tending. In so doing, he fashioned a new subject which Courbet, Degas, Bazille and Monet in his *Women in the Garden* [fig.7] all reflected in the 1860s, either directly or indirectly,[3] and which in turn anticipates the wider association of women and gardens in Impressionist work from the 1870s.

Saint-Jean's approach is nonetheless subtly different from the truth to season captured by Bony and the Impressionists. Summertime's asters, roses, poppies, and red and yellow dahlias, for example, are juxtaposed with a springtime white and purple flame tulip. Trails of white and blue morning glory, and other flowers with flowing shapes or spikes such as laburnum, hollyhock, and pink prince's plume, lead the eye to the uncultivated landscape beyond the garden. For all their sunlit vibrancy and botanical accuracy, the flowers of *The Gardener-Girl* are also symbolic, and the highly personal nature of their meanings already channels the Lyons *fleuristes*' predilection for emblematic imagery – inherited from Dutch seventeenth-century models – towards the emphasis on the individual, subjective perception found in Impressionism.

The Gardener-Girl, which appears originally to have had a decorative oval format, was Saint-Jean's bid to win recognition in Paris, and thereby persuade his new wife, Caroline Belmont, and her father, that marriage to an artist could succeed.[4] Roses, the flower of beauty and love, are at the centre of the main bouquet, and an acanthus leaf, the symbol of art, curls over the girl's arm. The tulip, pointing suggestively up the steps the girl ascends,

stood in the French nineteenth-century language of flowers for a declaration of love, whilst dahlias represented gratitude, and hollyhocks fecundity – this last a change of meaning since Bony's period.[5] The painting was apparently inspired by the sixteenth-century poet François de Malherbe's lines on his lover Rosette: ' … even Rosette cannot outlast the roses / Which only live one day'[6] – a reflection on the brevity of life which must have harmonised with Saint-Jean's fears for his own potential artistic fate, and was poignantly realised by his choice of model, a laundress neighbour dying of consumption.

In the event, the picture secured marital and artistic success for Saint-Jean; shown at the 1838 Paris Salon, it was bought by King Louis-Philippe, and led to recognition for the artist at the Great Exhibition in London in 1851, a gold medal at the Exposition Universelle in Paris in 1855, and, interestingly, patronage and friendship with Durand-Ruel who was to become the Impressionists' art dealer.

1. As recorded by his servant Lays; see Hardouin-Fugier 1977, pp.69–70.
2. Baudelaire, *Salon de 1846*, as translated in Hardouin-Fugier/Grafe 1978, p.75.
3. See Willsdon 2004, pp.44–51.
4. See Hardouin-Fugier 1977, pp.70–1.
5. See Willsdon 2004, p.38 and p.46.
6. See E. Montrevert, 'Notice nécrologique', in *Les Beaux-Arts*, 1 August 1860, pp.232–7.

3 Antoine Pierre Mongin 1761–1827
The Curious One, 1823

Oil on canvas 43.5 × 34.6cm
The Cleveland Museum of Art, Ohio

Mongin belongs to the generation of naturalists who, in the early nineteenth century, broke with the tradition of history painting, and his evident delight in the rich variety of trees in the walled garden shown in *The Curious One* takes its place alongside Huet's *Trees in the Park at Saint-Cloud* [7]. When he exhibited the picture at the Paris Salon of 1824, together with a partner work called *Rooftop Intrigue*, he added the description 'study from nature',[1] and one critic noted approvingly that although 'only portraits of houses coated in plaster, garden trees, almost trivial details … this pleases me greatly. Full of naivety, this is what I need in a landscape, as in a representation of man's actions.'[2]

The Curious One is not merely a piece of nature, however; it is also an early example of the merging of landscape and genre painting which forms one of the roots of Impressionist garden painting, and its naivety consists as much in the action of the young man scaling the garden wall, as in its loving attention to stones and leaves. For the garden wall bears the sign:

'School for Young Ladies directed by Mrs Wachsam'. The name *Wachsam* is of course ironic; it is German for 'watchful'. Peering over the wall to try to glimpse the 'Young Ladies' in their *hortus conclusus* (enclosed garden, like that of the Virgin Mary), the young man is as lacking in watchfulness as Mrs Wachsam, for he allows himself to be captured on canvas by Mongin. The picture in this sense highlights the watchful role of the artist as observer.

Metaphors of gardens and their privacy were, interestingly, used by several early supporters of Impressionism, just as the artist's garden, which first came to the fore in Impressionism, is typically a place for painting in private seclusion. Duranty, for example, in his landmark pamphlet of 1876 on *The New Painting*, wrote of how academic painters, alarmed by the innovations of the Impressionists, were 'beginning to look over the wall, into these artists' little garden, whether in order to throw stones into it, or to see what is going on there'.[3] He had already used the climbing of a garden wall as a metaphor for the expression of individual will in his novel *The Unhappiness of Henriette Gérard*, just as Zola made the private garden which arouses the curiosity of opposing parties a key image in his novel of provincial politics, *The Conquest of Plassans*.[4] Théophile Silvestre in turn likened the Impressionists' first group exhibition to a garden flowering in the ruins created by the Franco-Prussian War and the Paris Commune uprising.[5] Such metaphors, of course, derive ultimately from Biblical imagery of Eden and Paradise, and are reminders that the traditional ideal of the garden as a place of innocence and perfection, which underpins Mongin's picture, still persisted even after Darwin in the age of the Impressionists, and provided a key perspective in the reception of their art.

1. See d'Argencourt 1999, p.463.
2. Ibid., pp.463–4.
3. Duranty 1876, p.74.
4. For example, E. Duranty, *Le Malheur d'Henriette Gérard*, Paris 1981, p.31 and p.44 (first published 1860); and E. Zola, *La Conquête de Plassans* (preface G. Gengembre), Paris 1994, p.183 (first published 1874).
5. A. Silvestre, *Au Pays des souvenirs*, Paris 1887, pp.152–3.

4 François-Xavier Fabre 1766–1837
A View of Florence from the North Bank of the Arno, 1813

Oil on canvas 96 × 135cm
National Gallery of Scotland, Edinburgh

The motif of the public park is famously associated with Manet, whose *Music in the Tuileries Gardens* of 1862 [fig.4] – the picture reflecting Baudelaire's ideal of

modern life – laid a key foundation for the Impressionist garden. Fabre's *View of Florence from the North Bank of the Arno*, however, already portrays contemporary figures enjoying the splendid Cascine Park beside the River Arno. Still one of the great Florentine public gardens today, this was created in 1737 by the grand Duchy of Lorraine from a game reserve and cattle-grazing area originally owned by Alessandro and Cosimo I Medici (the latter a keen horticulturalist), and further developed in 1780 through the addition of various landscape garden features. The city of Florence can be seen in the background beyond the park, with the Duomo of Santa Maria del Fiore and campanile of Giotto clearly discernable at the left, and the Palazzo Vecchio and city bridges amongst the landmarks at the centre.

The main part of the picture is filled by the park's spacious lawns, laid out with varied trees and a meandering path which, in keeping with the landscape garden mode, leads up to the vantage point in the foreground where the figures are enjoying a picnic, their brightly coloured costumes catching the late afternoon sun (the Palazzo Vecchio clock stands at ten to four). It would be hard to tell from the lush grass and foliage that a fierce frost in 1811–12 had destroyed many plants and trees in Italy.[1] Fabre provides a vision of harmony between figures and nature – both in his attention to the man-made details of the garden such as its path and bench, and in the relaxed poses of the figures, which echo the rounded masses of the trees and shrubs. Although still reflecting the models of Claude, Poussin and Dughet which underpinned Neoclassical landscape in the early nineteenth century, this harmony of man and nature, and the note of domesticity and leisure provided by the picnic, clearly evoke the ideal of Italy as the garden of Europe which became current in the Romantic era, and was in turn taken up by the Italian Macchiaioli painters as an emblem of national identity [see 36]. In this context, it is perhaps not without significance that the picture was commissioned by Elisa Baciocchi, Grand Duchess of Tuscany, who was responsible for opening the Cascine Park to the public,[2] and whose brother, Napoléon Bonaparte, 'provided Italy with a prototype for unification' through his occupation of it.[3]

1. M. Ambrosoli, 'Conservation and Species Diversity in Northern Italy: peasant gardeners of the Renaissance and after', in Conan 2007, p.189.
2. Information on the Cascine Park and Fabre's painting kindly supplied by Michael Clarke.
3. Olson 1992, p.14.

5 Eugène Delacroix 1798–1863
A Vase of Flowers, 1833

Oil on canvas 57.7 × 48.8cm
National Gallery of Scotland, Edinburgh

6 Eugène Delacroix
Still Life with Flowers, 1834

Oil on canvas 74 × 92.8cm
Belvedere, Vienna

Delacroix is known as the painter of grand Romantic works such as *The Death of Sardanapalus* and *Liberty Leading the People*, but he was also captivated by the quieter beauty of flowers. These two paintings were amongst his very first flower pictures. *A Vase of Flowers* captures the play of light and shadow on a bunch of colourful dahlias and carnations, casually placed in a cut-glass vase, and includes anemone dahlias, only developed in 1826. A note thought to have been written by the first owner of *A Vase of Flowers*, Delacroix's friend Frédéric Villot, described it as a 'brilliant study', painted at Villot's home at Champrosay near Fontainebleau, and the stimulus for Delacroix's first finished paintings of flowers.[1] *Still Life with Flowers* is one of these. More elaborate than the 1833 study, it shows a mix of about twenty different flowers, both species and cultivars. A splendid pink tulip crowns the composition, and in the centre there are pink dahlias, a white rose (*Rosa gallica* or *Rosa centifolia*), and an orange lily suggestive of *Lilium bulbiferum var croceum*, a native of southern Europe frequently grown in French gardens. Delphinium and yellow Spanish broom are amongst the flowers at the left, with campanula, more tulips, and a yellow lily lower down. Scattered casually around the simple pottery vase are apples, luscious black grapes and figs. The picture's original owner was Delacroix's friend the novelist George Sand, and her recollections of witnessing his first attempts at flower painting reveal that he found the experience challenging:

He had studied botany in his childhood, and as he had an excellent memory, was still knowledgeable in it; but it had not captured his attention as an artist and its meaning was only revealed to him when he carefully reproduced plant colour and form. I came upon him in an ecstasy of delight before a yellow lily whose beautiful 'architecture' he had just come to understand…He hastened to paint, recognising that his model was at every moment changing its tone and bearing … He thought he had finished, and the result was marvellous; but in the morning, when he compared art with nature, he was dissatisfied and retouched the picture …[2]

Delacroix nonetheless went on to paint a further group of flower subjects in 1848–9,

in which he sought 'to make pieces of nature as they are found in gardens'.[3] These later works, however, are somewhat stilted in comparison with *A Vase of Flowers* and *Still Life with Flowers*, whose sense of airy spontaneity and evocation of their models' freshly-picked character arguably come closer to his garden ideal, and provide suggestive antecedents for the early flower pictures of Bazille, Renoir and Monet – artists who greatly admired Delacroix's use of colour and free, evocative brushwork [14, 15, fig.16].

1. L. Johnson, *The Paintings of Eugène Delacroix. A Critical Catalogue 1832–1863*, vol.3, Oxford 1986, p.258.
2. G. Sand, *Nouvelles Lettres d'un voyageur*, Paris 1877, p.78, as quoted in B. Kayser, *L'Amour des jardins*, Paris 1986, p.112.
3. Letter to C. Dutilleux, 6 February 1849, quoted in Johnson, see note 1, p.261.

7 Paul Huet 1803–1869
Trees in the Park at Saint-Cloud, c.1820

Oil on canvas 37.6 × 55.5cm
The National Gallery, London

One of Delacroix's closest friends, Huet belonged to the 'School of 1830', whose members also included Corot, Daubigny, Rousseau and Troyon. The freedom of these artists' styles was felt to match the liberty demanded by the supporters of the French Revolution of 1830. This style was much admired not only by the poet Baudelaire, but also by Monet, visiting the Salon of 1859 in Paris as a young art student. In a letter of 1859, Monet carefully recorded the advice of Troyon to 'go to the countryside to make studies, above all develop them'.[1]

Trees in the Park at Saint-Cloud is just such a study, although almost certainly intended for reference in preparing larger paintings, rather than for development in its own right. One of Huet's very earliest outdoor studies, its vigorous brushwork, sense of nature's plenitude, and evocation of scudding clouds on a breezy day clearly predict aspects of Impressionism. Its motif, a corner of the famous park of Saint-Cloud near Versailles, is a *paysage intime* (intimate landscape) – a spiritual forebear of the artist's garden of Impressionism, where the artist cultivated a piece of nature of his own inspiration.

Huet seems to have had a particularly deep affection for the park of Saint-Cloud. In old age he remembered how, at the start of his career, 'this enchanting place … whose every bush I knew, whose every felled tree I mourned like a lost friend, offered me the most beautiful subjects for study'.[2] Created in the seventeenth century by Catherine de' Medici, and developed

by the Orléans family, the park had been opened to the public following the French Revolution of 1789, and Huet's depiction of it as a place where nature has its way, rather than being overtly disciplined by man, perhaps reflects this democratic association. His interest in Saint-Cloud's natural aspects was continued in works by Daubigny [11] and Renoir, and is all the more striking as the formal layout of the park, inspired by the Renaissance garden of the villa d'Este in Tivoli, was still strictly maintained[3]; its English-style landscape garden area, added in the late 1820s, was not yet complete.

Whether or not intentionally political, *Trees in the Park at Saint-Cloud* clearly anticipates the 'natural painture' (*sic*) by Constable which impressed both Delacroix and Huet at the 1824 Salon. At the same time, its almost excessively tall trees dwarfing the fountain at centre-left, look forward to those used for decorative effect in the landscape murals shown by Huet at the 1859 Salon. Dubbed 'veritable poems of lightness, splendour and freshness' by Baudelaire,[4] these murals were inspired by Gaspar Dughet's Baroque landscape frescoes, and the Rococo decorations of Hubert Robert, which had often used park subjects. Huet believed that nature could 'lift the imagination into the infinite', like music, and was ideally suited therefore to decoration. On the walls of a hospital or hospice, he wrote, it could actually 'calm the spirit and revive exhausted energies'.[5] It is but a short step from such ideas to Monet's reported vision of a room decorated with images of his water lilies at Giverny as an 'asylum of peaceful meditation' where 'nerves weighed down by work would be relaxed', and even to Matisse's concept of art as 'a soothing, calming influence on the mind, something like a good armchair which provides relaxation'.[6] In this sense, Huet's unassuming little sketch contributes a fascinating link in a chain of evolution which culminates in Monet's celebration of nature's regenerative powers in his water lily murals for the Orangerie in Paris, painted as the French First World War memorial.

1. Letter from Monet to Boudin, 19 May 1859, in w.1, p.419.
2. Huet 1911, p.5.
3. Entry for Troyon, *Vue prise dans le parc de Saint-Cloud*, in Paris 1985.
4. 'The Salon of 1859', in Baudelaire 1965, p.198.
5. 'Notes de Paul Huet', in Huet 1911, p.73; and 'De la Peinture de paysage au point de vue de la décoration', in Huet 1911, p.101.
6. Marx 1909, p.529; Matisse, 'Notes of a Painter', 1908, in D. Lewer (ed.), *Post-Impressionism to World War II*, Oxford 2006, p.25.

8 Jean-François Millet 1814–1875
Garden Scene, 1854

Oil on canvas 17.1 × 21.3cm
The Metropolitan Museum of Art, New York

'How deep are the impressions of an early age and what an indelible mark they leave upon the character' wrote Millet to his friend and biographer Alfred Sensier.[1] *Garden Scene*, a sketch produced on a return from Paris to Millet's home village of Gruchy in Normandy to settle the estate of his recently deceased mother, might almost be a visual inventory of such impressions. The vegetables, labouring peasants, and distant glimpse of the sparkling English Channel depicted in the painting must have been amongst the artist's earliest childhood sights, as the son of a well-to-do peasant family there. Although it is not known if the picture portrays the Millets' actual garden, the man hoeing in the foreground is reminiscent of Millet's description of his great-uncle, a priest, working the land with 'the strength of a Hercules'.[2] The women picking fruits or vegetables in the middle distance likewise perform a task which must often have fallen to his mother and grandmother. The line of view, from one level of the terraced garden down to the next, and from the path to the open sea and broad sky, seems almost to project the journey into memory's depths and back again to the present which Millet must have taken as he painted this characterful study. After his life in Paris, struggling to support his young family, Gruchy must have seemed a paradise on earth. There is golden sunshine, whilst the tilling of the garden evokes renewal. Even the sea plays its part, as it was seaweed which the Gruchy peasants used to fertilise their crops. The figures, partly concealed by the garden's terracing, themselves seem rooted in the earth that they cultivate. It was in Gruchy in 1854 that Millet again met the priest who had taught him Latin, and if the horticulture of *Garden Scene* reinvents that of Virgil's *Georgics*, it also reminds us of Millet's assurance to this former teacher that the Bible and the Psalms were still his 'breviary'. 'I get from them all that I do.'[3]

Whilst Millet's impressions were thus somewhat different from those of the senses to be sought by the Impressionists, his feeling for the reciprocal relationship of land and figures – 'that things … have between them an innate and necessary connection', as he put it[4] – clearly looks forward to Pissarro's ideal of synthesis. During the 1860s, he went on to produce a series of drawings and pastels of rural gardens where peasants graft trees, cultivate vines, and tend vegetables in a way which still more directly predicts this ideal.

1. Sensier 1881, p.31.
2. Ibid.
3. Sensier 1881, p.108.
4. Quoted in K. Clark, *The Romantic Rebellion, Romantic versus Classic Art*, London 1976, p.302.

9 Filippo Palizzi 1818–1899
Orange Tree and Women, 1860

Oil on canvas 57 × 35cm
Galleria Nazionale d'Arte Moderna, Rome

'Do you know the land where the lemon trees grow?' asks the German writer Goethe at the start of his famous poem 'Mignon's Song' thereby giving pride of place to the cultivation of citrus fruit as a defining sight of late eighteenth-century Italy. However, when Palizzi painted *Orange Tree and Women* over sixty years later – one of a group of open-air studies he made at Sorrento near Naples – the tradition of Italy as the garden of Europe had become overlaid by new associations between land and identity, as Garibaldi strove to bring about a unified nation. Palizzi supported Garibaldi and painted a number of incidents from his campaigns, and it is perhaps no coincidence that, in the context of the struggle for unification, he should find artistic inspiration in one of the productive orchard gardens of the Naples region. For here is Italy's native soil, tended by its people, bringing forth bounty, in the year that Garibaldi triumphantly entered Naples, a move which led to the Kingdom of Italy in 1861, and brought unification (ultimately achieved in 1871) a key step nearer. The woman picking the fruit in *Orange Tree and Women* in fact wears a red scarf, implicitly declaring solidarity with Garibaldi's volunteers, who were known as 'red shirts'.

Whilst this picture can be viewed as a patriotic garden, it is also firmly part of the wider rise of impressionistic garden painting. Palizzi had visited France in 1855, and was familiar with the work of Corot and the Barbizon painters and their use of light effects in the Forest of Fontainebleau, as well as their ethos of sketching from nature to capture what Corot termed 'the first impression, which has moved us'.[1] Though he did not settle in France, as did his brother Giuseppe, who joined the Barbizon group at Fontainebleau from 1844, his use of light and shadow in *Orange Tree and Women* marries the lessons of his Barbizon colleagues with the legacy of the Neapolitan 'School of Posillipo', which had practised painting outdoors in the early nineteenth century. The picture's tonal contrasts, rendered in Palizzi's characteristic impasto, create an intricate, almost decorative interplay between the bright orange fruits, the patches of sunshine on the orchard floor, the faces and arms of

the women, and the bright summer clouds, and it is easy to see how his art in turn proved influential for the Macchiaioli or so-called Italian Impressionists, who used the 'accentuation of chiaroscuro in painting' – the expressive *macchia* – to convey their 'emotion' before nature.[2] Similarly, the role of the women, one picking the fruit and the other resting from her labours, is clearly prophetic of the 'importance of women in Macchiaioli paintings … often involved in useful work',[3] which still persists even in the late nineteenth century in Borrani's domestic garden scene, *Girls Winding Wool* [27].

1. Cited in Moreau-Nélaton 1924, vol.1, p.83.
2. Telemaco Signorini, as quoted in Manchester/Edinburgh 1982, p.35.
3. Olson 1992, p.41, note 33.

10 Thomas Couture 1815–1879
The Reading, 1860

Oil on canvas 81 × 65cm
Musée national du Château de Compiègne

Couture taught Manet, and both his advocacy of outdoor sketching and contemporary subject matter, and his effects of textured brushwork, were in turn influential on the wider Impressionist group, which has been called 'a planet receiving its light from Couture's sun'.[1] He also taught many American and German artists who came to study in France in the 1870s; the American Frederick Childe Hassam later lodged at his home at Villiers-le-Bel and painted the garden there [37, 38]. The garden shown in *The Reading*, however, is that of Couture's family home at Senlis in the rural Valois, to which Couture had recently returned from Paris after conflict with Napoléon III's Second Empire regime, which he accused of losing faith in his mural commission for the church of Saint Eustache. 'I made my retreat to my home at Senlis. It was an exile for me, but a voluntary exile in the midst of my youthful memories, amongst my fellow countrymen, and in my fine old family home', he wrote, and this sense of grateful presence in a place of security and happy association is clearly reflected in *The Reading*.[2]

Although showing Couture's wife Marie-Héloïse Servent, whom he had married in Paris the previous year, the composition, as seen in preparatory pencil sketches, seems initially to have consisted solely of the trellised bower. Mme Couture's figure appears to have been painted at a later stage. Absorbed in her book, Mme Couture is seemingly unaware of the vines and flowers which grow exuberantly around her, mirroring her own fertility – she was expecting their first child. In this context, the larger, garden area beyond the sunlit gate through

which she is about to pass perhaps suggests the new phase of life on which she will shortly embark as a mother, whilst her activity of reading creates a corresponding mood of meditation. With its play of light and sense of the open air, which already anticipate Couture's precept that 'what is flooded with light is [the] most beautiful',[3] the painting seems to share the ideals of Couture's close friend the Republican historian and philosopher Jules Michelet, who, in his popular book *Woman*, published in 1859, had advised husbands to ensure their expectant wives had 'the sustenance of all sustenances, vital air [in place of]… the jumble of fumes, evil emanations and wicked dreams which hovers over our dark cities!'[4] The tactile, buttery yellow on the gate and bright notes of green foliage make the sun an almost physical presence in the picture, as if in echo also of Michelet's belief that 'The human flower is, of all flowers, the one which most desires the sun.'[5] In this sense, Mme Couture's bower looks forward directly to the Impressionist garden as a place of life and renewal, and for the study of effects of light and atmosphere on figures out of doors.

1. Boime 1980, p.473.
2. Couture 1932, p.37.
3. Couture quoted in Boime 1980, p.386.
4. J. Michelet, *La Femme* (first published 1859), in Michelet 1985, pp.430–1.
5. Ibid., p.428.

11 Charles-François Daubigny 1817–1878
The Cascade at Saint-Cloud, 1865

Oil on canvas 122 × 198cm
Musée des Beaux-Arts et d'Archéologie de Châlons-en-Champagne

This grand, formal picture was a commission from the French State in response to a proposal by Daubigny for 'a series of paintings representing the imperial parks and châteaux', to match the Romantic painter Joseph Vernet's 'historical and picturesque' paintings of French ports.[1] Daubigny had already painted murals for the Ministry of State showing the Tuileries palace and gardens, and his proposal was clearly an astute appeal to Napoléon III's pride. The palace at Saint-Cloud, which, together with its park, had been remodelled by Louis XIV, is seen nestling amidst the trees in *The Cascade at Saint-Cloud*, and was used by Napoléon III as his principal summer residence. Daubigny's view is from the banks of the Seine; at the far left is the park's Great Fountain, whilst the Cascade itself – a hydraulic system of fountains emptying into a pool – appears at centre-left.

The Baroque splendour of the park at Saint-Cloud could hardly have formed a greater contrast with the 'plot of land thirty

perches in size all covered with beans, on which I will plant a few legs of lamb if you come to see me' that Daubigny described to a friend as constituting his own garden at Auvers.[2] It was, however, at home at Auvers that he painted much of this work from sketches; the finished picture was exhibited at the 1865 Salon. And something of the ease of his Auvers environs surely found its way into *The Cascade at Saint-Cloud*; in the words of a period critic, the picture 'hid[es] the stiffness of the quincuncial shapes' of the Saint-Cloud park, and 'infus[es] a great deal of light and air throughout the foliage'.[3] It was Daubigny's feeling for nature and light which made his art of such interest to the young Impressionists. Huet's earlier study of trees at Saint-Cloud [7] points the way to this approach.

By Daubigny's time access to the park had been vastly enhanced as a result of the building of a railway line from Paris. As much as the effects of nature and light, it is the detail of the day-trippers which catches our attention in his picture. A man and woman stroll in the left foreground, followed by a child bowling a hoop; other children sit on the grass; a gaggle of figures is watching or feeding the swans in the pool; and ladies in crinolines promenade gently. The prominence of these bourgeois leisure-seekers, picked out in the midday sunshine and so lively and colourful in comparison with the stone statues and Cascade, are reminders that despite his favour with Napoléon, Daubigny had strong Republican views and reputedly sang the *Marseillaise* while he worked. Public access to the park at Saint-Cloud and its designation as being for 'the pleasure of the citizens'[4] dated from the Revolutionary government of 1789. Daubigny's palpable empathy with the descendants of those citizens, and the way he makes Saint-Cloud's monuments to regal and imperial power – fountain, Cascade and palace – subtly merge into the shadows and tree masses clearly reveals the radical mind which, in artistic terms, made him such a staunch supporter of the Impressionists.

1. Letter to the Minister of State, 21 March 1862(?), as translated in Philadelphia/Detroit/Paris 1978–9, p.284.
2. Letter to F. Henriet, August 1860, quoted in Fidell-Beaufort/Bailly-Herzberg 1975, p.52.
3. F. Jahyer, quoted in Philadelphia/Detroit/Paris 1978–9, p.285.
4. Paris 1985, p.188.

12 Henri de Braekeleer 1840–1888
A Flemish Kitchen Garden: La Coupeuse de Choux, c.1864

Oil on canvas 47.6 × 58.4cm
Victoria & Albert Museum, London

The Antwerp artist Henri de Braekeleer was a nephew of the noted realist history painter Henri Leys, but found his subjects in contemporary life – in this case, in a local kitchen garden. The red-tiled roofs and glimpse through the distant doorway recall the courtyard views of Dutch seventeenth-century painters such as Vermeer and De Hooch, but the textural handling of the paint is closer to Courbet, who had exhibited in Brussels. Together with De Braekeleer's everyday motifs, this handling was to be of much interest to his younger colleague James Ensor [66].

The effects of sunshine in *A Flemish Kitchen Garden*, bouncing off the cabbage leaves, gable, and woman's scarf and shawl, and picking out the pink and white dahlias near the house, already look towards the luminous style adopted by De Braekeleer at the end of his career in the 1880s, in a Belgian counterpart to Impressionism. Pissarro's friend the critic Camille Lemonnier even noted that 'More or less right from the start', De Braekeleer had captured 'the sensuality of beautiful colours encrusted with gold and phosphorus'.[1] In *A Flemish Kitchen Garden*, the woman's dress is gilded by the sunlight, whilst the silvery-blue of the cabbage leaves is suggestively linked with the light sky by the washing pole. Like the Impressionists, De Braekeleer is using a garden, sheltered by surrounding trees and buildings, yet open to the sun and sky, as an artistic laboratory for the study of light and atmosphere. The sense of capturing a moment in time is underlined by the woman's action in picking the first cabbage of the season. Soon, the cabbage will be cooking in the pot, an event heralded by the smoke rising from the chimney at the left.

The cabbages are recognisably Savoys, probably the January King variety, known in the nineteenth century as Pontise or Milan de l'Hermitage, which was harvested from October to February. A climbing rose is still in bloom at the left, and there are dahlias – popular flowers for cutting – in the background. The tall plant with red flowers to the right of the cabbages, however, does not match a known species and seems simply to serve to create a splash of glorious crimson, another foretaste of De Braekeleer's future palette. Linking with the duller reds of the roofs, this parallels Pissarro's ideal of pictorial harmony, and with the rose and dahlias, makes the kitchen garden a place of beauty as well as utility. It is evident

why Lemonnier called De Braekeleer 'the ecstatic lover of the hours'.[2]

1. C. Lemonnier, *Henri de Braekeleer, peintre de la lumière*, Brussels 1905, in Sarlet 1992, p.78.
2. Lemonnier in Sarlet 1992, p.78.

13 Frédéric Bazille 1841–1870
The Oleanders, 1867

Oil on canvas 55.2 × 91.4cm
Cincinnati Art Museum

'[The] elegant habit, glossy foliage, profusion of bright rosy or white flowers, endowed, moreover, with an agreeable almond-like perfume, offer recommendations hardly to be exceeded by those of other plants.'[1] So wrote the British horticulturalist William Robinson of the oleanders he saw growing in pots all over Paris in 1867, but it is the full, vigorous growth of these flowers in the open soil of their native south which Bazille celebrates in this unfinished picture of the terrace of his family's estate at Méric near Montpellier. For although a figure on a bench is sketched in the foreground in the shade of a chestnut tree, it is the rich pink and cream mass of the oleander flowers, caught in full sunlight at the centre, which is Bazille's prime motif. And with good reason; their splendour is testimony to the success of the treatment for oleander fungus which Bazille's father, a prominent agriculturalist in the Languedoc, had discovered in 1864.[2]

It was Bazille's father who, after Frédéric had abandoned medicine for art, enabled him to study in Paris, where he became a close colleague of the future Impressionists before his tragic death in 1870 in the Franco-Prussian War. *The Oleanders* was painted on Bazille's summer vacation in 1867 at Méric, just a few months after his purchase of Monet's *Women in the Garden* [fig.7], whose rejection by the Salon had left his friend in dire financial straits. In this context, Bazille's addition of a figure to his work was perhaps an attempt – like his more elaborate *Family Reunion* (Musée d'Orsay, Paris), also painted at Méric in 1867, and showing his parents and relations – to create a southern counterpart to Monet's pioneering picture.

The figure seated beneath the cooling shade of the chestnut tree in *The Oleanders* also serves, however, to close off the part of the terrace where, under the burning southern sun, the gravel appears an almost abstract patch of dazzling brilliance. This patch in turn reflects light on to the oleanders and the Méric orangery in the background, and is complemented by the glimpse of luminous blue sky behind the chestnut leaves. The garden becomes a crucible of light, with the bright flowers in the foreground shade like escaping

sparks. These effects of bright sunshine are as bold as any in French painting at this period, and mark a decisive break with the more subdued tones of Daubigny and Corot [11, 16]. Nonetheless, in using the seclusion of the Méric garden for artistic experiment, Bazille perhaps discovered the paradox of Monet's remark to him a few years earlier, 'It is better to be all on your own, and yet, all alone, there are many things you cannot get to the heart of.'[3] With its sketchy figure, his picture is ultimately unresolved: a tantalising glimpse of the Impressionist he would surely have become had he not died three years later.

1. Robinson 1869, p.221.
2. *Bulletin de la Société centrale d'Agriculture et des Comices agricoles du département de l'Herault*, Montpellier 1864, p.388; see also Willsdon 2004, pp.90–1.
3. Letter from Monet to Bazille, 15 July 1864, no.8 in w.I, p.420.

14 Frédéric Bazille 1841–1870
African Woman with Peonies, 1870

Oil on canvas 60.3 × 75.2cm
Musée Fabre, Montpellier Agglomération

Bazille grew up with garden flowers. His father Gaston, an active member and later president of the Central Society for Agriculture of the Hérault Department, cultivated many fine specimens on the family estate at Méric, near Montpellier, which were regularly cut for the house. Bazille must have remembered the splendour of these Méric bouquets when, in his Paris studio in 1870, he painted *African Woman with Peonies*, and a similar picture showing the same model with a basket of spring garden flowers.[1]

Monet had recommended flowers to Bazille in 1864 as 'an excellent thing to paint'.[2] However, in this work Bazille takes a step beyond a pure still life by showing recently cut flowers being arranged by a dark-skinned model. This figure is in effect a modern 'gardener-girl', updating that by Saint-Jean [2], and it now pays homage to the black servant with a bouquet in Manet's *Olympia*. The sprig of laburnum in the model's right hand is surely an allusion to the poem by Manet's friend Baudelaire in praise of his mulatto mistress Jeanne Duval, the 'sorceress with ebony flanks'. Laburnum was called the 'ebony tree' because of its dark wood, and in the nineteenth-century language of flowers, its blossom signified a spell.[3]

These associations remind us of Baudelaire's definition of art as 'evocative magic'. However, the other flower held by the African woman – the one she is adding to the vase – is a peony. This flower was believed in antiquity to be capable of annulling spells;[4] Bazille seems to indicate

that art is as much about the tangible and real as the magical. He places his motif in a strong shaft of light, and the flowers appear with all the colour and luminosity that they would have in the sunshine in a garden whilst the African woman becomes a flesh and blood creature, in contrast to Saint-Jean's more idealised 'gardener-girl'.

Bazille would have been very familiar with Lyons flower painting as his father's agricultural society had reported on the prizes it won in the Montpellier Concours Régional of 1860.[5] Although the frank effects of light look forward to Impressionism, his picture is still in essence as symbolic as the work by Saint-Jean. As well as the evocative laburnum and peonies, it notably includes an iris, at the apex of the vase. This is the flower which, named after the Greek messenger of the Gods, traditionally 'announces events'.[6] Since Bazille painted *African Woman with Peonies* for his sister-in-law Suzanne Tissié, his iris presumably refers to the birth of her first son on 2 May 1870. The ultimate reality he celebrates is thus the new life represented by the child who now guaranteed the Bazille line. In this context, it is a poignant irony that this fascinating picture where Romanticism meets nascent Impressionism, and still life moves towards the painting of living flowers in gardens, was the last Bazille completed before his untimely death.

1. For the Bazille family estate, see G. Aggeri, 'D'un domaine agricole du XIXe siècle … un théatre des champs contemporain du Mas Méric et les avatars de l'idée du champêtre dans un parc urbain montpéllerain', in *Actes du séminaire 'Etapes de recherches en paysage'*, no.3, Ecole nationale supérieure du paysage, Versailles 2001, pp.15–16. Bazille's companion piece is *African Woman with Peonies*, 1870, National Gallery of Art, Washington DC.
2. Letter from Monet to Bazille, 26 August 1864, no.9 in w.I, p.421.
3. Baudelaire, 'Sed non satiata', in *Les Fleurs du Mal*, Paris 1857; De Neuville 1863, p.144. See also Willsdon 2004, pp.48–50.
4. Baudelaire, 'Philosophic Art', in Baudelaire 1964, p.207; text for plate 236 in *L'illustration horticole*, VII, March 1860. See also Willsdon 2004, p.46 and p.50.
5. See Willsdon 2004, p.51 and *Bulletin de la Société Centrale d'Agriculture et des Comices Agricoles du Département de l'Hérault*, 47th Year [1860], p.300.
6. De La Tour 1845, p.153.

15 Pierre-Auguste Renoir
1841–1919
Flowers in a Vase, c.1866

Oil on canvas 81.3 × 65.1cm
National Gallery of Art, Washington DC

Renoir's view that 'artists can only work where nature is left some freedom' is eloquently illustrated by this armful of freshly-gathered wild flowers in an earthenware jug. Its vibrant corn poppies

and simple daisies suggestive of white and yellow corn-chamomile directly anticipate his delight in the 'vast uncultivated lawn … strewn with poppies, convolvulus and daisies'[1] which lay behind his studio in Montmartre in 1876 [see 21]. Dating from a period in Renoir's early career when he was much interested in the work of Delacroix, the picture has much in common with the naturalistic bouquets of flowers which Delacroix had painted in the 1830s and 40s [5, 6]. At the same time, the play of light lends a liveliness to the composition which looks towards Renoir's mature Impressionist style, and his later description of flower painting as an opportunity for 'experiment' with 'tones and values'.[2]

The presence on the back of the picture of a railway label from Melun, a station used for access to the Forest of Fontainebleau, implies it may have been painted in this area, perhaps following a carefree excursion like that portrayed in the artist's *Outing in a Rowing Boat*, also from 1866, in which one of the women holds a bunch of wild flowers.[3] Renoir certainly spent time at Marlotte near Fontainebleau in the summer of 1866, staying with Sisley and another artist called Jules Lecoeur, and following the example of the Barbizon group by painting out of doors. He was very close at this time to Lise Tréhot, the sister of Jules Lecoeur's mistress, and it is possible to imagine the bouquet of flowers being picked on a stroll through the fields with Lise, perhaps accompanied by Lecoeur and her sister; Lecoeur was the picture's first owner. The flowers depicted are all typical of a midsummer cornfield. As well as the poppies and chamomile, they include what appear to be blue cornflowers, or perhaps round-headed rampion (upper right and lower left); hoary ragwort (upper left); wild parsley with its yellow ball-shaped heads; and small yellow flowers which may be Spanish broom (the flowers with thin stems leaning down near the handle of the jug).

In creating a still life from wild flowers, Renoir domesticates nature in a way which closely parallels the *Déjeuner sur l'herbe* subjects by Monet and Manet in the mid-1860s, with their contemporary figures treating a forest setting as if it was a private leisure garden. This sense of the countryside as a natural garden can be compared with the vision of Gustave Courbet and the utopian socialist Pierre-Joseph Proudhon who stated that, 'We have the whole of France to transform into a vast garden… where each new landscape contributes to the general harmony.'[4]

1. Rivière 1921, p.130.
2. Ibid., p.81, as translated in London/Paris/Boston 1985–6, p.183.
3. D. Cooper, 'Renoir, Lise and the Le Coeur

Family: A Study of Renoir's Early Development – I Lise', in *Burlington Magazine*, vol.ci, no.674, May 1959, p.167; *Outing in a Rowing Boat*, 1866, Private Collection, illustrated in White 1988, p.19 (sold as *La Mare aux Fées*, Christie's, New York, 11 May 1995; see London/Ottawa/Philadelphia 2007–8, fig.32).
4. Proudhon 1939, p.281 (written in collaboration with Courbet).

16 Camille Corot 1796–1875
The Parc des Lions at Port-Marly, 1872

Oil on canvas 81 × 65cm
Museo Thyssen-Bornemisza, Madrid

The poet Baudelaire had in 1845 called Corot 'the head of the modern school of landscape', and by the 1870s the roots of Impressionism were often traced to Corot's expressive brushwork and evocative light effects.[1] This work, however, dating from the final years of Corot's life, suggests that the artist popularly associated with pictures of nymphs in woods was now himself influenced by the Impressionist philosophy of painting modern life. It combines *sous-bois* (shaded woodland) with fashionably-dressed figures departing for a promenade – a girl with a sturdy walking stick, and a straw-hatted boy on a donkey, attended by a servant. These were the children of the former Paris stockbroker Georges Rodrigues Henriques, who had become a pupil of Corot; the place of their promenade was the seventeen-hectare park surrounding Rodrigues's Château des Lions in Port-Marly near Versailles. Corot stayed several times at the château during the early 1870s and his painting shows what was, in effect, an artist's garden.

Promenades were a popular form of leisure in nineteenth-century France, enjoyed alike by the Parisian working classes who took the train on Sundays to ramble in the rural suburbs, and by those with the wealth to ride in the Bois de Boulogne, or, like the Rodrigues to own their own land. Close to the former royal estate at Marly, the Parc des Lions was its bourgeois successor: an English or landscape garden. To ride and stroll there – even if accompanied by a servant – was to enjoy the personal communion with nature which Jean-Jacques Rousseau, an early enthusiast for the English garden, had described in his celebrated *Rêveries du promeneur solitaire* (*Dreams of the solitary walker*) – 'he loses himself … in the immensity of that beautiful system [nature] with which he identifies'.[2] Corot certainly makes the two principal trees in the Parc, one older and taller than the other, correspond to the Rodrigues siblings, as does the small bent tree to their servant.

The naturalness of the Parc des Lions must have formed a striking contrast with the artificial park filled with grottoes, caves and Gothic follies which the novelist Alexandre Dumas had created at his Port-Marly residence, the Château de Monte-Cristo. As such, it would have harmonised precisely with Corot's reputed answer to Rodrigues's request for artistic instruction: 'theories are worth nothing in comparison to practice, I will go and paint in front of you in the countryside'.[3] Yet Corot's pairing of trees and figures, and what contemporaries called his poetic blurring, are subtle reminders that his paintings were not literal records of nature, but elaborated in the studio from outdoor sketches. The very motif of *The Parc des Lions at Port-Marly* was, in the context of the early 1870s, surely no less deliberate. The Franco-Prussian War and the Paris Commune of 1870–1 had caused Corot much personal anguish, and the Prussians had actually occupied the Parc des Lions.[4] Thus the sight of Rodrigues's children again enjoying their family park must have been an especially potent emblem for Corot of the return of 'liberty … so dear', speaking as he did at this period of trying 'to see nature and render it like a child, without *parti-pris* (prejudice)'.[5] Devoid of *parti-pris*, this child's vision of nature was, of course, exactly what war – a conflict of parties – was not. In this sense, *The Parc des Lions at Port-Marly* is symbolic: an image of a place of liberty freely enjoyed by those with unprejudiced eyes. As such it looks forward to the intimate association of childhood and gardens in the art of another of Corot's pupils, Berthe Morisot [29, 31].

1. C. Baudelaire, 'The Salon of 1845', in Baudelaire 1965, p.24.
2. 'Septième Promenade', in Rousseau 1970, p.123.
3. Cited in Moreau-Nélaton 1924, vol.2, p.54.
4. Ibid, p.39; 'Edouard Georges Rodrigues Henriques'; http://www.nebuleuse-rh.org/georges-rh.html.
5. Letter to the artist La Rochenoire, 23 August 1870, in Moreau-Nélaton 1924, vol.2, p.39; comment cited in ibid., p.46.

17 Edouard Manet 1832–1883
The Croquet Party, 1873

Oil on canvas 72.5 × 106cm
Städel Museum, Frankfurt am Main

Unlike Monet, Caillebotte and others such as Bonnard and Liebermann, Manet did not cultivate a garden of his own. However, he made his parents' estate at Gennevilliers the setting of his controversial early painting of a female nude and two male companions, *Le Déjeuner sur l'herbe* [fig.5], and when he adopted Impressionist techniques in the 1870s, he often painted in the gardens of friends. According to his early biographer Adolphe Tabarant, *The Croquet Party* was begun in the Belgian painter Alfred Stevens's 'little garden … a charming corner of coolness' in the rue des Martyrs in Paris, and worked up in Manet's studio. Stevens's 'endless croquet parties' reminded Manet of those he had enjoyed and painted at Boulogne in 1871 after the horrific experience of the Paris Commune.[1]

The Croquet Party shows Stevens himself, seated on the ground at the left with his back turned, beside one of Manet's favourite models, Victorine Meurent, with whom Stevens was having an affair. To the right, their friend Alice Legouvé is about to hit a ball through the hoop in the foreground; she is positioned for the side stroke always used at this period by women croquet players, whose costume precluded more energetic shots. Reaching out as if to pick a flower concealed by the garden's greenery, is Manet's old schoolfriend Paul Roudier. If Roudier is supposed to partner one of the other figures – croquet is played in teams of two – he seems remarkably detached from the game. Although Manet is using Stevens's garden to study the effects of light and atmosphere on figures, he is also employing his famous wit. Roudier, despite his dandy's attire of boater and bow tie, has the pose of the antique Apollo Belvedere statue, and Stevens's pose is that in reverse of the river god in Raphael's *The Judgement of Paris*. Manet had already based a figure on this river god in his *Le Déjeuner sur l'herbe*. Now, in the intimacy of Stevens's garden, Manet effectively updates that work, using a lighter palette, impressionistic brushwork, and a contemporary theme: croquet was very fashionable at this period in France.[2] Victorine, who had been the model for the nude in *Le Déjeuner sur l'herbe*, is now fully clothed and instead of gazing challengingly at the viewer as in the earlier painting, she turns away to watch Alice, and in the process Roudier too. Is she hoping to catch Roudier's eye when he looks up from picking his flower, and even to demand that flower as her due, thereby embarassing her lover Stevens? The game of this picture may lie less, perhaps, in its mallets and hoops than in its psychology (which includes Manet's role as observer). This is not just a record of a tranquil summer garden, but a tightly choreographed dialogue of opposites and parallels: past and present in art, including Manet's own; relaxation and concentration; and male and female relations. Even the spout of the watering-can – an emblem of the work of horticulture which has been set aside for play – repeats the line of Stevens's arm, just as the profile of the fowl dozing on its feet beside the watering-can echoes Roudier's pose in miniature. The rambling garden growth and loose facture belie the tactical precision both of painter and of players.

1. Tabarant 1947, p.222–3.
2. Frankfurt/Munich 2006–7, p.208 and Rubin 1999.

18 Claude Monet 1840–1926
The Artist's House at Argenteuil, 1873

Oil on canvas 60.2 × 73.3cm
The Art Institute of Chicago

The garden in this painting, spread out before the viewer, seems almost like a stage; an outdoor answer to the theatre imagery of Manet and Degas.[1] But if the actor on the stage is the child with the hoop – Monet's young son Jean – the play is one of light and colour. Though the sun has moved west behind the Maison Aubry, Monet's first house at Argenteuil, it still illuminates the upper storey and part of the garden, and the shadows on the ground are imbued with mauve and lilac. Jean looks towards the last pools of sunshine, as if fascinated by the light which the popular Republican writer Jules Michelet had insisted was 'first and supreme' in a child's process of development.[2] Monet was to send Jean to a school run by a 'fierce Republican', and already seems to echo Michelet's ideas, derived from the progressive educationist Froebel, in showing his son playing with adults close at hand, but being allowed to discover for himself the garden's colours and sensations.[3] Monet's wife Camille is the figure at the door, looking implicitly at Monet, at his easel where the viewer stands. There is a sense of family unity; a harmony of personal relationships, with the artist painting a favoured subject – his family and their tranquil little world of house and garden. The plants glow with colour, even in the shadows. Orange-red flowers, probably nasturtiums, grow in the circular bed and under the trees, and under the window, red flowers are complemented by blue ones suggestive of lobelia, with cornflower or love-in-a-mist (*Nigella damascena*) further back. Nemesia or brompton stock, often placed under windows so that their scent drifts indoors in the evening, are also possibly shown here. Monet's fuchsias flourish in the window boxes, and cushions of the Paris daisy or marguerite (*Chrysanthemum frutescens*), cultivated in gardens since 1699, appear near the blue and white Delft-style pots, brought outdoors for the summer, which Monet would later take to Vétheuil [30].

The flowers have as important a role as Jean. As in Monet's *The Artist's Garden at Argenteuil*, painted at the Maison Aubry the same year, there is a palpable sense of horticultural pride. Monet's signature is suggestively positioned just below a flowering cactus (*Epiphyllum*, probably the type today called *Nopalxochia ackermannii*)

whose flamboyant red blooms had caused a sensation when it was introduced from Mexico in the early nineteenth century.[4] The pot at the left holds another exotic, its form suggestive of a *Dracaena fragrans*. Monet's pictures were selling well, and his floral paradise bears witness to his aspirations to the bourgeois good life. His imagery is not, in fact, as removed from wider events as might at first be assumed. Both gardens and children were favoured emblems of the renewal of the nation for which the French so longed after their defeat in the Franco-Prussian War.[5] It was in the summer of 1873, even as Monet must have been painting this work, that his enthusiastic response to the call by the Republican writer Paul Alexis for an association of independent artists launched what he and his colleagues hoped would be the renewal of French art – the first Impressionist group exhibition, held the following year.

1. Washington/Hartford 2000, p.88.
2. Michelet 1985, p.428.
3. w.1, p.83, note 592; Michelet 1987, p.393; see also Willsdon 2004, p.142 and pp.145–6.
4. See P.V. Heath, 'The Strange and Curious Tale of the True and False Epiphyllum ackermannii', in *Taxon*, vol.38, February 1989, pp.124–8.
5. Willsdon 2004, p.136.

19 Claude Monet 1840–1926
The Artist's Garden at Argenteuil (A Corner of the Garden with Dahlias), 1873

Oil on canvas 61 × 82.5cm
National Gallery of Art, Washington DC

During the 1860s, Monet lived variously in Paris, its suburbs, and Normandy, but on returning from refuge in London during the Franco-Prussian War and the Paris Commune of 1870–1, he settled with his wife and young son in the small town of Argenteuil near Paris. For the first time, he was able to cultivate on a sustained basis a garden of his own. *The Artist's Garden at Argenteuil* shows part of his extensive garden of around 2,000 square metres at the Maison Aubry, his first home in Argenteuil.[1] It is one of the earliest pictures in Impressionism to make a garden and its flowers the main subject, rather than a setting for figures.

The year 1873 was an extraordinary one for garden motifs in Monet's work at Argenteuil. He had begun to profit from sales to the Parisian dealer Durand-Ruel, and was literally ploughing back some of this money into his art. He completed some ten different known paintings showing his geraniums, nasturtiums, roses, pots of splendid fuchsias, and, not least, his dahlias, the principal motif of this painting, which portrays some of the splendid

double dahlias developed following the introduction from Mexico of the single variety at the Madrid royal botanic garden in 1789. The red flowers near the centre may be *Dahlia juarezii*, or one of its hybrids; this bright scarlet cactus dahlia had been developed from a tuber brought from Mexico to Holland and was first listed in 1864, launching a race of hybrids whose genetic legacy is still evident in cultivars today. Monet also includes several pinkish dahlias at the right of the border which, to judge from their size – confirmed by Renoir's famous portrait of Monet painting his dahlias [fig.19] – may even be the giant *Dahlia imperialis*. This had a large white nodding bloom with a tinge of red at its base, and had recently been brought to bloom in northern France.[2]

Although Delacroix had painted dahlias in still lifes, Monet now shows them firmly rooted in the soil, and thrusting vigorously skyward, so that light and atmosphere are as important as the flowers. The sun is lightly veiled by clouds, and since period maps suggest the neighbour's house in the background lay to the east or south-east,[3] it appears to be morning. The pools of shadow and light created by the relatively low sun suggest depth and distance, so that the eye moves from the carefully shaded foreground flowers, with their muted vibration of red petals against green leaves, through a crescendo of light, to the full display of the dahlia collection in all its late summer glory. The strolling couple, the neighbour's house, and the background fence and trees are subordinated to an unabashed celebration by Monet of his success in growing these gaudy flowers whose tones nonetheless so subtly harmonise.

Durand-Ruel quickly purchased the picture, and Renoir and Caillebotte subsequently painted evocative scenes of dahlias in their gardens [41]. Though exhibited in Paris and London, it was, interestingly, in Germany and Austria that *The Artist's Garden at Argenteuil* enjoyed its greatest success in Monet's lifetime, being shown in Berlin and Weimar in 1905, as well as in Vienna in 1910. Its botanical fireworks were perhaps remembered by the Berlin Impressionist Max Liebermann in planting and painting dazzling rows of tall flowers at Wannsee [94], as well as by Klimt in his *Italian Garden Landscape* [92]; Monet's art was described at the Vienna exhibition, together with work by Manet, as heralding the 'daring prospect of unsuspected possibilities' in painting.[4]

1. w.II, p.122; see also Walter 1966, p.335 and Philadelphia 1989, p.46.
2. See Carrière 1872, pp.170–1 and Willsdon 2004, p.21.
3. See fig.1 in Walter 1966 (derived from period cadastral maps of Argenteuil): Monet's second house lies south-west of his garden, and there is no

space for another house east or north of the garden.
4. '[dem] kühn entdeckten Ausblick auf ungeahnte Möglichkeiten', introduction, in Vienna 1910.

20 Paul Cézanne 1839–1906
The Pool at the Jas de Bouffan, c.1876

Oil on canvas 46 × 55cm
Sheffield Galleries & Museums Trust

Although Cézanne was to make his parents' estate at the Jas de Bouffan near Aix-en-Provence the subject of a series of paintings in the 1880s, this picture is one of a small group dating from his occasional visits there in the previous decade. This was a period of fraught relationships between the artist and his father, because of Cezanne's affair with Hortense Fiquet who had borne him a child in 1872.[1] It is one of the very few of Cézanne's garden paintings to include flowers. Although its foreground shows the formal pool which, like its avenue of horse chestnut trees, was one of the characteristic features of the Jas de Bouffan, the picture gives no indication of the square shape of this pool, nor its ornamental statues of dolphins and lions, that form structural elements in some of Cézanne's later views. Instead, the brightly sunlit edge of the pool reads in almost two-dimensional terms, as a plinth or support for the pink-flowered shrub and the spreading tree whose trunk so boldly bisects the upper two-thirds of the painting. The reflections of greenery in the pool itself, meanwhile, make it seem as if it is another strip of grass like that just beyond the shrub and trees.

Intriguingly, the shrub's pink flowers are not actually reflected in the pool's still, glassy surface, even though its foliage appears there in blurred, fluid brushwork which contrasts with the block-like strokes composing it in its real form beside the pool. The shrub thus appears as if it is an integral part of the countryside scene beyond the pool, its pink flowers linking visually with the bright corn ripening in the sunshine, which is also painted in firm, squarish strokes. During the 1870s, Cézanne was painting mainly with Pissarro at Pontoise, and in close touch with the group of artists around him who sympathised with the utopian socialist Pierre-Joseph Proudhon's ideals. Although the picture can be read on one level as an almost abstract composition of contrasted horizontals, verticals, and colour-zones, the way the garden's rich, mature growth merges seamlessly with that of the Provençal countryside surely also provides a reminiscence – even if only a subconscious one – of Proudhon's dream of the whole of France as a 'vast garden', where its people might enjoy a more perfect existence.[2]

1. See Edinburgh 1990, p.89.
2. Proudhon 1939, p.218; see also Willsdon 2004, p.60.

21 Pierre-Auguste Renoir
1841–1919
Woman with Parasol in a Garden, 1875–6

Oil on canvas 54.5 × 65cm
Museo Thyssen-Bornemisza, Madrid

'Painting flowers relaxes my mind … I arrange colours, I try out tonal relationships boldly, without being afraid of spoiling a picture … And the experience I gain from these experiments, I apply then to my major paintings. Landscape is also useful for a figure painter. The open air leads you to put on the canvas colours you would never imagine in the subdued light of the studio.'[1] Renoir made these comments to his friend Georges Rivière whilst painting a vase of roses, but they are also relevant to *Woman with Parasol in a Garden*. This painting's real protagonists are not the woman and the bending, straw-hatted gardener beside her, but the flowers which seem almost to explode across the foreground like fireworks. Both the woman in her dark dress and the gardener, by contrast, read visually as parts of the overgrown hedge or pergola in the middle distance, whilst the parasol frames the woman's face like some floral corolla. Touches of blue on the hedge – some of the 'colours you would never imagine in the subdued light of the studio' – evoke the shimmer of glossy leaves, but also echo the blue of the gardener's shirt and nearby flowers, further integrating figures and garden. And in turn, the painted and the real world connect, as the flowers – and their scent – reach towards us, anticipating Renoir's later comment that a picture should 'seize you, enfold you, carry you away'.[2]

The location of the garden is not recorded. However, its exuberant profusion, to which the gardener's labours are so palpably unequal, is reminiscent of that of Le Paradou in Zola's *La Faute de l'Abbé Mouret*, and although traditionally dated to 1873, the painting is now thought to represent the semi-wild garden of 12 rue Cortot in Montmartre, where Renoir stayed in 1876 when painting his *Ball at the Moulin de la Galette* (Musée d'Orsay, Paris). Renoir later compared this garden to Le Paradou, and Rivière certainly called it 'a beautiful abandoned park', recollecting that 'Once you had passed through the narrow corridor of the little house, you found yourself before a vast, uncultivated lawn strewn with poppies, convolvulus and daisies … We were enchanted.'[3]

Rivière's use of the word 'enchanted' here is surely significant. As well as poppies, daisies and convolvulus, the painting includes blue and lilac flowers, suggestive of cornflowers and irises. By weaving through the garden the colour of the sky – the traditional place of dreams and longing – these flowers lend the picture a decorative, even visionary character. It is as though Renoir updates the medieval *Lady with the Unicorn* tapestries with their *mille-fleur* (flower-dotted) grounds, thereby creating something far more than a mere experiment with colour. He was, in fact, strongly interested at this period in mural decoration. He proposed that his *Ball at the Moulin de la Galette* might serve as a mural for one of the new public buildings of Paris, and wrote in 1877 both of 'multicolour' as the essence of Delacroix's murals, and of decorative painting as a vital antidote to the geometric 'regularity' he so deplored in modern architecture.[4] *Woman with Parasol in a Garden* is surely an expression of these views, an inherently decorative painting, celebrating nature's irregularity. In this sense, its vibrant flowers amidst the lush green grass look directly forward to the association of gardens and decoration in Monet's water lily murals with their glowing notes of floral colour, as well as to Klimt's flower-filled peasant gardens, and the paintings of Van Rysselberghe and Le Sidaner with their pointillist colour dots [75, 97].

1. Cited in Rivière 1921, p.81; see also London/Ottawa/Philadelphia 2007, p.180.
2. Cited in Rewald 1973, p.582.
3. See London/Ottawa/Philadelphia 2007, pp.176–81; Rivière 1921, p.130.
4. P.-A. Renoir, 'Decorative and Contemporary Art', in Herbert 2000, pp.95–6. For his ideal of 'irregularity', see 'Grammar 1883–4', in Herbert 2000, pp.139–41; see also Willsdon 2004, pp.163–5, and Willsdon 2008, pp.114–15.

22 Joseph Bail 1862–1921
The Artist's Sister in her Garden, 1880

Oil on canvas 190 × 137cm
Musée des Beaux-Arts, Lyons

Joseph Bail came from an artistic family – both his father Antoine and his brother Franck were also painters – and is clearly captivated here by the brilliant floral colour of a garden in the sun. A bright blue parasol, which itself seems almost like a giant flower as it frames the face of his thirteen-year-old sister Claudine (known as Amélie), complements the vivid red of oriental poppies and the bold yellow of a potted shrub (perhaps mimosa, a large *Calceolaria* or woody chrysanthemum). The composition thus concentrates on the three primary colours. A taller yellow-flowered bush which may be mimosa

reaches up to the light near the garden wall, and other flowers in tubs and beds create a decorative band of varied forms and colours. Foreshortened into abstract shapes by the high sun, the shadows trace luminous patches in the foreground, and the silhouetted trellis with its flowers suggestive of honeysuckle leads the eye to the pattern of diagonals and diamonds formed by the background buildings.

The garden portrayed still exists, at the seventeenth-century house in avenue du Maréchal Foch at Bois-le-Roi near Fontainbleau in the Valmondois, where Bail's family spent the summers from 1875 (the house in the background belonged to a neighbour). With its splendid display of cultivated flowers, and prominent signs of domesticity – ornamental bench, small table, and ironwork suggestive of a water-pump – *The Artist's Sister in her Garden* provides a telling example of the shift by the age of Impressionism from the Barbizon painters' interest in the Fontainebleau region as a source of Romantic forest motifs to its attraction as a place of *bourgeois villégiature* (summer holiday residence). Daubigny had painted the trees and clearings of the Valmondois; Bail now celebrates the taste for cultivated, ornamental nature which the great horticultural movement had engendered in nineteenth-century France, and which the Impressionists had made a subject for art. However, he remained close in family terms to earlier traditions, as in 1889 his sister Amélie was to marry the painter Emile Boulard, whose father had been an intimate of the famous Barbizon artist Jules Dupré.[1]

1. Information on the house at Bois-le-Roi and Bail's family generously provided by Mme Brigitte Potiez-Stoh.

23 James Tissot 1836–1902
Holyday, c.1876

Oil on canvas 76.2 × 99.4cm
Tate, London

The French artist Tissot painted *Holyday* in the garden of his mansion at 17 Grove End Road in London's St John's Wood. It was here, that Edmond de Goncourt sniffily, that 'a footman in silk stockings' could be seen 'all day long … brushing and shining the shrubbery leaves'.[1] If such artifice, like Tissot's polished style, seems out of keeping with Impressionist gardens, it is worth noting that Monet asked his gardeners at Giverny to dust his lily pads to maintain their freshness, and that De Goncourt's friend Degas had in 1874 viewed Tissot's work as essential to the first Impressionist group exhibition: 'Look here, my dear Tissot, no hesitations, no escape. You positively must exhibit at the Boulevard …

Be of your country and with your friends'.[2]

Though Tissot declined Degas's appeal – he had patronage enough in Britain *Holyday* is a reminder that he did not forget his native country. Its picnic takes place beside the pool and the colonnade he had built at Grove End Road in imitation of the famous eighteenth-century *naumachie* (pond for mock water-battles) in the Parc Monceau in Paris. Curtained by yellowing chestnut leaves, and reflected in the pool's shaded surface, the colonnade contrasts wittily with the massive chestnut trunks, yet provides sufficient cover for a game of hide and seek by two of the picnickers.

Holyday belongs to a group of Tissot's works of the 1870s which feature his Parc Monceau pastiche. Its fresh complexioned female models flirt and share tea with manly cricketers from the nearby I Zingari club, recognisable by their banded caps. This evocation of robust good health may have been intended to complement Tissot's *The Convalescent* of around 1875 (Sheffield Galleries & Museums Trust), in which a frail young woman rests on a chaise longue by the pool. The word 'holy', present in the title's archaic spelling of 'holiday', derives from old English for 'health'.[3]

Memories of the Parc Monceau, and health-giving horticulture, are particularly suggestive in relation both to France in the 1870s and Tissot's personal position, as he had come to London to escape recrimination for his participation in the Paris Commune. By recreating part of the most elite park in Paris, he could flatter his visitors, but also rediscover life as it had been before the horrific *semaine sanglante* (Bloody Week) of May 1871, when government troops had staged mass executions of Communards in the Parc Monceau, which was close to Tissot's Paris home and a key Commune base. The vision of health in *Holyday* in this sense complements the enthusiasm in 1870s France for gardens as emblems of national renewal.[4]

Yet for all its pleasures – open air, refreshing tea, sportsmen relaxing – *Holyday* has an elegiac, even disturbing quality. Soon, the golden leaves will fall, and the pensive nature of the work is highlighted by the young woman at the foreground right and the elderly chaperone at the left, lost in thought. On the tablecloth, as if in subliminal echo of *La Semaine sanglante*, seven knives point towards the reclining cricketer, whose face is so expressionless that his prone body seems uncannily reminiscent of the fallen victim of the Commune bloodshed whom Manet had famously sketched. A period reviewer certainly saw the picture's shaded pool as 'unhealthy looking', rather than health-giving, and Oscar Wilde criticised its 'over-dressed, common-looking people',

and 'ugly, painfully accurate representation of modern soda water bottles'.[5] However, it was Tissot's very readiness to 'address … the artistic problems of modern life and our artificial society' that, for the sympathetic critic Frederick Wedmore, made his work inherently 'Impressionist'.[6]

1. De Goncourt, *Journal*, entry for 3 November 1874, as translated in Matyjaszkiewicz 1984, p.14.
2. Degas, letter to Tissot, 1874, in Harrison/Wood/Gaiger 2003, p.571.
3. Matyjaszkiewicz 1984, p.117; *Encyclopaedia Britannica*, Cambridge 1911, vol.13, p.620.
4. Boime 1995, p.96; Willsdon 2004, pp.136–7.
5. Matyjaszkiewicz 1984, p.98.
6. F. Wedmore, *The Standard*, 1 July 1882, as given in Denvir 1987, p.135.

24 Marie Bracquemond
1840–1916
On the Terrace at Sèvres, 1880

Oil on canvas 88 × 115cm
Association des Amis du Petit Palais, Geneva

Marie Bracquemond recalled crushing wild flowers to create the pigments for her very first painting, a childhood present for her mother's birthday.[1] She later became a pupil of Ingres, before turning to Impressionism in the 1870s. *On the Terrace at Sèvres* shows her sister Louise Quiveron, the model for both women in the painting, with an unidentified man at Bracquemond's home, the Villa Brancas near Sèvres, which was described by her friend the writer Gustave Geffroy as 'like a forest hermitage, built on the slope of Saint-Cloud park, with its garden of shrubs, flowers, rocks and ivy'.[2]

The picture is one of several in which Bracquemond used her garden to study dappled sunshine on light-coloured costumes and it was shown at the 1880 Impressionist exhibition. However, it still retains something of the symbolic approach of the ceramic designs showing the 'Muses of the Arts' which she had submitted to the Impressionist exhibition of the previous year. The veil covering the eyes of the figure on the left brings to mind the blindfold worn by personifications of Justice, and the closed parasol echoes the shape of Justice's sword. The figure on the right wears a white dress, a traditional symbol of innocence, on which is pinned a white rose – an emblem both of innocence and silence.[3]

Justice protects the innocent and in the brave new world of the Republican regime which had come to power in France in 1879, Justice was also a rallying call. Georges Clemenceau (later French premier) launched his famous newspaper *La Justice* in 1880, the year this work was painted, and Geffroy, who wrote for it, was

dubbed 'the just man of *La Justice*'. In this context, the reading lorgnette held by the veiled figure might even be viewed as a modern substitute for Justice's traditional pair of scales; the new Republican regime had ended press censorship, making reading the papers again a means to weigh opinions.

What Geffroy called the picture's 'afternoon sun and its fiery effects'[4] are also suggestive. The sun was a traditional Republican emblem, and as leader of a secret Republican society in the 1860s, Bracquemond's husband Félix had portrayed it on his 'Republican plate', a piece of symbolic tableware.[5] Now Marie deployed her new Impressionist technique to evoke the light of the sun at its afternoon hottest, so that, in Geffroy's words, '....The white dress … is golden and bluish-coloured, the pink dress is in some places muted and in others glowing; the face of the fair-haired woman is circled with light, the atmosphere of the landscape colours … [the] faces'.[6] Yet although this play of colours intimately connects Justice and Silence/Innocence, the figures remain psychologically separate, as if to point up the Republican ideal of individual liberty. The man appears at peace with himself, sitting back with a cigarette. Justice is thoughtful but erect, knowing her mind. Silence/Innocence seems undecided, head bowed, fingering her floral scarf. Have they been debating the innocence of the artist's eye? Félix Bracquemond opposed Impressionism and discussions on art at the Villa Brancas were often heated.[7] Are they perhaps reflecting on the loss of Alsace-Lorraine to Germany, whose poignant tenth anniversary fell in 1880? Desire for *Revanche* (revenge) – 'always think about it, never speak of it', as the Republican politician Gambetta, much admired by Félix, had said – was the 'silent' issue which perhaps most deeply underscored the quest for justice in late nineteenth-century France.[8] Marie's exact intentions may never be known, but in this painting the Impressionist garden is possibly a venue for meditation on contemporary ideas and conflicts, whether artistic, political or private.

1. Bouillon/Kane 1984–5, p.21.
2. Paris 1919, p.7.
3. See 'Les Couleurs', in A. Alciato, *Emblèmes*, 1549, at http://www.emblems.arts.gla.ac.uk/french/emblem.php?id+FALb110, and Willsdon 2004, p.135.
4. Paris 1919, p.4.
5. See J.-P. Bouillon, '"A Gauche": note sur la Société du Jing-Lar et sa signification', *Gazette des beaux-arts*, sér. 6, March 1978, p.108, and Boime 1995, p.13.
6. Paris 1919, pp.4–5.
7. Bouillon/Kane 1984–5, p.25.
8. See Thomson 2004, pp.185ff.

25 Henri Fantin-Latour 1836–1904
Nasturtiums, 1880

Oil on canvas 62.8 × 42.5cm
Victoria & Albert Museum, London

Though he kept a fine garden at Buré in the Orne, Fantin-Latour is thought of as the colleague of the Impressionists who painted cut, not living flowers, and choice roses rather than rustic nasturtiums – even if, as here, the latter are of a fancy double variety. In this intriguing picture, however, Fantin-Latour creates his own distinctive version of the Impressionist garden. The flowers, staked to slender canes, are growing vigorously, and are almost certainly rooted in a pot which the artist has brought indoors to paint, as he found outdoor lighting too variable. They are a portable garden in miniature, the exuberant growth entwined around the stakes encapsulating the quintessential character of horticulture as the marriage of nature's freedom and human intervention.

The apparent simplicity of a plant before a grey background does not prevent him from vividly evoking the 'secret life' of flowers, the source of their 'fragile changing beauty'.[1] Large mature leaves contrast with smaller, young ones; stems reach irregularly outwards and upwards; and the orange flowers themselves, living up to the nineteenth-century belief that nasturtiums contained phosphorus and were therefore 'luminous',[2] spark like bursts of orange fire amidst the green leaves and stems. Except for its medium, the picture could illustrate exactly the discoveries made by the critic Philippe Burty, an early supporter of the Impressionists, on his first day as a pupil in the class of the Lyons flower painter Pierre Chabal-Dussurgey:

He gave us a piece of charcoal and asked us to copy a simple nasturtium flower. We thought that insultingly easy. But when, seating himself among us, M. Chabal made us see that the petals were inserted as precisely as the limbs of a human body; that there was foreshortening as daring and difficult to paint as that of the arm and leg seen in perspective; that the masses of shadows were opposed to masses of light, attenuating details without suppressing them; that the density emphasized or reduced the form defined by the silhouette; that, lastly, a flower had its figure, grace, strength, and personality just as a living being; we understood then that art did not consist only in a vulgar exercise of the eye and the hand, but in an awakening of the more subtle qualities of attention and judgement.[3]

Because of the complex structure of their hood-like flowers, nasturtiums were a popular training subject for nineteenth-century flower painters, and *Nasturtiums* was purchased in 1884 by the South Kensington Museum in London as a model for its design school students. The elegance of Fantin-Latour's composition, with its linear stems and stakes complementing the flat leaf-shapes and fragile flower-clusters, anticipates the interest in decorative qualities which comes to the fore in the late Impressionist garden. In this sense, the picture relates to Armand Guillaumin's *The Nasturtium Path* [26], and its direct heirs are the murals showing nasturtiums climbing on a plain wall which Gustave Caillebotte created in 1892 for his home at Petit-Gennevilliers [39], Monet's paintings of his flower-strewn garden path at Giverny, and Henri Le Sidaner's *The Rose Pavilion, Gerberoy* [97].

1. Paris/Ottawa 1982–3, p.269.
2. Fleurs Lumineuses 1861, p.96.
3. P. Burty, 'Études et compositions de fleurs et de fruits', in *Gazette des beaux-arts*, vol.24, 1868, pp.102–3; partly translated in New York 1994, p.160.

26 Armand Guillaumin 1841–1927
The Nasturtium Path, 1880

Oil on canvas 79.5 × 63.5cm
Ny Carlsberg Glyptotek, Copenhagen

If Degas had had his way, the French Impressionists might be known as the 'Nasturtiums', and this picture would be their 'portrait'. For he proposed the brilliant orange flower as an emblem on the posters for the artists' first group exhibition in 1874, to be held at the Boulevard des Capucines in Paris which takes its name from the Capuchin monks.[1] Shaped like a monk's hood, the nasturtium is called *la capucine* in French. In the event, the Impressionists simply named themselves the 'Anonymous Society of Painters, Sculptors and Engravers … ', but in its day such a colourful image as *The Nasturtium Path* would still undoubtedly have seemed the essence of their art, both to its critics and supporters.[2] Guillaumin, a railway clerk and lover of the poetry of Baudelaire, contributed to six of the eight Impressionist exhibitions, and was described as the most *impressionist* of the group – even 'an extra-impressionist' – because of his high-keyed palette: 'M. Guillaumin gives us, with a great quantity of blue, red and green, a series of pictures as impressionist as possible', wrote one critic in 1880, whilst Félix Fénéon, in an 1886 review of the Impressionists, praised 'this furious colourist, this fine painter of landscapes bursting with vigour and panting for breath'.[3]

The Nasturtium Path has the most unsophisticated of motifs – a cottage garden with orange nasturtiums which climb so high on their stakes that those at the left vibrate against the calm blue sky, whilst those at the right seem like flames before the shadowed wall and partly-shaded path. Nasturtiums were believed by nineteenth-century scientists actually to emit light when in shadow[4]; unlike Fantin-Latour who also revelled in their brilliance, Guillaumin does not concern himself with the structure of their individual florets. Instead he uses tactile brushwork, and the way reds and oranges leap forward, to evoke the nasturtiums' ebullient growth, which repeats the vertical accents of the tree and chimney. Some of the flowers cluster together; others are orange dots or spots amidst the soft green leaves. The result is an almost decorative image which seems to anticipate the precept of the artist James McNeill Whistler, a friend of Fantin-Latour, that the true artist 'looks at [nature's] flower, not with the enlarging lens, that he may gather facts for the botanist, but with the light of one who sees in her choice selection of brilliant tones and delicate tints, suggestions for future harmonies'.[5]

Guillaumin's picture is, however, clearly more than just a study, or an artful arrangement of colours. Left-wing in politics, he had been one of the group around Pissarro at Pontoise who admired the socialist philosopher Proudhon, and something of Proudhon's utopian vision of 'the whole of France' as a 'vast garden'[6] in turn seems to resonate in the rural rusticity of *The Nasturtium Path*, which is thought to show a garden in the Ile-de-France. It is fitting that the picture's first owner was Gauguin, who used colours still more burningly intense in his Edenic vision of Tahiti.

1. Rivière 1921, p.44.
2. Cf. Munk 1993, p.26.
3. G. Japy, 'Les Impressionistes', in *Le Soir*, 3 April 1880, in Berson 1996, vol.1, p.294; P. de Charry, 'Le Salon de 1880: Préface: Les Impressionistes', in *Le Pays*, 10 April 1880, in Berson 1996, p.273; F. Fénéon, 'Les Impressionistes', in *La Vogue*, 13–20 June 1886, in Berson, p. 443.
4. See catalogue entry for Fantin-Latour's *Nasturtiums* [25], note 2.
5. J. McNeill Whistler, 'The Ten o'Clock Lecture', 1885 (first published in French in 1888), in Harrison/Wood/Gaiger 2003, p.842.
6. Proudhon 1939, p.281.

27 Odoardo Borrani 1833–1905
Girls Winding Wool, c.1880

Oil on canvas 68 × 45.5cm
Galleria Nazionale d'Arte Moderna, Rome

A close friend of Signorini [36], Borrani was one of the Macchiaioli – the Italian proto-Impressionists – who emerged in Florence in the 1850s and 60s, and with whom Degas associated in his early career. This striking scene of a corner of a modest urban garden develops the Macchiaioli idiom of contrasted tonal patches into a highly sophisticated harmony of partial

shade and pockets of sunlight, a reminder of the interest taken by these artists in the work of Corot. The strong Italian sunshine is reflected by the plastered walls of the houses, and picks out the brilliant reds of the blouse of the girl at the right and the flowers at the left. But if the composition is boldly divided in two by the nearest house and the garden path, the skein of wool caught in the light cleverly reunites the halves.

This unity is surely significant. Like Signorini, Borrani had fought in the Tuscan artillery during the struggle for a united Italy; now, a decade after the unification, his picture offers a quiet domestic sequel to the emotive scenes of a woman sewing the tricolour of united Italy, and women making the red shirts worn by Garibaldi's supporters, which he had painted earlier.[1] The green foliage of the pot plants taken outdoors for the summer, the red blouse and flowers, and the creamy-white walls, wool and apron inscribe the Italian tri-colour into the very substance of the scene. Even the garden growth appears symbolic, for whilst the red flowers to the left may belong to a begonia (perhaps *Begonia coccinea*), the distinctive heart-shaped leaves of aroids are much in evidence, a reminder that there is a native Italian form of aroid (*Arum italicum*), which bears fruit as red as a Garibaldi shirt. The plant in the pot just above the seated girl's head is perhaps *Zantedeschia aethiopica* (a common ornamental aroid); the red flowers to its left suggest Calla lilies, another form of *Zantedeschia*, and further aroid leaves appear in the unfinished foreground area. Erect and stately, the girl in the red blouse at the right is almost like an *Arum italicum* herself, her red blouse its fruit.

The arum was certainly a traditional symbol of purity, and if Borrani's composi-tion brings to mind the bi-partite structure of a Renaissance Annunciation painting (he started his career as an assistant to a restorer of early Italian frescoes), he surely invites us to see the domestic garden as an emblem of a new, purified nation, reaching to the light. The sunflowers behind the girl in red, and the morning glory wound as tightly round the canes at the left, as the wool in its ball, have yet to flower, but are already tall and vigorous. The motif of winding wool plays on the traditional association of femininity and touch, and also perhaps evokes the ancient metaphor of the 'thread of time'.[2] Borrani's Italian Impressionism implicitly puts the girls in their garden at the heart of his young growing nation.

1. *The 26th April 1859*, 1861, Private Collection, Milan; *The Seamstresses of the Red Shirts*, 1863, Piero Dini Collection, Montecatini.
2. For these associations, see Classen 1998, pp.92–9.

28 Filippo Palizzi 1818–1899
The Roses of my Terrace, 1881

Oil on canvas 83 × 60cm
Galleria Nazionale d'Arte Moderna, Rome

Gone are the swashbuckling Garibaldian images of Palizzi's earlier years, and his Italian answer to French Barbizon art in *Orange Tree and Women*; instead, the artist here is quietly at home in old age in Naples, painting one of the last *all'aperto* (open-air) studies of his career.[1] His flower-decked garden terrace is all he now needs to capture his effects of light and shadow which had earlier proved so important in the evolution of Italian Macchiaioli painting. The low viewpoint plays off the intricate, organic forms of the rose bushes against the sunlit geometry of the buildings glimpsed beyond, the ordered sequence of the earthen flower pots, and the plain stone wall on which they stand. The intimacy of the picture, evoking domestic relaxation, and celebrating flowers which Palizzi has presumably himself grown, is very different from the working orchard where women pick fruit in *Orange Tree and Women*, yet Palizzi's obvious delight in the delicacy of his roses against the luminous sky, lightly flecked with summer clouds, is perhaps not without a certain proud nod to Naples's historic claim to be the most beautiful site in Italy. Already in the fourteenth century Robert of Anjou had complemented its natural beauty with his famous royal gardens around the Bay of Naples, and one of the earliest public gardens in Europe had been laid out in the city in 1780. Roses, as the flower of the classical goddess Venus, are intimately associated with Italy, as affirmed in Johann Strauss II's celebrated waltz 'Roses from the South', which was composed soon after Palizzi's picture.

1. See Majo/Lanfranconi 2006, p.197.

29 Berthe Morisot 1841–1895
Child amongst the Hollyhocks, 1881

Oil on canvas 50.5 × 42.6cm
Wallraf-Richartz Museum & Fondation Corboud, Cologne

This most evocative example of the Impressionists' love of light and air shows Morisot's daughter Julie in the garden of the family holiday house at Bougival on the Seine. It was displayed at the Impressionists' 1884 exhibition, and was so admired by their dealer Paul Durand-Ruel that he hung it in his office when he later became its owner. Here in 1892, the critic Georges Lecomte was enraptured by its 'joyous brightness', describing how:
A fair-haired child dressed in pale blue is pulling a miniscule cart and horse along the garden paths. Playful trees, spirited plant-growth, and entanglements of stems, creepers and branches tower above the small toddler and her little toys. The sun darts across the child's skin and dress and the mass of delicate greenery, pale pinks, burgeoning forms, mauve corollas, violet campanulas. Beyond the green fence enclosing the garden appear the first houses of a village, red roofs amidst the trees …[1]

Despite the apparent spontaneity of Morisot's brushwork, the picture is composed with much sophistication, and was developed from preparatory sketches of Julie, Morisot's daughter, with her cart. The fence cutting across the canvas pushes Julie's world of fantasy and flowers into the foreground, heightening its contrast with the adult world of work represented by the line of washing at the foot of the steps, and making us sense the soft summer breeze, translucent petals and roughly-textured gate-post with all the vivid immediacy of a child's perception. The dappled sunshine links Julie in her light blue dress with the pale flowers, luminous sky and white washing, so that fantasy and reality merge in a larger, decorative harmony.

If Morisot makes us rediscover child-hood, Julie's self-assurance looks subtly forward to adulthood. The way she plays so independently, without sign of parental direction, corresponds very closely with the progressive educationist Friedrich Froebel's ideal of the 'child-garden', in which the child learns and matures through playing on its own in the natural world. Froebel's ideas had been promoted in France by the writer Jules Michelet, whose work was much admired in Impressionist circles.[2] As an adult, Julie was intriguingly to relive her childhood when she visited Bougival soon after her marriage and met M. Clouet, the gardener who had grown the hollyhocks in *Child amongst the Hollyhocks*, and remembered her infant games. His father had gardened for the Russian writer Ivan Turgenev, who spent his last years at Bougival.[3] It is likely that this painting shows some of the modern florists' hollyhocks with double blooms and subtle colours which were proudly cultivated in the nineteenth century by professional gar-deners such as the Clouets. With its fluvial soil, the Bougival area was certainly noted for its plant nurseries. Though Morisot dissolves parts of the garden in a flurry of evocative brushstrokes, just as she blurs the boundaries of childhood and adulthood, it was in this sense as fully up-to-date as Julie's Froebelian play.

1. Lecomte, 1892, pp.107–8; see also Lille/Martigny 2002, p.220.
2. See, for example, 'L'Evangile de Froebel', in *Nos Fils* in Michelet 1987, pp.454–7, also Willsdon 2004, p.145.
3. See M. and E. Houth, *Bougival et les rives de la Seine*, Saint-Germain-en-Laye 1970, p.149.

30 Claude Monet 1840–1926
The Garden at Vétheuil, 1881

Oil on canvas 60 × 73cm
Private Collection

With its sheaf of stakes like those used for peas or beans, this view of Monet's garden at Vétheuil is a reminder of the practical aspects of gardening. Intriguingly, however, Monet does not show the stakes in use; instead, picked out by the sunshine, they form a bold pictorial accent, repeating the diagonal of the tree on which they rest, and balancing that of the apple trees at the left. Cutting through the foreground, they make Monet's house, at the top right, appear the more distant; it was already separated from his garden by the Vétheuil road.

As they were in debt, the Monets had moved to rural Vétheuil, which was seventy kilometres north-west of Paris, in the summer of 1878. Vétheuil was cheaper than Argenteuil, their previous home, and they shared it with the family of Monet's former patron Ernest Hoschedé, himself on hard times. As the afternoon or evening sunlight casts a network of shadows over grass and path in this work, it is possible to imagine Monet returning from a day spent painting on the river, for his Vétheuil garden led down to the Seine. Patterns of light and shadow catch his eye as his Delft-style pots shimmer in the sun along the lowest terrace, and the sunlit steps form a vertical shaft of brightness, already predicting the 'path of light' effect in his water lily scenes [78, 80]. These are the steps Monet was to show flanked by giant sunflowers in four later paintings of 1881, but no sunflowers are evident in *The Garden at Vétheuil*, although accents of red suggest his gladioli and nasturtiums.

As Durand-Ruel purchased *The Garden at Vétheuil* in April 1881, Monet probably began work on it in summer 1880, or per-haps even earlier when the ill-health of his first wife Camille, who died in September 1879, had caused him to seek subjects close to home. The layered, multiple touches of paint certainly suggest the picture was developed over time, as if to gainsay the criticisms of haste levelled at him in 1879 and 1880 by the writer Emile Zola.[1] The solitude of the scene – empty of figures, despite the large household – creates an almost elegiac, meditative mood, as the shadows lengthen and the stakes await a purpose. Monet was, of course, looking up to the house where Camille had so recently died and was perhaps still suffering even as he began the picture. The remoteness of the house, partly veiled by the apple tree, is in this sense psychological. Monet's thoughts must in fact have been as complex as the play of sun and shadow for by 1881 he was growing ever closer to Alice Hoschedé,

his eventual second wife. At Giverny, the critics were to see the artist's mood and character reflected in the garden,[2] but in *The Garden at Vétheuil* this was perhaps already so.

1. See Wildenstein 1996, vol.1, p.160.
2. See, for example, A. Alexandre, 'Le Jardin de Monet', in *Le Figaro*, 9 August 1901.

31 Berthe Morisot 1841–1895
A Woman and Child in a Garden, *c.*1883–4

Oil on canvas 60 × 73.4cm
National Gallery of Scotland, Edinburgh

What is to be made of this unfinished picture? The composition, bisected by tree trunks, is awkward and unresolved; the draughtsmanship tentative, even ambiguous, and the light strangely bleached. If it is only possible in consequence to speculate on Morisot's intentions, there are, nonetheless, perhaps sufficient clues from wider contexts to suggest that this is one of the most personal demonstrations of the Impressionist garden as a place of emotional engagement.

Some things are certain: the garden is at the summer villa at Bougival owned by the Morisots; the woman sewing is Morisot's niece Paule Gobillard; and the little girl sailing a toy boat on the ornamental pond is Morisot's daughter Julie. Compared with a slightly earlier painting by Morisot of Julie with a boat in the Bougival garden, however,[1] there are startling differences. In the earlier picture, Julie is accompanied by her father, squatting at her level, empathising with her play, but in *A Woman and Child in a Garden* the figures seem estranged. Julie turns her back, as if to shun her cousin's feminine sewing for what, in the nineteenth century, was regarded as a boy's recreation. Girls played with dolls – virtually their sole toy according to the Larousse Dictionary – not boats.[2] Julie's pose, moreover, exactly echoes that of the girl in *The Railway* by her paternal uncle, Edouard Manet. Just as Manet's girl gazes at the white steam of a passing train – a marvel of the masculine world of technology – so Julie is captivated by the white sails of her boy's toy. The thought arises that the figure may perhaps represent Morisot herself, who, as a female painter, challenged nineteenth-century gender stereotypes.

Julie's apparently unwavering gaze certainly brings to mind the comparison by the great friend of both Manet and Morisot, the poet Stéphane Mallarmé, between a child's way of seeing, unencumbered by adult preconceptions, and that of the Impressionists in general.[3] The French word for sails is *toile* – the word also used

for an artist's canvas. Mallarmé famously described artistic freedom as the creative potential of blank white *toile*, and Julie was to recall a sailing trip when, asked if his boat had inspired any of his writings, he cast 'a glance at its sail' and said 'for once, I am leaving this great page white'.[4]

If the sails of Julie's boat are in this sense the unwritten pages of her future, it is only fitting that *A Woman and Child in a Garden* remained unfinished. Rather than white canvas, however, patches of brown undercoat are visible, from which, abandoning normal Impressionist practice for a traditional old-master method, Morisot has worked up to her lights and down to her darks. If she was pondering Julie's future, she was also looking to the past. With its dense foliage like that of a primeval wood, the garden itself seems a place where memory, dream and reality merge, as in the fantasy world of a child's imagination. In this sense, it was, perhaps, simply too poignant to complete. For, in a private moment, Morisot had regretted that Julie was 'not a boy. In the first place, because she looks like a boy; then, she would perpetuate a famous name'.[5] Julie's famous uncle Manet died the year Morisot began *A Woman and Child in a Garden*, and perhaps her failure to finish the picture, with its deep shadows, the boyish Julie, and the allusion to Manet's work was at some deep psychological level, a reflection of the pain of losing this closest of her friends. However, although it is possible to speculate that the picture's raw incompletion is, in effect, its very meaning, the fact of that incompletion ultimately frustrates a conclusive reading of her enigmatic imagery.

1. *Eugène Manet and his Daughter in the Garden*, 1883, Private Collection.
2. 'Jouet' in Larousse 1866–77, vol.9, p.1026.
3. Mallarmé 1876, p.97 ('a vision restored to its simplest perfection', i.e., a child's vision).
4. Julie Manet, *Journal*, entry for 11 September 1898, in Manet 1979, p.142; for Mallarmé's metaphor of the blank *toile*, see also his poem 'Salut' in L.J. Austin (introduction), *Stéphane Mallarmé Poésies*, Paris 1989, p.44.
5. Letter of 1879, in Morisot 1957, p.101.

32 Edouard Manet
The House at Rueil, 1882

Oil on canvas 92.8 × 73.5cm
National Gallery of Victoria, Melbourne

Two years before he died, Manet rented a villa at Rueil near Paris for a summer holiday. A letter to him from its landlord gives a poignant insight into the artist's declining state of health, as his motor ataxia, brought on by syphilis, made walking increasingly difficult: ' … the bath has been repaired during the past year and is in good condition. Furthermore,

there are still three wooden benches in the greenhouse, of which you may make use. I trust therefore that you will be satisfied on all points.'[1] Once settled at the villa, Manet made what he could of its tiny garden; a place where he might at least paint *en plein air* whilst resting his crippled leg, seated in the shade of an acacia tree.[2] His old friend the critic Théodore Duret, whom he had first met in Madrid in 1865, was deeply impressed by the results: 'he simply paints the house façade. It is banal, modern, foursquare, with grey shutters. He draws forth from this poor motif canvases which are luminous and seductive.'[3]

Although Duret does not mention the garden of the villa, it is, of course, the play of sunlight and shadow on greenery, tree and flowers which enlivens *The House at Rueil* and helps create its luminosity. The irregular branches and the foliage of the tree which so boldly bisects the composition, together with the thick grass, the rough texture of the tree trunk, and the lilac shadows on the path, offset the façade's stiff geometry and soften the starkness of its cream and orange paintwork. A wicker armchair under the tree invites the viewer to rest like Manet in the cooling shade.

Duret was not the only enthusiast for the works Manet painted in the Rueil garden, which included a horizontal version of *The House at Rueil*, a sketch of Berthe Morisot's daughter Julie sitting on a watering can, and studies of the garden path and its adjacent flowers and vegetation. *The House at Rueil* was quickly bought by the Paris Opéra singer Jean-Baptiste Faure, and then by the Hamburg collector Theodor Behrens, before eventually passing to the National Gallery of Victoria in 1927. Hugo von Tschudi, the francophile Director of the Berlin National Gallery, wrote in 1902 that there was 'no better example of the character of Manet's art',[4] whilst Max Liebermann took inspiration from Manet's horizontal version of the painting in his *Landhaus at Hilversum* of 1901 [fig.9]. Liebermann also acquired no fewer than five of Manet's late garden views, some painted at Rueil, and others in a villa garden at Bellevue in 1881.[5] This German enthusiasm can be set in the context of the 'Garden-Reform' movement in Germany, which treated house and garden as a unified whole, the one complementing the other – just as in *The House at Rueil* where Manet echoes the vertical of the column of the porch with that of the tree trunk, and makes the garden a room by setting a comfortable chair in it. Gardens, such as the one that Liebermann created from 1909 at Wannsee under the influence of the 'Garden-Reform' movement, were above all for living in, and Manet's *House at Rueil* already realised this ideal.

1. Letter from André Labiche to Manet, quoted in Tabarant 1947, p.450.
2. For the acacia tree, see Léon Leenhoff's *Carnet de notes*, Bibliothèque nationale Estampes, Fonds Moreau-Nélaton, cited in Paris 1983, p.496.
3. Duret 1902, p.156, quoted in Hamburg/Berlin 2004, p.35.
4. Tschudi, 1902, pp.34–5, quoted in Hamburg/Berlin 2004, p.35.
5. See Hamburg/Berlin 2004, pp. 34–7.

33 Henri Harpignies 1819–1916
The Painter's Garden at Saint-Privé, 1886

Oil on canvas 59.7 × 81.3cm
The National Gallery, London

The writer Anatole France called Harpignies 'the Michelangelo of trees'[1] – an allusion to the views of the forest of Fontainebleau for which, as a keen admirer of Corot and colleague of Daubigny, Harpignies was primarily known in his long life of ninety-seven years (he died in 1916). In *The Painter's Garden at Saint-Privé*, however, trees take a secondary place: it is the neat, flower-filled *corbeilles* (display beds) of the terraced garden of La Trémellerie, Harpignies's home at Saint-Privé near Fontainebleau, which fill the foreground. The early twentieth-century critic Léonce Bénédite left an evocative description of La Trémellerie which shows that its tidy garden was a direct complement to its interior:

that pretty manor-house … cheerful, airy, comely, all decorated inside with studies and photographs on crimson or faded pink walls, giving a picture of order and good upkeep … of the welcoming spirit of the master … in front, a flowerbed, this also well ordered, leading to a lawn, then, still rising, to a small wood, that wood where the artist found many of his favourite motifs …[2]

If Bénédite read Harpignies's character from his home and garden, the imagery in *The Painter's Garden at Saint-Privé* of nature ordered by human hand certainly parallels Harpignies's advice to a pupil the same year that the artist should beautify and select from nature: 'It is not enough to look at nature, to sit down before her, as people have told you, and to paint her … It must not be forgotten that we are dealing with a charming coquette who should not be clothed in ugly garments. Nor must it be forgotten that Lady Nature has no limits but our paper does'.[3] Just as standard roses and other flowers created focal points in the display beds at La Trémellerie – a horticultural practice introduced in the Paris parks, and in turn widely followed in private gardens – so *The Painter's Garden at Saint-Privé* is itself composed with an almost classical sense of balance, reflecting Harpignies's reverence for Italy. Two trees frame the composition, as in a view by

Claude, whilst the clouds decoratively echo the rounded shapes of the background trees, a reminder that Harpignies saw a necessary difference between a spontaneous sketch from nature and a finished work. Though this distinction was famously eroded by the Impressionists, by 1886 – the year of their final group exhibition – they too were increasingly using the studio to achieve what Pissarro called 'synthesis'.[4] In this sense, Harpignies's celebration of nature controlled twice over by the artist, both as gardener and as painter, was very much of its time.

1. Zola 2000, p.490.
2. L. Bénédite, 'Harpignies (1819–1916)', unsourced article in Harpignies file, Centre de Documentation, Musée d'Orsay, Paris.
3. Letter to 'Garcement', 23 May 1886, in 'Henri-Joseph Harpignies 1819–1916', in P. Miquel, *Le Paysage français au XIXe siècle 1824–1874. L'Ecole de la nature*, Paris 1975, p.766.
4. For Pissarro's 'synthesis' ideal, see London 1990, p.10.

34 Ernest Quost 1844–1931
Morning Flowers, c.1885

Oil on canvas 161 × 169cm
Musée municipal des Beaux-Arts, Bernay (Eure)

Though Ernest Quost is less familiar today than his Impressionist contemporaries, he won much acclaim at the turn of the century for his closely-observed yet poetic scenes of garden flowers. Taught by the flower painter Henri Aumont,[1] he was the nephew of a prominent horticulturalist in the Yonne, and himself kept a garden at his various homes in Montmartre; *Morning Flowers* probably shows one of these. He was advised by the painter Ernest Rouart to exhibit with the Impressionists, but although a 'fervent disciple of Corot, Chintreuil, Daubigny and Sisley',[2] he chose instead to show his work at the Paris Salon, first exhibiting there in 1866, and becoming Chevalier de la Légion d'Honneur in 1883 and Officier in 1903. In *Morning Flowers*, purchased by the French State at the 1885 Salon, we look through a screen of plants including morning glory, convolvulus and asters to the whitewashed wall of a house, reflecting the soft morning light. A pink rose opens its blooms beside a bench beneath the window, whilst a bird perched on the back of the bench, and another flying to join it, look enquiringly for crumbs, reinforcing the morning theme.

Quost's recorded description of how he came to paint garden rather than cut flowers is endearingly modest:

…up in my studio, under its zinc roof in the summer, it was unbearable, so I went down into the garden and, seeing that the flowers in their own environment were more beautiful than fading in a vase in my studio, I continued. Because I dedicated myself to nature, I passed for a revolutionary, but the contrary is true.[3]

Despite this avowed dedication to nature, Quost also said, however, that 'feeling must reinforce truth' – a credo which surely helps to explain Van Gogh's exclamation at the sight of a country garden, 'Ah, if only Quost was here!'[4] Van Gogh had met Quost at the shop of Père Tanguy who sold artists' materials, and he wrote admiringly of 'those magnificent, perfect hollyhocks of Quost, and his yellow irises'.[5] Although by 1888 Van Gogh's own vibrant colours were very different from what a reviewer had called the 'pearly' effect of *Morning Flowers*, 'veiled with dew and coloured with the most delicate and tender tints',[6] he clearly recognised Quost as a fellow contributor to the reshaping of Impressionism in more expressive directions. The evocative colour harmonies of *Morning Flowers* can in this sense perhaps be viewed as a pictorial equivalent to music, of which Quost was a keen lover, whilst the decorative effect of the picture's screen of flowers points to his commissions in the twentieth century for murals for buildings including the Ministry of Public Instruction in Paris and the French Embassy in Stockholm.

1. See 'Ernest Quost, "Le Vieux Jardinier"', in Talabardon et Gautier, *Le XIXe Siècle*, exh. cat., Paris 2009.
2. L. Vauxcelles, *Exposition de peintures et dessins de E. Quost*, exh. cat., Mercier Frères, Paris, June 1925.
3. E. Quost, *Notes inédits. Contour et forme. Discussion entre Carrier* [pseudonym for Quost] *et Gérard à l'atelier Fanelly*, quoted in 'Qui était Quost – Sa Place parmi ses contemporains – comment regarder un Quost', typescript in Musée d'Orsay, Paris, p.14.
4. E. Quost, 'La Fleur', *Académie des arts de la fleur et de la plante*, in *Moniteur du dessin*, as quoted in ibid., p.10b; Van Gogh, letter to Theo van Gogh, August 1888, as quoted in 'Qui était Quost … ' see note 3, p.3.
5. Ibid., comment by Van Gogh to Albert Aurier.
6. J. Noulens, *Artistes français et étrangers au Salon de 1885*, Paris 1885, as quoted in London/Boston 1995–6, p.160.

35 Charles Courtney Curran 1861–1942
Lotus Lilies, 1888

Oil on canvas 45.7 × 81.3cm
Terra Foundation for American Art, Daniel J. Terra Collection, Chicago

This spectacular picture of the American artist Curran's new bride Grace Winthrop Wickham, with her cousin Charlotte Taylor to the right, is not some imagined fantasy, despite the size and profusion of the flowers which surround their boat. For these are American lotus (*Nelumbo lutea*), flowers which are indeed luminescent yellow, twenty-five to thirty centimetres wide, with leaves up to sixty centimetres across, and stems capable of reaching ninety centimetres above the water. The effect of strong sunlight shining through the petals and catching the edge of the parasol is also clearly observed from nature in accordance with the Impressionist ideals which Curran had begun to absorb.

But can the estuary of Lake Erie in Ohio, where the scene is set, and where Grace's family had property, really be called a garden? Yes, when it is remembered that the ideal of the landscape itself as a garden – and gardens as forms of landscape – had become firmly established in North America, largely through the influence of the art critic and writer John Ruskin and the publication in 1841 of A. J. Downing's *Treatise on the Theory and Practice of Landscape Gardening*.[1] When French Impressionist paintings were shown by Durand-Ruel in 1886 in New York, while Curran was training there, it was Monet's views of poppy fields – nature as a garden – which thus attracted particular attention.[2] The way Curran echoes the shapes and colours of the lotus flowers and leaves in those of Grace's hat, her parasol, and the foreshortened boat, suggest he was perhaps in turn emulating the principle of repetition of forms which, according to the American critic Celin Sabbrin's major review of the 1886 exhibition, was evident in Monet's poppy landscapes.[3]

Curran's repeated forms celebrate Grace, who, haloed by her lotus-like hat and with her parasol shaped like a lotus leaf, becomes his saint or angel. Implicitly seated in the unseen portion of the boat, Curran breathes the sweet magnolia-like fragrance of the American lotuses at their feet. Since scent had not only erotic but also spiritual associations in the late nineteenth century,[4] Grace might even be seen as a latter-day Madonna, the lotuses in her lap substituting for the Christ Child, and transmuting into Christian form the sacred symbolism of the lotus of Buddhism and Hinduism, to which the American lotus is related. The picture similarly westernises the motif of women picking lotus lilies which is found in Japanese prints. And just as the still water mirrors the lilies, so the action of Grace's cousin in plucking a flower mirrors Curran's own in choosing Grace; her wedding bouquet was made of American lotus blooms when they married that summer.[5]

Lotus Lilies forms a fascinating American counterpart to the European enthusiasm for aquatic flowers which followed Joseph Paxton's success in introducing the giant Amazonian water lily (*Victoria regia*) at Chatsworth in 1849, and

Joseph Bory Latour-Marliac's development from 1877 of the coloured water lilies to be painted by Monet. When Curran exhibited the work at the Paris Salon in 1890, it was only fitting that a French critic called it 'the best of modernity'.[6]

1. See Gerdts 1983, pp.15–27 and p.111.
2. Ibid., p.53, and Rewald and Weitzenhoffer 1984, pp.76–7.
3. See ibid.
4. See C.Bradstreet, '"Wicked with Roses": Floral Femininity and the Erotics of Scent', in *Nineteenth Century Art Worldwide*, Spring 2007 at http://www.19thcartworldwide.org/spring_07/articles/brad_print.html
5. Curran, *Lotus Lilies* at http://www.terraamericanart.org/collections/code/emuseum.asp?collection=616&colle …
6. E. Huschedé, 'Brland de Salon' 1890, p.99, as cited in the website in note 5.

36 Telemaco Signorini 1835–1901
Summer Rain, 1887

Oil on canvas 66 × 110cm
Galleria Nazionale d'Arte Moderna, Rome

Signorini was the most cosmopolitan of the Macchiaioli, the Italian artists who developed a native counterpart to Impressionism. He lived and worked in Paris for periods in the 1860s and 70s, visited Vienna to exhibit there in 1873, and painted lively street scenes in London, Edinburgh and Leith in 1881. In *Summer Rain*, however, he is back on home territory, capturing a country garden of scattered roses and lush grass beneath a lowering sky at Settignano in the Florentine hills. The picture is one of a group he painted there in the late 1880s, and its unpromising motifs – untidy garden, weather-worn villa and rain – clearly reflect the principle adopted by the Macchiaioli that everything is beautiful in nature from the point of view of art. With its green expanse, the garden brings to mind the example cited by Signorini's colleague Adriano Cecioni to illustrate this principle: 'a field' which is 'one colour and, at the same time, thousands of colours, by virtue of the play which light creates over it, and because of the many small plantlets intermingled with the grass, all different in form and colour … '[1]

However, in contrast to the open-air sketches composed of tonal patches (*macchia*) which had earned the Macchiaioli their name back in the 1850s, *Summer Rain* is more finished and complex. Its domestic garden motif and its sense of light and atmosphere also suggest a response to the pioneering attempts to promote French Impressionism in Italy by the Florentine art critic Diego Martelli who was so memorably portrayed by Degas [fig.10]. Martelli had arranged for a painting of a kitchen garden by Pissarro to be shown in Florence in 1878[2], and Signorini's transient

weather effect in *Summer Rain* corresponds very closely with the idea which Cecioni had derived from Martelli, and published in 1885, that art should 'surprise' nature 'in one of its infinite moments'.[3] The cloud-laden sky indicates that rain has either recently fallen, or is imminent, whilst the rich green of the grass bears witness to the plentiful showers characteristic of a hilly region such as Settignano.

This intimate association of garden, weather and topography can be seen as part of a wider appreciation in late nineteenth-century Italy of the local landscape as the very substance of the recently unified nation[4] – the Italy for which Signorini, together with Martelli and Cecioni, had fought under Garibaldi in 1859. A private garden as a corner of nature adjacent to the home, is arguably the ultimate form of local landscape.

1. Adriano Cecioni, 'On the Importance of Technical Facility in Art' [1873], as cited in Broude 1970, p.405.
2. Pissarro, *In the Kitchen-Garden*, 1878, Galleria d'Arte Moderna, Florence.
3. Cecioni, 'Vicenzo Cabianca' (published in *La Domenica del Fracassa*, 12 July 1885), as translated in Broude 1970, p.412; Broude 1970, pp.411–12.
4. Broude 1994, p.175.

37 Frederick Childe Hassam
1859–1935
Gathering Flowers in a French Garden, 1888

Oil on canvas 71 × 51.1cm
Worcester Art Museum, Massachussetts

Gathering Flowers in a French Garden and *Geraniums* date from early in Hassam's career, when, following his first artistic education in Boston, the American had come to Paris to study for three years at the Académie Julian. As with *Geraniums*, this picture shows the garden of his friends the Blumenthals at Villiers-le-Bel near Paris, formerly owned by Thomas Couture. Summer has arrived, and the horse chestnuts are in bloom, the shapes of their candles echoed in the pattern of their leaves against the house. Almost like one of the candles, a young woman dressed in white – perhaps Hassam's wife – gathers flowers. She is, in effect, a modern 'gardener-girl', the mature Impressionist descendant of the women with freshly-picked bouquets which Saint-Jean and Bazille [2, 14] had painted. Now, however, the bouquets appear within their full garden context, amidst the counterpoint of light and luminous shadow on lawn, path, tree and flower beds which bears witness to Hassam's absorption of Impressionist ideals whilst studying in Paris. A basket in the foreground, perhaps of peonies or roses, catches the morning sunshine – flowers were traditionally picked in the cool of the morning – but is subordinate to the garden, rather than the main motif like the flowers in the paintings by Saint-Jean and Bazille. The open door of the house hints at the bouquets' destination, and from their size it is possible to imagine them forming lavish vases like those in Hassam's 1894 portrait of his compatriot the writer and gardener Celia Thaxter at home on the Island of Shoals in New Hampshire.[1]

Hassam kept in touch with Thaxter whilst in Paris, and the way the static, almost hieratic pose of the young woman lends a sense of self-absorption to her gathering of the flowers seems to predict Thaxter's description of her own love of horticulture. In her book *An Island Garden*, which was published in 1894 with illustrations by Hassam she wrote: 'All the cares, perplexities and griefs of existence, all the burdens of life slip from my shoulders and leave me with the heart of a little child that asks nothing beyond its present moment of bliss … I lose myself in the tranquillity of … [the flowers'] happiness'.[2] If the man sitting reading near the house in *Gathering Flowers* projects his thoughts beyond the garden, its flower-like woman lives for the present.

It is perhaps thus no coincidence that Hassam's striking composition, with its rising central path, echoes that of Monet's *The Artist's Garden at Vétheuil* of 1881.[3] When shown at Durand-Ruel's Impressionist exhibition of 1886 in New York, which Hassam saw, this picture had been praised by the influential critic Celin Sabbrin for its evocation of 'the present moment'.[4] However, where Monet excludes figures, Hassam's 'gardener-girl' imagery perhaps evokes something of Robert Herrick's message 'Gather ye Rosebuds while ye may', given his pride in America's English inheritance.[5]

1. *The Room of Flowers*, 1894, Private Collection.
2. C. Thaxter, *An Island Garden*, 1894, reprinted London 1989, p.113.
3. Mr and Mrs Herbert J. Klapper, USA (w.682); see Gerdts 1983, p.39.
4. Celin Sabbrin (pseudonym for Helen De Silver Michael), *Science and Philosophy in Art*, Philadelphia 1886, cited in ibid., p.38.
5. R. Herrick, 'To the Virgins, to Make Much of Time', in *Hesperides* [1648] in F.W. Moorman, *The Poetical Works of Robert Herrick*, Oxford 1915, p.84.

38 Frederick Childe Hassam
1859–1935
Geraniums, 1888–9

Oil on canvas 46.4 × 32.9cm
The Hyde Collection, Glens Falls, New York

Tender geraniums – properly known as pelargoniums – are often grown in pots, as shown here, since they have to be wintered indoors. They were a much-loved flower in nineteenth-century France where this dazzling picture was painted. As Hassam was American, it is perhaps worth considering whether the garden portrayed in *Geraniums* – that of Hassam's friends the Blumenthals at Villiers-le-Bel near Paris – attracted his attention at least in part because pelargoniums were also closely associated with the New World. President Jefferson famously grew them at the White House in 1809, and in the seventeenth century it was the Pilgrim Fathers and settlers in New England who had first brought them to America, following their introduction to Europe from South Africa.[1] Hassam proudly traced his descent from the New England settlers, as did his wife Maude, shown sewing in the background in *Geraniums*. In 1886, he had painted a woman tending a pot of red pelargoniums at a window suggestively overlooking the New England coast, and in later life was to paint the old-fashioned colonial gardens of Connecticut and Massachussetts.

Although Hassam had almost certainly encountered the work of the French Impressionists at Durand-Ruel's exhibitions in Boston and New York, it was only after he came to Paris in 1886 that his palette lightened and he began to use the effects of colour seen in *Geraniums*. The painting is part of the series he undertook at Villiers-le-Bel, and whilst it owes a debt to Monet's garden scenes at Argenteuil – some of which were included in the Boston exhibitions – it also has affinities with the *chiaroscuro* (shading from light to dark) found in Thomas Couture's art. Couture, who taught Hassam's Boston tutor, had lived on the Villiers-le-Bel estate and Hassam made a point of seeking out the examples of his work still kept there.

Hassam's delight in the brilliant red of the pelargoniums at Villiers-le-Bel looks forward to his famous views in the 1890s of the poppies growing in the traditional American cottage garden on the Isle of Shoals in New England owned by his friend the poet Celia Thaxter – works which earned him his credential as the leading American Impressionist of the day. Although Thaxter's semi-wild garden was very different in style from the disciplined flower beds and terraces at Villiers-le-Bel, Hassam's pleasure in its freedom is anticipated in the way he subtly subverts the regimented order of the flowerpots with his use of light and shadow. He cuts across their serried rows with a series of playful, even witty visual correspondences – between the glowing red flower-heads and their cool shadows on the ground and the large oleander pot at the right, for example; and between the spouts of the watering-cans and the diagonal blue shadows on the wall. The latter were presumably cast by branches above, or reflected in, the unseen glass awning which Hassam later recalled having sheltered this part of the garden.[2] A weft of forms and colours takes shape which complements Mrs Hassam's needlework, and makes her homely activity as one with its garden setting.

1. Coates 1968, p.200; H.P. Loewer, *Jefferson's Garden*, Mechanicsburg 2004.
2. Hassam interview with DeWitt McLellan Lochnan, 31 January 1927, quoted in New York 2004, p.85, note 69.

39 Gustave Caillebotte 1848–1894
Nasturtiums, 1892

Oil on canvas 80 × 69cm
Private Collection

40 Gustave Caillebotte
Daisies, 1892

Oil on canvas 80 × 69cm
Private Collection

Painted following correspondence between Caillebotte and Monet about 'floral decoration',[1] these two works of matching dimensions showing flowers in Caillebotte's garden at Petit-Gennevilliers on the Seine are thought to have been contributions to the mural scheme for his home there on which he was working when he died in 1894. This was perhaps inspired by the panels of flowers and fruits painted by Monet in the 1880s for Durand-Ruel's apartment in Paris, but whereas Monet's scheme was essentially a series of still lifes of cut flowers, Caillebotte's panels of living plants would have brought the garden right into the house, perpetuating summer throughout the year on its walls. In this sense the works already look towards the ideal of house and garden as an integrated, reciprocal unity which was to become important in the twentieth century, partly in response to the British Arts and Crafts movement.

The only sections of Caillebotte's mural scheme which he completed were door panels for his dining room showing views in his greenhouse of his orchids, begonias and other hothouse plants. However, in contrast to the trompe l'oeil effect of these panels, which created the illusion of looking through the door into

an actual conservatory, *Nasturtiums* and *Daisies* are flat, almost two-dimensional compositions which show traditional garden flowers rather than exotic species. *Nasturtiums*, which is clearly unfinished, portrays a runner of the exuberant flowers which had earlier inspired Fantin-Latour and Guillaumin, climbing across a plain surface, presumably a garden wall. *Daisies* is a close-up view of a bed of cultivated daisies (marguerites), where the pale flower-heads with their golden centres form a two-dimensional pattern against the dense, dark foliage. Caillebotte was to treat chrysanthemums in a similar way in a painting of 1893, which he gave to Monet, and may originally have been intended for his mural scheme;[2] Monet used its decorative viewpoint in his own chrysanthemum series of 1896–7.

The origins of Caillebotte's interest in mural painting can be traced to three decorative panels showing scenes of boating, fishing and bathing on the river on his family's estate at Yerres near Paris which he had shown at the Impressionists' fourth exhibition of 1879. These take their place alongside wider Impressionist interest in mural painting in the late 1870s and early 1880s [64]. As murals for a room used by his well-to-do family, showing their leisure activities, they would have echoed the observation of the writer Edmond Duranty in his famous essay of 1876 on Impressionism that the figure 'never appears in reality against neutral backgrounds … but around and behind him … [is] a setting which expresses his class, fortune, profession'.[3] Had they been installed, Caillebotte's floral panels for Petit-Gennevilliers would likewise have spoken vividly of his life there as an artist and gentleman of taste.

Whilst their flat compositions have something in common with the Japanese prints collected by Caillebotte's friend Edmond de Goncourt, there is a sense of the vigour and life of the nasturtiums and daisies in Caillebotte's two panels which remains very much in the Impressionist tradition of open-air painting and is a reminder that he was also a gardener who knew the habits of his plants. Bright sun plays over the spreading nasturtiums, throwing some leaves into shadow, just as it illuminates the pale, delicate petals of the daisies amidst the darker foliage. The year before Caillebotte painted these panels, he had had his close friends the Renoirs to stay at Petit-Gennevilliers, and his attention to the play of light and shade, the varied shapes and sizes of the daisy-heads, and the way the nasturtium leaves and stems spread unpredictably across the wall, compares with Renoir's credo that 'nothing in nature is regular'.[4] If

Nasturtiums and *Daisies* are already part of the trend to the decorative which develops in the late Impressionist garden and leads ultimately to Monet's water lily murals for the Orangerie, they are also firmly part of the engagement with real nature which Impressionism had inherited from Courbet and the still lifes of Delacroix.

1. See London/Chicago 1995, p.203.
2. Musée Marmottan, Paris; see ibid., pp.198–9.
3. Duranty 1876, p.78.
4. Renoir, *Grammar, 1883–1884*, in Herbert 2000, p.151.

41 Gustave Caillebotte 1848–1894
The Dahlias, Garden at Petit-Gennevilliers, 1893

Oil on canvas 157 × 114cm
Private Collection

When Caillebotte died prematurely a year after this picture was completed, his friend the critic Gustave Geffroy wrote in his memory that 'he loved the flowers which colour and perfume the atmosphere, and was the learned devotee of gardens'.[1] This comment could almost describe this work, with its vibrant flowers and view of the splendid garden which Caillebotte created from 1883 at Petit-Gennevilliers. Placed right under the viewer's nose, the dahlias invite us not only to admire their glowing colours, but also to 'smell' their distinctive, slightly sharp scent. Just beyond them stands Caillebotte's magnificent greenhouse – further testimony to his dedication to horticulture – and at the left is his mistress Charlotte Berthier, accompanied by her dog. Neither Charlotte nor the dog appears in a smaller version of the picture which Caillebotte also painted,[2] but they subtly enhance both the colour and the horticulture of his motif. Charlotte's blue apron supplies the one colour never found in dahlias, and joins the red and yellow of those in the foreground to make the three primary colours sing out from the composition. The tiny dog, meanwhile, emphasises the splendid size of the dahlias, a reminder that the soil at Petit-Gennevilliers was enriched by the sewerage outflow to the Seine from Paris.

Caillebotte's close-up view of the dahlias makes their leaves and flowers read almost as a pattern against the bright garden; an effect which compares with the murals of his flowers he was painting at this period for his home, which lies just beyond the greenhouse. This is a reminder of his friendship with Monet. The two artists not only shared horticultural knowledge, but corresponded in the early 1890s on floral decoration,[3] and Caillebotte's subject echoes that of Monet in *The Artist's Garden at Argenteuil* [19]. However, it also bears

witness to the renewed popularity of dahlias following the centenary in 1889 of their introduction to Europe from Mexico via Madrid. In this context, it is intriguing that Caillebotte does not include any of the numerous variegated dahlias developed by the 1890s. Instead he features two single-colour specimens, the one contrasting with the other exactly as the chemist Eugène Chevreul had recommended in his influential treatise on colour harmony and contrast, which had used single-colour dahlias as key examples.[4] In this sense, the picture complements Gertrude Jekyll's application of Chevreul's precepts to garden design in the late nineteenth century,[5] as well as Seurat's inspiration from Chevreul. Yet where Seurat sought to make art scientific, by applying his colours in tiny juxtaposed dots, Caillebotte's varied, irregular brushstrokes re-affirm traditional Impressionist concern with the subjectivity of our perception of sensations. Intently studying some object in her hands, Charlotte highlights this idea, and Geffroy certainly noted Caillebotte's dedication to art which 'concentrates man's sensations … which perpetuates our joy of seeing, the ecstasy of our spirit'.[6] From this point of view, *The Dahlias, Garden at Petit-Gennevilliers* was as much a renewal of Impressionism in a changing art-world as a retreat to a *paradis terrestre* from the barren streets of Paris which famously feature in so many of his earlier works.

1. Geffroy 1980, p.290.
2. *The House at Gennevilliers*, 1893, Collection of the Tri-Suburban Broadcasting Company, Columbia, Maryland.
3. London/Chicago 1995, p.203.
4. Chevreul 1859, pp.282–5.
5. See London/Chicago 1995, pp.204–5.
6. Geffroy 1980, pp.290–1.

42 Gaston La Touche 1854–1913
Phlox, 1889

Oil on canvas 160 × 130cm
Musée de La Roche-sur-Yon

La Touche began his career with dark-toned peasant subjects, but at the Café des Nouvelles Athènes in Paris he became acquainted with Degas, and Manet whom he asked for tuition. Manet advised him to adopt prismatic colour and modern subjects, and with the encouragement of Félix Bracquemond, the husband of Marie Bracquemond, he eventually did so from the late 1880s. *Phlox*, together with a similar work called *Peonies*, was one of his first significant Impressionist pictures, and shows the intimate garden kept by his wife at their home at Saint-Cloud near Paris. Exhibited in 1890, it was purchased by the State, launching a rapid ascent to high official favour. In the 1900s La Touche was

commissioned to paint murals in buildings including the Palais de l'Elysée, and the Ministry of Agriculture, as well as the liner *La France*.

The intimacy of the family meal in *Phlox* is heightened by the screens of flowers which partially enclose the figures and table, and the picture's appeal to the French State can be understood in view of both the emphasis on families as a key means to rebuild the nation after the Franco-Prussian War, and the correlation of 'the notion of modernity with the notion of privacy and interiority' which came to the fore from 1890 in Third Republic artistic policy.[1] Influenced by the recent investigations into psychological suggestion by Drs Charcot and Bernheim, as well as by Edmond de Goncourt's description of his 'House of an Artist' at Auteuil, this cult of the private saw the domestic interior as a place both of stimulus to memory and dream, and of their projection.[2] Floral and plant imagery was favoured in interior decoration for its perceived evocative properties, and gardens were considered outdoor rooms. La Touche's harmonies of white, the colour of innocence – white phlox, white tablecloth, white costumes of mother and child, all seen in the white dazzle of summer light – clearly parallel De Goncourt's sensitivity to the moods evoked by different colours, and their expressive effects in his garden.[3] Since phlox flowers are scented, their position in the foreground so that we look through them to the outdoor meal intensifies the presentation of the garden as a place of evocative stimuli – of perfume as well as colours and tastes.

Phlox were classified as fancy plants in French nineteenth-century horticulture, and were used on an ad hoc basis to create variety in gardens, in contrast to collection plants such as roses and chrysanthemums, which were felt to have more permanent roles.[4] In this sense, they aptly complement the sense of a fleeting, precious, dream-like moment which La Touche evokes in the brilliant shaft of sunshine, shimmering silverware, and screen of transient perfume.

1. Silverman 1992, p.9.
2. Ibid., pp.102–6.
3. See De Goncourt 1986, especially pp.310–15.
4. See, for example, Decaisne/Naudin, vol.II, p.61 and pp.65–6.

43 James Guthrie 1859–1930
Midsummer, 1892

Oil on canvas 101.8 × 126.2cm
Royal Scottish Academy (Diploma Collection), Edinburgh

The early twentieth-century historian of Scottish art Sir James Caw described this picture – Guthrie's diploma work for

the Royal Scottish Academy – as 'that charming piece of impressionism'.[1] Its motif of leisure and its virtuosic rendering of sunlight filtered through foliage could hardly be more different from the sombre tones and subjects of Guthrie's early rural paintings, such as *A Highland Funeral* (Kelvingrove Art Gallery, Glasgow), and they are thought to reflect an encounter with French Impressionism and possibly pastels by Degas.

Yet, for all its charm, the picture is not merely decorative, sensitive though Guthrie clearly was to the patterns created by the play of light and shade. David Martin, who in 1897 wrote one of the first appreciations of the group of painters known as the Glasgow Boys, which included Guthrie, noted of the artist that 'In his impressions … he conveys a world of meaning'.[2] *Midsummer* can be recognised as a sympathetic and insightful portrait of a fellow artist, the flower painter Maggie Hamilton, in the milieu which supplied her motifs, and the company of her supporters. She is the figure in white at the left, taking tea with a woman thought to be her sister (at the centre), and one of the Walton sisters, also artists. The three are seated in a shaded part of the garden of Maggie's family's home, Thornton Lodge, in the small seaside town of Helensburgh on the Clyde near Glasgow.[3] Helensburgh had, and still has, many gardens, which flourish in the mild west-coast climate, and the touches of white in the foreground, like the pink ones overhead, may well represent some of the flowers which Maggie also painted.

In keeping with Impressionist principles, Guthrie captures a moment in time – midsummer – when the bright sunlight, still strong even at tea time, creates a decorative arabesque on the lawn, and makes the silverware gleam on the elegant Japanese-style tea-table with its pink and white cloth. But he also evokes speech – something even more ephemeral than the play of light, for sound dies even as it is heard. Miss Walton is talking; Maggie is looking away from her book, considering her response, as her sister listens in the shadows. The painting's subtlety lies not just in its sympathetic portrait of fellow artists, and its conjuring of forms through the merest suggestion, but also in the way that Guthrie makes the garden a place of evocative synthesis: of nature and decorative effect, of the moment of summer and that of speech, and of the blossoming of flowers and that of art and friendship.

1. Caw 1975, p.368.
2. D. Martin, *The Glasgow School of Painting*, Edinburgh 1976 (first published 1897), p.21.
3. See J. Burkhauser, *Glasgow Girls: Women in Art and Design 1880–1920*, Edinburgh 1990, p.222.

44 Mary Fairchild MacMonnies
1858–1946
Roses and Lilies, 1897

Oil on canvas 133 × 176cm
Musée des Beaux-Arts, Rouen

Warm sun, fragrant flowers, the comforting roughness of wickerwork: this dazzling slice of summer invites us to rediscover childhood, when sensations are so vivid and intense. It shows the garden of the Villa Bêsche, the first home in Giverny of the American artists Mary and Frederick MacMonnies. The golden-haired infant in pink, playfully dancing a costume-doll, is the MacMonnies' first child Berthe, whilst the somewhat meditative woman, whose white dress reflects the garden's colours, is Mary MacMonnies herself.

Before joining the colony of artists attracted to Giverny in Monet's wake, the MacMonnies had trained in the USA and Paris, winning awards at the Paris Salon. They moved to the Villa Bêsche on returning from the World's Columbian Exposition of 1893 in Chicago, where Frederick had contributed a major sculpture, and Mary a mural entitled *Primitive Woman* which was a partner to Mary Cassatt's of *Modern Woman*. Although very different from rural Giverny, the Chicago Exposition provides a suggestive context for *Roses and Lilies*. Its Director of Decorations was Frank Millet, an American follower of the English artist and designer William Morris, whilst the interior designer of its Women's Building, where MacMonnies's mural was housed, was Candace Wheeler, another Morris disciple. MacMonnies's host of lilies, dancing in the summer breeze, yet silhouetted decoratively, are in this sense a sequel both to Francis Millet's lily-filled garden at Broadway in England, and to Wheeler's *Consider the Lilies* embroideries, which had won high praise at the Exposition.

It was Millet's Broadway garden which had inspired John Singer Sargent's *Carnation, Lily, Lily, Rose* (*c*.1885–6, Tate Britain), shown to much acclaim in Paris in 1889, and the likely model for *Roses and Lilies*. In 1897 at the Villa Bêsche, conversation must, in fact, have readily turned to Sargent, who had worked with Monet at Giverny, as well as to Wheeler; the MacMonnies were visited in May of 1897 by Sargent's protegé Bay Emmet, and her sister Rosina, an associate of Wheeler. However, MacMonnies's picture differs from Sargent's in important respects. Berthe is younger than Sargent's models, and sunlight replaces Sargent's evening, infusing the shadows with colour, and shining through petals, parasol and chiffon. The MacMonnies's Paris neighbour, James McNeill Whistler, recognised these differences in his typically barbed tribute to *Roses and Lilies* as 'a blue baby with purple shadows sort of thing'.[1]

MacMonnies's brushwork is also looser than that of Sargent, and weaves an intimate identity between figures and flowers. Berthe in her pink dress, with her red-costumed doll, is implicitly a rose, and Mary, in white, a lily. There are perhaps further echoes from the Chicago Exposition as the 'child garden' ideal of the progressive educationalist Froebel, in which children were encouraged to learn by play amid nature, had been enthusiastically adopted in Chicago, as well as promoted in the Chicago World's Columbian Exposition.[2] *Roses and Lilies* tellingly includes a multicoloured ball at the left – Froebel's 'First Plaything of Childhood'[3] – and is not only a fascinating synthesis of Morrisian and Impressionist values, but also, surely, of Froebel's ideas and MacMonnies's life. For even as MacMonnies portrayed her first child in *Roses and Lilies*, she was expecting her second. Berthe plays with a doll, a miniature adult, but the ball, suggestively placed above MacMonnies's signature and the date, evokes that first stage of play, so soon to recommence.

In 1898 the MacMonnies moved to Giverny's former monastery, developing a garden said to rival Monet's, but they divorced in 1909, and Mary returned to America with her second husband, the painter Will Hickok Low. *Roses and Lilies*, capturing those precious early years at the Villa Bêsche, won gold medals in Paris, Dresden and Rouen, and today remains a highlight of American Impressionism.

1. Cited from E.R. Pennell and J. Pennell, *The Whistler Journal*, Philadelphia 1921, in Smart 1983–4, p.24.
2. Wollons 2005.
3. Froebel 1909, p.32.

45 Mary Cassatt 1844–1926
Summertime, 1894

Oil on canvas 100.6 × 81.3cm
Terra Foundation for American Art, Daniel J. Terra Collection, Chicago

Warm sun, a cooling breeze, a gently-rocking boat: all the ingredients for a lazy summer's afternoon are set out in this boldly-brushed picture of an outing on the pond in the garden of Cassatt's country mansion, the Château de Beaufresne in the French Oise region. American by birth, Cassatt had contributed to the Impressionist exhibitions from 1879, and in spring 1894 had purchased the dilapidated château as a summer retreat where she could cultivate a garden of her own in her adopted country. The scent of the fine rose-garden she developed there was to give her much pleasure when she became blind in later years, but *Summertime*, together with a horizontal version of the same motif,[1] was one of her early works at Beaufresne. The sitters were probably hired models, and the picture translates to Cassatt's new garden context the subject of figures in a boat which she had recently painted on the coast at Antibes.

Lacking the view to the pond's distant bank offered by its horizontal partner, *Summertime* has a strongly decorative character which reflects Cassatt's admiration for Japanese prints, with their flattened perspective. The woman leaning to watch the mallard duck recalls in particular the figures in open boats who bend to pluck lotus flowers in prints by Harunobu, and the picture's imagery has been compared with the 'Asian concept of life as a voyage down an unending, ever-changing river'.[2] Cassatt had greatly admired the landmark exhibition of Japanese prints held in 1890 at the Ecole des Beaux-Arts in Paris, and at Beaufresne hung her own collection of such works.

The sheer panache of the brushwork in the painting nonetheless reveals Cassatt's admiration for Velázquez, whose works she had studied in the Prado in Madrid. Together with her warm palette, it gives the picture a very different mood from, for example, Monet's portraits of his stepdaughters boating in the mysterious shadows of the overgrown river Epte. The strong, hot sunlight in Cassatt's picture also differs from Berthe Morisot's almost dream-like, Watteauesque effects in her paintings of the late 1870s and 1880s showing women boating on the lake in the Bois de Boulogne.[3] Instead, Cassatt's central theme is surely the questing, intently-focused gaze of the woman and girl as they watch the progress of the mallard amid the watery reflections of pinks, reds and blues from their skin and costumes. With its close-up viewpoint, the picture might almost be a psychological study of the modern woman, intelligent, confident, attuned to nature yet ever-curious about her milieu, whose activities and attributes Cassatt had represented allegorically the year before in her mural of this name for the World's Columbian Exposition in Chicago.[4] This had in fact included a motif of women and ducks. Now, in the privacy of Beaufresne, it is as though Cassatt creates a contemporary Garden of Eden where, just as for her colleague Pissarro, the curiosity which made Eve pluck the fateful Biblical apple is no longer a sin, but something to be celebrated; vital evidence of the openness of mind and receptivity to new experience which, by all accounts, Cassatt herself displayed.

1. *Summertime*, 1894, The Armand Hammer Foundation, Los Angeles.

2. Chicago/Boston/Washington 1998–9, p.86.
3. For example, Monet's *In the 'Norvégienne'*, 1887, Musée d'Orsay, Paris, and Morisot's *Summer's Day*, 1879, The National Gallery, London.
4. Now destroyed; see Chicago/Boston/Washington 1998–9, p.87.

46 Albert André 1869–1954
Women Sewing, c.1898

Oil on canvas 69 × 61.5 cm
Carmen Thyssen-Bornemisza Collection, on loan to the Museo Thyssen-Bornemisza, Madrid

Born in 1869, André started his career as a silk designer in Lyons, where his father owned a factory making silk hats. This experience may well have made him receptive to the artist Maurice Denis's definition of a picture as 'essentially a flat surface covered with colours arranged in a particular pattern',[1] which he absorbed from Nabis colleagues such as Edouard Vuillard when in 1889 he enrolled in the Académie Julian in Paris to train as a painter. It is perhaps no coincidence that it was Renoir, who himself began his career in applied art as a porcelain painter, who launched André's career by recommending him to the art dealer Durand-Ruel in 1894.

Given the importance of floral motifs in Lyons fabrics, André's training perhaps predisposed him to the pictorial possibilities of gardens. He painted many scenes both of the parks of Paris, and of the garden at his family home at Laudun near Avignon, the setting for *Women Sewing*. The 'intimist' motif of this painting compares closely with the scenes of figures engaged in domestic activities which Edouard Vuillard and Pierre Bonnard painted during their Nabis phase in the 1890s. However, André's forms are more clearly legible, less merged into overall pattern, and there is a feeling of the garden as a place of pleasurable sensations – warmth, light, colours and textures – which remains, in essence, very close to Renoir's. Renoir certainly considered André's work 'the expression of delicate *joie de vivre*'.[2]

The way the women bending their heads echo the rounded shapes of the shrubs and trees also creates an implicit correspondence between human and plant worlds which, in less overtly decorative form, is already found in the flower-like figure of Renoir's *Woman with Parasol in a Garden* [21]. André's short, linear brushstrokes for foliage and flowers seem even to project the individual, careful stitches of the women's needlework, just as the red, blue and white colours of their costumes harmonise exactly with the red flowers, pink earth, brown tree trunks, and the blue sky with summer clouds.

This harmony was, however, now the result of work in the studio, for André painted from memory, using sketches made on the spot. Echoing Delacroix's principle, he argued that 'memory simplifies everything and only retains what is essential'.[3] It is perhaps only logical that his pictures have been likened to a 'family album which provides the pleasure of rediscovering all the artist's old memories'.[4] In this sense, *Women Sewing*, with its view of the André family's garden, takes its place within the wider association of gardens and memory at the turn of the twentieth century which reaches its climax in the writer Proust's *In Search of Lost Time*, with its recollections of the gardens of his childhood.

1. Pierre Louis (pseudonym for Maurice Denis), 'Définition du Néo-traditionism', in *Art et Critique*, Paris, 23 and 30 August 1890, as translated in Harrison/Wood/Gaiger 2003, p.863.
2. Sentiment attributed to Renoir by Jean Renoir, as quoted in entry for André's *Le Jardin de Renoir aux Collettes*, 1916, in T. Verlinden and J. Mayer-Boet, *Musée Renoir "Les Collettes", Cagnes-sur Mer*, from a leaflet published by the Musée Renoir, n.d.
3. Cited in anon., *Dessins et estampes de la collection Georges et Adèle Besson*, exh. cat., Musée des Beaux-arts et d'archéologie, Besançon, n.d.
4. C. Durand-Ruel Snollaerts, *Albert André*, in *L'Oeil*, October 1990, p. 8.

47 Léon Frédéric 1856–1940
The Fragrant Air, 1894

Oil on canvas 98 × 67.5cm
Private Collection

With its child dreamily smelling a rose in a garden bursting with roses, this picture may strike modern viewers as over-sentimental. But in 1890s Belgium – Frédéric's native country – children who survived to enjoy nature's beauties must have seemed blessed indeed. One of the most industrialised nations in the world, with attendant pollution and disease, Belgium at this period had very high infant mortality rates. In rural areas, one in five children under five died and in cities the number was one in three, with girls being at greater risk than boys.[1] Will Frédéric's infant share the fate of the flowers surrounding her, which include sweet-scented spring blooms as well as roses? If roses traditionally 'only live one morning', fragrance is still more ephemeral. Pliny famously noted that 'perfumes … die even as they are born'.[2]

Life, however, and the child's discovery of its vibrant sensations, are surely dominant here. Frédéric painted from nature each summer at Nafraiture in the Ardennes, where he perhaps found his ruddy-cheeked model, and the brilliant sunshine of *The Fragrant Air* forms a striking contrast to the industrial city and funeral hearse in his *The Ages of the Worker*, one of the epic social pictures for which he is perhaps best known today [fig.6]. Although Frédéric is often termed a Symbolist, his sunlight and brushwork fall heir to the Impressionist art frequently shown at the *Vingt* and *Libre Esthétique* groups with which he exhibited in Brussels.

Roses were popular in Belgium and by 1878 Van Houtte's Ghentbrugge horticultural establishment already contained 1,700 varieties.[3] Rather than the magnificent cabbage roses in *The Fragrant Air*, however, the rose, which the little girl smells appears, fittingly, to be a tiny four-petalled variety (*Rosa sericea*). Following its introduction from Nepal in 1822, *Rosa sericea* had been re-introduced from China in 1890 by the French missionary Père Delavay, and developed by Maurice de Vilmorin; a botanical event which would naturally have attracted Frédéric's attention, given his enthusiasm for the sciences.[4] Just above the girl, crowning her with its flowers and thorns, is a wild or briar rose – perhaps alluding to Christ's crown of thorns, but also a complement to her untutored innocence. The spring flowers are similarly evocative: poet's narcissus at the right recalls Narcissus, who fatefully admired his reflection, but the more prominently positioned red tulip, bowing its head to the girl, traditionally symbolises perfect love or grace. Yellow daffodils, nearby and at lower left, are associated in antiquity with death, but are also Christian symbols of resurrection and eternal life, whilst the flower at the girl's feet is, suitably, a miniature (grape) hyacinth. Though linked with remembrance, this is also the flower of Demeter, the Greek earth goddess and women's guardian, as well as a Christian symbol of wisdom.

In the climate of 1894, when unprecedented socialist election successes were widely celebrated in Belgium, Frédéric's evocation of youth, flowers and sunlight was surely a bold affirmation of faith in a brave if as yet uncertain new world, and of hope that fragrance and nature's beauty might prevail over factory smoke and urban crowding. The briar rose (*églantine*) crowning the child was in fact a socialist emblem.[5] Frédéric had already included a socialist red flag in *The Ages of the Worker* [6],[6] and *The Fragrant Air* can be compared with the vision of his contemporary Eugène Pottier, author of the *Socialist International*:

Everyone will have a place in the sun!
The budding generations
Will see their rosy babies flower
Like briars in the spring.
It will be the season of roses.
This world will have its own spring.
That's the people's future.[7]

Superficially sentimental, *The Fragrant Air* is as much a comment on its time as Frédéric's social paintings, making a further link between Impressionism and the belief of many of its artists in the essential goodness of life.

1. In rural areas, 203 children under five in every 1,000 died, and in major industrial cities the figure was 336 children in every 1,000; see T. Eggerickx and D. Tabutin, 'La Surmortalité des filles en Belgique vers 1890. Une approche régionale', in *Population*, 1994, vol.49, no.3, p.657 and pp.660–2; and R. Schofield et al. (eds), *The Decline of Mortality in Europe*, Oxford 2002, p.198 and pp.205–6.
2. For roses as flowers that 'only live one morning' (a phrase from the seventeenth-century poet François Malherbe's 'Consolation à M. du Perrier'), see Willsdon 2004, p.46 and p.258 note 55. Pliny's comment (*Natural History*, vol.XIII), is quoted in Paris 1987, p.25.
3. 'Van Houtte (Louis) (1810–1876)' in F. Le Texnier, *Notices sur les jardiniers célèbres et les amateurs de jardins*, Paris 1907, p.16 and p.33.
4. For this interest, see L. Jottrand, *Léon Frédéric*, Antwerp 1950, p.11.
5. See Joyaux 2007, p.45 and Giboult 1904, p.26.
6. R. Rapetti, 'Léon Frédéric et les âges de l'ouvrier, symbolisme et messianisme social dans la Belgique de Léopold II', in *Revue du Louvre*, vol.2, 1990, pp.136–45.
7. 'L'avenir social', in *Eugène Pottier Oeuvres complètes* (ed. P. Brochon), Paris 1996, p.134 (translated partly from E. Hobsbawm, 'Man and Woman in Socialist Iconography', in *History Workshop*, no.6, autumn 1978, p.133). A major edition of Pottier's poetry was published by J. Milot in Brussels in 1893 (*Recuil des chants démocratiques*).

48 Fritz Schider 1846–1907
The Chinese Tower at the English Garden in Munich, c.1873

Oil on canvas 140 × 111cm
Kunstmuseum, Basel

All Munich life seems represented in this atmospheric garden-café scene by the Austrian artist Schider. Old and young; poor and wealthy; the roguish and the respectable; the solitary and the sociable – each is enjoying the city's English Garden with its celebrated Chinese Tower, which was created in the late eighteenth century and is visible in the background. At the nearest table are a well-dressed young woman and her straw-hatted child, with an older companion, perhaps the girl's grandmother, lingering over her coffee as the baby slumbers in its pram. To the left, top-hatted burghers carouse, oblivious of a woman nearby in a worker's apron, whose attention is captured by the playing of a harp. A fiddler takes a breather, gazing upwards as if watching the people in the Tower. At the right, two bold young men in traditional costume attract the glance of a woman with a baby, and further off children dance in the sun. There is even a dog, tethered to the chair in the foreground.

The central player, however, is surely the sunlight itself. It floods the middle distance, silhouetting some of the figures in a pattern as intricate as the lattice-work on the

Chinese Tower. It finds its way between the leaves and branches of the trees, making the glass and china gleam, and picking out the harpist's fingers as if to render her melodies visible. It shines through the cigarette smoke at the centre, and outlines the top of the makeshift canopy. And it profiles the head of the straw-hatted girl like a cameo, pointing up her childish curiosity at the aproned woman.

Schider had become a member of the painter Wilhelm Leibl's Realist circle in Munich, and is recognised today as one of the most progressive German-speaking artists of the 1870s. He had been much impressed by work by Courbet and Manet at the First International Art Exhibition in Munich in 1869, and his park motif and contrasts of strong light and deep shadow in *The Chinese Tower* have affinities with Manet's *Music in the Tuileries Gardens* [fig.4], whilst his evocative preparatory studies for the picture[1] were influenced by the outdoor sketching demonstration Courbet had given his German admirers in 1869.

In these ways, and despite its lack of bright colour, *The Chinese Tower* takes its place at the heart of nascent German Impressionism, whilst its almost symbolic use of light looks forward to work by Fritz von Uhde. The very freedom of the play of dappled light unifies the composition, harmonising the varied figures, and perhaps even serving as a witty emblem of the bohemian liberalism or 'free philosophy' espoused by Schider and his Munich colleagues, who admired Courbet's support of the Paris Commune and its egalitarian ideals.[2] Schider certainly remembered his Munich years as 'the most beautiful time,'[3] and his choice of motif was perhaps not coincidental, given the traditional association between the English garden style and ideals of political liberty. His venture into Impressionism was coolly received, however, and by the 1880s, with a young family to support, he had swapped the garden for the mortuary, and was working as an illustrator in Basel for Julius Kollmann's influential anatomy handbook for artists. It was 'the fate of men', as Schider wrote ironically, which now almost solely supplied his 'models', in the cadavers and skeletons he drew for Kollmann. Some of his anatomical illustrations remained in use in modified form until the late twentieth century.[4]

1. See Los Angeles/London 1993, pp.230–1.
2. Letter from Schider to Leibl, 9 November 1877, quoted in B. Rörl, 'Der Maler und Graphiker Fritz Schider (1846–1907). Der Einfluss des Leibl-Kreises auf die Künstleranatomie', in *Zeitschrift für Kunstgeschichte*, vol.57, no.4, 1994, p 656; for sympathy with Courbet and the Paris Commune, see ibid., p. 655.
3. Ibid., p.656.

4. Ibid., p.662; letter from Schider to Leibl, 5 November 1882, quoted in ibid., p.659.

19 Claude Monet 1840–1926
The Parc Monceau, 1878

Oil on canvas 65 × 65cm
Private Collection

50 Claude Monet
The Parc Monceau, 1878

Oil on canvas 72.7 × 54.3cm
The Metropolitan Museum of Art, New York

Even as Monet was completing these pictures, the critic Théodore Duret observed that 'Monet … feels himself drawn to decorative nature and urban scenes. He paints by preference flower-gardens, parks and groves.'[1] Duret could hardly have asked for a better example of decorative nature – and one in an urban context – than the Parc Monceau. Created for the Duc d'Orléans by Louis Carmontelle exactly a century before, in 1778, the Parc Monceau had been acquired and opened to the public by Napoléon III in 1862. It was the most elite of the Paris parks, boasting ornamental 'plants from the most diverse countries of the globe', such as the giant Abyssinian 'Bruce banana', and 'Begonia fuchsioïdes … a hundred times more brilliant than the most beautiful coral'.[2] These were intended to compensate for Napoléon's contentious truncation of Carmontelle's park to make way for new boulevards, and the luxurious mansions shown in the background of Monet's pictures, whose owners included the chocolate manufacturer Menier.

Monet's imagery is, however, intriguingly selective. He offers only the tiniest glimpse of the park's celebrated flowers – a patch of orange-red behind the figures enjoying the shade of the trees in the New York picture, with more lawn than flowers in the same area in the other work – and there is no sign at all of Carmontelle's decorative follies, which Napoléon had preserved and augmented. These included the famous *naumachie* (ornamental pond) copied by Tissot in London [23], Roman baths, and a cave with artificial stalactites. Monet also shuns the axial carriageways which aligned with Napoléon's new boulevards. Instead, he focuses on a curving subsidiary path and the 'large ancient trees' remembered in the nineteenth century for 'surviv[ing] so many revolutions'.[3] (Marie-Antoinette had taken refuge in the park during the storming of the Bastille, and it had served as a mortuary in the Paris Commune of 1871.) It is as though he transfers to Paris a corner of the ancient forest of Fontainebleau where he had painted some of his earliest outdoor scenes

of figures. But he now uses the distinctive broken brushwork and *contre-jour* effects of mature Impressionism to create an alternative decoration to that instigated by Napoléon: one formed by the patterns of light filtering through the canopy of branches and leaves. Figures, costumes and path become a shimmering mosaic of subtle colours, echoed by those of the mansions beyond, and in the New York picture, the foreground grass is boldly striated with pale green and yellow. If the wealthy bourgeoisie who frequented the Parc Monceau enjoyed the reflected glory conferred by its aristocratic origins, these effects integrate them still more intimately with their garden setting.

Monet had painted several views of the park in 1876, and with these two views and one other he also painted in 1878, the year of its centenary, he surely hoped to attract the patronage of the Monceau bourgeoisie.[4] He had certainly already sold both works exhibited here by the end of June 1878. Whilst the houses and parts of the foliage are less clearly defined in the smaller picture, this work is by no means as summary as the view of the Tuileries Gardens which Monet had shown at the 1877 Impressionist exhibition under the title of 'sketch', as a complement to a finished version of the same motif. That he sold the smaller work also suggests it was more than simply a sketch for the larger picture. The way the lighting slightly differs in the pictures, with stronger contrasts of bright and shadowed areas in the larger version, would seem instead to develop Monet's tactic at the Gare Saint-Lazare the previous year, where he had explored varied effects of light and atmosphere, anticipating his serial practice at Giverny from the 1890s.

Interestingly, the New York painting differs from the other in that it includes a solitary male figure, seated slightly apart from the nannies, children and strolling figures. It is as though Monet perceived the scheme of more emphatic tonal contrasts in this picture as masculine, where the smaller oil has a softer, feminine harmony of luminous, more closely integrated tones. This possibility may in turn suggest a way of reading some of his later works, such as the more strongly contrasted tonalities of his 1907 vertical water lily series as compared with the mistier, pastel harmonies of his 1908 series of the same motif [see 78–80].

The male figure in *The Parc Monceau* also turns slightly to the right, inviting the viewer to imagine the park extending beyond the frame, just as the brightness – even rawness – of the bold patches of yellow at the foreground left seems to shift the eye into a different pictorial realm. Did Monet subconsciously identify

with this figure? He must have found the Parc Monceau a welcome surrogate for the beloved artist's garden he had been forced to abandon at the start of 1878 when creditors had evicted the Monets from their home at Argenteuil, yet it would also have offered different challenges, as a larger, grander space. The Monets had settled in Paris only ten minutes walk from the park, and it is possible to imagine Camille Monet, and their baby Michel and young son Jean, amongst the figures at leisure in the two pictures. The effects of filtered and reflected light, meanwhile, are a fascinating herald of Monet's interests in the ultimate artist's garden, his water garden at Giverny.

1. T. Duret, 'Les Peintres impressionistes', Paris 1878, reprinted in Riout 1989, p.217.
2. André 1862, pp.394–5.
3. P. Juillerat, 'Le Parc Monceau', in Silvestre 1897, p.140.
4. Cf Herbert 1988, p.263.

51 Camille Pissarro 1830–1903
The Public Garden at Pontoise, 1874

Oil on canvas 60 × 73cm
The Metropolitan Museum of Art, New York

Originally a private garden created in the eighteenth century by a royal financier called Levasseur de Verville, the garden in this picture was bought by the town of Pontoise in 1820 for public use, and still exists as such today. It was easily reached from the Pissarros' home in the early 1870s. Built on a hillside, partly on Pontoise's medieval defences, it afforded a noted view across the town and the Montmorency plains towards Paris.[1]

With the Prussian occupation of Pontoise during the Franco-Prussian War of 1870–1 still relatively recent, this view must have been especially sweet to its citizens: their own environs once more under their control. In 1873 Pissarro himself had donated a painting of ploughed fields near Pontoise to support *emigrés* from Alsace-Lorraine – the part of France lost to the Prussians.[2] Intriguingly, however, as Brettell has noted,[3] *The Public Garden at Pontoise* includes only a tiny glimpse – just behind the pinnacle of the town's Notre Dame church at the left – of the garden's celebrated view towards Paris. Instead, Pissarro concentrates on a section of the garden's terrace where the view is obscured by a tree-clad outcrop. Nonetheless, he includes people admiring the view, some from railed platforms on the outcrop, as if on theatre balconies, while others stroll or loiter, and schoolboys kick a ball. Touches of pink and cream amid the greenery suggest flowering horse chestnuts, lilac, or rhododendrons. A tall pine tree, intersecting the terrace wall, gives structure to the picture, but modern

decorative horticulture such as flower beds and borders is notable by its absence.[4] In this sense, although it had become a place of bourgeois leisure, the garden complements the old fashioned *jardins potagers* which Pissarro also painted at Pontoise.

Pissarro may have known Manet's *Exposition Universelle* (1867, Nasjonalgalleriet, Oslo) with its viewers placed in a park in the foreground, and he is likely also to have been familiar with Corot's paintings of Florence and Rome where gardens fill the foreground. The point of these works, however, is their juxtaposition of garden and view. In *The Public Garden at Pontoise*, by contrast, it is necessary to imagine what the gazing figures see: a celebration in the town? or fields of sprouting crops? Perhaps they even see a vision of the landscape itself as a garden, just as the utopian socialist Proudhon, much admired by Pissarro, had dreamt of 'the whole of France' becoming one 'vast garden'.[5]

If Pissarro's viewers lead the eye backwards, there is also a witty forward dynamic in the painting. The passive trios of viewers are complemented by the active trio of boys in the centre, who have just sent their ball hurtling forwards into the path of the elegant straw-hatted girl carefully raising her skirt above the dust. Meanwhile, at a slower pace, the woman with the toddler, and the nursemaids with the pram, advance towards us too. Near and far elide, reinforcing the flattened effect created by the steep outcrop. And, like the slender, centralised tree, this effect recalls Japanese prints.[6] Pissarro was in close contact at this time with the Japanophile critic Théodore Duret.

In nineteenth-century France, Japanese art, with its spatial freedom, was popularly associated with political liberty – an idea to which Pissarro perhaps alluded when he described Japan as 'very revolutionary in art' in a letter of 1873 to Duret, an ardent Republican.[7] As a former aristocratic garden, the municipal garden was itself evidence of the social changes brought about by the French Revolution. By leaving it to the viewer to conceive the prospect from it, Pissarro called into mental and visual play the individual liberty which both he and Duret, like Proudhon earlier, regarded as vital in contemporary society.

1. See P&DRS, vol.2, no.309, and Brettell 1990, p.209, note 21.
2. *Ploughed Fields near Osny*, 1873, Private Collection, P&DRS, vol.2, no.290.
3. Brettell 1990, p.209, note 21.
4. It is also absent from Pissarro's other known view of the park, showing its lower level (*The Municipal Garden, Pontoise*, 1873, State Hermitage Museum, St Petersburg, P&DRS, vol.2, no.309).
5. Proudhon 1939, p.281.
6. See Baltimore/Milwaukee/Memphis 2007–8, p.186.

7. Willsdon 2004, p.144; letter no. 20, Pissarro to Duret, 2 February 1873, in JBH, vol.1, p.79.

52 John Singer Sargent 1856–1925
The Luxembourg Gardens at Twilight, 1879

Oil on canvas 73.6 × 92.7cm
Minneapolis Institute of Arts

The American artist Sargent must have walked many times through the Luxembourg Gardens in Paris, just as the well-dressed couple at this picture's centre-left enjoy a balmy evening stroll there. For the seventeenth-century gardens are near to both the Ecole des Beaux-Arts, where Sargent had enrolled in 1874 as a student, and the rue Notre Dame des Champs, where his studio was located. Furthermore, Sargent had in 1877 helped his tutor Carolus-Duran paint an allegorical ceiling painting for the Luxembourg Palace (home of the French Senate) which stands in the gardens.[1]

Despite this official art commission, Sargent was keenly interested in Impressionism, and at the 1876 Impressionist exhibition had met Monet, with whom he was to paint at Giverny in the 1880s. The painting is thus likely at least in part to have been prompted by Impressionist park images such as Monet's recent views of the Tuileries and Parc Monceau [see 49, 50]. Where these capture the effects of summer sunlight, however, Sargent chooses twilight when a rising full moon extends the light of day and makes the Luxembourg Gardens a subtle harmony of pinks, silver, olive green and black, punctuated by occasional notes of red. It is as though he combines the poetic Nocturne theme of Whistler, whose work he also admired, with Impressionism's quintessential interest in the real light and atmosphere of a particular moment and place.

The moon, in reflecting the sun, is itself reflected in the famous Luxembourg *bassin* (formal pool) on which a few children are still sailing their toy boats. Its brilliance and prominence suggest that Sargent may even have been making witty play on the fact that the Luxembourg Gardens lay on the nineteenth-century line of the Paris Meridian – as visitors were reminded by the famous Paris Observatory at the southern end of the gardens, and the garden's meridian siting mark. In this sense, the fashionable couple, walking away from the pool pace out time's measure. For since the dome of the Panthéon can be seen on the horizon above the pool, they must be walking almost exactly along the meridian, which extended north through the gardens from the Observatory. Sargent draws

attention to the couple's line of movement by his low viewpoint, which makes the gardens like a stage for their walk along the path of time.

This suggestive topography, as precisely choreographed as a Degas ballet scene, is complemented by the way the line of the terrace and the position of the couple divide the composition. Such tightly integrated pictorial design is hardly surprising considering the complex foreshortening and placement of figures in relation to architecture in the Luxembourg Palace ceiling decoration, showing Marie de' Medici enthroned above the crowds, to which Sargent had recently contributed. It is certainly fitting that he dedicated this version of *The Luxembourg Gardens at Twilight* – rather than another in which he omitted the Panthéon[2] – to an architect friend, Charles Follen McKim, of McKim, Mead and White, who in 1914 built the original Minneapolis Institute of Arts, the picture's present owner.

1. *The Triumph of Marie de' Medici*, now in the Louvre; reproduced in London/Washington/Boston 1998–9, p.24.
2. *In the Luxembourg Gardens*, 1879, Philadelphia Museum of Art; see ibid., pp.84–5.

53 Maurice Prendergast 1858–1924
The Luxembourg Gardens, Paris, 1890–4

Oil on canvas 32.7 × 24.4cm
Terra Foundation for American Art, Daniel J. Terra Collection, Chicago

The Luxembourg Gardens in Paris, created in the seventeenth century for Marie de' Medici's palace, still retain their historic formal layout inspired by the Boboli Gardens in Florence, of tree-lined paths and a balustraded terrace enclosing an octagonal pool. What the American artist Maurice Prendergast's painting shows, however, is a slice of contemporary life. Nursemaids with babies rest on slatted benches and children play whilst their nannies gossip. The scene could almost be a blueprint for that in André Gide's Modernist novel of 1925, *The Counterfeiters*, where the fictitious writer Lucien outlines his latest project as he walks with a friend in the gardens: 'What I would like to do … is to tell the story not of a person, but of a place, – well, for example, of a garden path, like this one here; to recount what goes on there – from morning through to night. First children's nannies would come there, nursemaids with ribbons … '.[1]

Gide enjoyed walking in the Luxembourg Gardens in his youth, and Prendergast evokes exactly his sense of its regular attenders as generic types, rather than specific individuals. On arriving in

Paris in 1890 to train at the Académies Julian and Colarossi, Prendergast had adopted the technique of the *pochade* (rapid oil sketch), derived from the Impressionist ideal of capturing the fleeting moment. In *The Luxembourg Gardens, Paris*, this reduces faces to patches of pink and the nursemaids' charges to ciphers of cream, pink and green. Whilst he follows Impressionist interest in figures at leisure in parks, his nannies and nursemaids stand for all nannies and nursemaids, and his children for children as such. Together with his dramatic compositional sweep from near to far, this produces a strongly decorative quality which already looks beyond Impressionism. Prendergast was much impressed by the avant-garde Nabis exhibitions at the Barc de Bouteville Gallery in Paris from 1891, and the pattern of interlocking representative shapes in *The Luxembourg Gardens, Paris* of rounded tree and leaf-forms, children's hoops, and the nursemaids' almost identical floral hats, for example, compares with similar effects in the Nabis work of Bonnard and Vuillard.

After returning to America in 1894, Prendergast developed an even more overtly decorative style in paintings of the Boston and New York parks. In *The Luxembourg Gardens, Paris*, however, with its terrace and path catching the late summer sunshine, the symbolic and the decorative are held in balance with a quintessential Impressionist delight in the distinctive atmosphere and lighting of a particular moment. There are already autumnal leaves; all too soon the trees will become golden, and the children will have to run to keep warm. For now, however, the grass is still lush and only a few leaves have fallen – just as the Impressionist garden stands here at the threshold of its Post-Impressionist successor.

1. A. Gide, *Les Faux-Monnayeurs*, excerpted in Barozzi 2006, p.101.

54 Federico Zandomeneghi 1841–1917
The Place d'Anvers, 1880

Oil on canvas 100 × 135cm
Galleria d'Arte Moderna Ricci Oddi, Piacenza

Although part of Napoléon III's great scheme of parks and gardens, begun in 1852, to embellish Paris and improve its hygiene, the Place d'Anvers was not actually opened to the public until 1877, just a few years before the expatriate Italian artist Zandomeneghi captured its sunny tranquillity in this bold and colourful picture. Situated just off the Boulevard Rochechouart, not far from the Café des Nouvelles Athènes in Pigalle where Degas and Manet famously held court in the 1870s and early 80s, it was one of the

London-inspired squares which Napoléon intended as green lungs for less well-to-do areas. 'Before the establishment of the Paris squares, the existence of a great number of children was passed in confined and unwholesome districts … ', the press had reported approvingly,[1] and Zandomeneghi shows the Place d'Anvers as a veritable province of children, skipping and playing beside their nursemaids or, like the boy at the left standing between the back and seat of a bench, engaging in some private imaginative game.

Zandomeneghi was a close friend of Degas, who invited him to exhibit with the French Impressionists from 1879. *The Place d'Anvers* was his main work in their 1881 exhibition, and its petit bourgeois garden, ornamented only by formal rows of young trees and relatively modest beds of flowers, contrasts tellingly with the lush and fashionable Parc Monceau, the playground of the well-to-do, which Monet had painted a few years earlier. This choice of motif reflects Zandomeneghi's close association with Degas's Realist group at the Café des Nouvelles Athènes, as well as being a reminder that the Italian Macchiaioli with whom he had started his career had drawn important inspiration from the early French socialist thinkers Proudhon and Champfleury.[2] Nursemaids gossip in the shade at the right, a woman at the left uses an ordinary black umbrella as a makeshift parasol, and two lovers lean on the railings nearby, tactfully ignoring a nursemaid with a child who appears to have been caught short. Nobody stands on ceremony in this garden, and there is a corresponding frankness in the contrasts of bright light and luminous shadows, and the clean, bold colours and lines of the arresting, almost decorative composition.

In 1889, a statue of *Armed Peace* was to be installed in the Place d'Anvers, a response perhaps to growing calls for *Revanche* (revenge) for the Prussian defeat of France in 1871.[3] But, in 1880, the sunny tranquillity of Zandomeneghi's square celebrates the here and now. The painting offers a firmly upbeat vision of modern society which corresponds very closely with the ethos of the new left-wing 'Republican Republic' with which Zandomeneghi's Impressionist colleagues sympathised.

1. 'M.R. Mitchell in the "Constitutionnel"', quoted in Robinson 1869, p.87.
2. Olson 1992, p.29.
3. See Thomson 2004, chapter 4.

55 Marco Calderini 1850–1941
Winter Sadness, 1884

Oil on canvas 125 × 230cm
Galleria Nazionale d'Arte Moderna, Rome

This close-toned harmony of browns, ochres, greys and blues by the Italian artist Calderini shows the Royal Gardens at Turin. With its bare hedge and trees, empty seats, and stone memorial urns, the work could almost illustrate the evocation of winter by his period compatriot, the poet Giovanni Pascoli: ' … the thornbush is dry, and the stick-like plants mark the heavens with black designs, and empty is the sky, and the earth seems hollow, echoing to the step. / Silence, around … a brittle falling of leaves. It is the summer, cold, of the dead.'[1]

Calderini was one of the artists associated with the rise of Turin Impressionism who, working in Piedmont in northern Italy, also fell heir to the region's historic relationships with France. The Royal Gardens in Turin were in fact laid out in the seventeenth century by the French designer André Le Nôtre, and Calderini's viewpoint heightens the elegant outline of the formal pool in the foreground, capturing a decorative pattern of delicate reflections in the water. The formal park becomes a thing of modern beauty, and also of expression. Calderini had been a star pupil of the artist Antonio Fontanesi, the first incumbent of the Chair of Landscape Painting at the Accademia Albertina in Turin, who had known Corot and Daubigny and emphasised their doctrine of painting as sentiment. Corot's liking for screens of trees certainly seems to resonate in the dignified line of silhouetted trunks behind the pool in *Winter Sadness*, subtly varied by one leaning tree and one much smaller tree. Placed at the picture's centre, and suggestively juxtaposed with one of the urns, this vulnerable, smaller tree might almost stand for Calderini's friend Francesco Mosso. A fellow-pupil of Fontanesi, Mosso had died prematurely a few years previously, and *Winter Sadness* dates from the same year as a memoir of him by Calderini.[2]

Winter Sadness was part of a series of paintings by Calderini of the Royal Gardens in Turin under different seasonal conditions, and was exhibited at the 1884 Turin International Exhibition, and the great Italian Exhibition of 1888 in London. Calderini's younger colleague the Turin Impressionist Enrico Reycend also painted the Royal Gardens, using broader brushwork, but it is tempting to think that the evocative association of sentiment, site and stylish design in *Winter Sadness* was in the mind of the eminent twentieth-century art historian Roberto Longhi when he wrote of the 'carefully cultivated "royal garden" of Piedmontese landscape painting'.[3]

1. Giovanni Pascoli, *Novembre*, as translated in G. Kay (ed.), *The Penguin Book of Italian Verse*, Harmondsworth 1965, p.327.
2. Majo/Lanfranconi 2006, p.302.
3. Enrico Reycend, *The Royal Gardens in Turin*, Galleria d'Arte Moderna, Turin; Longhi, cited in Olson 1992, p.87.

56 William Merritt Chase
1849–1916
In the Park. A By-path, c.1890

Oil on canvas 35.5 × 49cm
Carmen Thyssen-Bornemisza Collection, on loan to the Museo Thyssen-Bornemisza, Madrid

Chase has been called 'the first American painter to create Impressionist works in the United States'.[1] He trained at the Munich Academy, adopting the realism of Wilhelm Leibl as did Fritz Schider. Unlike Schider's convivial *The Chinese Tower at the English Garden in Munich*, however, *In the Park* – showing Central Park in New York – is here almost devoid of human presence. The only figures are Chase's wife on a bench in the background, and his young daughter Alice, walking towards her unseen father at his easel. The composition is dominated instead by the shaded, empty path and the massive, rough stone wall which contrasts with Alice's clean, white dress. This wall was part of the foundations of the former convent of Mount Saint Vincent at Central Park's north-eastern corner,[2] but Chase makes no allusion to this aspect of its history.

This choice of a seemingly insignificant motif is consistent with Leibl's teaching. However, the sense of design created by the empty foreground now also brings to mind both the art of Degas, and Japanese prints, which Chase collected. Chase had visited Paris in 1881, meeting Cassatt and helping to secure the first works by Manet for an American collection, and over the following decade he developed a close familiarity with French Impressionism through further visits to Europe. *In the Park* is one of a series of views he painted of Central Park, just as Monet had painted Parisian parks. Together with Chase's Brooklyn Park views of the 1880s, these formed a new motif in American art. In 1889 the American critic Kenyon Cox had called them 'little jewels … Let no artist complain again of lack of material, when such things as these are to be seen at his very door'.[3]

The low viewpoint of *In the Park* vividly evokes the native character of Central Park, as the earliest of the great landscape parks in American cities. These sought the moral and physical improvement of the populace through contact with nature. Created by Frederick Law Olmsted and Calvert Vaux

from 1857, Central Park drew inspiration from landscaped gardens such as the Bois de Boulogne in Paris and Windsor Park in Britain, and some of its trees and shrubs were actually imported from Britain.[4] It preserved the rocky outcrops of its original site – one is shown in the background of Chase's picture – and was valued for 'the rest [it] give[s] to eyes and mind, to heart and soul'.[5] In this sense, the solitude and silence of *In the Park* are a celebration of the inherent character of its motif – a piece of American wilderness constructed in the heart of New York.

1. Giverny 1992, p.74.
2. K.W. Maddox, *In the Park. A By-path*, at http://www.museothyssen.org/thyssen_ing/coleccion/obras_ficha_texto_print243.html.
3. Kenyon Cox, 'William M. Chase, Painter', in *Harper's New Monthly Magazine*, vol.78, March 1889, cited in ibid.
4. Roper 1983, p.147.
5. Period writer quoted in R.G. Pisano, *Idle Hours: Americans at Leisure 1865–1914*, Boston/Toronto/London 1988, p.57.

57 Paul Gauguin 1848–1903
Skaters in Frederiksberg Gardens, 1884

Oil on canvas 65 × 54cm
Ny Carlsberg Glyptotek, Copenhagen

This is the first of three seasonal views of Copenhagen's parks which Gauguin painted early in his career whilst working in the city as a commercial agent, before turning to art full-time.[1] Frederiksberg Gardens, beside Frederiksberg Palace, were originally designed in formal Baroque style but were converted to an English landscape park around 1800, when they were also first opened to the public. The gardens were very close to the family home of Gauguin's wife Mette, who was Danish. Whilst the varied patterns of the winter trees in the painting are a logical sequel to the screens of trees often favoured by Pissarro, with whom Gauguin had painted at Pontoise, there is a sense of the smallness of man in the face of nature's grandeur which marks a departure from Pissarro's more domestic imagery. The massive tree at the left dwarfs the man walking nearby, just as that in the foreground towers before the skaters, one of whom has fallen over, and is being helped by a companion. If nature has the upper hand, it was certainly the distinctive forms taken by individual trees which Gauguin was to cite the following year when, seeking to move beyond Impressionism, he set out a new Symbolist vision of individual lines and colours as expressive of emotions.[2]

In this context, it is perhaps worth remembering that it was a garden – his uncle Zizi's in Orléans – where Gauguin

had already shown strong emotions himself, as a child. 'Stamping his foot and throwing the sand about', as his uncle recalled, he had staged tantrums there, but he had also dreamt there 'in silent ecstasy, beneath a nut-tree'.[3] Such reverie anticipates Gauguin's eventual definition of art as a symbolic 'abstraction' which the artist must 'draw ... forth from nature by dreaming before her'.[4] Although rendered with small, impressionistic brushstrokes, and based on a real phenomenon, the red carpet of leaves in *Skaters in Frederiksberg Gardens* offers an early pointer to the abstract red field of Gauguin's first major Symbolist work, *The Vision of the Sermon* (National Gallery of Scotland, Edinburgh), just as the leaning tree tentatively prefigures that which separates real from imagined worlds in the same work. Working in the idiom and tradition of Impressionism, Gauguin seems in *Skaters in Frederiksberg Gardens* already to be experimenting in the context of observed nature with directions his art was to take from the later 1880s. He was to write in his Symbolist phase of seeking 'a perfect vermilion',[5] and the picture includes streaks of pure vermilion amongst the greens, browns, greys, and blues of the branches and tree trunks. Equally, the red, pink, yellow and orange strokes making up its red ground are interspersed with touches of green, so that the picture vibrates as if its carpet of leaves was one of the Oriental rugs whose juxtaposed colours Gauguin called 'so marvellously eloquent'.[6] It is as though, amongst the dead leaves of Frederiksberg, the first seeds of Gauguin's exotic Eden – his colourful, Symbolist vision of Tahiti – were already being planted.

1. The other views are *Oestre Anlaeg Park*, 1885, Kelvingrove Art Gallery, Glasgow and *The Queen's Mill, Oestervold*, 1885, Ny Carlsberg Glyptotek, Copenhagen.
2. Letter to Emile Schuffenecker, January 1885; see Fort Worth/Ordrupgaard 2005–6, p.227.
3. Recollection by Gauguin, quoted in Ursula Frances Marks-Vandenbroucke, 'Gauguin – ses origines et sa formation artistique', *Gazette des beaux-arts*, ser. 6, vol.47, 1956, p.29.
4. Comment by Gauguin to Schuffenecker, 1888, quoted in Wildenstein 2002, vol.2, p.435.
5. P. Gauguin, 'Natures Mortes', in *Essais d'Art libre*, January 1894, p.273 as quoted in Wildenstein 2002, vol.2, p.437.
6. *Synthetic Notes*, as translated in Harrison/Wood/Gaiger 2003, p.996; see also Fort Worth/Ordrupgaard 2005–6, p.231.

58 Alfred Sisley 1839–1899
Winter at Louveciennes, 1876

Oil on canvas 59.2 × 73cm
Staatsgalerie, Stuttgart

Sisley appears to have settled in 1871 at Louveciennes, a village some seventeen kilometres west of Paris, and he remained there or at neighbouring Voisins for much of the next decade. Looking towards the village church across walled gardens filled with fruit trees, *Winter at Louveciennes* evokes a very different scene, however, from that described by his contemporary, the playwright Victorien Sardou, who also lived near Louveciennes and delighted in its 'little houses lost amongst the foliage ... the most delightful contrasts of light and greenery ... these thousands of country scents ... the open sky ... the freedom of the wind ... the cry of the bird ... the clucking of hens ... the sound of a distant hammer on the anvil ... the murmur of children in school or that of bees in the hive'.[1] In place of the colour and activity which for Sardou, author of *Tosca*, was the essence of Louveciennes, Sisley presents a close-toned harmony of whites, greys, blues and blacks which powerfully evokes the silence and stillness of the dead season. The figures make their way laboriously through the deep snow, and in the frozen gardens the twisted forms of the trees are blurred by its soft, thick mass. The dormant vista is a reminder that Impressionism was not only a movement concerned with colour, light, the stirring of life in spring and the saturated effects of midsummer heat, but also one which could convey the sentience of winter – the crispness of footfall, the chill of the air, and the loneliness of the traveller – and perhaps even reinvent the emotional numbness and 'frozen tears' of Schubert's Romantic *Winterreise* song cycle.

However, the twisted forms of the fruit trees, like the figures moving in different directions, and the zigzag line of the snow on the garden walls, lend some animation to the picture. The eye is led to the huddle of houses on the hillside and the spire which echoes the verticals of the tall trees at the right, which presumably belong to the garden of one of the large mansions of the village. Their height emphasises the small size of many of the fruit trees. It was only in relatively recent times, as a result of the ravages of vineyards by mildew and the *Phylloxera* insect, that the traditional culture of wine-growing in this part of France had given way to fruit production.[2] The composition of the picture is in fact reminiscent of that of Constable's *The Cornfield* of 1826, with its zigzag of light and shadow in the middle distance. Sisley, who was half-British, would have known this picture well from his visits to the National Gallery in London, and *Winter at Louveciennes* could certainly be described by Constable's famous dictum 'I should paint my own places best'.[3] The very stillness of the scene creates a subtle mood of anticipation; the gardens at the centre provide a hint that, with time, the white of the snow on the trees will be replaced by that of blossom, so that both the world described by Sardou, and that evoked in Constable's *The Cornfield*, will again come into being.

1. Sardou, 'Louveciennes et Marly', preface to *Promenades autour de ma maison*, quoted in Palewski 1968, p.10.
2. See ibid.; Phlipponneau 1956, p.64; and *Encyclopaedia Britannica* 11th edition, 1911, vol.21, pp.547–8 and vol.28, pp.94–5.
3. London/Paris/Baltimore 1992–3, p.9; Constable, letter to Fisher, 23 October 1821, in Harrison/Wood/Gaiger 2003, p.118.

59 Camille Pissarro 1830–1903
Kitchen Gardens at L'Hermitage, Pontoise, 1874

Oil on canvas 54 × 65.1cm
National Gallery of Scotland, Edinburgh

It would be hard to imagine from this tranquil, early autumn scene, with its ordered cycle of harvesting, preparation for market, and ploughing, that the preceding months had been a roller coaster of emotions and crises for Pissarro. In April 1874 his beloved daughter Jeanne had died, aged only nine, but in July, his wife had borne a son, whom they hopefully named Félix. Despite good prices for his work in January 1874, a crash in the French economy and hostile reactions to his work at the Impressionists' first group exhibition in April-May, had, by the autumn, left him virtually bereft of buyers. Pissarro later recalled that 'around 1874', after his friend the critic Théodore Duret had told him he was 'on the wrong path ... I sounded myself out, the situation was critical. Should I, yes or no, persevere (or set out) on a completely different path. I concluded that I should.'[1]

Kitchen Gardens at L'Hermitage was completed just before Pissarro embarked on his new path by leaving Pontoise in October 1874 for an extended stay in Brittany, to focus on what Duret regarded as his strong point – 'the association of man and animals in an open air landscape'.[2] This work, with its central figure ploughing, and its peasants loading produce for market into a basket on the back of a donkey, looks forward to this new emphasis. At the same time, however, as if in determined defiance of the critic Castagnary's complaint at the Impressionist exhibition at the artist's 'deplorable fondness for market gardens', and refusal to 'shrink from any depiction of cabbages or other domestic vegetables',[3] Pissarro places a bed of blue-green cabbages right in the centre foreground. These map a partial triangle, whose apex, when projected, lies suggestively in the ploughman's hips. This triangle is echoed by the blue roof beyond whose red chimney implies a hearth and cooking pot. Traditional rural gardens like those at L'Hermitage fed their peasant owners first, and only what remained was sold. This imagery of rural self-sufficiency can be related to the utopian ideals of the socialist Pierre-Joseph Proudhon, who was much admired by Pissarro.[4]

However, it is also clearly part of what Pissarro called a 'unity' or 'harmony' in art.[5] The soft blue-violet shadows of the cabbages, imbued with reflected light, link visually with the blue sky, roofs and peasants' aprons, as well as with the acid green vegetables and fence to the right. The golden corn introduces a contrasting group of warm colours – rich browns and red roof – whilst little buff-coloured areas provide a bridge between cool and warm notes. This careful harmonising of colours was to be developed in works such as Pissarro's *The Côte des Boeufs at L'Hermitage* [64].

If *Kitchen Gardens at l'Hermitage* was both a transitional work in Pissarro's oeuvre, and a richly suggestive harmony, it was surely also one of his most personal works. He loved the autumn, considering its golden light and changing colours far more interesting than what he later described as the 'solid monotonous green' of summer.[6] In the context of his own uncertain market prospects in 1874, he must have relished the age-old rhythms of the Pontoise peasants' horticulture, and projected into their labours his own discovery that 'in the joy of working I forget and am even unaware of all the sadness, all the bitterness, all the pains'.[7] Fittingly, this comment was published by Octave Mirbeau, the left-wing writer and a friend of Pissarro, on the occasion of the first exhibition of *Kitchen Gardens at L'Hermitage, Pontoise*, at the great retrospective exhibition in 1904 which followed the artist's death.

1. Letter to Lucien Pissarro, 9 May 1883, JBH vol.1, letter no.145, p.203, as translated in P&DRS vol.1, p.147.
2. Letter to Pissarro in Fritz Lugt Collection, Institut Néerlandais, Paris, quoted in P&DRS vol.1, p.147.
3. J. Castagnary, 'Exposition du boulevard des Capucines: Les Impressionistes', in *Le Siècle*, 29 April 1874, p.3, in Berson 1996, vol.1, p.16 (as translated in P&DRS vol.1, p.143).
4. See Willsdon 2004, pp.193–4 and Shikes/Harper 1980, p.67.
5. Letter to Esther Isaacson, 5 May 1890, in JBH vol.2, no.587, p.349 ('unity'); letter to Lucien Pissarro, 5 May 1891, in JBH vol.3, no.658, p.72 ('harmony' as an ideal he admired in Monet's art); see J. House, 'Camille Pissarro's idea of unity' in Lloyd 1986, pp.15–34, and J. Pissarro, 'Camille Pissarro's Vision of History and Art', in P&DRS vol.1, pp.62–3.
6. Letter to Lucien Pissarro, 15 September 1893, JBH vol.3, no.930, p.368; see also London 1990, p.10.
7. Quoted by O. Mirbeau in 'Préface' to *Catalogue des oeuvres de Camille Pissarro exposées chez Durand-Ruel du / au 30 avril 1904*, reprinted in Mirbeau 1990, p.205.

60 Alfred Sisley 1839–1899
The Fields, 1874

Oil on canvas 46 × 61cm
Leeds Museums & Galleries (Leeds Art Gallery)

Stéphane Mallarmé, describing Sisley's art, said that 'Sisley seizes the passing moments of the day; watches a fugitive cloud and seems to paint it in its flight; on his canvas the air moves and the leaves yet thrill and tremble. He loves best to paint them in spring … or in autumn; for then space and light are one, and the breeze stirring the foliage prevents it from becoming an opaque mass, too heavy for such an impression of mobility and life.'[1] One of the earliest appreciations of the artist's work, this was published two years after The Fields, but exactly sums up this airy picture, whose fields are actually some of the market gardens of the Louveciennes region near Paris. As Sisley was in London from July to October 1874, the scene portrayed must be late spring or early summer. Although a variety of crops are flourishing in the pinkish, sun-warmed earth, the stakes which poke into the scudding clouds are still largely bare, awaiting the growth of the plants – perhaps peas or beans – they are meant to support.

If, for Mallarmé, Sisley's fleeting effects of atmosphere were paramount, in The Fields these are intriguingly allied to a motif which in itself bears witness to the rapidly changing nature of horticulture at this period in the Ile-de-France. For the traditional peasant smallholding of a few rows of vegetables and a fruit tree or two behind a house – the kind portrayed in Pissarro's Kitchen Gardens at L'Hermitage, Pontoise – was giving way to larger commercial operations like that shown here by Sisley. The produce of these new market gardens fed the burgeoning population of Paris, and, from 1870, had to compete with the ever greater volumes of fruit and vegetables which arrived there every day by the new Paris-Nice railway.[2] The market gardens often utilised modern, scientific advances, such as the new fertiliser described in Bouvard et Pécuchet, Flaubert's famous satire of two city clerks trying their hand at modern agriculture, but the mature spreading tree at the left of Sisley's picture speaks of continuity and what the French call la durée (the span of time). Sisley's imagery, in short, represents a complex alliance of the old, the new and the transient, just as his technique combines careful preliminary underdrawing in black chalk – visible in the tree and foreground vegetables – with vigorous brushwork which suggests the spontaneous response to sensations so admired by Mallarmé.

1. Mallarmé, 'The Impressionists and Edouard Manet', in The Art Monthly Review and Photographic Portfolio, vol.1, no.9, 30 September 1876, in Berson 1996, vol.1, pp.95–6.
2. See Edinburgh 1986, Williamstown 1985 and Vienna 2007, p.153.

61 Arthur Melville 1855–1904
A Cabbage Garden, 1877

Oil on canvas 45.5 × 30.5cm.
National Gallery of Scotland, Edinburgh

Like James Ensor in Belgium, the Scottish painter Arthur Melville developed a native counterpart to Impressionism's contemporary life subjects and effects of light and atmosphere. Although familiar with the Dutch Impressionism of the Hague School, and works by Corot and Daubigny – all collected in Scotland from an early date – Melville first went to France in 1878, the year after he painted A Cabbage Garden. It was while visiting Spain in 1891 that he embraced the full brilliance of sunshine, in virtuosic watercolours. Yet the play of sunlight on the thrusting young cabbages and the basket in the foreground of A Cabbage Garden already reveals a concern with the present moment which is essentially impressionistic, as is the looseness of handling of the figures and background.

There is also a vigorous sense of the horticultural moment. It is late summer; a cottar (hired worker), or perhaps a smallholder, is pausing from hoeing a maturing cabbage garden in Melville's native East Lothian to acknowledge a young woman with a basket, who may perhaps be seeking its produce. The cabbages will have been sown in May and transplanted in June. Now, as they reach their prime, the gardener is performing the late summer task of taking out the weeds which have grown with them. Their shape implies they are one of the many drumhead varieties cultivated in the nineteenth century for late summer harvesting, such as Wellington, Great Drum, or – especially fitting – the coincidentally named Melville's Hybrid. As the art historian Laura Newton has noted, the gardener is 'rooted' in his cabbage patch, as much a part of the garden as the vegetables are.[1] This is only logical, as horticulture had long been established in East Lothian. Although cabbages, as brassicas, were native to Scotland, trade between the east of Scotland and the Low Countries had enriched East Lothian gardens with more edible continental varieties. Port records show that from the late seventeenth century over a hundred tons of brassica seed were shipped each year to the east coast of Scotland.

A native of East Lothian, John Reid, wrote the first Scottish gardening book, The Scots Gard'ner (1683), whilst another, John Abercrombie, was responsible in the eighteenth century for numerous horticultural publications, including the great Gardener's Calendar, which went through more than twenty editions.[2] Melville's picture does not show a timeless arcadia, like Corot's Souvenir d'Italie – one of the French paintings in Scottish hands in the nineteenth century[3] – but it clearly celebrates a heritage and way of life which largely escaped the agricultural depression experienced at the period in many other parts of Scotland. In this sense, its garden is as much a place of harmony and well-being as those of Pissarro at Pontoise or Van Gogh at Arles.

1. L. Newton, 'Cottars and Cabbages: Issues of National Identity in Scottish "Kailyard" Paintings of the Late Nineteenth Century', in Visual Culture in Britain, vol.6, no.2, 2005, p.56.
2. I am grateful to David Mitchell for this information on East Lothian horticulture.
3. Bought by J. Forbes-White; now in Kelvingrove Art Gallery, Glasgow.

62 Camille Pissarro 1830–1903
The Artist's Garden at Eragny, 1898

Oil on canvas 73.4 × 92.1cm
National Gallery of Art, Washington DC

Pissarro and his family lived in the village of Eragny on the Epte from 1884 until his death in 1903. Although he complained in 1892 that they had 'far too much garden' there for his wife Julie, who tended it, and 'has moaned about it often enough',[1] the Pissarros' relative impecunity made such a garden essential. Hens occupied one part, and vegetables with some fruit trees grew in the area shown in this painting. Julie is probably the figure planting seeds near a bundle of sticks for supporting peas or beans. The house portrayed belonged to a neighbour.

However, The Artist's Garden at Eragny also shows a border of flowers suggestive of dahlias in their form and foliage, a reminder that, as a former florist's assistant, Julie liked to cut bouquets for the house – the inspiration for Pissarro's still lifes. Pissarro himself wrote from Eragny in May 1898, after a period of intensive work in Paris on his views of the grand boulevards, that 'I'm so happy to be able to breathe a bit of the air here and see some greenery and flowers.'[2] Though probably begun the previous year, when Pissarro was in Eragny at the late summer period suggested by the plants, The Artist's Garden is surely the visual counterpart to this comment.

A letter Pissarro wrote at Pontoise in 1877 after a premature frost certainly reveals a keen affection for flowers, and even ascribes feelings to them: 'the trees, sky, sun are changing, passing from exuberant gaiety to melancholy … The day before yesterday I was enraptured by the dahlias in our flower-bed, since then the frost has burnt them, the leaves are limp all black, the flowers have only a remnant of beauty, they seem struck with consternation.'[3] There is a similar sense of personal identification with nature in this work, which clearly celebrates Julie as the garden's genius. The leaves and flowers shimmer like jewels, as light from the high, midday sun bounces off them, whilst Julie occupies the same axis as the tall sunflowers nodding above her. Rooted by her shadow to the sun-warmed soil, she realises the description by Pissarro's friend the writer Octave Mirbeau of the figures in his paintings as 'human plants.'[4]

Earlier in the 1890s, Mirbeau had sent the Pissarros many gifts of plants from his own splendid garden at Les Damps, not far from Eragny. Some of the flowers in The Artist's Garden at Eragny perhaps originated from these gifts, which included dahlias and also sunflowers (Helianthus annuus) like those in the picture.[5] Other flowers portrayed were perhaps descended from the Pontoise dahlias or even from plants in Monet's garden; irises from Giverny rhizomes were grown well into the twentieth century by Pissarro's family.[6] In this sense, The Artist's Garden at Eragny evokes memories and friendships as well as summer and Julie.

1. Letter to Lucien Pissarro, 20 May 1892, JBH vol.3, no.786, as translated in P&DRS vol.1, p.236.
2. Letter to Lucien Pissarro, 2 May 1898, JBH vol.4, p.478, as translated in P&DRS vol.1, p.282.
3. Letter to Eugène Murer, 13 October 1877, JBH vol.1, p.106.
4. O. Mirbeau, 'Camille Pissarro', in L'Art dans les deux mondes, 10 January 1891, reprinted in Mirbeau 1990, p.194.
5. Letter from Mirbeau to Pissarro, 11 February 1893, in Mirbeau 1990, no. 61, p.142.
6. Preface by 'La famille [Pissarro]' to JBH vol.2.

63 Paul Cézanne 1839–1906
The Hermitage at Pontoise, 1881

Oil on canvas 46.5 × 56cm
Von der Heydt-Museum, Wuppertal

Cézanne often painted at Pontoise with Pissarro in the 1870s, and produced this picture when he spent summer 1881 in its ancient Hermitage quarter, living in the same street as Pissarro. It shows the Jardin de Maubuisson, a collection of traditional kitchen plots behind their homes, and is a reprise of a motif Pissarro had painted around 1867 (Le Jardin de Maubuisson, Národní Galeri, Prague). However, where Pissarro had created a vista of sun-warmed earth worked by peasants, from which lines of cabbages and a thickly-planted orchard form a transition to the steeply rising hillside, Cézanne includes no human activity, and all but omits the

orchard. His painting divides into two, the horizontal receding plane of the Jardin de Maubuisson, and the vertical plane of interlocking shapes formed by the houses on the hill, whose light colours and red roofs advance towards us, flattening the composition. If Cézanne saw the great formal tree-lined avenues of Versailles whilst at work on the picture – he made a brief visit there in summer 1881 to watch the fountains playing[1] – he seems almost wilfully to emphasise the awkwardness of the path or low wall which forms a line of pinkish colour at centre right. This does not diminish in width as it recedes but might almost be a strip of paper stuck to the picture's surface. Such an apparently arbitrary treatment of planes anticipates some of the effects in Cézanne's late work which so interested the Cubists, yet the composition remains unresolved without, for example, the branches cutting across the foreground which connect near and far in some of Cézanne's views of Mont Saint-Victoire.

Cézanne in fact wrote from Pontoise in 1881 to his friend Emile Zola that he was 'working a little but with much indolence', and the picture is clearly unfinished.[2] Bare canvas is visible between the horizontal strokes of green enlivened with touches of blue which block in the Jardin de Maubuisson. These horizontal strokes nonetheless create a decorative contrast with the vertical dabs representing the tree foliage and the irregular curves and diagonals of the haphazard trunks; the outlines round the buildings provide further linear accents. The result is a weft of colours and exposed canvas grain which already brings to mind Cézanne's friend Gustave Geffroy's comparison of his paintings with 'the muted beauty of tapestry', as well as Cézanne's own later comment that 'one must be a worker in one's art … Make use of coarse materials'.[3] It is almost as though the 'tapestry' of brushstrokes, evincing the work of the artist, takes the place of the work of the gardeners which has been so conspicuously omitted from the scene.

Cézanne left the picture with Pissarro at the end of the summer of 1881, perhaps with the intention of taking it up again the next summer, but he never did so. *The Hermitage at Pontoise* remains a fascinating unresolved document of Cézanne's final stay in Pontoise, which follows in the tradition of his colleague's kitchen garden imagery, yet already reaches out to the emphasis on structure and design which was to characterise his mature work in the south of France.

1. See letters from Cézanne to Zola, 20 May and June 1881, in P. Cézanne, *Correspondance* (ed. J. Rewald), Paris 1978, pp.200–1.
2. Quoted in J. Rewald, *The Paintings of Paul*

Cézanne: a catalogue raisonné, vol.2, *The Plates*, New York 1996, p.327.
3. Geffroy, 'Paul Cézanne', in *Le Journal*, 25 March 1894, as translated in London/Paris/Philadelphia 1995–6, p.32; Cézanne as cited in E. Bernard, 'Paul Cézanne', in *L'Occident*, July 1904, as translated in ibid., p.38.

64 Camille Pissarro 1830–1903
The Côte des Boeufs at L'Hermitage, Pontoise 1877

Oil on canvas 114.9 × 87.6cm
The National Gallery, London

An orchard, where horticulture yields the sweet delights of fruit, is one of the most evocative and ancient kinds of garden. Egyptian frescoes show fruit trees bordering fishponds; Homer described a perpetually self-renewing *orchatos*;[1] and the Greek poet Longus wrote in *Daphnis and Chloë* of his own 'beautiful orchard … so thickly planted with trees … you would call it a forest'.[2]

Pissarro and his son Lucien illustrated *Daphnis and Chloë* in the 1890s, as did Emile Bonnard. In this painting, there is neither the sensual langour of these later works, nor the mature flowering trees of many of Pissarro's other orchard pictures. Instead, the painting shows an infant version of Longus's 'thickly-planted … forest' of fruit-trees, protected by a windbreak of soaring poplars, and crowned with pinky-ochre blossom. A few older trees weave an intricate linear pattern, but they bear no leaves or blossom; the future lies with the young ones. The theme of renewal continues in the hamlet – Pissarro's home of L'Hermitage in Pontoise – which includes modern, red-roofed houses.

The Côte des Boeufs at L'Hermitage, Pontoise was one of three large garden paintings by Pissarro included in the 1877 Impressionist exhibition. The others show ornamental flower gardens,[3] probably inspired by Monet's recent 'Decorative Panel' of his garden at Argenteuil which was in the Impressionists' exhibition of the previous year.[4] In this painting, however, motif and format are especially closely interlinked. As Pissarro's young trees look to future harvests, assuring the orchard's continuity, so decorative or monumental painting is typically intended to endure; to adorn a building for posterity, or, at the least, address generations still to come. Whilst the linear patterns formed by the older trees encourage the picture to be read as a decorative design, the imposing scale lends an almost philosophical dimension to the renewal portrayed – an interpretation encouraged by the two figures at the left in contemplative pose.

Renewal is even conveyed by the painting's surface, for this is encrusted

with successive layers of paint, and recent conservation studies have revealed an elaborate process of painting and re-painting over time.[5] For all its evocation of fleeting sensations – the fresh spring breeze, the warming sunshine – the picture was clearly a richly deliberative work, which looks forward to the close association between garden motifs and decorative or mural painting in later Impressionism, notably in Monet's water lily murals.

With this in mind, it is understandable why *The Côte des Boeufs at L'Hermitage, Pontoise* was displayed at the 1877 Impressionist exhibition as the partner to Renoir's seemingly very different *Ball at the Moulin de la Galette* [fig 8],[6] with its utopian vision of artists dancing in harmony with artisans in the garden of a Montmartre restaurant. Murals were being used by the Third Republic government in France to express its social ideals, and Renoir proposed that his work would make a suitable decoration for a public building.[7] Did Pissarro intend *The Côte des Boeufs at L'Hermitage, Pontoise*, at least on one level, to be a similar statement of belief? Peasant horticulture was certainly associated with radical Republicanism by the writer Jules Vallès in the 1870s,[8] whilst poplars – the trees which protect the young orchard in the painting – were famous as the historic emblem of the people in the 1789 and 1848 Revolutions. And Pissarro had close contact at Pontoise in the 1870s with the radical Republican deputy Maria Deraismes, whose flower garden is in fact that shown in one, if not both, of his other large garden paintings in the 1877 exhibition. In the event, neither Renoir's *Ball at the Moulin de la Galette* nor Pissarro's *The Côte des Boeufs at L'Hermitage, Pontoise* attracted a government purchaser – but something of the latter painting's character was surely grasped by Renoir's friend Georges Rivière when he described Pissarro's work in the 1877 exhibition as having 'epic dignity'.[9]

1. Homer's *orchatos* occurs in the garden of Alcinoos in *The Odyssey*; see P. Nys, 'Art et nature: une perspective généologique' in Brunon 1999, p.259, and Barozzi 2006, p.24.
2. M.M. Fontaine, 'Mécènes au jardin', in Brunon 1999, p.142.
3. *Le Jardin des Mathurins, Pontoise, propriété des dames Deraismes*, 1876, Nelson-Atkins Museum of Art, Kansas City, P&DRS vol.2, no.448; *Dans le Jardin des Mathurins, Pontoise*, 1877, Private Collection, P&DRS vol.2, no.355.
4. Monet, *The Luncheon*, 1873, Art Institute of Chicago, shown as 'Decorative Panel' at the Impressionists' 1876 exhibition; see Brettell 1990, p.175 and P&DRS vol.2, p.325.
5. New York/Los Angeles/Paris 2005–6, pp.52–5 and p.163; see also http://moma.org/exhibitions/2005/cezannepissarro/conservation/layering_paint.html.
6. R. Brettell, 'The "First" Exhibition of Impressionist Painters', in San Francisco 1986, p.195.
7. White 1988, p.81.

8. See Jules Vallès, *L'Enfant*, Paris 1879.
9. G. Rivière, 'L'Exposition des impressionistes', in *L'Impressioniste*, 14 April 1877, in Berson 1996, vol 1, p.183.

65 Christian Krohg 1852 1925
Portrait of Karl Nordström, 1882

Oil on canvas 61 × 46.5cm
The National Museum of Art, Architecture and Design, Oslo

With its spring sun and growth, and fresh country air, this portrait by the Norwegian painter Krohg of his Swedish colleague Nordström contemplating the garden view from the window of his room at the Hôtel Laurent at Grez-sur-Loing in the rural Seine-et-Marne vividly conveys the sense of new beginnings which both artists must have felt at the time of the painting's creation. They had trained and worked in their respective countries and Krohg had also studied in Berlin, but now, in spring 1882, they were amongst the first Scandinavians to join the colony of plein-air painters at Grez, where the light was so much brighter than at home.

Nordström later described how 'We had studied the Impressionists at an exhibition in Paris and were filled with the new ideas. Krohg saw me one day at the open window wearing my blue suit silhouetted against the garden. He asked me eagerly to stand still in my pose, fetched a canvas … and in a few seconds the work was in full action.'[1] Nordström had seen the Impressionists' 1881 exhibition but it is that of 1882 to which he refers here. This had included a substantial number of landscape and garden scenes, as well as three views by Caillebotte from balconies[2] – the likely inspiration for Krogh's arresting composition. Krohg's light, delicate brushwork certainly has clear affinities with French Impressionist technique, as does his evocation of the dazzling spring sunlight flooding the garden and decoratively silhouetting the balcony ironwork. In this sympathetic portrait, Krogh forecasts the course of Nordström's own work at Grez, for it was the garden of the Hôtel Laurent, as well as others in the village, which were to become the latter's principal subject there.

Krohg himself regarded Impressionism as inherently linked with social reform, a counterpart to the novels on the ills of modern urban society by Zola and the Goncourts,[3] and in this sense, his rural kitchen garden motif is perhaps an emblem of a more desirable way of life. In depicting his colleague allowing the sensations of spring to register in his mind's eye, he also paves the way for the openly subjective aim to 'paint after memory'[4] which Scandinavian artists such as Edvard Munch

and Richard Bergh were to pursue in the 1890s under the influence of Symbolism.

1. Quoted in Varnedoe 1988, p.147.
2. *Man on a Balcony, Boulevard Haussmann*, 1880, Private Collection, Switzerland; *A Balcony, Boulevard Haussmann*, 1880, Private Collection, Paris; and *Boulevard seen from Above*, 1880, Private Collection, Paris.
3. See Gunnarsson 1998, p.181 and Jacobs 1985, p.104.
4. Munch: 'If you do not seek to paint after memory, but use models, you will inevitably get it wrong', notebook entry, 1889, in Harrison/Wood/Gaiger 2003, p.1041.

66 James Ensor 1860–1949
The Garden of the Rousseau Family, 1885

Oil on fabric 96.2 × 82.6cm
The Cleveland Museum of Art, Ohio

Ensor is thought of as the Belgian Symbolist whose mock-epic painting *The Entry of Christ into Brussels in 1889* (Getty Museum, Malibu), and scenes of skeletons taking tea and wearing carnival masks, look forward to the Surrealist world of his compatriot Magritte. Yet, he was deeply impressed by the works of Courbet and De Braekeleer, and even before the exhibitions of French Impressionist work mounted in the 1880s by the avant-garde group *Les Vingt* – which he helped to found – he had developed his own impressionistic idiom. *The Garden of the Rousseau Family* is one of the best examples of this. Its motif of a barrow of cabbages in the lush green garden of his friends Ernest and Mariette Rousseau in the Brussels suburb of Watermael can nonetheless be seen as an entirely logical complement to his later fantastical subjects, for he argued that 'Everything is material for painting, everything is good to paint, everything is beautiful to paint.'[1]

If the effects of textured, visible brushwork in *The Garden of the Rousseau Family* bear vivid witness to the pleasure simply in putting paint on canvas which this comment also implies, the variety of greens and blues in the cabbages clearly meets the criterion for Impressionism outlined the following year by Ensor's friend the critic Emile Verhaeren: 'the task consists in refining, in discovering, the greatest number of tones in colour and the greatest number of nuances in tones'.[2] And whilst the placing of the cabbages on display in the foreground recalls Ensor's admiration for the Flemish still-life tradition, the garden setting adds a new atmospheric dimension which is also consistent with Impressionism. The blue sky with its great white clouds lends an airy spaciousness, whilst the glimpse of a red-roofed house and the scattered beginnings of autumnal colour heighten the brightness of the greenery. The garden's dampness and earthiness can be felt; here is nature in the raw, although arranged by the gardener's hand.

This effect must surely have pleased Mariette Rousseau, for whom the painting was probably made: she and her husband, the professor of physics and rector of Brussels University were its first owners.[3] The daughter of a botanist, Mariette was one of Ensor's staunchest admirers, and herself an amateur scientist, whom Ensor drew at her microscope. The cabbages in *The Garden of the Rousseau Family*, laid out as if for inspection, but also suggesting in their shape a giant pair of eyes looking back at the viewer, were perhaps a witty play on her scientific scrutinies, underlining the picture's richly individual contribution to the Impressionist garden.

1. Quoted in P. Hassaerts, *James Ensor*, Brussels 1957, p.80.
2. E. Verhaeren, 'Le Salon des XX', 1886, in Sarlet 1992, p.93.
3. See L. d'Argencourt et al., *The Cleveland Museum of Art European Painting of the Nineteenth Century*, Cleveland 1999, p.256.

67 Pierre Bonnard 1867–1947
The Large Garden, 1895–6

Oil on canvas 168 × 220cm
Musée d'Orsay, Paris

Bonnard believed, like his contemporary the writer Marcel Proust, that 'the true paradises are the paradises we have lost'.[1] *The Large Garden* is one of Bonnard's most personal expressions of this credo, for it shows three of his sister's children in the orchard of his family home at Le Grand Lemps in the Dauphiné, where he himself had spent his childhood holidays, – and it does so from a low, child's eye viewpoint, with a child's attention to sensory experience. Although Bonnard returned each summer to Le Grand Lemps until 1928, he could only vicariously recapture his youth there. In *The Large Garden*, a carpet of rich green grass extends before us, on which fallen apples glow in the subdued evening light like balls of burnished gold. The low viewpoint makes us empathise with the children's solemn cameraderie and the *joie de vivre* of the child skipping out of the painting at the right, so that we feel the smoothness of the apples, the roughness of the basket handle, and the lushness of the grass underfoot.

That picking the fruit was a shared pleasure at Le Grand Lemps is suggested by a letter Bonnard sent to his brother Charles from there in the 1890s: 'I ... hope you can get leave next Sunday so we can all be together ... There are masses of fruit. Maman does her rounds every afternoon with her basket.'[2] The children's apple-gathering certainly has an almost ritual character, forming as it does a midpoint in a sequence leading from the hen in profile and the sheepdog at the left to the almost hieratic profile of the maid, and the skipping child, at the right. This horizontal progression is echoed by the hens and cocks beside the fence, and the distant line of trees. If it creates a decorative effect, *The Large Garden* is in fact the most elaborate of a group of paintings by Bonnard of children playing in orchards, apparently intended as a scheme of domestic decoration.[3] In this, the maid and skipping child would have provided a forward link to the next panel. Bonnard certainly wrote to Vuillard in September 1895 of 'working on a large surface which is keeping me quite busy', a comment believed to refer to *The Large Garden*.[4]

As a mural, *The Large Garden* would have formed a backdrop to the daily rituals of the home. Compared, however, to Bonnard's *Women in the Garden* panels of 1891,[5] painted in his early Nabi style of flat zones of colour and pattern, it is much more impressionistic. It is, in fact, his first decorative panel to present a perspectival view, setting the model for his large landscape and garden murals of the 1900s. Although Bonnard dated his discovery of Impressionism to 1897, when Caillebotte's bequest of works by Monet and his colleagues was first displayed, *The Large Garden*'s complex textures, high horizon, and foreground expanse of open ground already have much in common with the Eragny field and orchard views Pissarro was exhibiting in the mid-1890s.[6]

With this in mind, *The Large Garden* offers an intriguing counter to Seurat's scientific reinvention of Impressionism in his famous *A Sunday on La Grande Jatte* completed in 1886, which also includes a woman in profile and little girl skipping [fig.22]. For, in contrast to Seurat's public park and prismatic colour, Bonnard's intimate evening garden, coloured by nostalgia, develops the subjectivity of Impressionism, predicting his comment that the artist must look 'both around him and inside him',[7] whilst, as a decoration, making paradise live again in our lives too.

1. Watkins 1994, p.76.
2. P. Bonnard, *Correspondance*, Paris 1944, in Chicago/New York 2001, p.74.
3. Chicago/New York 2001, pp.73–6.
4. Terrasse 2001, p.32.
5. Musée d'Orsay, Paris.
6. For example, P&DRS nos. 927, 962, 966, 969, 976, 983 (exhibited 1893); 969, 1001, 1019 (exhibited 1894); also no. 918, owned by Octave Mirbeau, who was close to Bonnard's friends and patrons the Natansons (Chicago/New York 2001, p.45).
7. 'Pierre Bonnard nous écrit', *Commoedia*, 10 April 1943, quoted in London/New York 1998, p.9.

68 Charles-François Daubigny
1817–1878
Orchard in Blossom, 1874

Oil on canvas 85 × 157cm
National Gallery of Scotland, Edinburgh

Pomology – the science of cultivating apples, pears, and other orchard fruit – was a major aspect of French horticulture in the second half of the nineteenth century. By 1864 the horticultural journal *La Revue horticole* was already reporting numerous regional conferences of the French General Pomological Congress. At the same time it regretted the increasing strength of Lyons in the congress; fully half the controlling committee had the previous year been from Normandy.[1] It is an orchard either in Normandy or the neighbouring Ile-de-France which is almost certainly shown in Daubigny's painting, for these were his favourite sites after he settled in Auvers in the Oise in 1860. They were regions where fruit trees had been grown for generations, but the expansion of the rail routes serving Paris meant that by the 1860s and 1870s they faced competition from orchards in the south, including those for soft fruits. It is not surprising that pomologists throughout France sought in this context to promote ever greater expertise in the cultivation of fruits with stones and pips.[2]

Daubigny, however, gives no hint of such horticultural changes; rather, he presents a seemingly timeless, almost bucolic scene, where two figures relax in the soft spring air beneath irregularly-planted clusters of fruit trees in blossom, whilst another figure at the right appears to gather the white and yellow flowers which grow at random amidst the grass. This might almost be Homer's perfect orchard of 'large flowering trees ... [whose] fruits do not die or want ... ', or that filled with flowers and 'thickly planted with trees' described by Longus in *Daphnis and Chloë*.[3]

Daubigny's broken, spontaneous brushwork and attention to effects of sun and shadow are clear reminders that, after being one of the most stalwart supporters of progressive painting in the 1860s, he was now himself influenced by Impressionism. At Auvers in the 1870s, he was in touch with Pissarro at nearby Pontoise, as well as Cézanne, and when painting *Orchard in Blossom* in 1874 he must have followed with interest the mounting that year of the first Impressionist group exhibition. Although his colours remain more muted than in orchard scenes of the period by Pissarro, Monet and Sisley, Daubigny's incidental figures are reminiscent of those who enjoy the countryside almost proprietorially in Monet's paintings of poppy fields of 1873. In this sense, his idyllic motif is perhaps not so timeless after all, for it can be seen

as part of the wider mood of celebration by the French of their native soil in the aftermath of the Franco-Prussian war.

1. J.A. Barral, 'Chronique horticole (deuxième quinzaine de mars)', in *Revue horticole*, 1864, p.122.
2. See Phlipponneau 1956, pp.66–7 and Barral, note 1.
3. Homer, *The Odyssey*, Song VII as given in Barozzi 2006, p.22; Longus, *Daphnis and Chloë*, as given in Brunon 1999, p.142.

69 Vincent van Gogh 1853–1890
Orchard in Blossom (Plum Trees), 1888

Oil on canvas 54 × 65.2cm
National Gallery of Scotland, Edinburgh

This shimmering vision of pink and white blossom against a limpid blue sky is one of the series of fifteen paintings of 'a Provençal orchard of outstanding gaiety' which Van Gogh began shortly after his move to Arles in February 1888.[1] Writing to his brother Theo, he had explained his decision to leave Paris, where his palette had begun to brighten under the influence of Impressionism, with the comment 'Look we love Japanese painting, we've experienced its influence – all the impressionists have that in common – and we wouldn't go to Japan, in other words, to what is the equivalent of Japan, the south?'[2] This comment, where Van Gogh ranks himself amongst the Impressionists, may have been prompted by the experience of the fictitious painter Coriolis in the Goncourts' novel *Manette Salomon*, who finds consolation for the drabness of a Parisian winter in albums of Japanese prints: 'He lost himself in that azure where the pink blossoms of the trees drowned themselves.'[3]

Orchard in Blossom is nonetheless clearly a sequel to the fruit trees of the kitchen and market gardens which Daubigny and Pissarro had painted. Van Gogh had expressed appreciation of Daubigny's paintings of orchards [68] and planned to use some of his own Arles series to form decorative triptychs – an intriguing sequel to the mural character of Pissarro's *Les Côte des Boeufs at L'Hermitage, Pontoise*.[4] *Orchard in Blossom* also emphasises the reciprocity of man and nature which Pissarro had portrayed, and which forms the essence of horticulture. The painting shows clearly the whitewash used by market gardeners on the trunks of their fruit trees to deter attack by borer insects,[5] and Van Gogh uses its brightness to create a link between the white blossom and blue sky and the white and yellow flowers growing in the grass beneath the trees. Despite Van Gogh's equation of Arles and Japan, he does not echo the angular, highly stylised trees so often seen in Japanese prints, but instead faithfully records the

'airy globular shape' created by the market-gardeners' pruning, which 'open[s] up the branch structure, admitting light and air that will make for better fruit'.[6] Not least, he carefully marks out the boundary fence enclosing the orchard, which separates it from the factory in the background with its brilliant red chimney. The centuries-old tradition of man's productive cultivation of the land, which this brash factory points up, seems in turn to find a subliminal echo in Van Gogh's visibly thick paint and linear brushwork, which speaks of his own artistic labour in creating the picture.

1. Van Gogh, letter to Theo van Gogh, on or about 3 April 1888, Van Gogh Museum, Amsterdam, as translated at http://vangoghletters.org/vg/letters/let592/letter.html.
2. Van Gogh, letter to Theo van Gogh, on or about 5 June 1888, Van Gogh Museum, Amsterdam, as translated at http://vangoghletters.org/vg/letters/let620/letter.html.
3. Quoted in Sund 1992, p.165.
4. Van Gogh, letter to Joseph Isaäcson, 25 May 1890, Van Gogh Museum, Amsterdam, at http://vangogh-letters.org/vg/letters/RM21/letter.html# ; Chicago/Amsterdam 2001–2, p.102.
5. Griswold 1987, p.137.
6. Ibid.

70 Henri Le Sidaner 1862–1939
An Autumn Evening, 1895

Oil on canvas 50.2 × 61.9cm
Carmen Thyssen-Bornemisza Collection, on loan to the Museo Thyssen-Bornemisza, Madrid

The critic Camille Mauclair wrote in 1901 of the French painter Le Sidaner that although 'born out of Impressionism', he was 'as much the son of Verlaine' as of Monet.[1] *An Autumn Evening*, with its subdued, close-toned harmonies, certainly seems to share the poet Paul Verlaine's famous ideals of 'nuance' and 'imprecision' which so impressed the Symbolists.[2] Painted possibly at Saint-Cloud or Suresnes near Paris,[3] the painting dates from Le Sidaner's early career, when, after training with the academic painter Alexandre Cabanel and spending nearly a decade painting at Etaples, he had returned to Paris. Together with his friend the artist Henri Martin, he had become closely involved in the Symbolist movement although the handling of this work still remains impressionistic.

In *An Autumn Evening* this handling combines with the muted colours to heighten the enigmatic imprecision, of which the blurred greyish void behind the woman – indicating an unseen garden below – is perhaps the most intriguing manifestation. Trees and a hint of creeper on the wall are evident to the left of this garden, but what lies within its depths? The woman, who may perhaps be Le Sidaner's future wife Camille Navarre,[4] provides no

clue. Engrossed in her reading, she pays the invisible garden no regard as she passes high above it on the empty, stage-like terrace, patterned with sombre nuances of lilac, pink and blue. What is she reading so intently, where is she going and why all alone? Is the deep distant green-blue a bank of protective hills, or the ocean itself, vast and dangerous? And although it is autumn, why is there the red moon of April, which in French country lore influenced young plants, or is this the sun?[5] Does this picture show dream or reality? Le Sidaner leaves it to the viewer to decide.

From 1902, in the ancient village of Gerberoy near Beauvais, Le Sidaner was to create a garden of his own which became a veritable artistic laboratory for mysterious twilight effects and the nuance of floral colours [97]. *An Autumn Evening* – a rural counterpart to Sargent's Parisian twilight garden [52] – clearly looks towards this.

1. C. Mauclair, 'L'Art en silence', 1901, p.156, as translated J. House et al., *Post-impressionism: cross currents in European Painting*, exh. cat., Royal Academy of Arts, London 1979, p.89.
2. P. Verlaine, 'Art Poétique' (1874) in *Jadis et Naguère*, 1884, in Y.-G. Le Dantec (ed.), *Verlaine Oeuvres poétiques complètes*, Paris 1951, pp.206–7.
3. I am grateful to M.Yann Farinaux-Le Sidaner for this suggestion.
4. Suggestion kindly provided by M. Yann Farinaux-Le Sidaner.
5. 'Lune' in *Nouveau Petit Larousse illustré*, 130th edition, Paris 1932, p.597.

71 Leopold Graf von Kalckreuth 1855–1928
The Rainbow, 1896

Oil on canvas 71 × 100.5cm
Neue Pinakothek, Munich

The German artist Kalckreuth was a founding member of the Munich Secession and a close friend of Liebermann and Uhde. Thirty years after painting *The Rainbow*, he recalled its inspiration from his country estate at Höckricht in Silesia: 'Springtime – in the background, our house. The pear tree was the only large fruit tree. The woman with the little boy is my wife with my second son Johannes. Naturally, it represents a real experience'.[1]

Kalckreuth had recently become a protégé of Alfred Lichtwark who encouraged young German artists to emulate French Impressionism, with its depiction of contemporary life – what Kalckreuth here calls 'real experience'. However, Kalckreuth also remembered the 'experience' depicted in *The Rainbow* as being 'like a dream!'[2] The flash of spring sunlight illuminating the wet garden gives the picture an almost visionary quality. The figures with their backs turned – a typical device of Romantic artists such as Caspar David Friedrich – invite the viewer to follow

their gaze and see the garden's pristine brilliance with the wonder of the child led by its mother. With its opening flowers and patches of earth where seed has yet to spring, the garden in turn mirrors the child, still to reach maturity. The rainbow, of course, is a traditional emblem of hope and new beginnings.

As well as promoting French Impressionism, Lichtwark was at the forefront of a revival of interest in Romanticism. He was to buy work by Friedrich for the Hamburg Art Gallery, of which he was director, as well as some of the mystical pictures of children and flowers by the Romantic artist Philipp Otto Runge, who had argued that artists must again become children. He also admired the colour theories of Runge and Goethe, which privileged 'the colour sense of the individual' over Newton's science.[3]

In this context, Kalckreuth's vision of his Höckricht garden can perhaps be viewed as figuring what Runge called the 'Paradise which lies within us'.[4] The child's orange-red coat and its mother's luminous blue shawl certainly compare exactly with Runge's description of yellow-orange colours as masculine, and blues as feminine.[5] And it was the sight of yellow crocuses just like those in the immediate foreground of *The Rainbow* which had prompted Goethe to notice how a colour viewed in full light induces a perception of its complementary in the adjacent shadows. It was this observation which, codified by Michel Chevreul as the 'law of simultaneous contrast',[6] had influenced the high-keyed palette typical of French Impressionism. Kalckreuth uses green, the complementary of his son's red coat, in the son's shadow, and makes his wife's white skirt shimmer with reds, purple-blues and yellows, like a rainbow itself. The white blossom is silhouetted in turn against the reddish roof and dark blue sky. Figures, garden and house become a close-knit unity – just as the ephemeral rainbow complements the sturdy tree arching towards it.

If *The Rainbow* approaches Impressionism via Romanticism, its garden offers a further link to the past. For its geometric flower beds, straight paths intersecting at right angles, and productive fruit trees are typical of old-fashioned German *Bauerngarten* (farm gardens) which Lichtwark had recommended as ideal painting subjects. From 1906, with Lichtwark's advice, Kalckreuth took inspiration from the *Bauerngärten* tradition in the artist's garden he created at Eddelsen near Hamburg; this inspired many of his later paintings, as well as influencing Liebermann's garden at Wannsee. *The Rainbow* lays a key foundation for these developments, as well as for Klimt's delight

in the colours of Austrian farm gardens, and it can be recognised as a central work in German *Stimmungsimpressionismus* (mood Impressionism).

1. Letter from Kalckreuth to Hugo Kehrer, 25 March 1927, cited in Hamburg 2005–6, pp.24–5.
2. Ibid.
3. Runge, *Brief an seinen Vater*, in Busch/Beyrodt 1982, vol.1, p.104; Lichtwark, *Die Erziehung des Farbensinnes*, Berlin 1902, as translated in D.R. Coen, 'A Lens of Many Facets. Science through a Family's Eyes', in *Isis*, vol.97, 2006, p.409.
4. Runge, quoted in Edinburgh/London/Berlin 1994, p.63.
5. Runge, *Hinterlassene Schriften*, Hamburg 1840; see J. Gage, 'Color in Western Art: an Issue?', in *Art Bulletin*, vol.72, no.4, December 1990, p.519.
6. C. Blanc, *Grammaire des arts du dessin*, Paris 1867, as translated in Harrison/Wood/Gaiger 2003, p.621.

72 Vincent van Gogh 1853–1890
Garden with Path, 1888

Oil on canvas 73 × 92cm
Gemeentemuseum den Haag

Around 24 July 1888 Van Gogh reported from Arles to his brother Theo, 'I have a new drawing of a garden full of flowers; I have also two painted studies of it.'[1] One of these studies was *Garden with Path*, showing a traditional Provençal farmhouse garden of flowers, vegetables and olive trees. Van Gogh's pleasure in his new motif follows on his decision to abandon a painting he had begun of Christ in the Garden of Olives, because he felt unable to paint 'figures of that importance without a model'.[2] In *Garden with Path* his almost obsessive attention to the multitude of different floral and plant colours and forms clearly reflects his wariness of Gauguin's ideal of painting from the imagination. He was, however, pleased by the older painter's acceptance of his invitation to stay in his Yellow House at Arles as part of Van Gogh's vision of a cooperative brotherhood of artists, which he revealingly implied was an 'association of impressionists'.[3] Although the linear brushwork and spots of brilliant colour give *Garden with Path* a richly decorative aspect, its character as an image of a real, observed motif is in essence a declaration of solidarity with Impressionism's principle of painting from nature.

Van Gogh was especially interested during the summer of 1888 in his brother Theo's reports of Monet's recent high-keyed work at Bordighera on the Italian Riviera, and *Garden with Path* can be seen as part of his attempt to create an art of brilliant colour of his own, using sunlit Provence as inspiration. He was to write in September 1888 that 'the painter of the future is a *colourist such as there hasn't been before*',[4] and was clearly attracted to *Garden with Path*'s motif on account of the opportunities to

paint arresting juxtapositions of intense, saturated hues. Spontaneous strokes of red and orange vibrate against green, a reminder of Van Gogh's interest also in Seurat's Neo-Impressionist colour contrasts, whilst the short, straight brushstrokes representing the tussocks of grass beside the path, like the sinuous red trunks of the olive trees crowned by blue-green foliage, continue the red-green dialogue. Varied jabs and zigzags meanwhile evoke blue flowers. The whole work, indeed, is more suggestive of drawing with paint. Only in rendering the zigzag of the sky, the walls and the footpath does Van Gogh resort to more solid areas of colour, creating a richly vibrant composition. It is easy to see why the German Expressionist Emil Nolde was so excited by Van Gogh's garden paintings;[5] his renowned series of flower-garden paintings forms their natural successor.

1. Letter to Theo van Gogh, between 17 and 20 July 1888, at http://vangoghletters.org/vg/letters/let644/letter.html.
2. Letter to Theo van Gogh, 8 or 9 July 1888, Van Gogh Museum, Amsterdam, at http://vangoghletters.org/vg/letters/let637/letter.html.
3. Letter to Theo van Gogh, 28 or 29 May 1888, Van Gogh Museum, Amsterdam, at http://vangoghletters.org/vg/letters/let616/letter.html.
4. Letter to Theo van Gogh, 4 May 1888, Van Gogh Museum, Amsterdam, at http://vangoghletters.org/vg/letters/let604/letter.html.
5. See M. Reuther et al., *Nolde im Dialog 1905–1913*, exh. cat., Städtische Galerie, Karlsruhe and Stiftung Seebüll Ada und Emil Nolde 2002–3, pp.104–5.

73 Vincent van Gogh 1853–1890
Undergrowth, 1889

Oil on canvas 73 × 92.5cm
Van Gogh Museum, Amsterdam (Vincent van Gogh Foundation)

This image of what Van Gogh described as 'thick tree-trunks covered with ivy, the ground also covered with ivy and periwinkle'[1] is one of four paintings of this motif which he made in the garden of the Saint-Paul-de-Mausole sanatorium at Saint-Rémy-de-Provence. He had voluntarily come here to try to cure the mental illness which followed his dispute with Gauguin and the incident when he mutilated his ear, and for the first part of his stay he was not permitted to leave its grounds. Although so apparently un-promising in subject, *Undergrowth* and its partner works were described by Van Gogh to his brother as evidence that 'considering that life happens above all in the garden, it isn't so sad'.[2] With its shafts of shimmering sunlight filtering between the ivy-clad trees, and its view to a luminous area of sunlight in the background, the picture can in fact be recognised as a recollection of the Barbizon tradition of the *sous-bois* (shaded woodland), which Corot and his colleagues

had made their leitmotif. It also echoes the close-up focus on a small patch of ground with flowers or foliage which Millet had used in a group of studies. Corot and Millet were artists greatly admired by Van Gogh.

The picture's most important con-notations of pleasure, however, lie in its affinities with the great overgrown garden of Le Paradou which forms the site of the illicit love-making of the priest Serge and the wild child Albine in Zola's novel *The Fault of Abbé Mouret*. Van Gogh loved this book, writing already in 1883 that he hoped one day to 'tackle a Paradou',[3] and he had drawn on its imagery in his pictures of 1888 of lovers in the public garden at Arles. Writing to his brother Theo about one of his *Undergrowth* paintings, he explained that it showed 'eternal nests of greenery for lovers' – a direct allusion to Le Paradou with its ivy-clad trees.[4] In this sense, *Undergrowth* can be interpreted as an image of longing as well as of pleasurable recollection, for Van Gogh still nursed the hope of finding love himself. His evident delight in the subtlety of colours in the foliage, and the vigour of its growth – rendered in energetic, tactile dabs of thick paint – provides a logical sequel to Renoir's comparison of *his* garden in Montmartre with Le Paradou, and his evocation of its 'irregular', semi-wild growth [21]. Now, in Van Gogh's hands, the garden has become a vehicle for intensely personal hopes and dreams, and even for catharsis. He had told Theo in 1889 that 'I would try to console myself…by thinking that illnesses like that [his own mental imbalance] are perhaps to man what ivy is to the oak.'[5]

1. Letter to Theo van Gogh, on or about 23 May 1889, Van Gogh Museum, Amsterdam, at http://vangoghletters.org/vg/letters/let776/letter.html.
2. Ibid.
3. Letter to Theo van Gogh, on or about 30 May 1883, Van Gogh Museum, Amsterdam, at http://vangoghletters.org/vg/letters/let347/letter.html.
4. Letter to Theo van Gogh, on or about 23 May 1889, Van Gogh Museum, Amsterdam, at http://vangoghletters.org/vg/letters/let776/letter.html; and as interpreted in Frankfurt/Munich 2006, p.227.
5. Letter to Theo van Gogh, 28 April 1889, Van Gogh Museum, Amsterdam, at http://vangoghletters.org/vg/letters/let763/letter.html; see also Frankfurt/Munich p.227.

74 Johann Viktor Krämer
1861–1949
In the Sunshine, 1897

Oil on canvas 95 × 95cm
Belvedere, Vienna

Krämer was a founding member of the Vienna Secession and in 1901 became the first artist to be given a solo exhibition by the group, a mark of its considerable respect for his art. *In the Sunshine*, painted

from sketches Krämer made on visits in 1894 and 1897 to Taormina in Sicily, was displayed at this exhibition. However, when Gustav Klimt, president of the Secession, had portrayed the ancient Greek theatre of Taormina with a sweeping vista of bay and limpid sky in his celebrated ceiling painting for the Vienna Burgtheater, Krämer evokes the enclosed, intimate space of a private villa garden. In the sizzling heat of midday, even a sunflower droops, but pelargoniums or nasturtiums in pots and beds create vibrant notes of red. Oranges growing at the door of the villa harmonise with the warm stonework of its wall and with the sunlit path, steps, and terracotta vases, whilst doves and pigeons peck in the dust, or swoop from the roof to drink water from one of the vases. Although the square format of the painting and the ordered geometry of the receding path, steps, vases and villa create a subtly decorative effect, a reminder of Krämer's Secessionist affiliation, the broken brushwork and atmospheric colour are overtly impressionistic. Together with his Secession colleagues Theodor Hörmann, Josef Engelhardt and Wilhelm Bernatzik, Krämer was a keen admirer of modern French art, and he had made a study visit to Paris in 1890–1.

It is possible that whilst in Paris Krämer saw the 'path with steps' composition of the view by Monet of his sunflowers at Vétheuil, then in the collection of the art dealer Durand-Ruel.[1] But if he recalls this in his picture, he portrays a very different kind of garden. The southern garden of *In the Sunshine*, with its brilliant light reflecting off wall and path and brightening the shadows, is surely born as much of the Germanic Romantic tradition of longing for Italy as of familiarity with French Impressionism.[2] Its path in Goethe's 'land where the lemon trees grow' is, after all, the diametric opposite of the 'bare paths' of the north described by the Viennese poet and Secession supporter Hugo von Hofmannsthal, paths to which, as spring approaches, the wind finally brings memo-ries of 'acacia blossoms' and 'smiling lips'.[3] A path is a traditional emblem of longing and desire, and Krämer's in this sense projects the Vienna Secession's revival of Romantic ideals –only the previous year Hofmannsthal had written 'we are in a new age of Romanticism'.[4] Just as in Marie Egner's slightly later *In the Pergola*, also painted in Italy, the Impressionist garden has acquired a distinctively Viennese accent.

1. Monet, *The Artist's Garden at Vétheuil*, 1881, Private Collection (w.684); see also C.A.P. Willsdon, catalogue entry for *In the Sunshine* in Vienna 2007, p.161, and Willsdon 2007, p.138.
2. See Willsdon 2007, p.138.

3. Hofmannsthal, 'Vorfrühling'.
4 For example, Baudelaire's imagery of the path as a symbol of longing (see A. Fairlie, 'Aspects of Expression in Baudelaire's Art Criticism', in Finke 1972, p.44), and Zola's *allée* imagery (see S. Cullut, *Les Lieux du désir Topologie amoureuse de Zola*, Paris 1992, pp.130–9). Hofmannsthal, 'Fin Neues Wiener Buch', in *Reden und Aufsätze*, vol.1, 1891–1913, Frankfurt 1979, p.227.

75 Théo Van Rysselberghe

1862–1926

Fountain in the Park of Sans Souci Palace near Potsdam, 1903

Oil on canvas 81.8 × 105cm
Neue Pinakothek, Munich

Everything sings in perfect harmony on this golden autumn day in the gardens of Frederick the Great's 'German Versailles', created in the eighteenth century, for living without a care (*sans souci*). As they cascade from the fountain, droplets of water refract the bright sunlight, producing a rainbow whose arc repeats that of the pool-edge. Composed of small touches of colour – blues, pinks, ochres, white and violet – the whole picture seems in turn to grow from this rain of droplets. Cumulus clouds echo the forms of the trees, dappled light and shadow on the path continue the pattern of reflections in the pool, and all parts mesh and interlink. The fountain and the pool divide the canvas according to the Golden Section believed to be inherently harmonious to the eye.

It was Seurat who famously called art 'harmony',[1] and Van Rysselberghe – a founding member of the avant-garde Belgian group *Les Vingt* – had been deeply impressed by Seurat's Neo-Impressionist work when this was shown in 1887 with *Les Vingt*. When based in Paris during the 1890s, he had adopted Seurat's technique of dots of complementary colour. But by 1903, when he painted *Fountain in the Park of Sans Souci Palace near Potsdam*, his approach had become more lyrical, and his brushwork looser and freer; his picture reinvents the quintessentially Impressionist conception of the garden as a theatre of light, colour and seasonal effects. It is not surprising that in Brussels the following year Van Rysselberghe helped plan Emile Verhaeren's major exhibition of French Impressionism.[2] A prominent Belgian poet and critic, Verhaeren had written of Neo-Impressionism as continuing a 'living pictorial tradition … which comes from Delacroix and leads to Manet, Renoir and Pissarro, via Corot and Jongkind'.[3]

Just as *Fountain in the Park of Sans Souci Palace near Potsdam* takes the style of Impressionist garden painting in a new direction, so it also favours a different type of garden. Statuary, monumental trees, and

the architecture of the pool and fountain replace the colourful flowers and more freely-ordered gardens painted earlier by Monet or Renoir in Paris, and they throw into prominence the transience of the rainbow, fleeting clouds and autumn leaves. The painting in fact takes its place as part of a wider revival of enthusiasm for formal gardens, with attendant connotations of nostalgia or longing for perfect worlds. Edward Lutyens in Britain, the Duchêne brothers in France, and Lichtwark in Germany were amongst the garden designers who took up this formal idiom at the *fin de siècle*, whilst artists such as Henri Martin, Le Sidaner and Klimt, as well as Van Rysselberghe, found inspiration in its careful balance between nature's freedom and man-made order. Even Monet used the word *bassin*, the term for a formal garden pool, for the water lily pond he had begun to paint at Giverny.[4]

Although Van Rysselberghe portrays an energetic fountain rather than the still water dotted with flowers which so fascinated Monet at this period, both artists contribute to a new emphasis on the Impressionist garden as a place of artifice, and for projecting moods and feelings. Van Rysselberghe's visual alchemy in which light becomes rainbow colour might almost illustrate Verhaeren's idea of art as 'psychic and sensual delight'.[5]

1. Letter to Maurice Beaubourg, 29 August 1890, in Broude 1978, pp.17–18.
2. Held at La Libre Esthétique; see Sarlet 1992, pp.124–5.
3. E. Verhaeren, 'Tho van Rysselberghe', *L'Art Moderne*, 13 March 1898, in Sarlet 1992, p.125.
4. Hoschedé 1960, vol.1, p.48.
5. E. Verhaeren, 'La Sensation artistique', in *L'Art Moderne*, 7 December 1890, in Sarlet 1992, p.121.

76 Fritz von Uhde 1848–1911

The Artist's Daughters in the Garden, 1903

Oil on canvas 84.5 × 90.9cm
Wallraf-Richartz Museum & Fondation Corboud, Cologne

This garden, at Uhde's country house at Perchau on Lake Starnberg near Munich, with its gravel path, wooden fence, some grass, saplings and a kitchen chair, is plain in the extreme. What makes it bloom are Uhde's daughters, Anna, Amalie and Sophie. Caught in a shaft of sunlight, they are a dazzling, almost insubstantial vision, their hair turned gold, their dresses an incandescent shimmer amidst the flurry of green and yellow strokes representing the foliage. Stéphane Mallarmé's description in 1876 of one of the garden paintings by his friend Manet could equally apply to that of Uhde here: 'the luminous and transparent atmosphere struggles with the figures, the

dresses and the foliage, and seems to take to itself something of their substance and solidity'.[1]

By 1903 there was, in fact, much enthusiasm for Manet in progressive art circles in Germany. The francophile director of the Berlin National Gallery, Hugo von Tschudi, had purchased Manet's *In the Conservatory* in 1896 – the first work by a French Impressionist to enter a German public collection – and Uhde was a good friend of the painter Max Liebermann, who had advised on this purchase and himself owned several garden paintings by Manet. Both Tschudi and the critic Julius Meier-Graefe had in turn published eulogies of Manet in 1902. The almost visionary intensity of *The Artist's Daughters* is a reminder that Manet's German supporters prized his art as much for what Tschudi called its 'temperament' as for its *plein-airisme*.[2] What artists such as Uhde and Liebermann sought in turn to create was *Stimmungsimpressionismus* – mood Impressionism.

In this sense, *The Artist's Daughters* is a direct complement to Uhde's contemporary-life renderings of Biblical stories, in which the lighting is deeply symbolic. For the picture celebrates Uhde's very close bond with his daughters, whom he had brought up single-handedly following his wife's premature death in 1886 when giving birth to Sophie, and it captures Sophie's transition from child to adult. As she steps forwards at the centre, clasping the arm of one older sister, she glances suggestively backwards; her other sister, at the left, meanwhile looks outwards, as if to their father at his easel. A variant of this painting shows the object of Sophie's glance to be the Uhdes' dog, her beloved childhood companion.[3] In this version, it is the summer light which makes child and adult one, as Sophie is transfigured by its brilliance. The play of light and shadow, youth and age, and anticipation and nostalgia is mirrored in the contrast of the small sapling in the foreground with the older, taller tree at the right. Echoing the line of Sophie's backward glance, the older tree in turn directs attention to the empty chair in shadow. Uhde had portrayed his wife seated on just such a kitchen chair in a garden, accompanied by Anna and Amalie as toddlers, in one of his earliest plein-air paintings.[4]

At the same time, the picture firmly celebrates nature's life-giving powers. It was one of a series showing his daughters at Perchau which Uhde began in 1901 whilst convalescing after a serious illness, and can be compared with the description by the poet Detlev von Liliencron – like Uhde, a former soldier – of a battlefield transformed into a garden of roses and

nightingales. It is possible to see why Uhde's first biographer wrote that his art 'speaks through the eyes to men's souls'.[5]

1. Mallarmé 1876, p.94.
2. H. von Tschudi, *Edouard Manet*, Berlin, 1902, p.44, cited in Jensen 1994, p.228.
3. *The Artist's Daughters in the Garden*, 1903, Kunsthalle, Bremen.
4. *In der Sommerfrische*, 1883, plate 39 in Rosenhagen 1908.
5. Detlev von Liliencron, 'Krieg und Friede', 1891; Rosenhagen 1908, p.XLIX.

77 Ernst Eitner 1867–1955

Spring, 1901

Oil on canvas 198.5 × 150cm
Hamburger Kunsthalle

Eitner was a member of the Hamburg Artists' Club, founded in 1897 with support from the radical first Director of the Hamburg Art Gallery, Alfred Lichtwark. Eager for Germany to be recognised not just for its military prowess, but also for modern art,[1] Lichtwark encouraged the Hamburg artists to paint directly from nature in vibrant, luminous colours, as did the French Impressionists. *Spring* depicts Eitner, his wife Antonia and his infant son Georg taking breakfast in the garden of their first home at Fühlsbüttl near Hamburg. It follows Lichtwark's pioneering purchase of work by Monet for the Hamburg Art Gallery, as well as visits made by Eitner to Paris. Its motif was suggested by Lichtwark and its imagery has some affinities with that of Monet's *The Luncheon* [fig.18] which Eitner could have seen on his 1900 visit to Paris.

However, where the figures are secondary to the garden in Monet's picture, Eitner creates a tightly-woven unity of family, garden and season. Father, mother and child in wickerwork high-chair are sheltered by a canopy of spring blossom and a mass of burgeoning foliage, much as the poet Richard Dehmel – a close colleague of the Hamburg artists – described how 'from many trees/Blossoms … nodded to our love,/Amidst the pure, dreamy greenery'.[2] As the sun shines between and through the petals and leaves, it traces lace-like patterns on the garden bench, the tablecloth, and Eitner himself, holding up what appears to be a dark-faced doll to distract the child. Although the child is still in life's springtime, this doll hints at the larger world it will encounter later, beyond the garden; Hamburg had historic trade links with America and the West Indies. For the moment, however, the sun catches the front of the child's bonnet and the brim of the mother's hat, so that, shimmering like haloes, they lend an almost sacramental aura to the domestic rituals of pouring coffee and eating croissants.

Lichtwark certainly wrote that *Spring* 'does not merely represent, it expresses … on the human side, it strikes such a beautiful pure note – even just the child itself! – that it does one good!'[3] This comment is richly revealing as Lichtwark sought not only to promote modern painting but was also at the forefront of the 'Garden-Reform' movement in Germany. As the architect Hermann Muthesius explained, in terms reminiscent of William Morris, a garden offered vital defence against the 'consuming, corrupting effects of the vast hoarding-together of mankind in cities'.[4] Eitner's imagery of innocence and seclusion – where his garden becomes a holy place, and the world beyond a mere child's plaything – complements this idea. The way the garden serves as an outdoor dining room, complete with table and seating, also matches Lichtwark's and Muthesius's advocacy of garden rooms – discrete yet interlinked areas, like the rooms of a house.

With its evocative association of child and garden growth, and its decorative play of light, and of greens, browns and red chair against whites and creams, *Spring* in turn aligns Impressionism with *Jugendstil* (the 'style of youth'). Complementing the dawn of the new century, *Jugendstil* embraced garden reform, and provides a German counterpart to Art Nouveau in France and the Arts and Crafts movement in Britain. Though Lichtwark bought *Spring* for the Hamburg Art Gallery, its near-mural size makes it easy to imagine it taking its place beside the finely-crafted furnishings of a *Jugendstil* home, in the service of the *Jugendstil* ideal of 'das schöne Leben' – living itself as a form of art.[5]

1. See Kay 2002.
2. R. Dehmel, *Bitte*, in *Dichtungen: Briefe: Dokumente* (ed. P.J. Schindler), Hamburg 1963, p.38.
3. Lichtwark, letter to Eitner, 25 November 1901, quoted in Hamburg 1997, p.115.
4. H. Muthesius, *Das Englische Haus*, Berlin 1904, vol.1 p.2 and vol. 2, p.138, as quoted in J.H. Hubrich, *Hermann Muthesius. Die Schriften zu Architektur, Kunstgewerbe, Industrie in der 'Neue Bewegung'*, Berlin 1971, p.62; see also 'Reformgärten-Volksparkbewegung und Gartenkunstreform im beginnenden 20. Jahrhundert', in Hamburg 2006, p.232.
5. For this concept, see H. Fritz, *Literarischer Jugendstil und Expressionismus. Zur Kunsttheorie, Dichtung und Wirkung Richard Dehmels*, Stuttgart 1969, pp.97ff.

78 Claude Monet 1840–1926
The Water Lily Pond, 1904

Oil on canvas 89 × 92cm
Denver Art Museum
(Edinburgh only)

79 Claude Monet
Water Lilies, 1907

Oil on canvas 92 × 81.2cm
The Museum of Fine Arts, Houston

80 Claude Monet
Water Lilies, 1908

Oil on canvas 100.5 × 81.3cm
Amgueddfa Cymru – National Museum Wales, Cardiff

These views of the pool in Monet's garden at Giverny were first exhibited at his great *Paysages d'eau* (Waterscapes) show of 1909 at Durand-Ruel's gallery in Paris. 'I only stayed at your exhibition for a second. Your paintings gave me vertigo!' Degas told him – a comment clearly made in jest, which nonetheless is a reminder of how boldly the three pictures reinvent the Impressionist garden.[1] Their substance, after all, is reflection – the mysterious, intangible effects of sky, trees and vegetation as seen in the surface of Monet's pool, on which the scattered water lilies themselves seem like sparks of coloured light, or scintillating gems. Although the 1904 picture includes a glimpse of the pool's further bank, the emphasis is already on the reflections in the water; the other two works, painted from Monet's Japanese bridge, offer no coordinates at all – only the water surface with its red, yellow, and white flowers, and a pathway of reflected sky cutting vertically through the composition. If Degas felt dizzy, the critic Louis Gillet's review of the exhibition sums up why, describing 'upside-down painting' in which 'the sky – an ingenious surprise – touches the lower edge of the frame, instead of forming a vault above, and the brightest note, instead of being at the top of the picture, is here at the base'.[2]

Monet does not, however, paint his pool purely as a mirror, as the colour and gentle movement of the water, like the vapour which hovers above its surface, cause the reflections of the garden and sky to be subtly altered so that they shimmer before the eye in multiple, flickering strokes. At the same time, the horizontal accents formed by the groups of water lilies contrast with the sense of depth produced by the reflections of the sky, trees and foliage, and the intimations of mud and vegetation below the water surface. Many reviewers of the exhibition likened these complex effects to a dream, poetry or music.[3]

Monet himself had written in 1908 to his close friend Gustave Geffroy that 'these scenes of water and reflections have become an obsession. It's beyond my old man's strength and yet I want to succeed in representing what I feel.' He likewise told a later interviewer that 'I had always loved sky and water, leaves and flowers. I found them in abundance in my little pool'.[4] These comments suggest his pictures deal with emotion and memories as much as forms and colours. From this point of view, the central path of light in the 1907 and 1908 paintings is not only a recollection of that created by the sun's reflection in the grand seaport paintings by Turner and Claude which Monet admired; it is also surely a reincarnation of the intimate garden path motif he had associated with people and places he loved in pictures such as *Women in the Garden* [fig.7], *The Parc Monceau*, his Vétheuil garden scenes and his views of the Giverny nasturtium path.[5] And if the lilies transpose into vibrant, living colour the island patterns of the grey ice floes on the Seine he had painted back in 1880 when stricken with grief at his first wife's death, they also give life to the 'yellow patches floating like coloured rafts in the reflection of the blue sky' he had seen in Holland in 1886, when surplus flowers from the Dutch bulbfields were thrown into the canals to rot.[6]

Monet's very title of *Paysages d'eau* (Waterscapes) for his 1909 exhibition itself recalls the *Paysages de mer* (Seascapes) exhibition held in 1867 by his Realist mentor Courbet. And for all its effects of dream or music and its personal associations, his imagery was, like Courbet's, still firmly based in observed reality – a reality now shaped by Monet himself, however, to the point that he even called his Giverny garden his 'most beautiful work of art'.[7] In 1893 he had diverted a tributary of the River Epte to make a pool on land adjacent to his flower garden, and in this had planted some of the hybrid garden water lilies recently developed by the Bordeaux grower Joseph Bory Latour-Marliac. 'Coloured with all the tints of the prism',[8] these flowers would have embodied the refraction of light by water, just as they opened and closed in response to the intensity of light, registering time's passage in their very being.

In 1901–03, Monet had in turn extended the pool to three times its original size, enabling him to frame the lilies with larger areas of reflective water; he also employed a gardener to keep this water clear of debris, and wipe dust off the lily leaves. Like the other works in the 1909 exhibition, the three paintings here were a direct outcome of this bringing of greater light, space and colour to the pool. From 1904, Monet also grew rare hybrid water lilies such as *Atropurpurea*, classified by Lagrange of Oullins, one of the seedsmen he patronised at Giverny, as 'brilliant crimson red'; and *William Falconer*, a North-American variety of 'intense bright garnet interspersed with ruby tones'.[9] The pink-red flowers in the 1907 and 1908 paintings may be some of these new acquisitions since, in a sunnier variant of the 1908 painting, they are clearly garnet- or ruby-coloured. Interestingly, these new water lilies were marketed by Lagrange in colour 'series' – just as Monet used 'series' of canvases at Giverny to capture successive effects of light and atmosphere.

If Giverny is arguably the apotheosis of the artist's garden – nature arranged by an artist for painting – Monet was nonetheless quoted in the critic Roger Marx's review of his 1909 exhibition as calling himself nature's 'tributary'.[11] It is this review which in turn describes Monet's idea for a continuity of plant and human worlds through water lily 'decorations' for a room which would offer 'the illusion of a totality without finish, a wave without horizon and bank; nerves overburdened with work could [here] be relaxed … [in an] asylum of a peaceful meditation at the centre of a floral aquarium'.[12] After further alteration of his pool to strengthen and curve its banks following a serious flood in 1910, Monet was ultimately to realise this vision in his water lily decorations at the Orangerie in Paris – images of nature's powers of self-renewal, given by him to France as a First World War memorial – and his three water lily paintings offer fascinating staging posts towards this scheme. The complex intersection of plane and depth in the 1904 painting, for example, clearly looks forward to the Orangerie imagery. In the 1907 painting, with its urgent, expressive strokes of paint which suggest a response to the new Fauve movement, water lilies occupy the foreground, as in the 1908 picture, and in several of the Orangerie panels, where this position enhances the effect of being surrounded by water. The 1908 painting's gossamer veil of blues and lilacs punctuated by green reflections in turn predicts the colour scheme of the panels depicting morning in the Orangerie.

In the 1920s, the 1907 picture became the foundation work in the Parisian Henri Canonne's collection of no fewer than ten of Monet's water lilies – an Orangerie in miniature. But water is traditionally a 'feminine' element,[13] just as flowers are traditionally associated with women. In this sense, it is perhaps only fitting that, following the 1909 exhibition, the 1904 and 1908 paintings were both bought by women – Katherine A Toll of Denver, and Gwendoline Davies, who, with her sister, was one of the earliest collectors of Impressionism in Britain.

1. Cited in Chicago 1995, p.241.
2. Gillet 1909, p.411.
3. For example, ibid., p.412; letter from Romain Rolland to Monet, 14 June 1909, in Geffroy 1980,

p.412; Marx 1909, p.526; see also Levine pp.232–6 and pp.311ff
4. Letter to Geffroy, 11 August 1908, no.1854 in WIV (1974–91), p.374; Monet quoted in Thiébault-Sisson 1927, p.48.
5. See Willsdon 2007, pp.115–6
6. Duc de Trévise, 'Le Pèlerinage de Giverny', in Revue de l'art ancien et moderne, vol.51, 1927, p.127; translated from Paris 1983 A, p.44.
7. Hoschedé 1960, vol.1, p.70.
8. Thiébault-Sisson 1927, p.44.
9. Lagrange, Plantes aquatiques ornementales et rares. Collection unique (seed catalogue in Royal Botanic Garden, Edinburgh, published Oullins, Rhône, post 1900), p.5 and p.2. For Monet's purchase of these water lilies from Latour-Marliac, see Holmes 2001, pp.97–100.
10. Water Lilies (w.1730), Maspro Denkoh Art Museum.
11. Marx 1909, p.528.
12. Ibid., p.529.
13. See L. Gillet, 'Après l'Exposition Claude Monet. Le Testament de l'impressionisme', in Revue des deux mondes, vol.19, 1 February 1924, p.670.

81 Gustav Klimt 1862–1918
Rosebushes under the Trees, 1904

Oil on canvas 110 × 110cm
Musée d'Orsay, Paris

At first sight, this view of the orchard garden of the Litzlberg Brewery on the Attersee in Upper Austria, Klimt's summer retreat from 1900 until 1907, seems a world away from Impressionism. The way the fruit trees all but fill the composition, leaving only a tiny glimpse of hill and sky at upper right and left, creates a richly decorative effect, whilst the tall, slightly inclining shapes of the rose bushes have an anthropomorphic air, as if figures in conversation. The roses themselves seem to float upon their foliage like points of ethereal light, a reminder of the comment by Klimt's friend the writer Hermann Bahr that 'there is something in the soul that is a rosebush', and of the symbolic lovers' rose bush in Klimt's Beethoven Frieze of 1902.[1] The young apples or pears on the trees, meanwhile, glow like reflective beads amidst the green, lilac, and purple touches which represent their leaves. This effect has often been compared with the Pointillism of Seurat or Signac.

However, Klimt's points of contrasted colour clearly result as much from reality – the rounded shapes of the flowers, fruits, branch-nodes and leaves – as from theory. When Rosebushes under the Trees was exhibited at the 1908 Kunstschau (Art Show) in Vienna together with other Attersee garden scenes by him, critics certainly noted this engagement with nature: 'What catches the eye is Klimt's most recent predilection for meadow flowers and whatever plants are cultivated in farmers' gardens … these very "cuttings from nature" are evidence that Klimt is always in search of the most intimate contact with nature, that he has never lost it'.[2] Observers of Klimt at the

Attersee likewise wrote of 'a man in a large meadow in front of an easel, in spite of the drizzle and cold, painting an apple tree, with photographic accuracy'.[3] Though Klimt typically completed his summer paintings back in his Vienna studio, their origins lay in the Impressionist tradition of plein-air painting.

Further, since roses were often grown in farm gardens and orchards in Austria as flowers to cut for the house (the Viennese horticultural press called them a Volksblume, or 'people's flower'), the very ordinariness of Klimt's motif is clearly reminiscent of his Secessionist colleague Carl Moll's precept that 'Nothing is so insignificant … that it does not offer scope for artistic endeavour'.[4] This precept, recorded by Klimt himself, reflects Moll's training in the Barbizon-influenced school of Austrian Impressionism, and his picture can be seen as an heir to works such as Monet's Spring (an orchard subject of 1875) and Sisley's Blossoming Apple Trees (1873) which were exhibited at the Secession's great Impressionist exhibition of 1903. These paintings, according to the critic E. Heilbut's review of the exhibition, were examples of Impressionism's 'liking for the most insignificant motif'.[5] The mass of leaves in Rosebushes under the Trees might also be viewed as a Secessionist answer to the screen of Barbizon forest foliage in Monet's early Le Déjeuner sur l'herbe sketch, again part of the 1903 exhibition.

Coinciding with the Vienna Municipal Council's resolution in 1905 to create 'a belt of woods and meadows around Vienna' as a step towards a modern 'Garden City',[6] Klimt's rural Impressionist garden would also have been highly topical. As such, it takes its place in the wider association of farm gardens with modern art which reaches from Van Gogh, Kalckreuth, and Liebermann to Emil Nolde and Egon Schiele, founders of Expressionism.

1. Bahr, essay on Klimt, 1901, as quoted in Ottawa 2001, p.109; for the Beethoven Frieze rose tree, see Willsdon 1996, p.60.
2. K. Kuzmany, Die Kunst, 1908, p.518, as translated in Ottawa 2001, p.115.
3. Irene Hölzer-Weineck, quoted in Koja 2002, p.47.
4. K. Josefsky, 'Rosen', in Wiener Illustrierte Gartenzeitung, 1904, p.412; R. Feuchtmüller, Kunst in Österreich vom frühen Mittelalter bis zur Gegenwart, Vienna/Munich/Basel 1973, p.232.
5. E. Heilbut, 'Die Impressionistenausstellung der Wiener Secession', in Kunst und Künstler, vol.5, February-March 1903, p.175.
6. L. Hevesi, 'Wien eine Gartenstadt', 6 April 1907, in Hevesi 1909, pp.231–2.

82 Paul Cézanne 1839–1906
The Big Trees, c.1904

Oil on canvas 81 × 65cm
National Gallery of Scotland, Edinburgh

Painted two years before Cézanne's death, this view against the light of ancient trees reaching skywards from the red earth of his native Provence could almost symbolise his own sense of attachment to the region. In 1896, he had written to his friend Joachim Gasquet of 'the links which bind me to this old native soil' of Provence, 'so vibrant, so austere, reflecting the light so as to make one screw up one's eyes and filling with magic the receptacle of our sensations'.[1] This sentiment arguably makes the whole Provençal landscape, with its bent trees sculpted by exposure to the mistral, Cézanne's garden, as the local landscape he knew and loved.

Although the exact site portrayed in The Big Trees is not known, its imagery can be set in the context of Cézanne's especial affection for the neglected, semi-wild estate of the Château Noir, not far from his family home of the Jas de Bouffan near Aix-en-Provence. In 1899, when Cézanne's mother died and the Jas de Bouffan was sold, he had unsuccessfully tried to purchase the Château Noir. Now, as in several of his other works of the early 1900s, The Big Trees looks back to the almost elemental scenes of trees and vegetation he had painted at the château in the 1890s. Now, however, he allows greater space between the trees, so that light floods through the scene, brightening the mood. Comparison with a preparatory pencil and watercolour sketch[2] shows that Cézanne made the right-hand tree taller in the final painting, creating a stronger geometric design. Areas of white canvas are also left bare, enhancing the luminosity, whilst short, parallel brushstrokes are combined with linear ones, and with areas of colour wash; the picture is at once both a drawing and a painting. The rationale for this highly distinctive procedure was described by Cézanne the following year: 'the sensations of colour, which give the light, are for me the reason for the abstractions which do not allow me to cover my canvas entirely nor to pursue the delineation of the objects … from this it results that my image or picture is incomplete'.[3]

Cézanne's reference again here to 'sensations' – as in his letter to Gasquet – is richly revealing, as it was 'sensations' that his old mentor Pissarro had defined as the basis of Impressionist art.[4] If the garden in The Big Trees is now defined by personal sentiment and associations, rather than walls or fences, it still has fundamental connections with Impressionism.

1. Letter to Gasquet, 21 July 1896, as cited in Edinburgh 1990, p.187.
2. Private Collection, Edinburgh 1990, no. 65.
3. Letter to Emile Bernard, 23 October 1905, as translated in London/Paris/Philadelphia 1995–6, p.484.
4. Pissarro, letter to Lucien Pissarro, 13 May 1891, in JBH vol.III, p.82.

83 Joaquín Sorolla y Bastida
1863–1923
The Garden of Sorolla's House, 1920

Oil on canvas 104 × 87.5cm
Museo Sorolla, Madrid

84 Joaquín Sorolla y Bastida
Skipping, 1907

Oil on canvas 105 × 166cm
Museo Sorolla, Madrid

85 Joaquín Sorolla y Bastida
The Reservoir, Alcázar, Seville, 1910

Oil on canvas 82.5 × 105.5cm
Museo Sorolla, Madrid

'Impressionism? The word might have been expressly invented to describe Sorolla's painting', wrote the Spanish critic Ramiro de Maeztu in a review of his compatriot's great exhibition of 278 works in London in 1908 – the complement to Sorolla's similarly vast and successful exhibitions in Paris and New York earlier in the 1900s.[1] After study in Valencia and Rome, Sorolla had become very familiar with French Impressionism, including the art of Monet, through frequent visits to Paris. However, he regarded Velázquez as the 'supreme impressionist master' whose 'ecstatic swiftness of execution' inspired his own 'attempts to catch and seize' light and colour,[2] and he developed a richly individual idiom sometimes described as Luminism. One period critic wrote of his 'divisional taches, spots, cross-hatchings, big sabrelike strokes … refulgent patches, explosions, vibrating surfaces',[3] and Skipping, The Reservoir, Alcázar, Seville and The Garden of Sorolla's House are evocative examples of the inspiration he took from gardens in this pursuit of vibrant effects of sunshine and seasonal colour.

Sorolla first began to paint gardens in the summer of 1907 when his family visited La Granja de San Ildefonso, the historic hilltop residence in Segovia of the Spanish monarchy, to help his daughter Maria recover from tuberculosis in the 'Alpine' air and sunshine there;[4] Skipping was one of the most exuberant – yet also subtle – results of this visit. Although the gardens at La Granja were laid out in the eighteenth century on the model of Versailles, Sorolla does not include any of the sumptuous fountains, such as the Baths of Diana which prompted Philip V's famous reported remark, 'It has cost me three millions and amused me three minutes.'[5]

The motif used in Skipping of a small subsidiary pool, around which children skip after each other from light into shadow and back into light again, seems to reinvent the traditional association of gardens with well-being and healing, and

the children vividly embody the health and vigour the Sorollas sought for their daughter. The lively brushwork invites a sense of kinaesthetic empathy with the figures whilst the way they spin off to the left and top edges of the picture as they skip round the pool is exactly in keeping with recent scientific findings, prompted by research including that of the Spanish neurologist Santiago Ramon y Cajal, that the peripheral area of human vision was the most sensitive to movement.[6] Sorolla makes us see the children's exercise in a way which intensifies its rhythmic vigour. His viewpoint which situates the partly-shadowed pool and its surrounding path at the centre of our field of vision, likewise emphasises the contrasting stillness of the garden.

Sorolla had worked as an assistant in the photographic practice of his father-in-law Antonio Garcia, and must certainly have been aware of the 'sequential' photographs of moving figures pioneered by Edward Muybridge and Etienne Marey in the late nineteenth century, which, viewed in rotating devices such as the praxinoscope, had led to cinematography. It is perhaps no coincidence that *Skipping*, with its figures moving in circular sequence, and its play of red and green, coincides with early cinematography and the use of red and green filters to create the first 'moving pictures' in colour. At the same time, there is a richly decorative quality to the painting, as the brilliant red of the foreground girl's hair-ribbons is echoed in the flowers in the distance, and the shape of the pool is repeated in the arcs formed by the luminous shadows and the rising and falling skipping ropes.

The Reservoir, by contrast, with its sombre yet light-filled reflections, evokes tranquillity and coolness, with a hint of slow, spacious movement suggested by the passing clouds. Showing one of the pools so essential for keeping plants watered in the gardens of the ancient Moorish palace of the Alcázar in Seville, it belongs to a group of twenty pictures which Sorolla painted in January and February 1910 in these gardens, in preparation for a show of his work that year in New York. Once again, it is a modest corner rather than a grand view which attracts his attention; the play of springtime light and shadow is what creates the picture's poetry. The sunlight, less brilliant than that of summer shown in *Skipping*, reflects from the whitewashed wall at the centre right, echoing the bright white clouds, and catching the sides of the flowerpots, which presumably contain plants requiring care: succulents such as *Crassula sp.* or *Aeonium sp.*, for example. A shrub, perhaps acacia or mimosa, creates lacy patterns of yellow

and cream against the wall and the deeper-toned evergreen foliage.

The Garden of Sorolla's House is one of the artist's very last works. It was completed in the spring of 1920 just a few months before his career was ended when he had a stroke whilst painting a portrait in the garden depicted – that of his own home in Madrid, now the Museo Sorolla. Using the proceeds of his foreign exhibitions, he had begun the construction of this home in 1910, and the garden he designed there became a favourite motif in his later years, both in its own right and as a setting for portraits. The painting shows the chair on which he liked to sit; the sun reaching across the patio and dappling the pink flowers (probably pelargoniums in pots); the low white wall decorated with blue Valencian tiles; and the plinths with statuettes which, with the tiles, formed a distinctive feature of the garden. The Sorollas' colonnaded house is seen beyond.

None of the shadows is dark; imbued with subtle blues and violets, they are reminders of the brilliance of the Spanish sunshine which is reflected from the surrounding surfaces – the patio, walls, and plinths. The chair meanwhile invites rest. In 1918 Sorolla had written to his wife of the 'emotion' which overcame him when painting, leaving him 'shattered, exhausted; I cannot put up with so much pleasure, I cannot bear it as I used to … This is because painting, when one feels it, is superior to anything else. No, I meant to say: it's nature which is so beautiful.'[7] In his artist's garden in Madrid, art and nature were, of course, symbiotically combined.

1. Maeztu in *La Prensa*, 1908, quoted in C. Garcia, *The Painter Joaquín Sorolla y Bastida*, p.81, as given in Broude 1994, p.240.
2. Quoted in H. Tyrell, review of Sorolla's Hispanic Society of America exhibition, in *The New York World*, 13 February 1909, in De Beruete 1909, vol.2, p.213.
3. James Gibbons Huneker, 'Sorolla y Bastida', in ibid., vol.1, pp.378–83.
4. Pons-Sorolla 2009, p.176.
5. Quoted in 'La Granja' in *The Encyclopaedia Britannica*, New York 1911, vol.16, p.78.
6. See Carey 2001, p.290 and pp.294–5.
7. Sorolla, letter of 1918, quoted in C. Garcia, 'Sorolla y Bastida, Joaquín, *The Courtyard of the Sorolla House*, 1917', at http://www.museothyssen.org/thyssen_ing/coleccion/obras_ficha_texto_print227.html.

86 Marie Egner 1850–1940
In the Pergola, c.1912–13

Oil on canvas 68 × 86.7cm
Belvedere, Vienna

The Austrian painter Marie Egner would surely have appreciated 'September' from her compatriot Richard Strauss's *Four Last Songs*, those evocative last echoes

of 'Vienna 1900' written in the late 1940s, some years after her death:
The summer shudders
silently towards its end.
Leaf after golden leaf drops …
The summer smiles, astonished and weary,
Into the garden's dying dream …

A couple of years after Egner painted *In the Pergola*'s ripened gourds, luscious grapes and yellowing vine leaves in a garden in Italy when she was in her early sixties, she certainly confided to her diary that Strauss pleased her the most 'of all the moderns'; he 'is always distinguished and has splendid colour'.[1]

This comment is revealing, as it was colour that Egner prized in painting. Ineligible as a woman for admission to the Vienna Academy of Arts, she had painted with Emil Jakob Schindler, the leader of the Austrian school of atmospheric Impressionism, but it was studying in London from 1887 until 1888 with the Scottish watercolourist Robert Weir Allan, who admired French Impressionism and was mentor also to Arthur Melville [61], that encouraged her love of colour. Whilst in London she taught flower painting at a school in Wimbledon, and subsequently made many visits to France, becoming familiar with Impressionism at first hand. *In the Pergola*'s combination of a still life with a garden setting is perhaps in turn an echo of this device in nineteenth-century Lyons paintings; she visited the Lyons Musée des Beaux-Arts in 1905.

However, Egner's merging of two genres is also complemented by that of two seasons. As the late summer sun shines through the translucent yellow leaves, already turning brown at their edges, it points up the blue and lilac shadows on the tablecloth and path, hinting at autumn chillness, just as it picks out the heads of white chrysanthemums, the traditional flower of mourning, to the left of the pergola. The pergola itself is similarly transitional, an outdoor room whose link to the house is emphasised by Egner's addition at the right of a piece of canvas representing a wall. She had written in 1908 that colouring 'consists of the play of the iris which never stands still, always gleams, hurries, sparkles, so that "movement" is its true element',[2] and her imagery of transience and transformation in the garden can equally be recognised as a logical comple-ment to a distinctive Austrian concept of Impressionism, neatly summarised by her contemporary the writer Hermann Bahr after the Vienna Secession's great *The Evolution of Impressionism* exhibition of 1903: 'one thing runs into another and is eternally becoming, always in a ceaseless process of change' where even 'the physical and the psychological run together'.[3] This

definition was influenced by the Austrian physicist Ernst Mach's account of sensory perception as inherently subjective, and is vividly demonstrated by *In the Pergola*'s treatment of the garden as a place of mood evoked by colour.

1. 'September' (poem by Hermann Hesse), no.2 of Strauss's *Four Last Songs*, as translated in S.S. Prawer, *The Penguin Book of Lieder*, Harmondsworth 1964; Egner, diary entry, December 1915, in Suppan/Tromayer 1981, vol.1, p.81.
2. Egner, diary entry, May 1908, in ibid., p.72.
3. Bahr, 'Impressionismus', from *Dialog vom Tragischen*, Berlin 1904, in Bahr 1968, p.197.

87 Gaetano Previati 1852–1920
Mammina, c.1908

Oil on canvas 99.5 × 78cm
Galleria Nazionale d'Arte Moderna, Rome

Pausing beside flowering bushes in a garden suffused with the warm light of evening, a mother lifts up her young child to witness their beauty. Silhouetted against the light, she has an aura almost like a halo, whilst the child stretches out its chubby arms towards the shimmering mass of flowers as if entranced by their colour and perhaps their perfume too. The flowers are not portrayed in sufficient detail to enable the species to be identified, although their pinkish colour and heads of multiple florets suggest they may perhaps be lilac. What the Italian artist Previati seems concerned to create is not a portrait or a gardenscape, but a sense of symbiotic, almost mystical, relationship between mother, child, and garden setting. The light seems to come not only from behind the figures, but also to emanate towards them from the flowering bush, as though this were on fire like the Biblical burning bush from which God spoke to Moses.

Previati was a prominent member of the Italian Divisionists, who followed scientific principles of colour juxtaposition but used a distinctive linear technique – rather than the dots or points of contrasted colour with which their French or Belgian colleagues, such as Van Rysselberghe, sought to reform Impressionism. In this painting, however, with its tender glance from mother to child, and child's gesture of embrace towards the flowers, it is surely emotion rather than science which dominates, together with an echo of the Renaissance 'Madonna and Child in a *hortus conclusus*' tradition (Previati admired Botticelli). The picture's exact purpose can only be surmised, but its garden of beauty, light and innocence would certainly have stood in powerful contrast to the drab, industrialised habitat of so many children at this period in Previati's home city of Milan. In this sense the work compares closely with Frédéric's *The Fragrant Air* [47]. Previati had in 1901

condemned the 'artifice' of modern city life, and spoken of his aim to 'recreate either a vanished or an ideal environment'[1]

At the same time, the child's eagerness to see, touch and perhaps also smell the colourful flowers, and the mother's encouragement of this, are very much in keeping with the contemporary ideas of Maria Montessori, the progressive Italian educationist who in the 1900s was transforming the lives of the slum children of Rome. Montessori advocated the child's self-education under adult guidance, with the development of its senses as the key foundation for this. From this point of view, although now very different in style, *Mammina* continues the tradition of Impressionist gardens which include children, such as those of Morisot and McMonnies.

1. Cited in London/Zurich 2008–9, p.51; also London 1989, p.33.

88 Pierre Bonnard 1867–1947
Blue Balcony, c.1910

Oil on canvas 52.5 × 76cm
The Samuel Courtauld Trust, The Courtauld Gallery, London

This picture seems to break all the rules. There is no foreground and the elevated viewpoint plunges the eye straight into the expanse of garden in the middle distance, as if Bonnard seeks to emulate his favourite writer Mallarmé, who had started his great essay of 1876 on Impressionism with the comment, 'Without any preamble whatsoever, without even a word of explanation to the reader … I shall enter at once into [my] subject'.[1] The garden path, so prominently placed just to the right of centre, does not 'lead to a focal point', as traditionally recommended in garden design.[2] A mass of expansive trees blocks off the perspective, and it is only by knowing that the River Epte lay beyond this garden – the garden of the house called 'Ma Roulotte' at Vernon near Giverny, which Bonnard was to purchase two years later – that the patches of pinky-white between the trunks of the trees are recognisable as water. And, only after a closer look can the tiny chair and table positioned under the trees at the end of the path be spotted.

But there is a wonderful sense of spaciousness; the sweeping viewpoint transcends the petty details of everyday life, and even Bonnard's wife Marthe as she bends forwards on the blue balcony at the left. It makes the garden a place of possibilities and perhaps even dreams, complementing the theme of seasonal renewal indicated by the trees in blossom at either side of the path, and the flowers beginning to bloom. It also makes the

garden a place of subtle correspondences: seen from a distance, the tablecloth on the washing line becomes part of the pattern of glimpses of the pale trees, yet its pink checks also decoratively echo the shapes of the bricks on the wall at the left, and the squarish areas of bare earth beside the path. The blue balcony itself becomes a second receding path, its almost turquoise colour a lighter version of the slightly acid green of the grass and trees. It is as though Bonnard teases the viewer, making us experience directly the 'adventures of the optic nerve' which he said constituted painting.[3] He was certainly to let nature have free adventure in the garden over the years which followed, delighting in the way the areas of lawn became richly overgrown by tangled, intricate foliage, so that it increasingly resembled his lush garden of the south at Le Cannet. In this picture he creates an intriguing though very different counterpart to his friend Monet's exploration at the same period at nearby Giverny of the artistic possibilities of a view 'down over' a motif – in Monet's case, over the surface of his lily pond.

1. Mallarmé 1876, p.91.
2. F. Barillet, 'Du Tracé des jardins', in *Revue horticole* 1872, p.469.
3. Bonnard, diary note, 1 February 1934, as translated in London/New York 1998, p.33.

89 Henri Martin 1860–1943
In the Garden, c.1910

Oil on canvas 60 × 75 cm
Palais des Beaux-Arts, Lille

What thoughts pass through this young woman's head, as she sits so still and silent in Martin's garden in the Lot region of France? Seen in part profile against the bright sunshine, her finely-cut features and tied-back hair have an almost classical character, as if some antique or Renaissance portrait bust has been imbued with light and colour. Martin had in fact begun his career as a painter of historical and Symbolist allegories, before developing a pointillist form of Impressionism as a result of his friendship with Seurat's circle. This style found expression not only in easel painting, but also in monumental murals. From 1900 he spent his summers painting at or near Marquayrol, the traditional farmhouse he purchased that year at Labastide-du-Vert near Cahors. The Italianate garden he created there, with its cypress path, circular pool, creeper-covered pergola and plants in pots, provided inspiration for numerous pictures including *In the Garden* and *Garden in the Sun*.

In the Garden portrays one of several young women who posed for Martin at Marquayrol, and this sitter also appears

in his Mediterranean landscape murals for the dining room of Dr d'Herbécourt's Paris mansion at Avenue Wagram,[1] and the harvest scene in his Conseil d'Etat murals at the Palais Royal in Paris. In both these schemes, she is associated with harmony and balance between mankind and nature – the 'Virgilian atmosphere' of the d'Herbécourt panels[2] and the cycle of seasonal labour at the Conseil d'Etat – and the same is true of *In the Garden*. The woman is seated at the crossing point of the Marquayrol garden's paths,[3] so that her figure, flanked by bright geraniums, takes its place within a rhythmic symmetry of pine trees and tubs of oleanders. The branches of a further tree in the background form a feathery aureole around the woman's head, lending her an almost otherworldly quality; at the same time, her skin echoes the pinks of the oleanders, just as her gauzy dress reflects the blue sky and green foliage, so that she becomes as one with her garden setting.

In the early twentieth century, many French artists from Matisse to Bonnard and Denis were attracted by the south of France's 'spirit of latinity',[4] derived from its associations with antiquity, and Martin's picture can be placed in this context. Yet his technique of delicate brushstrokes and his sensitivity to the nuances of atmosphere and light imbue the scene with an evocative poetry, softening both the garden's formal structure and the effect of a portrait bust. The southern garden here becomes a place beyond time, for meditation and reverie.

1. Now re-installed in the Musée départemental de l'Oise, Beauvais.
2. M.-J. Salmon and J. Galliègue, *De Thomas Couture à Maurice Denis. Vingt ans d'acquisitions du Conseil general de l'Oise*, p.72.
3. Cahors 2008–9, p.131.
4. Chicago/New York 2001, p.147.

90 John Lavery 1856–1941
My Garden in Morocco, c.1911

Oil on canvas 101.6 × 127cm
Private Collection

Although born in Belfast, Lavery grew up in Scotland, and during the early 1880s absorbed Impressionist ideas in Paris and Grez-sur-Loing. Associated in turn with the Glasgow Boys, he achieved such success as a portraitist – in Rome, Berlin and Madrid as well as Britain – that by 1908 the art historian James Caw described him as 'the most cosmopolitan of the group … Vice-President of the "International Society" … Cavaliere of the Crown of Italy, member of the Société Nationale des Beaux-Arts, Paris, and of the Sécessions of Berlin, Munich and Vienna'.[1]

My Garden in Morocco bears vivid

witness to this success, as it was the proceeds from exhibitions in Berlin that appear to have enabled Lavery's purchase in 1903 of his winter residence near Tangier. The house named Dar-el-Midfah (the House of the Cannon) after the weapon half-buried in its garden (a relic, presumably, of the Spanish siege of Gibraltar in the eighteenth century) was situated on Mount Washington overlooking the Straits of Gibraltar, and used by Lavery until 1923. *My Garden in Morocco* depicts part of its terracing where bougainvillea grew – the plants with brilliant pink bracts introduced to Europe from Brazil in 1768 by the French explorer De Bougainville. In the background is the entrance to Lavery's studio, a glimpse of Moorish architecture which, with its screen of trees, creates a decorative effect reminiscent of a Bakst design for Diaghilev's Ballet Russe. *Schéhérazade* was in fact performed by the Ballet Russe in London in the summer of 1911, when Lavery also painted one of the company's most famous dancers, Anna Pavlova.

If the foreground area in turn resembles a stage, this was, however, for intimate domestic drama, as the place where the Laverys welcomed friends and fellow-expatriates to tea. The women at the well-laden table are thought to include Eileen, Lavery's daughter from his first marriage, whilst the man may be Walter Harris, the Moroccan correspondent of the *The Times*. Lavery's wife Hazel basks in the sunshine on a chaise-longue, watching their daughter Alice – the child who, as she gazes out of the picture, implicitly makes her father painting the garden the spectacle.[2]

This reversal of expectations is matched by the way that indoor dining chairs and a table are placed in the open air, and by Lavery's substitution of the garden for his studio. But if Lavery's fluent brushstrokes underline the informality, they also weave a pattern of light and dark as complex as a piece of Moorish latticework, in which the sunny steps, pale house and dresses, and pink bougainvillea contrast with dark trees, black chairs, and shaded terrace. A personal, intimate memento of a place Lavery loved, the picture was fittingly purchased by a private collector. Although exhibited at the Royal Glasgow Institute of the Fine Arts in 1917, it is thought not to have been shown in public since.

1. Caw 1975, p. 376.
2. I am grateful to Professor Kenneth McConkey for details of the painting's history and motif.

91 Henri Martin 1860–1943
Garden in the Sun, c.1913

Oil on canvas 83 × 81cm
Musée de la Chartreuse, Douai

This view to the midday brilliance of a southern summer garden invites the viewer to step through the doors of a room at Marquayrol, Martin's farmhouse in the village of Labastide-du-Vert in the Lot in France. Yet although the prime subject is the burst of colour of the garden – the green leaves made luminous by the light shining through them, the shimmering red and white flowers of the pelargoniums in pots, and the oleander beside them – Martin also shows how it affects the interior. The blinding light spangles the floor with patches of yellow and cream, whilst the pinkish touches on the walls and floor suggest the complementary 'after-effect' experienced when turning away after looking into sunshine – an effect thought to have been exploited by Matisse a few years earlier.[1] The tones of the walls and door-arch are also brightened by light bouncing off the unseen wall across the room. Far from being opposites, the darker interior and bright exterior are intimately linked in a subtle harmony.

After turning in 1889 from Symbolism to Impressionism and pointillist approaches, Martin earned much acclaim for large-scale murals. In *Garden in the Sun*, the framing device of the open doors makes the garden in effect a living mural, a three-dimensional sequel to the painted woodland settings in his *Apollo and the Muses* murals of 1898 for the Hôtel de Ville in Paris, and his seasonal landscapes of Labastide-du-Vert in murals of 1903 for the Toulouse Capitole.

At the period of *Garden in the Sun*, he had just embarked on his vast 'Working France' murals of field, forest, street and harbour motifs for the Conseil d'État in Paris, and *Garden in the Sun*'s imagery offers an intriguing domestic counterpart to their vision of the *terre natale* (native land) productively worked by human hand.[2] It shows a corner of his garden where nature grows abundantly, yet where the path and ordered pots of pelargoniums give evidence of the gardener's care, and complement the architecture of the house. Similarly, the young trees – perhaps Locust or False Acacia, often grown in the south of France – evoke the organic origins of the finely-crafted wooden chair and doors. Garden and house become symbolically as well as visually united. His picture not only makes a highly individual contribution to the association of 'Impressionist gardens' and decorative painting developed by Bonnard and Monet; it also provides an evocative southern partner to the vision of the garden as an extension of the house which is found in his friend Le Sidaner's work at Gerberoy, and that of his contemporaries Liebermann and Lichtwork at Wannsee near Berlin.

1. Matisse, *Red Studio*, 1911, Museum of Modern Art, New York; see J. Elderfield, *Matisse in the Collection of the Museum of Modern Art*, exh. cat., Museum of Modern Art, New York 1978, pp.86–8; and Gage 1993, p.212.
2. See Willsdon 2000, p.105 and p.107, and Toulouse/Paris 1983, nos.54, 59, 72–4 etc; for *terre natale* see R. Thomson, 'Henri Martin at Toulouse', in Thomson 1998, pp.162–3.

92 Gustav Klimt 1862–1918
Italian Garden Landscape, 1913

Oil on canvas 110 × 110cm
Kunsthaus Zug, Stiftung Sammlung Kamm

Klimt loved flowers. His colleague Egon Schiele recalled how, in Vienna 'every year, Klimt adorned the garden surrounding the house in Feldmühlgasse (his studio) with flower beds – it was a joy to go there surrounded by blossoms and old trees'.[1] He also made drawings of flowers with notes on their colours for reference when creating the floral motifs and backgrounds of so many of his figure paintings. In a postcard of 1916 to his friend Emilie Flöge, he even wrote of how, at the sight of crocuses in his sunlit garden, 'the mind lightens and courage and strength [return]',[2] and it is something of this sense of jubilation at nature's blooming which *Italian Garden Landscape* surely already evokes, with its display of colourful flowers cascading towards the viewer. Painted on a visit to Lake Garda with Emilie Flöge from August to early September of 1913, the southern profusion of its motif is captured in varied, textural brushwork – sometimes linear, sometimes involving tiny touches of pigment – which vividly evokes the individual character of each plant or flower.

The pink and white flowers which dominate the foreground at the left, thrusting themselves right under our noses, are rosebay (*Nerium oleander*), which has a sweet scent; a mass of these flowers in turn runs back beside the hedge to the whitewashed house in the background. Orange-red Italian corn poppies and a patch of French lavender vibrate against the green grass towards the right, whilst the foliage of a climber, probably morning glory, grows down over the hedge, and flowers with yellow centres, suggestive of Kingfisher daisies, spill towards the viewer. Apart from a glimpse of Lake Garda's shimmering blue at upper left, trees and bushes entirely fill the background, enfolding the little white house in a nest of greenery. Whilst Klimt's impasto brushwork and outlining of forms can be compared with the art of Van Gogh, which he greatly admired, the motif of a mass of flowers receding towards a white house intriguingly echoes that of Monet's *The Artist's Garden in Argenteuil (A Corner of the Garden with Dahlias)* [19]. This painting had been one of the major works in the important *Manet-Monet* exhibition mounted by Klimt's friend Carl Moll at the Galerie Miethke in Vienna in 1910. If Klimt's other paintings of 1913 at Lake Garda, which show architectural subjects, reflect his encounter with Cubism on his 1909 visit to Paris,[3] it would seem that the garden he portrayed there prompted him to renew his interest in Impressionism.

1. Koja 2002, p.127 from F. Karpfen, *Das Egon Schiele Buch*, Vienna 1921, p.89.
2. March 11, 1916, no.345 in W.G. Fischer, *Gustav Klimt und Emilie Flöge. Genie und Talent, Freundschaft und Besessenheit*, Vienna 1987, as translated in W.G. Fischer, *Gustav Klimt and Emilie Flöge. An Artist and his Muse*, New York 1992, p.165 and Ottawa 2001, p.113.
3. See Koja 2002, p.116.

93 Pierre Bonnard 1867–1947
Resting in the Garden, c.1914

Oil on canvas 100.5 × 249cm
The National Museum of Art, Architecture and Design, Oslo

In January 1914, Vuillard wrote from Paris to his good friend Bonnard: 'Deep crisp cold but dusty and sad here … Flu everywhere … May the villa Joséphine and its pretty horizons inspire you.'[1] Bonnard was at Saint-Tropez for two months, renting the Villa Joséphine – the home of the Polish painter Jósef Pankiewicz – and *Resting in the Garden* is believed to be the fruit of the inspiration Vuillard wished for him there as it appears to show the villa's garden, with an unidentified woman taking a siesta, and a view to the southern French landscape.[2] But where Saint-Tropez had inspired Bonnard's friend Matisse to adopt a bold new style of simplified zones of flat, saturated colour, it encouraged Bonnard to 'develop' Impressionism through greater emphasis on 'composition' and on 'colour as a means of expression'.[3]

In *Resting in the Garden*, where the figure, table and cat occupy the foreground plane, the composition is even reminiscent of an antique frieze. This perhaps reflects the wider association in the early twentieth century between the south of France and antiquity; a link which acquired particular resonance as war broke out with Germany in 1914.[4] But, at the same time, there is Bonnard's increased concern with colour: the leaves of the central tree, seen *contre-jour* (against the light), turn to gold, shadows are infused with pink, blue and velvet brown, and the garden merges with the larger landscape, as if seen through dreaming, half-closed eyes. Light and colour in this sense *are* the mood of indolence portrayed, and a reminder of Bonnard's comment that 'before I start painting I reflect, I dream'.[5] He worked not from nature but from memory and pencil notes. Rather than the spring blossom which would have been in flower at the Villa Joséphine in January, *Resting in the Garden* in fact shows ripening plums on the tree, together with red fruits at the far right, and the freshly-picked cherries whose ruby skins are complemented by the carmine check of the tablecloth. The garden is ultimately a magical space where reality fuses with dream, and the close-up viewpoint draws the spectator into this alchemy. For the woman is awake to sensation, as she raises her arm, revelling in the warmth of the sun, yet she is also clearly asleep; likewise, though alert – seated, rather than lying – the cat, a traditional erotic symbol, closes its eyes. It is as though, in their respective ways, both woman and cat are the somnolent faun, himself part-man, part-beast, who represents the poet or artist in the *Prélude à l'après-midi d'un faune* by Bonnard's favourite writer Mallarmé. Here, 'made heavy by pleasure', the faun's eyelids and body 'succumb to the antique midday siesta' – and the reader in turn 'becomes' the faun-artist, for Mallarmé adds 'Let *us* sleep.'[6]

There are still deeper levels of expression in *Resting in the Garden*, however, for the woman's gesture of one arm raised above the head is a reprise of the famous antique statue in the Louvre called *The Dying Slave*, a statue much studied by Bonnard. If this suggests that sleep and dream are neighbours to death, it is surely no coincidence that the garden also includes, silhouetted at the right, a row of foxgloves (*Digitalis*). Though intrinsically poisonous, foxgloves heal in medicine. If the Villa Joséphine garden invites us to withdraw from life, Bonnard thus also offers the means to keep our hold on life – and our enjoyment, therefore, of sunshine, warmth and ripened fruits. Yet these very sensations in themselves, of course, call us again to indolence and dream. In this endlessly repeating cycle we begin to see why Bonnard called art 'a stopping of time'.[7]

1. Terrasse 2001, p.62. Although this comment could also be translated as ' … Discontents everywhere … ', 'Flu everywhere' seems the likelier meaning in the context of winter.
2. See London/New York 1998, p.106 and Chicago/New York 2001, p.186.
3. Recollection by Bonnard in late life, in J. Bouret, *Bonnard: Séductions*, Lausanne 1967, p.44, cited in Chicago/New York 2001, p.149.
4. See Werth 2002, and Watkins 1994, p.76.
5. Cited in London/New York 1998, p.9.
6. These lines are cited in relation to Bonnard's

Indolence (1898 or 1899) in London/New York 1998, p.16, but since spoken by the faun in a pastoral landscape, are arguably still more relevant to *Resting in the Garden*

7. Comment from M. Makarius, 'Bonnard et Proust. Les Couleurs du temps retrouvé', in *Cahiers d'art moderne*, Paris 1984, pp.110–13, as translated in Watkins 1994, p.56.

94 Max Liebermann 1947–1935
The Artist's Granddaughter with her Governess in the Wannsee Garden, 1923

Oil on canvas 75.7 × 100cm
Carmen Thyssen-Bornemisza Collection, on loan to the Museo Thyssen-Bornemisza, Madrid

The German Impressionist Max Liebermann constructed his summer residence at Wannsee near Berlin between 1909 and 1910, and over the remaining twenty-five years of his life, its garden became a prime source of his artistic inspiration. In contrast to Monet's concentration at this period on his pond surface in Giverny, however, Liebermann often chose expansive views at Wannsee.[1] *The Artist's Granddaughter with her Governess in the Wannsee Garden* looks down over the flower terrace and lawn behind the house to the Wannsee itself, the shimmering blue lake dotted with sailing boats at the centre of the picture. To the left run Liebermann's hedged garden rooms, flanking the path to his jetty; to the right is the great avenue of birch trees, where Maria, his granddaughter, is returning home with her governess as the shadows lengthen. Sunshine filtering between the trees stripes the lawn and dapples the red flowers and the agapanthus plants (not here in flower). It is possible to imagine the scent of lime blossom drifting across the lawn from the *Lindenkarree* (square of lime trees) in the first garden room, just as the breeze from the lake ruffles the leaves of the birches, blurring their forms.

Liebermann designed his garden with advice from the Director of the Hamburg Art Gallery Alfred Lichtwark, and their mutual friend Leopold Graf von Kalckreuth. Prominent in the early twentieth-century 'Garden-Reform' movement in Germany and Austria, with its quest for an architectural unity of house and garden layout, Lichtwark took important stimulus from the straight paths and geometric flower beds of the traditional *Bauerngarten* (farm garden). Already in 1892 he had described showing such a garden to a friend, thought to be Liebermann, who 'made a frame with his hands before his eyes and tried the motifs for painting as painters do. "A hundred paintings could be painted here", he said,

"each one more beautiful than the last".[2]

If Liebermann's Wannsee paintings were the realisation of this vision, the view he 'framed' in this work is especially intriguing. Looking down on the garden from a slight elevation, he dispenses with an immediate foreground, so that the eye travels swiftly to the point where the garden meets the ethereal blue of the distant lake. This is the part of his garden he had called 'pure Faust Part II' – an allusion to Faust's project in Goethe's famous play of reclaiming territory from the sea to create a 'paradisal land'.[3] Liebermann had similarly purchased part of the lake to construct a 'piazzetta'.[4] And just as the elevated viewpoint makes the lake seem nearer, so too does Liebermann's loose impressionistic style treat the red flowers on the terrace with the same imprecision as the distant boats. This infusion of the near with the character of the 'far-away' is reinforced by the figures moving towards us, whose white costumes echo the luminosity of the lake and sky.

The 'far-away' is a traditional metaphor for utopian or paradisal ideals and from the 1890s the *Fernbild* (distant view) had become established in Germanic art and thought as an expression of harmony, and even of civilisation.[5] It is as though, in leading the eye to the distant lake, and conferring impressionistic distance on the whole paradisal garden of the work, Liebermann reasserts the liberal, civilised values he felt the First World War had so brutally compromised. In this sense, he was perhaps not so different after all from Monet in the 1920s, painting his water lily garden as a First World War memorial, and reflecting the infinite sky amidst its flowers.

1. Hamburg/Berlin 2004, p.31.
2. Lichtwark 1894, p.50, at http://www.museothyssen.org/thyssen_ing/coleccion/obras_ficha_texto_print289.html. For identification of Liebermann as the friend, see Hamburg/Berlin 2004, p.31.
3. Letter from Liebermann to Lichtwark, 31 July 1910, in Pflugmacher 2003, p.346; Goethe, *Faust II*, line 11569.
4. See letters from Lichtwark to Liebermann, 22 December 1909, p.316; and from Liebermann to Lichtwark, 13 January 1910, p.324, and 31 July 1910, p.346, in ibid.
5. See Koja 2002, p.175; for the term *Fernbild* see for example, A. von Hildebrand, Das *Problem der Form* (1903) in Busch/Beyrodt 1982, p.265.

95 Claude Monet 1840–1926
The Water Lily Pond, 1918–19

Oil on canvas 119.5 × 88.5cm
Musée d'art et d'histoire, Geneva

Completed whilst Monet was working on his water lily murals for the Orangerie, this is one of a group of pictures of 1916 to 1919 of his water garden at Giverny. Most of these portray a weeping willow, thought

perhaps to encapsulate his sorrow at the First World War, but three, including *The Water Lily Pond*, show the north-eastern part of the pool, opposite the Japanese bridge, with part of the curving bank Monet had created in 1901.

The intimate, secluded composition is intriguingly similar to that of Monet's 1878 paintings of the Parc Monceau [49,50]. The curving, sunlit bank replaces the park's grass and path, and a group of water lilies substitutes for its figures. The red and pink colours of these water lilies are picked up in the rambler roses in the background, which Monet trained both on trees and metal supports. Like his rose garden and rose-arcade, these ramblers were a not insignificant horticultural achievement, for the Giverny soil is chalky, a type disliked by roses.[1] Those near the pond included specimens of *Belle Vichyssoise*, described by Monet's friend the horticulturalist Georges Truffaut as 'of extraordinary vigour', with 'long clusters of little pink perfumed roses';[2] many of Monet's water lilies were also scented. The way the reds and pinks of the roses and water lilies echo through different parts of the painting – on the path, in the water, metamorphosed into threads of violet shadow in the foliage – certainly brings to mind the pervasive qualities of perfume, whilst the animated brushstrokes flickering across the canvas complement this effect, making the painting a virtual paean to synaesthesia. It is as though the ageing Monet, whose cataracts would shortly distort his vision, was recalling not only the intimacy of the Parc Monceau, but also the 'delicious perfume' he had described finding 'everywhere' in his letters from Bordighera on the Riviera in 1884.[3]

Perfume, of course, had been famously described by many writers from Baudelaire to Proust as itself a stimulus to memories.[4] If Monet's weeping willow paintings are sombre in mood, *The Water Lily Pond*, with its apparent recollections of places he had loved, surely looks to the garden as a place of consolation, as his great friend and fellow rose-enthusiast Georges Clemenceau had urged when the painter was grief-stricken at the death in 1911 of his second wife Alice – and just as Monet painted his water lilies as a First World War memorial.

Monet gave one of his *Water Lily Pond* series to the Museum at Grenoble, to encourage modern artists.[5] The *Belle Vichyssoise* rose, meanwhile, is today only found in the garden at Giverny, as if encapsulating its spirit.

1. See 'F.J.', 'Les Roses de Claude Monet', in *Rosa Gallica. Revue français des amateurs de roses*, no.46, July-August 2007, p.30.
2. G. Truffaut, 'Le Jardin de Claude Monet', in *Jardinage*, November 1924, no.87, p.55.

3. Monet, letter to Alice Hoschedé, 13 February 1884, no.417 in w.II, p.238.
4. For example, Baudelaire's 'Harmonie du Soir', 'La Chevelure' and 'l'Invitation au Voyage' in his *Fleurs du Mal*, Paris 1857, and Proust's *A la Recherche du Temps Perdu*, Paris 1913–27.
5. W II76, n.892.

96 Claude Monet 1840–1926
The House among the Roses, 1925

Oil on canvas 92.3 × 73.3cm
Carmen Thyssen-Bornemisza Collection, on loan to the Museo Thyssen-Bornemisza, Madrid

'The moment you open the little door leading off the single main street in Giverny, you think … you are entering a paradise … If it's rose-time, all the marvels with the glorious names surround you with their nuances and perfumes. There are rose trees, rose bushes, roses in hedges, growing *en espalier*, climbing on the walls, trained over pillars and over the arches of the central path. There are the rarest and also the most ordinary, which are not the least beautiful, the single roses, the clusters of briar roses, the most vivid as well as the palest.'[1] *The House among the Roses* provides a tantalising glimpse of the horticultural delights so evocatively described here by Monet's close friend the writer Gustave Geffroy. One of a series of views Monet painted in his final years of a corner of his rose garden at Giverny with its iris-planted lawns and the backdrop of his slate-roofed Normandy house, this picture has, intriguingly, the same composition as his 1907 and 1908 *Water Lilies* [79, 80]. Tall, vigorous rose bushes laden with pink flowers, however, now replace the insubstantial reflections at left and right of these earlier pictures. And although the painting is plainly unfinished, the energetic brushwork speaks visibly of the 'second youth' Monet said he experienced in summer of 1925, when, following his cataract operations, he commented, 'I am working as never before, am satisfied with what I do, and if the new glasses are even better, my only request would be to live to be one hundred.'[2]

The House among the Roses must in fact have been a welcome diversion for Monet from the task of completing his vast water lily murals for the Orangerie, which had to be painted in his studio. Out of doors amongst his roses, he could breathe the fresh, perfumed air, and look up to the sky's scudding clouds instead of down to their watery reflection. In this picture, the blue of the sky in turn resonates in the mauve tones of the house, the last vestiges of the iris flowers, and the acid-greens of the grass and leaves, heightening by contrast the pink of the roses. It is almost

as if the garden itself has taken on the properties of the 'azur' – the name given to the sky by Monet's late friend the poet Mallarmé, for whom it had been a key symbol of the ideal. And just as Mallarmé had argued that, for those who know how to see it, the ideal lies ultimately in 'the gardens of this star' – the tangible, real world –[3] so *The House among the Roses*, despite being unfinished, was surely a poignant restatement of this philosophy. Geffroy certainly concluded his description of Monet's rose garden with the comment that its 'flowers [speak] of an enchanted hour; the singing choir of summer, they make you believe that happiness is possible'.[4]

1. Geffroy 1980, p.443 (first published 1924).
2. Letter to Marc Elder, 16 October 1925, w.IV no.2683, as translated in Spate 1992, p.285; letter to Barbier, 17 July 1925, w.IV no.2609, as translated in London/Boston 1998–9, p.83.
3. See *Stéphane Mallarmé Poésies* (ed. B. Marchal), Paris 1992, p.226.
4. Geffroy 1980, p.443.

97 Henri Le Sidaner 1862–1939
The Rose Pavilion, Gerberoy, 1936–8

Oil on canvas 73 × 60cm
Fondation Surpierre, on loan to the
Wallraf-Richartz Museum & Fondation
Corboud, Cologne

Le Sidaner's words of introduction to a group of visitors to his garden at Gerberoy near Beauvais almost perfectly encapsulate *The Rose Pavilion, Gerberoy*: 'Fourteen centuries of history sleep under my roses … Joan of Arc has passed where you stand … It is difficult … for a garden to be more French … And yet it is so with a little liberty … '.[1] The astonishing profusion of flowers cascades over the little pavilion Le Sidaner had designed and constructed in 1906 on the upper terrace of the former feudal ramparts at Gerberoy, as part of his artist's garden. These ramparts had been the site of battles with the English in medieval times.[2] The rose, meanwhile, is perhaps *the* flower of France; the flower so enthusiastically developed by its horticulturalists from the time of the Empress Joséphine, with her renowned rose collection at Malmaison, to the 3,000 square metres of rose beds which formed one of the sights of the Paris Exposition Universelle of 1900. And with its motif of geometric architecture overlaid by freely-growing roses, *The Rose Pavilion, Gerberoy* is in turn a perfect example of the ideal of harmony between the formal and the natural of which Le Sidaner spoke.

Le Sidaner developed his garden at Gerberoy from 1902, and used the building shown in *The Rose Pavilion, Gerberoy* as a summer studio, as he painted largely from memory. After the twilight motifs which dominate his early work in the small Picardy village and reflect his Symbolist affinities, this picture marks a return to more traditionally Impressionist sunlit effects, combined with a keen sense of the decorative. The pink and red roses which fill the picture surface like some millefleurs in a tapestry were the only colours he grew in his rose garden beside the pavilion, and they complement the red roof and the barely visible red bricks from which the latter was constructed in emulation of British Arts and Crafts architecture.[3] In this way, the picture contributes to the wider period ideal of unity between house and garden promoted by designers such as Gertrude Jekyll in Britain and Hermann Muthesius and Alfred Lichtwark in Germany, becoming as much a part of the international Impressionist garden as a celebration of French identity in the years after the First World War.

1. Words of Le Sidaner to correspondents of *Lecture pour tous*, as quoted in Beauvais/Douai 2001–2, p.21.
2. For details of Le Sidaner's garden and its layout, see Beauvais/Douai 2001–2.
3. Ibid., pp.119–21.

Notes

Introduction *pages 11–19*

1. Rivière 1921, p.130.
2. Mirbeau, letter to Monet, around 27 September 1890, no.47 in Mirbeau 1990A, p.111.
3. Liebermann, letter to Lichtwark, 21 June 1913, in Pflugmacher 2003, p.464.
4. Lichtwark, letter to Liebermann, 27 June 1913, in Pflugmacher 2003, p.465.
5. Hoschedé 1960, vol.1, p.70.
6. Mallarmé 1876, p.93.
7. E. Reclus, 'Du Sentiment de la nature dans les sociétés modernes', in *Revue des deux mondes*, vol.63, p.365.
8. Examples include: Los Angeles/Chicago/Paris 1984–5; T.J. Clark, *The Painting of Modern Life. Paris in the Art of Manet and his Followers*, London and New York 1985; Pollock 1988; N. Broude, *Impressionism: a Feminist Reading, the Gendering of Art, Science, and Nature in the Nineteenth Century*, New York 1991; Herbert 1988; Brettell 1990; F. Frascina et al., *Modernity and Modernism: French Painting in the Nineteenth Century*, New Haven and London 1993; J. Rubin, *Impressionism and the Modern Landscape – Productivity, Technology and Urbanisation from Manet to Van Gogh*, Berkeley 2008; and Boime 1995.
9. For discussion of gendered 'spheres', see for example, Pollock 1988, p.63, pp.67–70, and p.79.
10. J. Manet (preface J. Griot), *Journal de Julie Manet*, Paris 1979, p.110.
11. J. House, 'The Imaginative Space of the Impressionist Garden', in Frankfurt/Munich 2006–7, pp.191–7.
12. Sand 1867, p.1202.
13. Monet, letter to Caillebotte, 3 April 1891, Centre de Documentation, Musée d'Orsay, cited in M. Alphant, *Claude Monet. Une Vie dans le paysage*, Paris 1993, p.563.
14. See Willsdon 2003, pp.108–13; Haussmann 1893; Alphand 1867–73, and Choay 1975, pp.83–99.
15. See J. Clavé, 'Les Plantations de Paris', in *Revue des deux mondes*, vol.XV, 1865, p.783 and p.785 and Limido 2002, pp.91–3.
16. G. Clémenceau, 'Causerie horticole', in *Revue horticole*, 1867, p.434; see also Willsdon 2004, pp.13–15 and pp.56–60.
17. C. Baudelaire, 'The Salon of 1845', in Baudelaire 1965, p.32.
18. Renoir 2001, p.56.
19. Eitner, unpublished notes, 10 January 1952, p.1 and p.5, quoted by kind permission of Ernst-Christian Wolters.
20. Ibid., p.5.
21. I. Brook, 'Making Here Like There: Place Attachment, Displacement and the Urge to Garden', in *Ethics, Place and Environment*, vol.6, no.3, 2003, p.228.
22. Pissarro, letter to Lucien Pissarro, 13 May 1891, in JBH vol.3, p.82.
23. Guy de Maupassant, 'Propriétaires et lilas', 1881, in *Chroniques*, vol.1, 22 October 1876–23 February 1882, Paris 1980, p.215.
24. See J. Beecher and R. Bienvenu (eds), *The Utopian Vision of Charles Fourier, Selected Texts...*, London 1971, pp.32ff; and letter from Olmsted to Parke Godwin, 1 August 1858, quoted in Roper 1983, p.141.
25. Renoir 2001, p.45.
26. M. Conan, 'Horticultural Utopianism in France in the late 18th Century' in Conan/Kress 2007, pp.202–3.
27. Display panel text in *Endless Forms: Charles Darwin, Natural Science and the Visual Arts*, exhibition curated by D. Donald and J. Munro at the Fitzwilliam Museum, Cambridge, 2009.
28. *Flore des serres et jardins de l'Europe*, vol.1, Ghent 1845, p.33.
29. See R. Kendall, 'The Impressionist Encounter with Darwinism', in Cambridge 2009, pp.293–318, and R. Kendall, 'Monet, Atheism and the "Antagonistic Forces of his Age"', in Fowle 2006, p.136.
30. Crarey 2001, p.351.
31. See Henri Lecoq, *Etudes sur la géographie botanique de l'Europe et en particulier sur la végétation du plateau central de la France*, vol.4, Paris, New York, London and Madrid, 1855, p.39.
32. J. Laforgue, letter to Charles Henry, 27 July 1883, in J. Laforgue, *Oeuvres complètes* (ed. J.-L. Debauve et al.), vol.1, Lausanne 1986, p.832, no.83. For French art as a 'civilising power', see J. Laforgue, 'L'Art moderne en Allemagne' (posthumously published in *La Revue Blanche*, vol.IX, no.56, 1 October 1895), as reprinted in ibid., vol.3, p.341; see also ibid., vol.1, p.332.
33. J. Laforgue, 'L'Impressionisme' [1883], in J. Laforgue, *Mélanges posthumes, Oeuvres complètes*, 4th edition, Paris 1902–3, as translated in Harrison/Wood/Gaiger 2003, p.937.
34. See Hamburg/Berlin 2004, pp.34–6.
35. For example, Celin Sabbrin's *Science and Philosophy in Art*, Philadelphia 1886; see also Gerdts 1983, p.27 and pp.35–51.
36. Limido 2002, p.63; Sand 1867, p.1201; and also Brunon 1999, p.259.
37. J.-J. Rousseau, *Discours sur l'origine et les fondements de l'inégalité parmi les hommes*, Paris 1964, vol.3, p.164, quoted in Brunon 1999, p.259, note 41; Conan 2007, p.169; Limido 2002, p.20 and p.83, and Willsdon 2004, p.136.
38. R. Hamann, *Der Impressionismus in Leben und Kunst*, Cologne 1907.
39. Quoted in H. Tyrell, 'Sorolla's 300 Sunny Spanish Pictures', in *The New York World*, 13 February 1909, in De Beruete 1909, vol.2, p.213.
40. C. Mauclair, *L'Impressionisme, son histoire, son esthétique, ses maîtres*, Paris 1906, as translated in Denvir 1987, p.196.
41. 'V.S.', 'Die XVI Ausstellung', in *Ver Sacrum*, 1903, p.28.
42. E. Zola, 'Les Paysagistes', in *L'Evénement illustré*, 1 June 1868, in Zola 2000, p.217.
43. Geffroy 1980, pp.289–90.
44. F. Thiébault-Sisson, 'About Claude Monet', in *Le Temps*, 8 January 1927, as translated in Stuckey 1985, p.349.

Towards the Impressionist Garden *pages 21–5*

1. J.-J. Rousseau, *Julie, ou la Nouvelle Héloise* [1761], quoted in Sieveking 1899, pp.164–5; N. Green, 'Rustic Retreats: Visions of the countryside in mid-nineteenth-century France', in *Reading Landscape: Country-City-Capital* (ed. S. Pugh), Manchester 1990, p.169.
2. J. Lemer, *La Vallée de Montmorency – promenades sentimentales, histoire, paysage, monuments, moeurs et chroniques*, Paris 1847, quoted in ibid.
3. Quoted in Los Angeles/Chicago/Paris 1984–5, p.74.
4. Constable, letter to John Fisher, 23 October 1821, in Harrison/Wood/Gaiger 2003, p.118.
5. Quoted in Fidell-Beaufort/Bailly-Herzberg 1975, p.68 (translated by C. Willsdon).
6. Imbriani, fourth letter on the 5th 'Promotrice' exhibition, in *La Patria*, 9 January 1868, in ibid., p.543.
7. Conan 2002, p.169.
8. Limido 2002, p.20 and p.73.
9. Ibid., p.91 and p.100.
10. Ibid., pp.72–3 and p.77.
11. See Willsdon 2004, p.17 and Goody 1993, pp.232ff.
12. See P. Desormaux, *Les Amusements de la campagne*, Paris 1826, chapter 3, and Conan 2002, p.174.

13. Classen 1998, pp.91ff; review of 4th edition of Mme Millet's *Maison rustique des dames*, in *Revue horticole*, 1859, p.619.
14. C. Baudelaire, review of Salon of 1845, as translated in E. Hardouin-Fugier and E. Grafe, *French Flower-Painters of the Nineteenth Century: A Dictionary* (ed. P. Mitchell), London 1989, p.26.
15. See Willsdon 2004, pp.46–8.
16. Renoir, letter to Paul Durand-Ruel, 15 April 1901, in Denvir 1987, p.192.
17. Monet, letter to Bazille, 26 August, 1864, no.9, W.I, p.421; and Renoir, quoted in Rivière 1921, p.81.
18. See Willsdon 2004, pp.80–5.
19. 'Dr. L.', Prologue, 28 December 1853, in *Cercle pratique d'Horticulture et de Botanique De l'Arrondissement du Havre*, Le Havre 1854.
20. R. Delange, 'Claude Monet', in *L'Illustration*, 15 January 1927, p.59.

Flower & Leisure Gardens of Mature Impressionism
pages 41–5

1. Brunon 1999, p.27.
2. Ibid.
3. See for example J.C. Loudon, *The Suburban Gardener and Villa Companion*, London 1838; L. Johnson, *Every Lady her own Flower-Gardener*, London 1840; and A.J. Downing, *A Treatise on the Theory and Practice of Landscape Gardening Adapted to North America...*, 8th edition (enlarged and revised), New York 1859 (first published 1841). See also G. Taylor, *The Victorian Flower Garden*, London 1952, and J. Dixon Hunt and J. Wolschke-Bulmahn (eds), *The Vernacular Garden*, Washington DC 1993, p.15.
4. For Haussmann's 'transformations' of Paris, see introduction to this catalogue, also Haussmann 1893; Alphand 1867–73; Pinkney 1958; Choay 1975; Willsdon 2003; and Willsdon 2004, pp.61–3 and pp.97–111.
5. Letter from Olmsted to Parke Godwin, 1 August 1858, quoted in Roper 1983, p.141.
6. Sand 1867, vol.2, p.1199.
7. Mangin 1867, p.3.
8. See Willsdon 2004, pp.149–50.
9. Rivière 1921, p.130; Renoir, 'Decorative and Contemporary Art', in *L'Impressioniste*, 21 April 1877, in Herbert 2000, pp.95–6 and p.196; Haussmann 1893, vol.3, pp.91–2. See also Willsdon 2004, p.106 and pp.163–4.
10. Renoir, '*Draft*, 1882–1884', in Herbert 2000, p.103 and p.200 ('Société des

Irréguliers'), and 'The "Société des Irrégularistes", May 1884', in ibid., pp.108–10 and pp.203–4.
11. *I Giardini*, early 1860s, as quoted in Limido 2002, p.124.
12. C. Baudelaire, 'The Life and Work of Eugène Delacroix', in Baudelaire 1964, p.60.
13. Zola, 'Les Paysagistes', in *L'Evénement illustré*, 1 June 1868, in Zola 2000, p.217.
14. Renoir, 'Notes, 1883–1884', in Herbert 2000, p.121 and p.212.
15. See Willsdon 2004, pp.141–5.
16. Duranty 1876, p.74 and p.76 as translated in San Francisco 1986, p.42; G.B. Ladner, 'Vegetation Symbolism and the Concept of Renaissance', in *De Artibus Opuscula*, XL, *Essays in Honour of Erwin Panofsky* (ed. M. Meiss), New York, 1961, pp.303–22.
17. See Willsdon 2004, p.140, and J.F. McMillan, *France and Women 1789–1914: Gender, Society and Politics*, London and New York 2000, p.50.
18. O. Mirbeau, article on Pissarro in *L'Art dans les deux mondes*, 10 January 1891, quoted in Mirbeau 1990, p.12.
19. For example, J. Michelet, 'L'Evangile de Froebel', chapter VII of *Nos Fils*, in Michelet 1987.

Kitchen, Peasant & Market Gardens from 1870 *pages 89–92*

1. Renoir 2001, p.194.
2. See M. Haja, '"Kraut und Rüben". Beobachtungen zur österreichischen Freilicht-Malerei im späten 19. Jahrhundert', in *Mitteilungen der Österreichischen Galerie*, vol.30, no.74, 1986, pp.43ff.; Weniger and Müller 1991, p.30; and Koja 2002, pp.177–9.
3. Brettell 1990, pp.31–2.
4. For 'nature employée', see F. Cachin, 'Le Paysage du Peintre', in *Les Lieux du Mémoire*, II, *La Nation* (ed. P. Nora), Paris 1986, p.465.
5. Pissarro, letter to Georges Pissarro, 17 August 1899, no.1647 in JBH, vol.5.
6. J. Castagnary, 'Exposition du boulevard des Capucines: Les Impressionistes', in *Le Siècle*, 29 April 1874, and in Berson 1996, vol.1, p.16; and P. Adam et al., *Le Petit Bottin des lettres et des arts*, Paris 1886, p.109.
7. Letter to O. Mirbeau, 17 December 1891, no.732 in JBH, vol.3, p.169; letter to L. Pissarro, 29 May 1894, in *Camille Pissarro:

Lettres à son fils Lucien* (ed. J. Rewald), Paris 1950, p.241; see also Willsdon 2004, p.268, note 5.
8. See catalogue entry for Ensor, *The Garden of the Rousseau Family* [66], note 1.
9. Duret 1878, as excerpted in Riout 1989, p.219.
10. Zola, 'Les Paysagistes', in *L'Evénement illustré*, 1 June 1868, in Zola 2000, p.217.
11. Duranty 1872, p.328.
12. See catalogue entry for Van Gogh, *Orchard in Blossom* [69], notes 1 and 4.
13. See Lloyd 1986, pp.15–34, and P&DRS vol.1, pp.62–3.
14. Zola, 'Les Naturalistes' in *L'Evénement illustré*, 19 May 1868, as translated in P&DRS, vol.2, p.108.
15. See for example, A. Sarti, *Le Jardin potager*, Limoges 1872, pp.10–13.
16. Comment by Bonnard to R. Cogniet, quoted in Watkins 1994, p.52.
17. M. Conan, 'Horticultural Utopianism in France in the Late Eighteenth Century', in Conan/Kress 2007, p.220, note 1.
18. Proudhon 1939, p.258; P. Kropotkin, *The Conquest of Bread and Other Writings* (ed. M.S. Schatz), Cambridge 1995, p.197; see also Willsdon 2004, p.181 and p.190.
19. Pissarro, letter to O. Mirbeau, 21 April 1892, no.774 in JBH, vol.3, p.217.
20. A. Collignon, *Diderot. Sa Vie, ses oeuvres, sa correspondance*, Paris 1895. I am grateful to the Institut de France and Fondation Claude Monet for permission to consult Monet's library at Giverny.
21. L. Daudet, *Souvenirs des milieux littéraires, poétiques, artistiques et médicaux*, Paris 1920, p.3.
22. See Nord 2000, p.52.

Fresh Growth & New Blooms in Late Impressionism
pages 109–14

1. Lichtwark, 'Die Pariser Impressionisten', in *Die Gegenwart*, 22 December 1883, p.401.
2. For influences of Giverny on Wannsee, see Hamburg/Berlin 2004, pp.29–38.
3. Pissarro, draft letter to Hugues Le Roux, prior to 16 May 1886, quoted in M. Ward, *Pissarro, Neo-Impressionism and the Spaces of the Avant-Garde*, Chicago and London 1996, p.282, note 3.
4. Boime 1995, pp.141–85.
5. O. Mirbeau, 'Claude Monet', in *L'Art dans les deux mondes*, 7 March 1891, in Mirbeau 1993, p.433; see also Willsdon 2004, p.213.

6. Photograph by Theodore Robinson, engraved in Guillemot 1898.
7. H. van Hofmannsthal, 'Gärten', in *Die Zeit* (Vienna), 17 June 1906, in Hofmannsthal 1979, p.581.
8. De Goncourt 1986, p.308 and p.314; for De Goncourt's text and Symbolism, see Simpson 2008.
9. See Hamburg/Berlin 2004, pp.29ff.
10. De Goncourt 1986, p.310; C. Baudelaire, 'Correspondances', in *Les Fleurs du Mal*, Paris 1857.
11. Mirbeau 1993, p.429.
12. F. Fénéon, 'Néo-Impressionisme', in *L'Art moderne*, Brussels, 1 May 1887, as translated in Harrison/Wood/Gaiger 2003, p.969.
13. M. Denis, 'Définition du Néo-traditionalisme', in *Art et Critique*, Paris, 23 and 30 August 1890, as translated in Harrison/Wood/Gaiger 2003, p.863.
14. See Vienna 1903.
15. C. Mauclair, 'M. Sorolla y Bastida', in *Art et décoration*, October 1906, reprinted in De Beruete 1909, p.143.
16. Marx 1909, p.527.
17. Mallarmé, 'Brise marine'; Hofmannsthal, 'Mein Garten'.
18. See Frankfurt/Munich 2006–7, pp.245–7.
19. See Werth 2002, p.213.
20. H. von Hofmannsthal, 'Englischer Stil', in *Frankfurter Zeitung*, 3 April 1896, in Hofmannsthal 1979, p.572.
21. See Willsdon 2004, p.221 and Willsdon 2007, p.138.
22. Letter to Alice Hoschedé from Bordighera, 13 February 1884, no.417 in Wildenstein 1974–1991, vol.2, p.238; see Willsdon 2004, p.209.
23. Liebermann 1916, p.XIV, as quoted in Hamburg/Berlin 2004, p.19; Hoschedé 1960, vol.1, p.70.
24. De Goncourt 1986, p.315 and p.307.
25. See Hamburg/Berlin 2004, p.32 and p.58.
26. See for example, letters from Lichtwark to Liebermann, 22 June 1911, and from Lichtwark to Käthe Liebermann, 20 December 1909, in Pflugmacher 2003, p.313 and p.377; see also Hamburg/Berlin 2004, p.58.
27. Beauvais/Douai 2001–2, pp.94–7 and p.147.
28. Hofmannsthal 1906, p.579 and p.581.
29. For Futurist interest in Impressionism, see London 1989, p.33.

Bibliography

ABBREVIATIONS:

JBH: Bailly-Herzberg 1980–91

P&DRS: Pissarro/Durand-Ruel Snollaerts 2005

W.+ I, II, III, IV: Wildenstein 1974–91

W.+no. Wildenstein 1996

ADAMS 1997
S. Adams, *The Barbizon School and the Origins of Impressionism*, Oxford 1997

ADLER 1989
K. Adler, 'The Suburban, the Modern, and "Une Dame de Passy"', in *Oxford Art Journal*, vol.12, no.1, 1989

ALPHAND 1867–73
A. Alphand, *Les Promenades de Paris*, 2 vols, Paris 1867–73

ANDRE 1862
E. André, 'Le Parc de Monceaux', in *Revue horticole*, vol.2, 1862, pp.394–6

ANDRE 1867
E André, 'Les Jardins de Paris' in *Paris Guide*, vol.2, Paris 1867, pp.1204–16

ANDRE 1879
E. André, *L'Art des jardins:traité générale de la composition des parcs et jardins*, Paris 1879

BAHR 1968
H. Bahr, *Zur Überwindung des Naturalismus. Theoretische Schriften 1887–1904* (ed. G. Wunberg), Stuttgart 1968

BAILLY-HERZBERG 1980–91
J. Bailly-Herzberg (ed.), *Correspondance de Camille Pissarro*, vols 1–4, Paris 1980–9; vol.5, Saint-Ouen-l'Aumône 1991

BALTIMORE/MILWAUKEE/MEMPHIS 2007–8
K. Rothkopf, *Creating the Impressionist Landscape*, exh. cat., Baltimore Museum of Art, Milwaukee Art Museum and Memphis Brooks Museum of Art 2007–8

BAROZZI 2006
J. Barozzi (ed.), *Le Goût des jardins*, Paris 2006

BAUDELAIRE 1964
C. Baudelaire, *The Painter of Modern Life and Other Essays* (translated and edited by J. Mayne), London 1964

BAUDELAIRE 1965
C. Baudelaire, *Art in Paris 1845–1862 Salons and other Exhibitions reviewed by Charles Baudelaire* (translated and edited by J. Mayne), London 1965

BEAUVAIS/DOUAI 2001–2
J. Galiègue et al., *Henri Le Sidaner en son jardin de Gerberoy*, exh. cat., Musée départemental, Beauvais and Musée de la Chartreuse, Douai 2001–2

BERLIN/MUNICH 1996–7
J.G. Prinz von Hohenzollern and P.-K. Schuster, *Manet bis van Gogh. Hugo von Tschudi und der Kampf um die Moderne*, exh. cat., Nationalgalerie Berlin; Neue Pinakothek, Munich 1996–7

BERSON 1996
R. Berson (ed.), *The New Painting Impressionism 1874–1886*, 2 vols, San Francisco and Washington 1996

DE BERUETE 1909
A. de Beruete et al., *Eight Essays on Joaquín Sorolla y Bastida*, 2 vols, New York 1909

BOIME 1980
A. Boime, *Thomas Couture and the Eclectic Vision*, New Haven and London 1980

BOIME 1995
A. Boime, *Art and the French Commune Imagining Paris after War and Revolution*, Princeton 1995

BOUILLON/KANE 1984–5
J.-P. Bouillon and E. Kane, 'Marie Bracquemond', in *Woman's Art Journal*, vol.5, no.2 (autumn 1984–winter 1985), pp.21–7

BREMEN/LEIPZIG/MUNICH 1998–9
D. Hansen, *Fritz von Uhde: von Realismus zum Impressionismus*, exh. cat., Kunsthalle Bremen; Museum der bildenden Künste, Leipzig; Neue Pinakothek, Munich 1998–9

BRETTELL 1990
R.R. Brettell, *Pissarro and Pontoise The Painter in a Landscape*, New Haven and London 1990

BROUDE 1970
N. Broude, 'The Macchiaioli as "Proto-Impressionists": Realism, Popular Science and the Re-Shaping of Macchia Romanticism, 1862–1886', in *The Art Bulletin*, vol.52, no.4 (December 1970), pp.404–14

BROUDE 1978
N. Broude (ed.), *Seurat in Perspective*, New Jersey 1978

BROUDE 1987
N. Broude, *The Macchiaioli. Italian Painters of the Nineteenth Century*, New Haven and London 1987

BROUDE 1994
N. Broude, *World Impressionism: the International Movement, 1860–1920*, New York 1994

BRUNON 1999
H. Brunon (ed.), *Le Jardin, notre double, sagesse et déraison*, Paris 1999

BUMPUS 1990
J. Bumpus, *Impressionist Gardens*, London 1990

BURRAGE 1911
M. Giddings Burrage, 'Art and Artists at Giverny', in *World Today*, March 1911, pp.344–51

BUSCH/BEYRODT 1982
W. Busch and W. Beyrodt, *Kunsttheorie und Malerei Kunstwissenschft*, vol.1, Stuttgart 1982

CAHORS 2008–9
Henri Martin (1860–1943): Du rêve au quotidien, exh. cat., Musée de Cahors Henri Martin; Musée départemental Rignault, Saint-Cirque-Lapopie; Musée des Beaux-Arts, Bordeaux; Musée de la Chartreuse, Douai 2008–9

CAMBRIDGE 2009
D. Donald and J. Munro, *Endless Forms. Charles Darwin, Natural Science and the Visual Arts*, exh. cat., Fitzwilliam Museum, Cambridge 2009

CARRIERE 1872
E.A. Carrière, 'Dahlia Imperialis', in *Revue horticole*, 1872, pp.170–1

CAW 1975
J.L. Caw, *Scottish Painting Past and Present 1620–1908*, Bath 1975 (first published 1908)

CHEVREUL 1859
M.E. Chevreul, *The Principles of Harmony and Contrast of Colours and their Application to the Arts*, London 1859 (French original first published 1839)

CHICAGO 1995
C.F. Stuckey, *Claude Monet 1840–1926*, exh. cat., Art Institute of Chicago 1995

CHICAGO/BOSTON/WASHINGTON 1998–9
J. Barter et al., *Mary Cassatt: Modern Woman*, exh. cat., Art Institute of Chicago; Museum of Fine Arts, Boston; National Gallery of Art, Washington 1998–9

CHICAGO/NEW YORK 2001
G. Groom et al., *Beyond the Easel Decorative Painting by Bonnard, Vuillard, Denis, and Roussel, 1890–1930*, exh. cat., Art Institute of Chicago; Metropolitan Museum of Art, New York 2001

CHICAGO/AMSTERDAM 2001–2
D. Druick and P. Zegers, *Van Gogh and Gauguin: the Studio of the South*, exh. cat., Art Institute of Chicago; Van Gogh Museum, Amsterdam 2001–2

CHOAY 1975
F. Choay, 'Haussmann et le système des espaces verts parisiens', in *Revue de l'art*, no.29, 1975, pp.83–99

CLARKE 1991
M. Clarke, *Corot and the Art of Landscape*, London 1991

CLASSEN 1998
C. Classen, *The Colour of Angels: Cosmology, Gender and the Aesthetic Imagination*, London and New York 1998

CLEMENCEAU 1928
G. Clemenceau, *Claude Monet: Les Nymphéas*, Paris 1928

CLEMENCEAU 1965
G. Clemenceau, *Claude Monet par Georges Clemenceau. Cinquante ans d'amitié*, La Palatine, Paris and Geneva 1965

COATES 1968
A.M. Coates, *Flowers and their Histories*, London 1968

CONAN 2002
M. Conan, 'The Coming of Age of the Bourgeois Garden', in J. Dixon Hunt and M. Conan (eds), *Tradition and Innovation in the French Garden. Chapters of a New History*, Pennsylvania 2002, pp.160–83

CONAN/KRESS 2007
M. Conan and W.J. Kress (eds), *Botanical Progress, Horticultural Innovations and Cultural Changes*, Washington 2007

COPENHAGEN 2006–7
S.M. Søndergaard, *Women in Impressionism: from Mythical Feminine to Modern Women*, exh. cat., Ny Carlsberg Glyptotek, Copenhagen 2006–7

COUTURE 1932
C. Mauclair (ed.), *Thomas Couture Sa Vie son oeuvre par lui-même et par son petit fils*, Paris 1932

COX 1993
M. Cox, *Artists' Gardens from Claude Monet to Jennifer Bartlett*, New York 1993

CRAREY 2001
J. Crarey, *Suspensions of Perception: Attention, Spectacle, and Modern Culture*, Cambridge (Mass.) and London 2001

D'ARGENCOURT 1999
L. d'Argencourt et al., *European Paintings of the 19th Century*, vol.2, Cleveland 1999

DECAISNE/NAUDIN
J. Decaisne and C. Naudin, *Manuel de l'amateur des jardins. Traité général d'horticulture*, 4 vols, Paris (n.d. but c.1862)

DELACROIX 1936
E. Delacroix, *Correspondance* (ed. A. Joubin), Paris 1936

DENVIR 1987
B. Denvir (introduction), *The Impressionists at First Hand*, London 1987

DURANTY 1872
E. Duranty, *Le Peintre Louis Martin*, in *Le Siècle* 13 November 1872 (reprinted in E. Duranty, *Le Pays des arts*, Paris 1872, pp.315–56)

DURANTY 1876
E. Duranty, *La Nouvelle Peinture: A propos du groupe d'artistes qui expose dans les galeries Durand-Ruel*, Paris 1876 (reprinted in Berson 1996, vol.1, pp.72–81)

DURET 1878
T. Duret, *Les Peintres impressionistes Claude Monet, Sisley, C. Pissarro, Renoir, Berthe Morisot*, Paris 1878

DURET 1902
T. Duret, *Histoire d'Edouard Manet et de son oeuvre*, Paris 1902

EDINBURGH 1986
M. Clarke, *Lighting up the Landscape: French Impressionism and its origins*, exh. cat., National Gallery of Scotland, Edinburgh 1986

EDINBURGH 1990
R. Verdi, *Cézanne and Poussin: The Classical Vision of Landscape*, exh. cat., National Gallery of Scotland, Edinburgh 1990

EDINBURGH 2003
M. Clarke and R. Thomson, *Monet: the Seine and the Sea 1878–1883*, exh. cat., National Gallery of Scotland, Edinburgh 2003

EDINBURGH/LONDON/BERLIN 1994–5
K. Hartley (ed), *The Romantic Spirit in German Art 1790–1990*, exh. cat., Scottish National Gallery of Modern Art, Edinburgh; Hayward Gallery, London; Nationalgalerie Berlin 1994–5

ERNOUF/ALPHAND 1886
A.A. Ernouf and A. Alphand, *L'Art des jardins*, 5th edition, Paris 1886 (first published 1868)

FIDELL-BEAUFORT/BAILLY-HERZBERG 1975
M. Fidell-Beaufort and J. Bailly-Herzberg, *Daubigny*, Paris 1975

FINKE 1972
U. Finke (ed.), *French 19th-Century Painting and Literature with Special Reference to the Relevance of Literary Subject-Matter in French Painting*, Manchester 1972

FLEURS LUMINEUSES 1861
'Fleurs lumineuses', extract from the *Indépendance belge*, in *Flore des serres et jardins de l'Europe*, vol.XIV, 1861, p.96

FORT WORTH/ORDRUPGAARD 2005–6
R.R. Brettell and A.B. Fonsmark, *Gauguin and Impressionism*, exh. cat., Kimbell Art Museum, Fort Worth; Ordrupgaard Museum 2005–6

FOURIER 1972
The Utopian Vision of Charles Fourier Selected Texts on Work, Love and Passionate Attraction (translated, edited and introduction by J. Beecher and R. Bienvenu), London 1972

FOWLE 2006
F. Fowle (ed.), *Monet and French Landscape: Vétheuil and Normandy*, Edinburgh 2006

FOWLE/THOMSON 2003
F. Fowle and R. Thomson (eds), *Soil and Stone: Impressionism, Urbanism, Environment*, Aldershot 2003

FRAIN 1991
I. Frain, *La Guirlande de Julie*, Paris 1991

FRANKFURT/MUNICH 2006–7
S. Schultze (ed.), *The Painter's Garden. Design Inspiration Delight*, exh. cat., Städel Museum, Frankfurt; Städtische Galerie im Lenbachhaus, Munich 2006–7

FROEBEL 1909
F. Froebel *Friedrich Froebel's Pedagogics of the Kindergarten; or, His Ideas concerning the Play and Playthings of the Child* (ed. W.T. Harris), New York 1909 (first edition 1895, translated from German original first published 1861)

GAGE 1993
J. Gage, *Colour and Culture: Practice and Meaning from Antiquity to Abstraction*, London 1993

GEFFROY 1980
G. Geffroy, *Claude Monet sa vie, son oeuvre* (ed. C. Judrin), Paris 1980 (first published 1924)

GERDTS 1983
W.H. Gerdts, *Down Garden Paths. The Floral Environment in American Art*, New Jersey 1983

GIBOULT 1904
G. Giboult, *Les Fleurs nationales et les fleurs politiques*, Paris 1904

GIFU 1990
La Gloire de Lyons. La Peinture de l'Ecole Lyonnaise du XIXe siècle, exh. cat., Museum of Fine Arts, Gifu 1990

GILLET 1909
L. Gillet, 'L'Epilogue de l'impressionnisme Les "Nymphéas" de M. Claude Monet', in *La Revue hebdomadaire*, vol.8, 21 August 1909, pp.397–415

GIVERNY 1992
W.H. Gerdts et al., *Lasting Impressions American Painters in France 1865–1915*, exh. cat., Musée d'Art Américain, Giverny 1992

GIVERNY/CHICAGO 2007
K.M. Bourguinon (ed.), *Impressionist Giverny: A Colony of Artists, 1885–1915*, exh. cat., Musée d'Art Américain, Giverny; Terra Foundation for American Art, Chicago 2007

VAN GOGH
L. Jansen, H. Luijten and N. Bakker (eds), *Vincent van Gogh: the Letters*, London 2009, at http://vangoghletters.org/vg/

DE GONCOURT 1986
E. de Goncourt, *La Maison d'un Artiste* [1881], in E. and J. de Goncourt, *Oeuvres Complètes*, Geneva and Paris 1986, vol. XXIV–XXXV

GOODY 1993
J. Goody, *The Culture of Flowers*, Cambridge 1993

GRISWOLD 1987
M. Griswold, *Pleasures of the Garden. Images from the Metropolitan Museum of Art, New York*, New York 1987

GUILLEMOT 1898
M. Guillemot, 'Claude Monet', in *Revue Illustrée*, vol.1, 15 March 1898

GUNNARSSON 1998
T. Gunnarsson, *Nordic Landscape Painting in the Nineteenth Century*, New Haven and London 1998

HAMBURG 1997
H.R. Leppien and D. Zbikowsi, *Hundert Jahre danach: der Hamburgische Künstlerclub von 1897*, exh. cat., Kunsthalle, Hamburg; Altonauer Museum, Hamburg 1997

HAMBURG/BERLIN 2004
J.E. Howolt and U.M. Schmeede, *Im Garten von Max Liebermann*, exh. cat., Kunsthalle, Hamburg; Alte Nationalgalerie, Berlin 2004

HAMBURG 2005-6
J. Maltzahn-Redling and J.E. Howolt, *Leopold von Kalckreuth Poetischer Realist*, exh. cat., Kunsthalle, Hamburg 2005-6

HAMBURG 2006
C. Horbas et al., *Gartenlust und Blumenliebe. Hamburgs Gartenkultur vom Barock bis ins 20. Jahrhundert*, exh. cat., Museum für Hamburgische Geschichte, Hamburg 2006

HARDOUIN-FUGIER 1977
E. Hardouin-Fugier, 'Simon Saint-Jean et le symbolisme végétal au Musée des Beaux-Arts de Lyons', in *Bulletin des musées et monuments Lyonnais*, vol.VI, no.4, 1977

HARDOUIN-FUGIER/GRAFE 1978
E. Hardouin-Fugier and E. Grafe, *The Lyon School of Flower Painting*, Leigh-on-Sea 1978

HARRISON/WOOD/GAIGER 2003
C. Harrison, P. Wood and J. Gaiger (eds), *Art in Theory 1815–1900. An Anthology of Changing Ideas*, Oxford 2003

HAUSSMANN 1893
E. Haussmann, *Mémoires du Baron Haussmann*, 3 vols, 3rd edition, Paris 1893

HERBERT 1988
R.L. Herbert, *Impressionism: Art, Leisure and Parisian Society*, New Haven and London 1988

HERBERT 2000
R.L. Herbert (ed.), *Nature's Workshop: Renoir's Writings on the Decorative Arts*, New Haven and London 2000

HEVESI 1909
L. Hevesi, *Altkunst-Neukunst Wien 1894–1908* (ed. O. Breiche), Vienna 1909 (reprinted Klagenfurt 1986)

HOBHOUSE 1992
H. Hobhouse, *Plants in Garden History*, London 1992

HOFMANNSTHAL 1979
H. von Hofmannsthal, *Hugo von Hofmannsthal. Gesammelte Werke. Reden und Aufsetze* (eds. B. Schoeller and R. Hirsch), vol.1, 1891–1913, Frankfurt 1979

HOLMES 2001
C. Holmes, *Monet at Giverny*, London 2001

HOSCHEDE 1960
J.-P. Hoschedé, *Claude Monet ce mal connu. Intimitié familiale d'un demi-siècle à Giverny de 1883 à 1926*, 2 vols, Geneva 1960

HOUSE 1986
J. House, *Monet: Nature into Art*, New Haven and London 1986

HOUSE 2003
J. House, 'Monet's Gladioli', in *Bulletin of the Detroit Institute of Arts*, vol.77, no.1/2, 2003, pp.0–17

HUET 1911
R. P. Huet, *Paul Huet (1803–1869) d'après ses notes, ses correspondances, ses contemporains*, Paris 1911

HUNT 1992
J. Dixon Hunt (ed.), 'French Impressionist Gardens and the Ecological Picturesque', in *Gardens and the Picturesque: Studies in the History of Landscape Architecture*, Cambridge (Mass.) and London 1992

JACOBS 1985
M. Jacobs, *The Good and Simple Life Artist Colonies in Europe and America*, Oxford 1985

JBH *SEE* BAILLY-HERZBERG 1980–91

JENSON 1994
R. Jenson, *Marketing Modernism in Fin-de-Siècle Europe*, Princeton 1994

JOYAUX 2007
F. Joyaux, 'De la rose franc-maçonne à la rose socialiste' in *Rosa Gallica*, no.46, July-August 2007, pp.39–45 (article originally published in *Géopolitique*, no.97, January 2007)

JOYES 1975
C. Joyes, *Monet at Giverny*, London 1975

KAY 2002
C. Kay, *Art and the German Bourgeoisie: Alfred Lichtwark and Modern Painting in Hamburg 1886–1914*, Toronto 2002

KEPETZIS 2003
E. Kepetzis, 'Uhde (Friedrich Hermann Karl) Fritz von', in *Biographisch-Bibliographisches Kirchenlexicon*, vol. XXVII, 2003, at http://www.bautz.de/bbkl

KNIGHT 1986
P. Knight, *Flower Poetics in Nineteenth-Century France*, Oxford 1986

KOJA 2002
S. Koja (ed.), *Gustav Klimt Landscapes*, Munich, Berlin, London and New York 2002

DE LA TOUR 1845
C. de La Tour, *Le Langage des Fleurs*, 6th edition, Paris 1845

LAROUSSE 1866-77
P. Larousse, *Grand Dictionnaire universel du XIXe siècle*, 17 vols, Paris 1866–77

LAUSANNE 2005
J. Cosandier et al., *Caillebotte au coeur de l'impressionisme*, exh. cat., Fondation de l'Hermitage, Lausanne 2005

LECOMTE 1892
G. Lecomte, *L'Art impressioniste, d'après la collection privée de M. G. Durand-Ruel*, Paris 1892

LEVINE
S. Levine, *Monet, Narcissus and Self-Reflection: the Modernist Myth of the Self*, Chicago and London 1994

LICHTWARK 1894
A. Lichtwark, *Makartbouquet und Blumenstrauss*, Munich 1894 (first published *Hamburger Weihnachtsbuch* 1892)

LIEBERMANN 1916
M. Liebermann, *Die Phantasie in der Kunst*, Berlin 1916

LILLE/MARTIGNY 2002
S. Patry et al., *Berthe Morisot 1841–1895*, exh. cat., Palais des Beaux-Arts, Lille; Fondation Pierre Gianadda, Martigny 2002

LIMIDO 2002
L. Limido, *L'Art des jardins sous le Second Empire: Jean-Pierre Barillet-Deschamps (1824–1873)*, Seyssel 2002

LLOYD 1986
C. Lloyd (ed.), *Studies on Camille Pissarro*, London and New York 1986

LONDON 1989
E. Braun (ed.), *Italian Art in the 20th Century. Painting and Sculpture 1900–1988*, exh. cat., Royal Academy of Arts, London 1989

LONDON 1990
R. Thomson, *Camille Pissarro: Impressionism, Landscape and Rural Labour*, exh. cat., City Museum and Art Gallery, Birmingham; Burrell Collection, Glasgow 1990

LONDON/BELFAST/MANCHESTER 2004–5
The Garden in British Art, exh. cat., Tate Britain, London; Ulster Museum, Belfast; Manchester Art Gallery 2004–5

LONDON/BOSTON 1995-6
J. House et al., *Landscapes of France Impressionism and its Rivals*, exh. cat., South Bank Centre, London; Museum of Fine Arts, Boston 1995–6

LONDON/BOSTON 1998-9
P. Hayes Tucker et al., *Monet in the 20th Century*, exh. cat., Royal Academy of Arts, London; Museum of Fine Arts, Boston 1998–9

LONDON/BOSTON/CHICAGO 1989-90
P. Hayes Tucker, *Monet in the 90s: the Series Paintings*, exh. cat., Royal Academy of Arts, London; Museum of Fine Arts, Boston; Art Institute of Chicago 1989–90

LONDON/CHICAGO 1995
A. Distel et al., *Gustave Caillebotte the Unknown Impressionist*, exh. cat., Royal Academy of Arts, London; Art Institute of Chicago 1995

LONDON/NEW YORK 1998
S. Whitfield and J. Elderfield, *Bonnard*, exh. cat., Tate Gallery, London; Museum of Modern Art, New York 1998

LONDON/OTTAWA/PHILADELPHIA 2007–8
C.B. Bailey et al., *Renoir Landscapes 1865–1883*, exh. cat., National Gallery, London; National Gallery of Canada, Ottawa; Philadelphia Museum of Art 2007–8

LONDON/PARIS/BALTIMORE 1992–3
M. A. Stevens (ed.), *Alfred Sisley*, exh. cat., Royal Academy of Arts, London; Musée d'Orsay, Paris; Walters Art Gallery, Baltimore 1992–3

LONDON/PARIS/BOSTON 1985-6
J. House et al., *Renoir*, exh. cat., Hayward Gallery, London; Grand Palais, Paris; Museum of Fine Arts, Boston 1985–6

LONDON/PARIS/PHILADELPHIA 1995-6
F. Cachin et al., *Cézanne*, exh. cat., Tate Gallery, London; Grand Palais, Paris; Philadelphia Museum of Art 1995–6

LONDON/WASHINGTON/BOSTON 1998–9
E. Kilmurray and R. Ormond (eds), *John Singer Sargent*, exh. cat., Tate Gallery, London; National Gallery of Art, Washington; Museum of Fine Arts, Boston 1998–9

LONDON/ZURICH 2008-9
S. Fraquelli et al., *Radical Light. Italy's Divisionist Painters*, exh. cat., National Gallery, London; Kunsthaus Zurich 2008–9

LOS ANGELES/CHICAGO/PARIS 1984–5
A.P.A. Belloli (ed.), *A Day in the Country: Impressionism and the French Landscape*, exh. cat., Los Angeles County Museum of Art; Art Institute of Chicago; Grand Palais, Paris 1984–5

LOS ANGELES/NEW YORK/LONDON 1993–5
P. Wegmann et al., *Caspar David Friedrich to Ferdinand Hodler: A Romantic Tradition Nineteenth-Century Paintings and Drawings from the Oskar Reinhardt Foundation, Winterthur*, exh. cat., Los Angeles County Museum of Art; Metropolitan Museum of Art, New York; National Gallery, London 1993–5

LYONS 1982
M. Rocher-Juneau et al., *Fleurs de Lyons 1807–1917*, exh. cat., Musée des Beaux-Arts, Lyons 1982

MAJO/LANFRANCONI 2006
E. di Majo and M. Lanfranconi, *Galleria Nazionale d'Arte Moderna Le Collezioni*, vol.2, XIX *Secolo*, Milan 2006

MALLARME 1876
S. Mallarmé, 'The Impressionists and Edouard Manet', 1876, in *The Art Monthly Review and Photographic Portfolio*, in Berson 1996, vol.1, pp.91–7

MANCHESTER/EDINBURGH 1982
T. Clifford (introduction), *The Macchiaioli. Masters of Realism in Tuscany*, exh. cat., Manchester City Art Gallery; Edinburgh City Art Centre, Edinburgh 1982

MANET 1979
J. Manet, *Journal (1893–1899): sa jeunesse parmi les peintres impressionistes et les hommes de lettres* (preface J. Griot), Paris 1979

MANGIN 1867
A. Mangin, *Les Jardins: histoire et description*, Tours 1867

MARX 1909
C. Roger Marx, 'Les Nymphéas de M. Claude Monet', in *Gazette des beaux-arts*, 1909, vol.1, pp.523–31

MATYJASZKIEWICZ 1984
K. Matyjaszkiewicz (ed.), *James Tissot*, Oxford 1984

MCCONKEY 2002
K. McConkey, *Memory and Desire: Painting in Britain and Ireland at the Turn of the Twentieth Century*, Aldershot 2002

MICHELET 1985
J. Michelet, *L'Amour La Femme*, in *Oeuvres Complètes de Michelet* (ed. P. Viallaneix), vol.XVIII, Paris 1985

MICHELET 1987
J. Michelet, *Nos Fils, Oeuvres Complètes de Michelet* (ed. P. Villaneix), vol.XX, Paris 1987

MIRBEAU 1990
O. Mirbeau, *Correspondance avec Camille Pissarro* (ed. P. Michel and J.-F. Nivet), Tusson 1990

MIRBEAU 1990 A
O. Mirbeau, *Correspondance avec Claude Monet* (ed. P. Michel and J.-F. Nivet), Tusson 1990

MIRBEAU 1993
O. Mirbeau, *Combats esthétiques* (eds P. Michel and J.-F. Nivet), 2 vols, Paris 1993

MOREAU-NELATON 1924
E. Moreau-Nélaton, *Corot raconté par lui-même*, 2 vols, Paris 1924

MORISOT 1957
B. Morisot, *The Correspondence of Berthe Morisot* (ed. D. Rouart), London 1957

MORRIS 1868–70
W. Morris, *The Earthly Paradise*, Kelmscott 1868–70

MOSSER 2000
M. Mosser, *The History of Garden Design: the Western Tradition from the Renaissance to the Present Day*, London 2000

MOSSER/NYS 1995
M. Mosser and P. Nys (eds), *Le Jardin, art et lieu de mémoire*, Paris 1995

MUNK 1993
J. P. Munk, *Catalogue French Impressionism Ny Carlsberg Glyptotek*, Copenhagen 1993

DE NEUVILLE 1863
A. de Neuville, *Le Véritable Langage des fleurs*, Paris 1863

NEW YORK 1994
G. Tinterow and H. Loyrette, *Origins of Impressionism*, exh. cat., Metropolitan Museum of Art, New York 1994

NEW YORK 2001
A. Peck and C. Irish, *Candace Wheeler: The Art and Enterprise of American Design, 1875–1900*, exh. cat., Metropolitan Museum of Art 2001

NEW YORK 2004
H. Barbara Weinberg et al., *Childe Hassam American Impressionist*, exh. cat., Metropolitan Museum of Art, New York 2004

NEW YORK/LOS ANGELES/PARIS 2005–6
J. Pissarro, *Pioneering Modern Painting Cézanne & Pissarro 1865–1885*, exh. cat., Museum of Modern Art, New York; Los Angeles County Museum of Art; Musée d'Orsay, Paris 2005–6

NORD 2000
P. Nord, *Impressionists and Politics: Art and Democracy in the Nineteenth Century*, London and New York 2000

OLSON 1992
R.J.M. Olson, *Ottocento. Romanticism and Revolution in 19th-Century Italian Painting*, Florence and New York 1992

OTTAWA 2001
C.B. Bailey (ed.), *Gustav Klimt Modernism in the Making*, exh. cat., National Gallery of Canada, Ottawa 2001

OTTAWA/CHICAGO/FORT WORTH 1997–8
C.B. Bailey, *Renoir's Portraits: Impressions of an Age*, exh. cat., National Gallery of Canada, Ottawa; Art Institute of Chicago; Kimbell Art Museum, Fort Worth 1997–8

P&DRS SEE PISSARRO/DURAND-RUEL SNOLLAERTS 2005

PALEWSKI 1968
J.-P. Palewski, *Louveciennes. A Travers les Alpes Galantes de l'Ile de France*, Saint-Germain-en-Laye 1968

PARIS 1919
G. Geffroy (introduction), *Oeuvres de Marie Bracquemond (1841–1916) exposées du 19 au 32 mai 1919 chez M. Bernheim-Jeune et Cie*, exh. cat., Paris 1919

PARIS 1983
F. Cachin et al., *Manet 1832–1883*, exh. cat., Grand Palais, Paris 1983

PARIS 1983 A
J. and M. Guillaud et al., *Claude Monet at the Time of Giverny*, exh. cat., Centre Culturel du Marais, Paris 1983

PARIS 1985
G. Poisson et al., *Département des Hauts-de-Seine, Château de Sceaux: Catalogue raisonné des collections Hauts-de-Seine*, Paris 1985

PARIS 1987
G. Meurges et al., *Parfums des plantes*, exh. cat., Muséum national d'histoire naturelle, Paris 1987

PARIS/OTTAWA 1982–3
D. Druick and M. Hoog, *Fantin-Latour*, exh. cat., Grand Palais Paris; National Gallery of Canada, Ottawa 1982–3

PFLUGMACHER 2003
B. Pflugmacher (ed.), *Der Briefwechsel zwischen Alfred Lichtwark und Max Liebermann*, Hildesheim, Zürich and New York 2003

PHILADELPHIA 1989
C.B. Bailey et al., *Masterpieces of Impressionism and Post-Impressionism. The Annenberg Collection*, exh. cat., Philadelphia Museum of Art 1989

PHILADELPHIA/DETROIT/PARIS 1978–9
A. Jolles et al., *The Second Empire, 1852–1870: Art in France under Napoleon III*, exh. cat., Philadelphia Museum of Art; Detroit Institute of Arts; Grand Palais, Paris 1978–9

PHLIPPONNEAU 1956
M. Phlipponneau, *La Vie rurale de la banlieue parisienne*, Paris 1956

PINKNEY 1958
D.H. Pinkney, *Napoleon III and the Rebuilding of Paris*, Princeton 1958

PISSARRO 1993
J. Pissarro, *Camille Pissarro*, New York 1993

PISSARRO/DURAND-RUEL SNOLLAERTS 2005
J. Pissarro and C. Durand-Ruel Snollaerts, *Pissarro Catalogue critique de peintures*, 3 vols, Paris and Milan 2005

POLLOCK 1988
G. Pollock, *Vision and Difference: Femininity, Feminism and the Histories of Art*, London 1988

PONS-SOROLLA 2009
B. Pons-Sorolla, *Joaquín Sorolla*, London 2009

PROUDHON 1939
P.-J. Proudhon, *Du Principe de l'art et de sa destination sociale* (ed. C. Bouglé and H. Moysset), Paris 1939 (first published 1865)

REFF 1982
T. Reff, *Manet and Modern Paris*, Washington 1982

RENOIR 2001
J. Renoir *Renoir, My Father* (ed. R.L. Herbert), New York 2001

REWALD 1973
J. Rewald, *The History of Impressionism*, 4th edition, London 1973

REWALD/WEITZENHOFFER 1984
J. Rewald and F. Weitzenhoffer, *Aspects of Monet. A Symposium*, New York 1984

RIOUT 1989
D. Riout, *Les Ecrivains devant l'impressionisme*, Paris 1989

RIVIERE 1921
G. Rivière, *Renoir et ses Amis*, Paris 1921

ROBAUT 1965
A. Robaut, *L'Oeuvre de Corot par Alfred Robaut, catalogue raisonné et illustré, précédé par l'histoire de Corot et ses oeuvres par Etienne Moreau-Nélaton*, Paris 1905 (reprinted Paris 1965, with supplements 1948 and 1974)

ROBINSON 1869
W. Robinson, *Gleanings from French Gardens: comprising an account of such features of French horticulture as are most worthy of adoption in English gardens*, 2nd edition, London 1869 (first published 1868)

ROBINSON 1869 A
W. Robinson, *The Parks, Promenades and Gardens of Paris described and considered in relation to the wants of our own cities and of public and private gardens*, London 1869

ROBINSON 1870
W. Robinson, *The Wild Garden, or, Our Groves and Shrubberies made Beautiful*, London 1870

ROPER 1983
L. Roper, FLO, *a Biography of Frederick Law Olmsted*, Baltimore 1983

ROSENHAGEN 1908
H. Rosenhagen, *Uhde des Meisters Gemälde*, Stuttgart and Leipzig 1908

ROUSSEAU 1970
Jean-Jacques Rousseau, *Les Rêveries du promeneur solitaire* (ed. R. Bernex), Paris, London, Brussels and Lausanne 1970 (first published 1782)

RUBIN 1999
J.H. Rubin, 'Croquer le croquet: Manets Gartenpartie', in *Impressionisten: 6 französische Meisterwerke* (ed. S. Schultze), exh. cat., Städel Museum, Frankfurt; Musée d'Orsay, Paris 1999, pp.66–83

SAN FRANCISCO 1986
C.S. Moffett et al., *The New Painting Impressionism 1874–1886*, exh. cat., Fine Arts Museums of San Francisco 1986

SAND 1867
G. Sand, 'La Rêverie à Paris', in *Paris Guide*, vol.2, Paris 1867, pp.1196–1203

SARLET 1992
C. Sarlet, *Les Ecrivains d'art en Belgique 1860–1914*, Brussels 1992

SENSIER 1881
A. Sensier, *Jean François Millet Peasant and Painter* (translated H. De Kay), London 1881

SHENNAN 1996
M. Shennan, *Berthe Morisot: First Lady of Impressionism*, Stroud 1996

SHIKES AND HARPER 1980
R.E. Shikes and P. Harper, *Pissarro: His Life and Work*, London 1980

SIEVEKING 1899
A F. Sieveking, *In Praise of Gardens*, London 1899

SILVERMAN 1992
D. Silverman, *Art Nouveau in Fin-de-siècle France: Politics, Psychology and Style*, Berkeley, Los Angeles and Oxford 1992

SILVESTRE 1897
A. Silvestre et al., *Paris en plein air. Textes de MM. Silvestre, Céard, Maillard, etc*, Paris 1897

SIMPSON 2008
J. Simpson, 'Nature as a *Musée d'Art* in the French Fin-de-Siècle Garden: Uncovering Jules and Edmond de Goncourt's "Jardin de Peintre", in *Garden History*, vol.36, no.2, December 2008

SMART 1983–4
M. Smart, 'Sunshine and Shade: Mary Fairchild MacMonnies Low', in *Woman's Art Journal*, vol.4, no.2, autumn-winter 1983–4, pp.20–5

SPATE 1992
V. Spate, *The Colour of Time Claude Monet*, London 1992

STOCKHOLM/COPENHAGEN 2002–3
T. Gunnarsson et al., *Impressionism and the North. Late 19th-Century French Avant-Garde Art and the Art in Nordic Countries 1870–1920*, exh. cat., National Museum, Stockholm; Statens Museum for Kunst, Copenhagen 2002–3

STRONG 2000
R. Strong, *The Artist and the Garden*, New Haven and London 2000

STUCKEY 1985
C. Stuckey (ed.), *Monet: A Retrospective*, New York 1985

SUPPAN/TROMAYER 1981
M. Suppan and E. Tromayer, *Marie Egner eine Österreichische Stimmungsimpressionistin*, 2 vols, Vienna 1981

TABARANT 1947
A. Tabarant, *Manet et ses oeuvres*, 4th edition, Paris 1947

TERRASSE 2001
A. Terrasse (ed.), *Bonnard Vuillard Correspondance*, Paris 2001

THIEBAULT-SISSON 1927
F. Thiébault-Sisson, 'Un Nouveau Musée parisien: Les Nymphéas de Claude Monet', in *Revue de l'art ancien et moderne*, vol.52, 1927, pp.41–52

THOMSON 1998
R. Thomson (ed.), *Framing France: the representation of landscape in France, 1870–1914*, Manchester 1998

THOMSON 2000
B. Thomson, *Impressionism: Origins, Practice, Reception*, London 2000

THOMSON 2004
R. Thomson, *The Troubled Republic: Visual Culture and Social Debate in France 1889–1900*, New Haven and London 2004

TOULOUSE/PARIS 1983
Henri Martin 1860–1943. Etudes et peintures de chevalet, exh. cat., Association des Amis de l'Ecole des Beaux-Arts, Toulouse; Mairie annexe du 5e arrondissement, Paris 1983

TSCHUDI 1902
H. von Tschudi, *Edouard Manet*, Berlin 1902

TUCKER 1982
P. Hayes Tucker, *Monet at Argenteuil*, New Haven and London 1982

VARNEDOE 1988
K. Varnedoe, *Northern Light Nordic Art at the Turn of the Century*, New Haven and London 1988

VIENNA 1903
W. Bernatzik et al., *Entwicklung des Impressionismus in Malerei u. Plastik. XVI Ausstellung der Vereinigung bildender Künstler Österreichs Secession Wien*, exh. cat., Wiener Secession, Vienna 1903

VIENNA 1910
Manet-Monet, exh. cat., Galerie Miethke, Vienna 1910

VIENNA 1992
R. Schmidt , *Grenzenlos Idyllisch: Garten und Park in Bildern von 1880 bis heute*, exh. cat., Österreichische Galerie Wien in Schloss Halbthurn, Vienna 1992

VIENNA 2002
U. Storch and E. Doppler, *Gartenkunst. Bilder und Texte von Gärten und Parks*, exh. cat., Historisches Museum der Stadt, Vienna 2002

VIENNA 2007
A. Husslein-Arco (ed.), *Gartenlust. Der Garten in der Kunst*, exh. cat., Belvedere, Vienna 2007

WALTER 1966
R. Walter, 'Les Maisons de Claude Monet à Argenteuil', in *Gazette des Beaux-Arts*, vol. LXVIII, December 1966

WASHINGTON/HARTFORD 2000
P. Hayes Tucker, *The Impressionists at Argenteuil*, exh. cat., National Gallery of Art, Washington; Wadsworth Museum of Art, Hartford 2000

WATKINS 1994
N. Watkins, *Bonnard*, London 1994

WENIGER/MULLER 1991
P. Weniger and P. Müller, *Die Schüle von Plankenberg*, Graz 1991

WERTH 2002
M Werth, *The Joy of Life: the Idyllic in French Art c.1900*, Berkeley 2002

WHEELER 1899–1900
C. Wheeler, 'Content in a Garden', in *The Atlantic Monthly*, part 1, vol.85, 1899, pp.779–84; part II, vol.86, 1900, pp.99–105; part III, vol.86, 1900, pp.232–8

WHITE 1988
B.E. White, *Renoir: His Life, Art and Letters*, New York 1988

WILDENSTEIN 1974–91
D. Wildenstein, *Claude Monet: Biographie et catalogue raisonné*, 5 vols, Lausanne 1974–1991 (vol.I, 1840–81, 1974; vol. II, 1882–6, 1979; vol.III 1887–98, 1979; vol.IV 1899–1926, 1985; vol.V, Additions, Drawings, Pastels, 1991)

WILDENSTEIN 1996
D. Wildenstein, *Monet, or, The Triumph of Impressionism*, 4 vols, Cologne, 1996

WILDENSTEIN 2002
D. Wildenstein et al., *Gauguin. A Savage in the Making. Catalogue raisonné of the paintings (1873–1883)*, 2 vols, Milan 2002

WILLSDON 1996
C.A.P. Willsdon, 'Klimt's Beethoven Frieze: Goethe, *Tempelkunst* and the Fulfilment of Wishes', in *Art History*, vol.191, March 1996, pp.44–73

WILLSDON 2000
C.A.P. Willsdon, *Mural Painting in Britain 1840–1940: Image and Meaning*, Oxford 2000

WILLSDON 2003
C.A.P. Willsdon, '"Promenades et plantations": Impressionism, conservation and Haussmann's reinvention of Paris', in Fowle/Thomson 2003, pp.107–24, Aldershot 2003

WILLSDON 2004
C.A.P. Willsdon, *In the Gardens of Impressionism*, London 2004

WILLSDON 2007
C.A.P. Willsdon, 'Impressionistische Gartenmalerei und *Weg in Monets Garten*', in Vienna 2007, pp.131–40

WILLSDON 2008
C.A.P. Willsdon, 'Petali, profumi e brezze: i giardini di Renoir', in *Renoir: La Maturità tra classico e moderno* (ed. K. Adler), exh. cat., Complesso del Vittoriano, Rome 2008, pp.107–19

WITHAM FOGG 1976
H.G. Witham Fogg, *History of Popular Garden Plants from A to Z*, London 1976

WITTMER 1991
P. Wittmer, *Caillebotte and his Garden at Yerres*, New York 1991

WOLLONS 2005
R. Wollons, 'Kindergarten Movement', in *The Electronic Encyclopaedia of Chicago* 2005, at http://www.encyclopaedia. chicagohistory.org/pages/691.html (print version published Chicago 2004)

ZOLA 2000
E. Zola, *Ecrits sur l'art* (ed. J.-P. Leduc-Adine), Paris 2000

ZURICH 2004–5
C. Becker et al., *Monet's Garden*, exh. cat., Kunsthaus, Zurich 2004–5

Author's Acknowledgements

The very diversity of Impressionist gardens in this book – from spacious public parks to private floral havens, in Europe as well as the USA – has produced a correspondingly wide-ranging debt of gratitude. Galleries and collectors internationally have generously lent their treasures to the accompanying exhibition, whilst artists' descendants as well as botanists and art historians have given as freely of their knowledge and time. I am extremely grateful to them all.

Special thanks are due to Michael Clarke, Director of the National Gallery of Scotland, for responding so enthusiastically to my suggestion of Impressionist gardens as the theme for the exhibition; I have benefited greatly from his knowledge and insights in preparing this book. Amongst his colleagues at the Gallery, I am particularly grateful to Dr Frances Fowle (Senior Curator of French Art and Lecturer in History of Art, University of Edinburgh) and Ros Clancey (Registrar). At the Museo Thyssen Bornemisza in Madrid, the ready and sympathetic collaboration of Guillermo Solana, Chief Curator; Paula Luengo, Assistant Curator; and their colleagues has been invaluable in the selection of works and development of the project.

The enthusiasm and expertise of David Mitchell (Curator-Projects) and Dr Ian Edwards (Head of Exhibitions) at the Royal Botanic Garden, Edinburgh, have enabled the exhibition and book to forge an enriched partnership between the Royal Botanic Garden, the National Gallery of Scotland, and the University of Glasgow, and I am especially grateful to David Mitchell for his botanical identification of plants and flowers in Impressionist paintings. This has added a unique dimension to the work; bringing to light previously unsuspected layers of meaning in individual paintings, it enhances our understanding both of the Impressionist garden and of its artists' varied intentions.

Amongst those who have generously shared with me their knowledge of individual artists, or given access to archives, collections, or other practical help, I would like to give warm thanks to Dr Kathy Adler; Professor Philippe Bordes, Université Lyons II; Dr Andreas Blühm, Director, and Dr Barbara Schaeffer, Curator, Wallraf-Richartz Museum, Cologne; Katherine Bourguignon, Associate Curator, Terra Foundation for American Art; Gérard Bruyère, Documentation Department, Musée des Beaux-Arts de Lyons; Vivien Hamilton, Research Manager Art, Glasgow Museums; Yann Farinaux-Le Sidaner; Marion Lawson, Librarian, Department of History of Art, University of Glasgow; Sophie Lévy, Curator, Musée d'art moderne, Lille Métropole; Claudette Lindsey, Secretaire générale, and her colleagues, Fondation Claude Monet, Giverny; Emeritus Professor Kenneth McConkey, University of Northumbria; Claire Pace, Honorary Senior Research Fellow, Department of History of Art, University of Glasgow; Brigitte Potiez-Stoh; Anne Pritchard, Assistant Curator of Historic Art, National Museum Wales; Dr Christopher Riopelle, Curator of Post-1800 Paintings, National Gallery, London; Dr Franz Smola, Sammlungskurator, Leopold Museum-Privatstiftung, Vienna; Professor Richard Thomson, Watson Gordon Professor of Fine Art, University of Edinburgh; Patricia Truffin, Assistante de Conservation, Palais des Beaux-Arts de Lille; Dr David Weston, Assistant Director, Glasgow University Library; Ernst-Christian Wolters, administrator of the family assets of Ernst Eitner; and Professor Alison Yarrington, Richmond Professor of Fine Art, University of Glasgow.

I would like also to express my appreciation to the Institut de France for allowing me to consult Monet's library at Giverny, and to the staffs of the Centre de Documentation, Musée d'Orsay; Bibliothèque de la Société nationale d'horticulture de France; Lindley Library, Royal Horticultural Society, London; Royal Botanic Garden Library, Edinburgh; and Glasgow University Library, for their help with access to material in their care. Study Leave from the University of Glasgow Faculty of Arts was invaluable in helping me to complete the writing of this book.

Finally, but not least, I am grateful to my parents for their ever-stimulating insights and cheerful encouragement; this book is very affectionately dedicated to them.

DR CLARE A.P. WILLSDON
Glasgow 2010

Acknowledgments

PHOTOGRAPHIC ACKNOWLEDGEMENTS
Figs 5, 6, 7, 8, 18, plate 67 © RMN (Musée
d'Orsay) / Hervé Lewandowski; figs 9, 13
© bpk / Nationalgalerie, Staatliche Museen
zu Berlin. Photo: Jörg P. Anders; fig.10,
plates 4, 5, 31, 59, 61, 68, 69, 82 Antonia
Reeve Photography; fig.14 © Ipswich
Borough Council Museums and Galleries,
Suffolk, UK / The Bridgeman Art Library;
fig.15, plates 8, 51 © 2010. Image copyright
The Metropolitan Museum of Art /
Art Resource / Scala, Florence; fig.16
© Cleveland Museum of Art, OH, USA /
Lauros / Giraudon / The Bridgeman Art
Library; fig.17 © Hamburger Kunsthalle,
Hamburg, Germany / The Bridgeman
Art Library; fig.19 © 2009. Wadsworth
Atheneum Museum of Art / Art Resource,
NY / Scala, Florence; fig.20, 26, plates
6, 74, 86 © Belvedere, Vienna; fig.21
© Archives Wildenstein Institute, Paris;
fig.22 © The Art Institute of Chicago,
IL, USA / The Bridgeman Art Library;
plates 1, 2, 22 © Lyon MBA / Photo Alain
Basset; plates 9, 27, 28, 36, 55, 87 © foto
Giuseppe Schiavinotto; plate 10 © RMN
/ Daniel Arnaudet; plate 11 © Hervé
Maillot; plates 12, 25 © V&A Images /
Victoria and Albert Museum, London;
plate 14 © Musée Fabre de Montpellier
Agglomération - photograph by Frédéric
Jaulmes; plates 15, 19, 62 Image courtesy
of the Board of Trustees, National Gallery
of Art, Washington; plates 16, 21 © Museo
Thyssen-Bornemisza, Madrid. Fotografía:
José Loren; plate 17 © U. Edelmann -
Städel Museum / ARTOTHEK; plate 20
© Museums Sheffield / The Bridgeman
Art Library; plate 23 © Tate, London
2010; plate 24 © Studio Monique Bernaz,
Geneve; plates 26, 57 © Ole Haupt; plate 29
Rheinisches Bildarchiv Köln; plates 30,
50 Prudence Cuming Associates; plate 38
Photograph by Michael Fredericks; plate 44
© RMN / Agence Bulloz; plates 46, 56,
72, 94, 96 © Colección Carmen Thyssen-
Bornemisza en depósito en el Museo
Thyssen-Bornemisza, Madrid. Fotografía:
Hélène Desplechin; plate 47 © Whitford
Fine Art, London, UK / The Bridgeman
Art Library; plate 48 Photo: Kunstmuseum
Basel, Martin P. Bühler; plate 49 Photo:
Malcom Varon © 2009. Image copyright
The Metropolitan Museum of Art Art
Resource / Scala, Florence; plate 58
© Foto: Staatsgalerie Stuttgart; plate 60
© Leeds Museums and Galleries (City
Art Gallery) UK / The Bridgeman Art
Library; plates 65, 92 © Jacques Lathion;
plates 73, 75 © Bildarchiv Preussischer
Kulturbesitz, Berlin, 2010; plate 76
Rheinisches Bildarchiv Köln; plate 77
© Hamburger Kunsthalle / bpk. Foto: Elke
Walford; plate 78 Photography courtesy
of the Denver Art Museum; plate 81
© RMN (Musée d'Orsay) / Gérard Blot;
plate 89 © RMN / Thierry Le Mage; plate 91
© Daniel Lefebvre; plate 92 © Kunsthaus
Zug, Alois Ottiger; plate 95 © Musée
d'art et d'histoire, Ville de Genève;
plate 97 © Fondation Surpierre, repro
scan Rheinisches Bildarchiv Köln. All
other photography is copyright the named
institutions.

COPYRIGHT ACKNOWLEDGEMENTS
Fig.6, plates 47, 66 © DACS 2010; figs 23, 24,
plates 46, 67, 88, 89, 91, 93 © ADAGP, Paris
and DACS, London 2010; plates 35, 44, 55,
74, 77, 86 © Artist's Estate; plate 90 © By
courtesy of Felix Rosenstiel's Widow & Son
Ltd., London on behalf of the Estate of Sir
John Lavery.

COLLECTION ACKNOWLEDGEMENTS
Fig.2, plate 17 Property of Städelscher
Museums-Verein e.V.; fig.3; fig.15 H.O.
Havemeyer Collection, Bequest of Mrs
H.O. Havemeyer, 1929. Acc.n.: 29.100.128;
fig.16 The Cleveland Museum of Art,
Ohio, Gift of the Hanna Fund, 1953.155;
fig.19 Bequest of Anne Parrish Titzell.
1957.614; fig.22 Helen Birch Bartlett
Memorial Collection, 1926.224; fig.25 Mr
and Mrs Lewis Larned Coburn Memorial
Collection, 1933.433; plate 3 The Cleveland
Museum of Art, Ohio, Gift of Mr and
Mrs Noah L. Butkin 1977.116; plate 8 The
Metropolitan Museum of Art, New York,
Bequest of Maria DeWitt Jesup, from
the collection of her husband, Morris
K. Jesup, 1914. Acc.n.: 15.30.24; plate 13
Cincinnati Art Museum, Gift of Mark P.
Herschede. Accession #: 1976.433; plate 15
National Gallery of Art, Washington DC,
Collection of Mr and Mrs Paul Mellon;
plate 18 The Art Institute of Chicago, Mr
and Mrs Martin A. Ryerson Collection,
1933.1153; plate 19 National Gallery of Art,
Washington DC, Gift of Janice H. Levin,
in Honor of the 50th Anniversary of the
National Gallery of Art; plate 23 Tate:
Purchased 1928; plate 32 National Gallery
of Victoria, Melbourne, Felton Bequest,
1926; plate 34 Inv. 2008–2–94, (dépôt de
l'Etat du 9 décembre 1885, transfert de
propriété de l'Etat à la ville de Bernay le 13
octobre 2008) Musée municipal, Bernay
(Eure), France Cliché Jean-Louis Coquerel;
plate 35 Terra Foundation for American
Art, Daniel J. Terra Collection, Chicago,
1999.35; plate 37 Worcester Art Museum,
Worcester, Massachusetts, Theodore T.
and Mary G. Ellis Collection; plate 38 The
Hyde Collection, Glens Falls, New York
1971.22; plate 45 Terra Foundation for
American Art, Daniel J. Terra Collection,
Chicago, 1988.25; plate 49 The Metropolitan
Museum of Art, New York, The Mr and
Mrs Henry Ittleson Jr Purchase Fund, 1959.
Acc.n.: 59.142; plate 51 The Metropolitan
Museum of Art, New York, Gift of Mr
and Mrs Arthur Murray, 1964. Acc.n.:
64.156; plate 52 Minneapolis Institute of
Arts, Gift of Mrs C.C. Bovey and Mrs
C.D. Velie; plate 53 Terra Foundation for
American Art, Daniel J. Terra Collection,
Chicago, 1992.62; plate 62 National Gallery
of Art, Washington DC, Ailsa Mellon
Bruce Collection; plate 66 The Cleveland
Museum of Art, Ohio, Gift of Leonard C.
Hanna, Jr., 1950.582; plate 78 Denver Art
Museum, Funds from Helen Dill bequest,
1935.14; plate 79 The Museum of Fine Arts,
Houston, Gift of Mrs Harry C. Hanszen;
plate 91 Musée de la Chartreuse, Douai,
Inventory no. 2788; plate 97 Fondation
Surpierre. On loan to the Wallraf-Richartz-
Museum & Fondation Corboud, Cologne ,
Inv. Nr. WRM Dep. 929.

Index